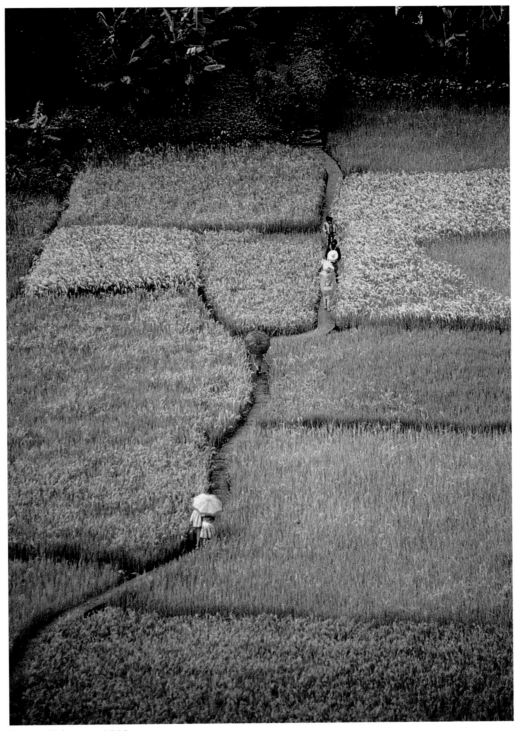

Baguio, Philippines, 1989

Photographs Edited by Paul Chesley and Tom Walker
Produced by Paul Chesley
Designed and Packaged by Tom Walker
Edited by Dawn Sheggeby

Editorial Advisors:
Gretchen Chesley Lang, Margaret Chesley,
Corinne W.L. Ching, Gita Ghei, Carole Lee Vowell
Technical Production: Leilani Ng, Jonathan Kingston, Raz Keren
Copy Editor: Charmae Lewis

Photographs from the Collection of Paul Chesley
Photographs by Paul Chesley@2013
www.paulchesley.com
Original transparencies scanned by National Geographic Society Imaging Lab

PAUL CHESLEY

A PHOTOGRAPHIC VOYAGE

Photographs by Paul Chesley

Essays and Reflections by Keith Lorenz

Introduction by Bert Fox

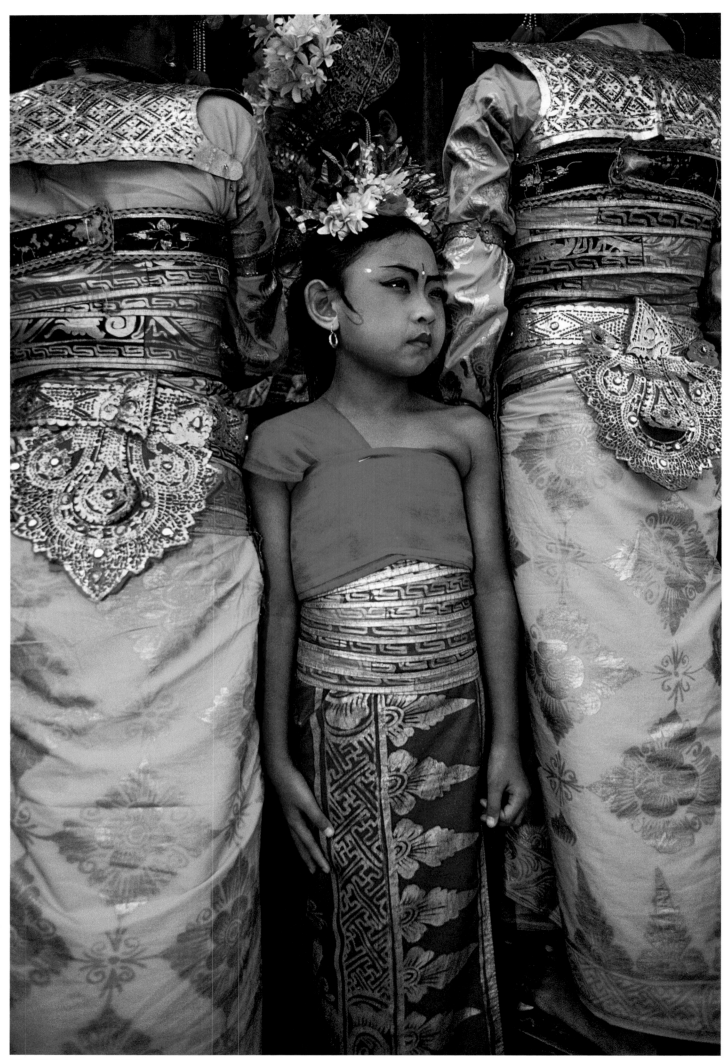

Ubud, Bali, Indonesia, 1989

Dedication

I lovingly dedicate this book in memory of
my parents, Jean and Frank;
and to my sisters, Margaret and Gretchen,
and their children and grandchildren.

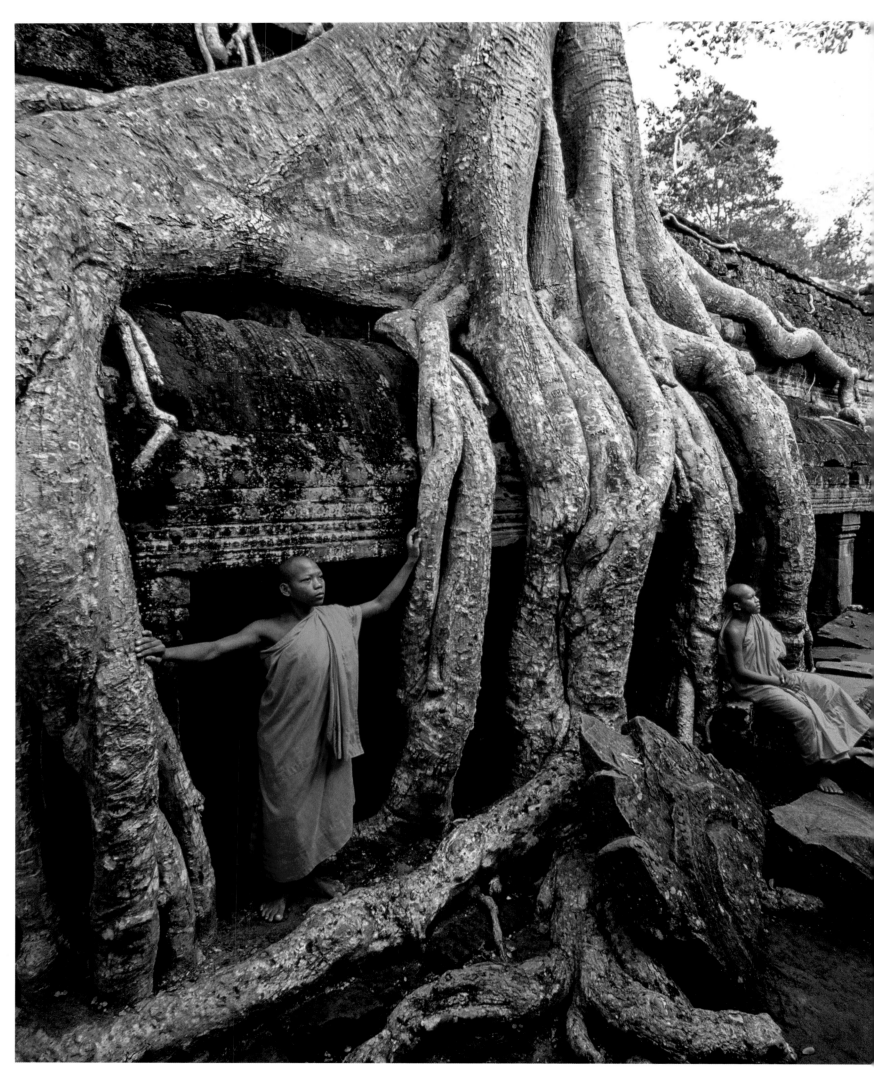

Ta Phrom, Cambodia, 1996

Table of Contents

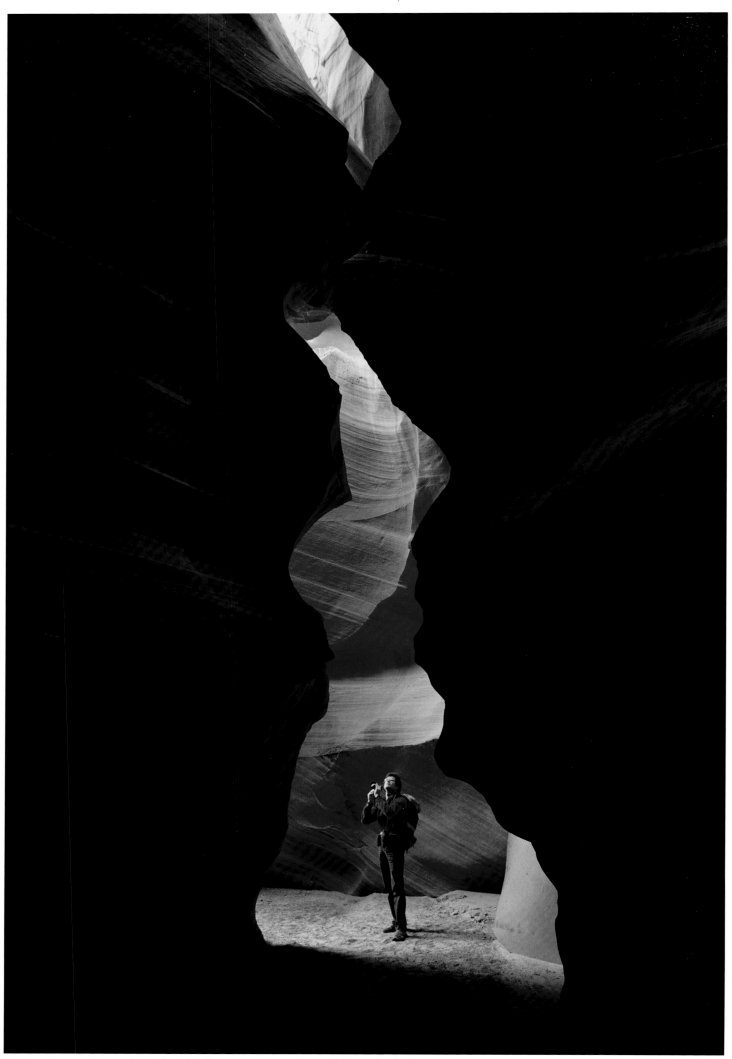

Antelope Canyon, Arizona, 1982, Paul Chesley on assignment. Photograph by Frank Chesley

Preface

Flying high above Western Australia's remote Kimberley region, I felt as though time were standing still—such a beautiful, pristine landscape to see from the air. Suddenly there was silence! The tiny Cessna's single engine had quit. My 19-year-old bush pilot, Kenny, fought to restart it. As we drifted rapidly toward earth, he said matter-of-factly, "We won't live the night if we have to ditch in the mangroves."

I assumed that he was referring to the dreaded saltwater crocodiles—or perhaps the myriad of poisonous snakes down there. Now we were plummeting! Seconds felt like hours.

Just a thousand feet above the ground I heard the engine start. What a relief! I took a few more aerial photos, but by now the sun had gone down and it was getting dark. On the way back to Kununurra, Kenny explained to me that because I had asked him to tip up one wing for so long while I was shooting the sunset, we had run out of fuel in one tank.

As we approached the field next to his family's farm, where we had taken off a few hours earlier, it was almost pitch black. How would we land with no runway lights? Kenny said, "No problem, mate. Dad will be out there with a flashlight." And indeed he was—the plane landed smoothly. This was but one of many adventures I experienced on assignments around the world in my forty years as a photographer.

Growing up in rural Red Wing, Minnesota, I always had a camera in hand. When I was given my first Kodak Brownie at the age of five, I was still reading *The Travels of Babar.* The drawings of exotic, unknown places first inspired my urge to explore. My wanderlust was further fueled hearing my great-aunt Helen's tales from her around-the-world trip in 1925, as a curator with the Field Museum of Natural History of Chicago. She had a wonderful way of telling stories that sparked my imagination.

We were always a "photographic family." Thanks in part to my father's chemistry background, we had a well-equipped darkroom. I loved the atmosphere, the smells of chemicals, the soft yellow glow of the safe light, seeing the images beginning to appear, using tongs to keep away the air bubbles. My mother had a Zeiss Ikon Nettar, and later a Zeiss Ikon Ikoflex. My father had a Bell & Howell 16mm movie camera, a Contax Zeiss 35mm, and a 4.5 Graflex. Like me, my two sisters started with Kodak Brownies. We also had several of the early Polaroid cameras around the house, just to capture a few family memories. When I was seventeen, it was a big moment when I got my first professional camera, a Nikon 35mm.

We took stills and movies of every activity, especially family vacations. I remember these three-week-long trips in the 1950s as the highlights of my summers. We would all pile in the car and head either east, to Cape Cod to visit my grandmother, or west, to Yellowstone, Yosemite, Grand Canyon and Glacier national parks. I remember my sister Gretchen once took a roll and a half of photos during a single eruption of Old Faithful Geyser. Years later, I would go on assignments to all these same places that I had grown to love in my youth.

In addition to the American West, I was captivated by Asia early on. My first trip there was to Japan in 1973. I went to shoot some stories for myself, hoping to sell a few photos to the magazines and launch my career as a professional photojournalist. I shot hot springs, the bullet train, and villages

set in the beauty of the Japanese countryside. Later, the German magazine *GEO* assigned me to make cover stories on each of these subjects that I had started documenting on my own.

Soon afterward, I started working for the National Geographic Society. Over three decades, my assignments took me from the jungles of Borneo to the tops of the French Alps. In the first ten years of my career, I traveled to six continents. I was fortunate to explore many new and exotic locations and meet interesting people across the world, many of whom remain my lifelong friends.

I have always believed in the power of photography to evoke a distant culture by capturing the everyday lives of its people. And, beyond being a rewarding effort for the photographer, I believe that images can, in the long run, help peoples and cultures understand each other better.

With this in mind, I had long considered doing a book that would bring together some of my best work from many years in the field. When I moved to Honolulu from Colorado in 2005, and settled into my new studio, I began the daunting task of editing 18,000 yellow boxes of slide film, a process of discovery that took ten months to complete. National Geographic had only published the images that they wanted, and had sent me back the rest. And of course, there were outtakes from dozens of stories I had shot for other magazines and book projects. During this editing process, I came upon a multitude of pictures that I had never viewed before—many of these became the top selects of my photographic archives. The best are in this book, dozens seen here for the first time in print.

About this time I met Keith Lorenz, who lived in Honolulu and had long worked in Southeast Asia as a news correspondent—in many of the same countries where I had been on assignment. We knew many of the same people. Eventually we had the idea to work on my book together. Keith would write the essays to complement the photographs, but not specifically to mirror the images. He would add personal reflections to recapture the flavor of years past.

We talked about the countries that we would focus on. It was remarkable how many of our

memories overlapped, even though some of Keith's early travel experiences went back to the 1950s, twenty years before mine. This gave the combined text and photographs a longer history. The book took unexpected twists and turns as we discussed the varied regions, as well as the milestones, that formed the record of my life's work. We showed the first couple of chapters to friends in the photojournalism and art worlds, and got a very favorable response, so we continued. Chapter after chapter fell in place, with the talented assistance of a great design and editorial team.

I hope that the pages ahead will take you on a colorful carpet ride, as Babar and Queen Celeste did for me as a child, and will conjure up a touch of magic at times. It has been a privilege and an honor that so many remarkable people have shared their lives with me through the lens of my camera.

Paul Chesley

Paul Chesley
Honolulu, 2013

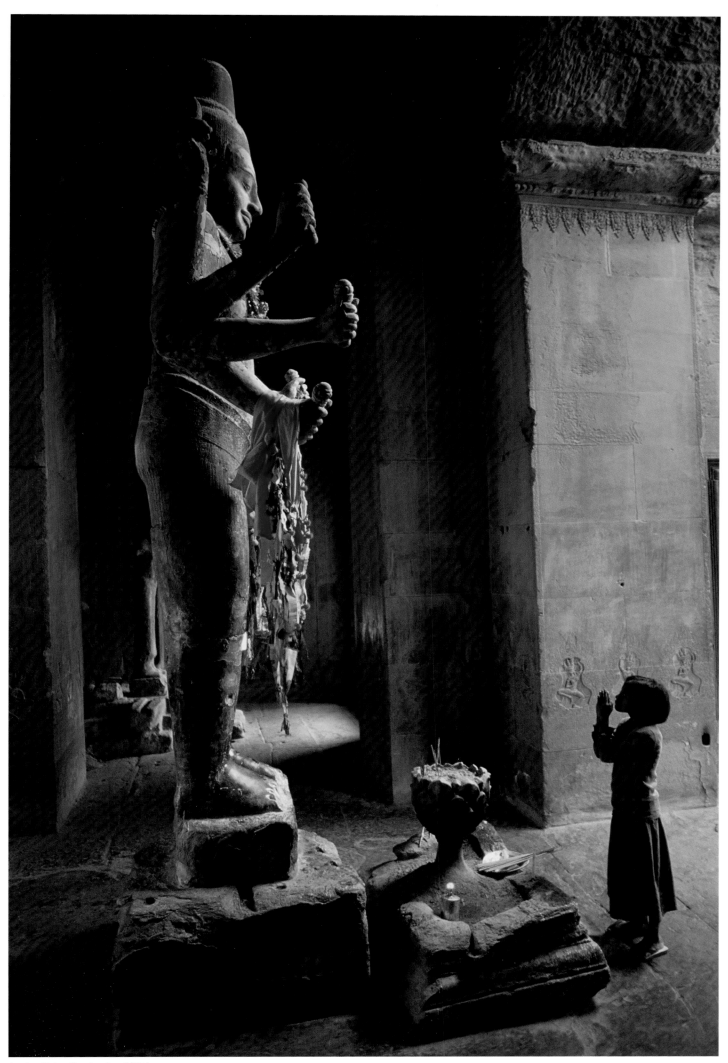

Angkor Wat, Cambodia, 1996

Foreword

I was introduced to Paul Chesley by mutual friends on the terrace of the Outrigger Canoe Club in Honolulu in 2005. We ordered ginger ale bitters from a waitress in tailored khaki shorts. Sailboats and small yachts bobbed off the beach. The sun was commencing its downward arc toward another breathtaking Pacific finale. The ripple of a piano and a ukulele drifted from the reception area, enhancing the twilight mood.

"You look a tad familiar," I said. "Were you in Luang Prabang a few years back? Or was it Phnom Penh?"

"Why, yes," said Paul. "Both places are on my rounds. Do you know Yvan Outrive?"

"Of course!" I exclaimed. "Perhaps we all had a drink at the Raffles together."

It turned out that Paul knew many of the same people I had become acquainted with during my quarter-century traipsing around Southeast Asia and Oceania.

It seemed that for years, we had just missed one another by a hair's breadth in Bali, Bangkok, or Manila. Soon we were exchanging names of photographers, journalists, publicists, writers, and art dealers, as well as miscellaneous charlatans from the common expatriate rolodex.

At the time of this meeting, Paul was in the process of moving to Honolulu from Aspen, Colorado, where decades earlier he had launched his career shooting for the National Geographic Society and other publications.

Paul, I could see, was not just another purveyor of travel pictures: a Hindu temple here, a smoking volcano there! Here was an explorer of the old breed! I would discover that what Paul loved best was venturing beyond the comforts of the modern world, seeking to capture the essence of remote peoples and cultures.

Soon it seemed to me that, whether I happened to be in a dentist's office, a hotel lobby, an airport newsstand—or even the decaying veranda of a guest house in Sarawak—I would find a publication with a photograph by Paul Chesley. I got the impression that, through the years, Paul had often arrived in a place a day or two ahead of me, and then vanished—with a secret or two on film that I had totally overlooked for my own story, in my haste to shower, put up my feet, and order a gin and tonic.

So, now at last, I had cornered him in Honolulu. Pity, by this time many of the world's exotic places had devolved into carbon copies of each other, urban sterility, and numbed youth glued to tiny blue screens. I wondered, what was there left to photograph?

This was more reason to preserve the passing moment, to treasure the fleeting serendipity of one's vanished youth, I thought. How well Joseph Conrad had put it, "Our weary eyes looking still, were looking always, looking anxiously, for something out of life, that while it is expected is already gone—has passed unseen, in a sigh, in a flash—together with the youth, with the strength, with the romance of illusions."

Port Louis, Mauritius, 1993

From Bhutan to Bali, from the Galápagos to the Rockies, from China to Yap, Paul has captured not only Conrad's "romance of illusions." He has also caught the magic of reality in thousands of instants. I am delighted to write the essays for this *Photographic Voyage* through an artist's life, starting when Paul took his first photograph at the age of five and began, to quote Conrad, "looking anxiously, for something out of life."

Keith Lorenz

Keith Lorenz
Honolulu, 2013

Introduction

THE EYE OF
THE BEHOLDER

By Bert Fox

It was the summer of 1994. In a grueling late-night voting session, five picture editors were looking at slides projected on a large screen, selecting the best images to include in the book *A Day in the Life of Israel*, shot by more than sixty photographers in a single day. From the darkness, Howard Chapnick passed judgment on the photograph currently up for debate. "Well, it's no Paul Chesley!" The bar had been set—and it was high. The phrase "It's not a Chesley!" became our somewhat humorous shorthand to mean, "It's good—but it's not great."

Like all "Day in the Life" projects, this one was a whirlwind. The book's director of photography, Peter Howe, had gathered a group of photo editors, including Laurie Kratochvil, Sandra Eisert, Howard Chapnick, and me, to pore over the 100,000 pictures shot for the project, and choose the best to be included in the book. With so many of the world's best photojournalists involved, these projects were extremely competitive. Paul Chesley was not only the most prolific photographer on this project— shooting 94 rolls of film in that single day—but he also had the most pictures selected for publication: fourteen.

That's where I first saw Paul's work—by opening yellow slide boxes with his name scribbled on their sides, and looking through them frame by frame. The initial edit of a roll of film is a bit like watching a movie in slow motion. When I am editing photographs, I pull "moments" that come together either through gesture or touch or expression. The good pictures seem to leap at me; something inside me reacts on a gut level. I also look

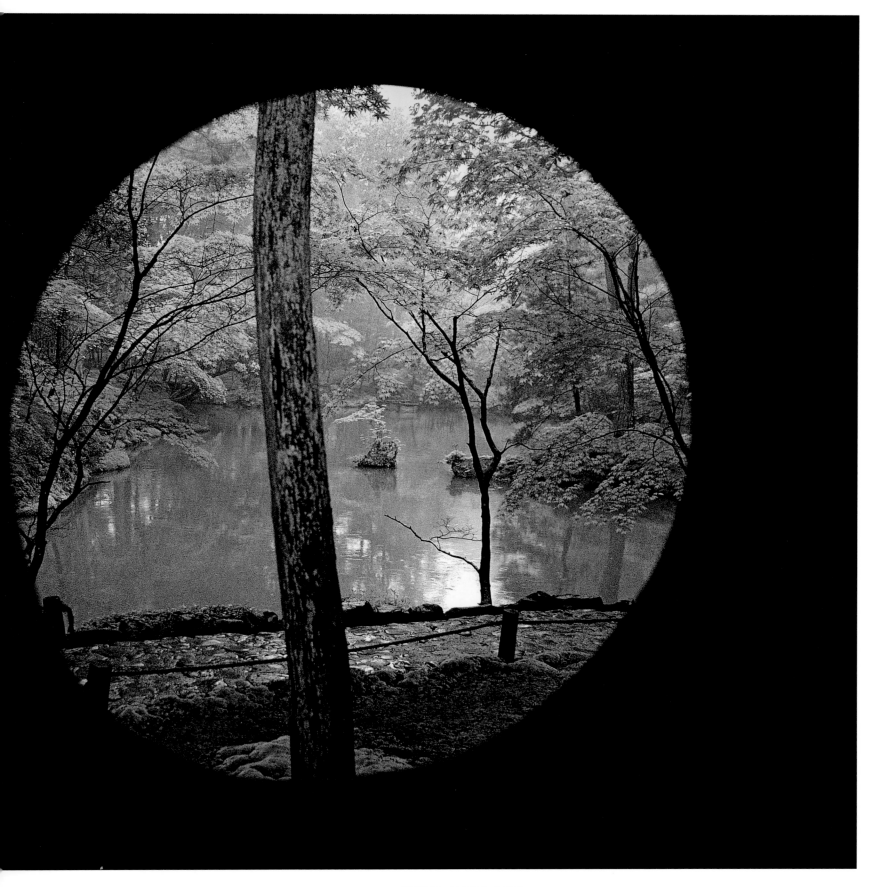

KYOTO, JAPAN, 1988
View from a tea house in Saiho-ji Temple.

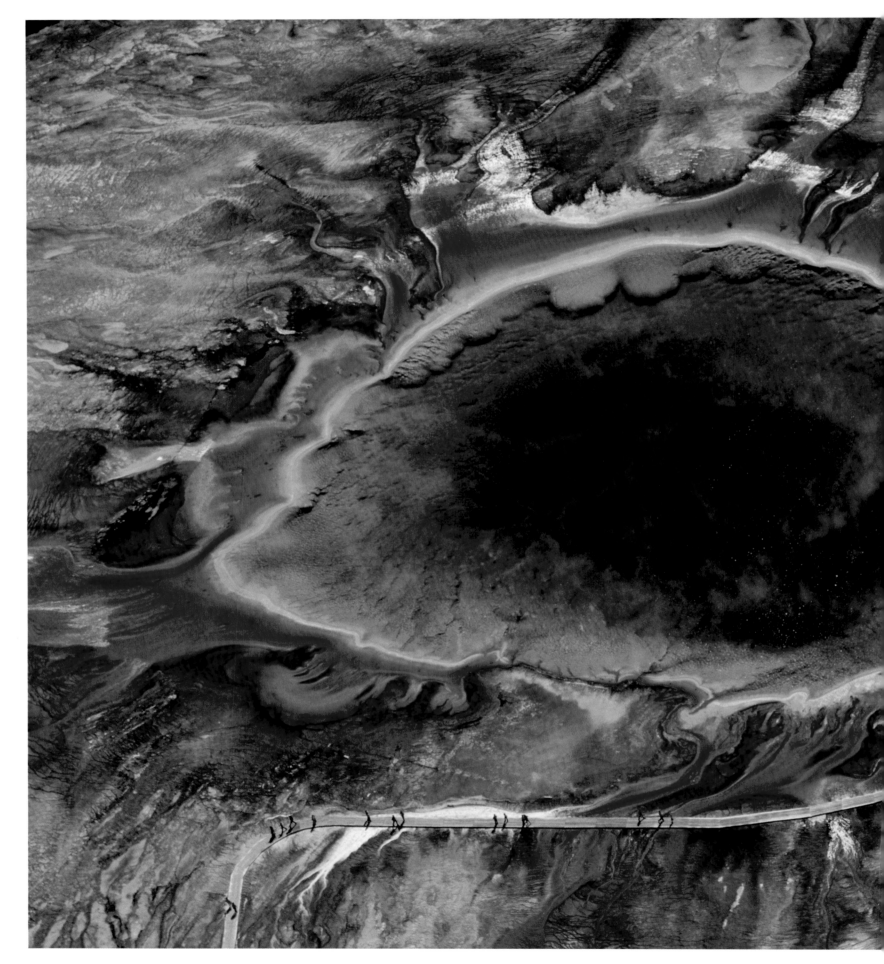

YELLOWSTONE NATIONAL PARK,
WYOMING, 1977

The vibrant colors of the Grand Prismatic Spring in the
Midway Geyser Basin are the result of thermophilic bacteria,
which thrive in the pool's over-160°F temperatures.

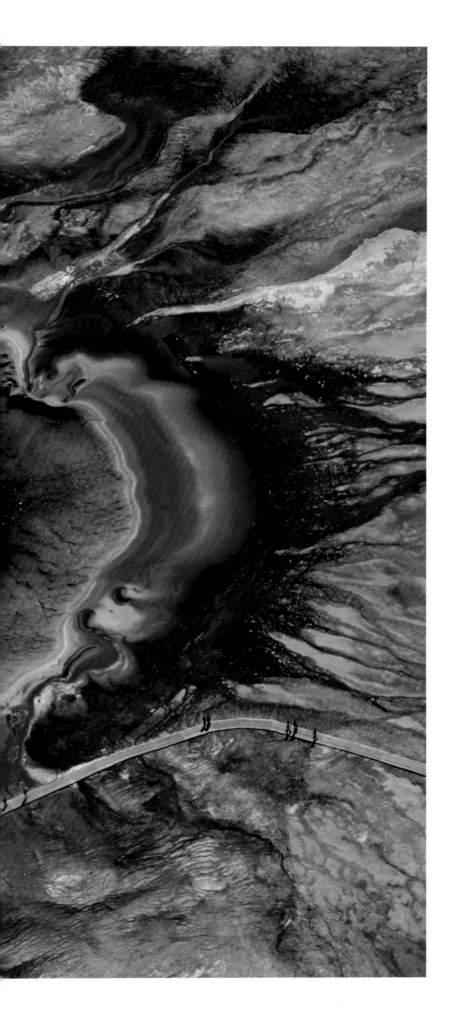

for images lacking "visual noise"—annoying light, color, or objects that take away from a picture's impact.

As I reviewed Paul's unedited pictures from that one day in Israel, I could see how he saw. I felt like I was moving with him around the room. He seemed to be invisible to the people he photographed. When they moved so did he. His best frames captured emotion and intimate interaction, set against a cultural context.

Great photographers, like Paul, don't just "grab" moments. They lead the viewer through their pictures by their choice of lens and point of view, carefully creating a backdrop that will drive the viewer's eye to the most important part of the picture. The photographer examines the room, looking for optimum angles and the perfect light; and then captures emotive moments as they arise. If I can read his subjects' feelings weeks later on my light table, he has succeeded. From that first edit, Paul's vision made an impression on me. The human condition unfolded in his pictures.

Fast-forward two years. It's 1996 and I've joined the picture editing staff of *National Geographic* magazine. Unlike "Day in the Life" book projects, stories for the magazine would last a year or two from inception to print. Our resources, time, and effort knew few limits. Assignments lasting several months gave photographers the opportunity to go beyond the obvious and search for images with visual complexity and deeper meaning. The National Geographic Society's visual culture spawned a golden age of photography.

Paul had a long association with the Society that began in the late 1970s after he made a stunning aerial photograph of a Yellowstone hot spring (*left*). The image, published on the cover of *GEO* magazine, caught the eye of Bob Gilka, *National Geographic*'s legendary director of photography. Gilka was so impressed with Paul's portfolio that he gave him an assignment shooting a story on puffer fish for the magazine.

Paul would ultimately find himself shooting regularly for National Geographic's book division. In 1988, Paul was assigned to shoot two stories in Japan for the book *Exploring Your World*. He would be making pictures in two closed societies: sumo wrestlers and the geisha. It seemed the chances were slim that any outsider would be able to make intimate, natural pictures in these

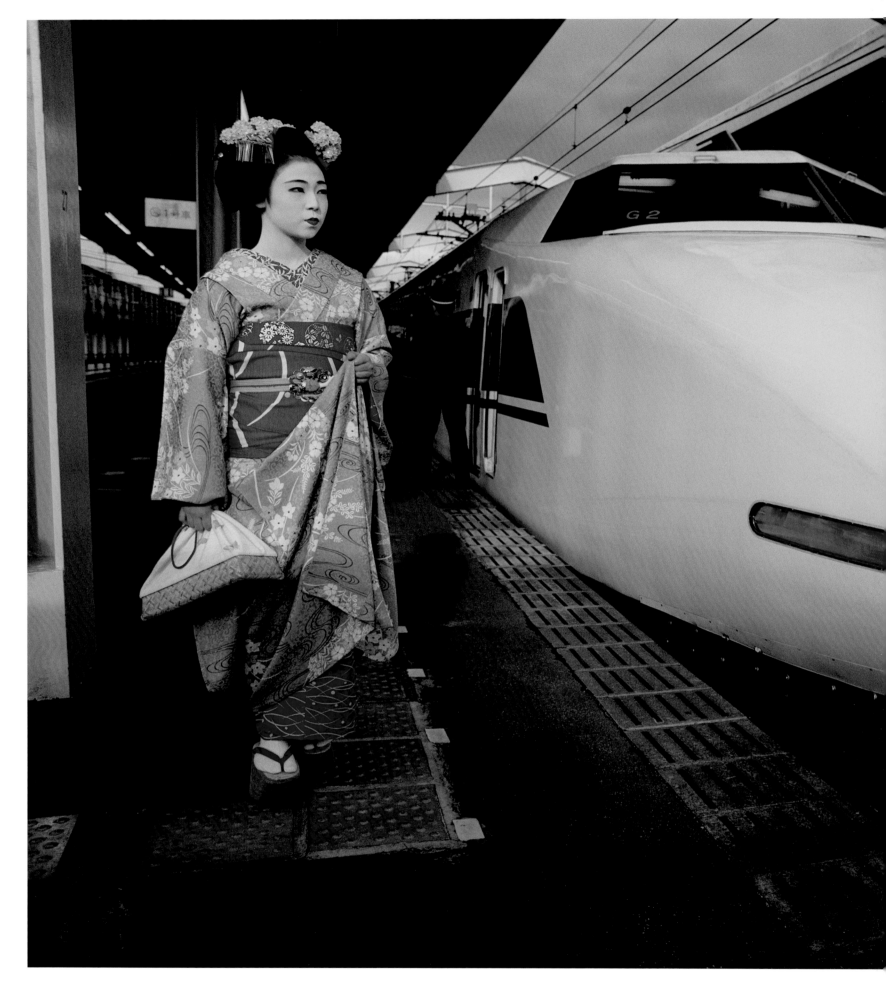

KYOTO, JAPAN, 1988

A *maiko* (apprentice geisha) boards a high-speed
bullet train to take her to the nearby city of Osaka
where she will entertain at a dinner party.

environments. Fortunately, Paul had time to acquaint himself with his subjects and see how they lived, and to develop a mutual trust. Slowly, the secret moments of their cultures unfolded. His resulting pictures were voyages of discovery that revealed both persona and ritual.

Paul also shot the pictures for two National Geographic books on the West: *High Country Trail Along the Continental Divide*, in 1981, and *The Rockies, Pillars of a Continent*, in 1996. The second was a herculean assignment that lasted a year and took Paul from Mexico to the Canadian border over four seasons.

In those days, all the exposed film was shipped from the photographer to our headquarters for processing and feedback. Compared with digital photography's instant review, it was a slow and tedious process. Imagine, you are a photographer working in some isolated corner of the world, waiting a week or more for assurances from your editor that you had "made the picture."

On Paul's yearlong Rockies assignment, he shot more than 1,000 rolls of film, and didn't see a frame until the end, when he traveled to National Geographic's headquarters in Washington, D.C. He spent two months alone in a borrowed office, looking at every picture. He pulled about a thousand selects to show the book's illustration editor, Charles Kogod. Of these, 150 made it into the book. Three of them, in particular, were what brought me together with Paul once again.

At *National Geographic*, I was always on the prowl for great visual stories. That search brought me back to Paul. I'd become enthralled by the geology of the mountains of the West. In 1997, I proposed a story to my editors at the magazine about the origins of the Rocky Mountain range, illustrated with aerial landscapes of what remains today after eons of metamorphosis.

I would begin my search for images with Paul's pictures. I remembered his spectacular image of an eight-mile-long volcanic dike radiating from the base of Shiprock in northwestern New Mexico (*see page 136*). Another showed the sun-drenched cliffs of the Chinese Wall in Montana's Bob Marshall Wilderness Complex. A third showed a blue-and-white sky filled with snow blowing off a ridge in Wyoming's Teton Range (*see page 134*). These three images would be the cornerstones of my story, and Paul's work from the Rockies would be the richest source to explore for the remainder of the pictures.

I contacted Paul, who was then based in Aspen, and asked if I could come to his Colorado office and spend a week looking through his outtakes. He said sure, and a few days later I was stooped over his light table at Photographers Aspen. I began looking for images, surrounded by thousands of boxes of color slides.

Paul's files were well-organized, thanks to years of work by his project manager, Carole Lee Vowell, so we were able to review film at a furious pace. Unlike many other successful photographers, Paul is a very good editor of his own work, and he had not left many hidden gems in those boxes of outtakes. However, Paul's original selects proved fertile ground for my story. As my stay in Aspen grew into a week, the number of favorite pictures I had gathered grew, as well.

My days began with coffee, croissants, and a couple of runs down the ski slopes—ending at the door to Paul's office, where I shed my parka and donned a magnifying loupe to work my way through more frames. At each day's end, Paul and I would be off to a restaurant for a quiet meal and more talk about our world of photography. Paul was delighted to take part in my editing adventure, even though I was searching for images made earlier in his career. We discussed Paul's ongoing work, mainly photographing people and cultures; he had found Asia to be his favorite part of the world in which to make pictures.

I returned to Washington and presented the Rocky Mountain story to the magazine's editors. I was thrilled when it was given the nod of approval. But after months of being the "next best story," it was finally set aside.

More lasting than that one story idea, of course, is the sixteen-year friendship Paul and I began that week in Aspen. For those who know Paul, he is a quiet and gentle man, but his pictures reveal another side to him— a tenacious "make it till it's right" photographer. When a scene is rich with possibilities, he will shoot over and over until the light, lens, camera angle, and moment are all the best they can be, using everything he has—creatively, physically, and emotionally.

This book will bear testament to Paul's lifetime of making wonderful, sumptuous, and sometimes breathtaking pictures. Thanks, Paul, for sharing.

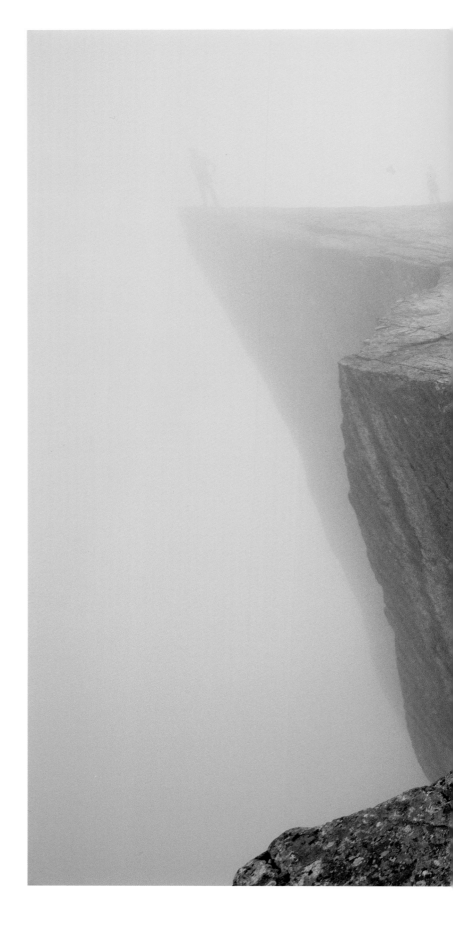

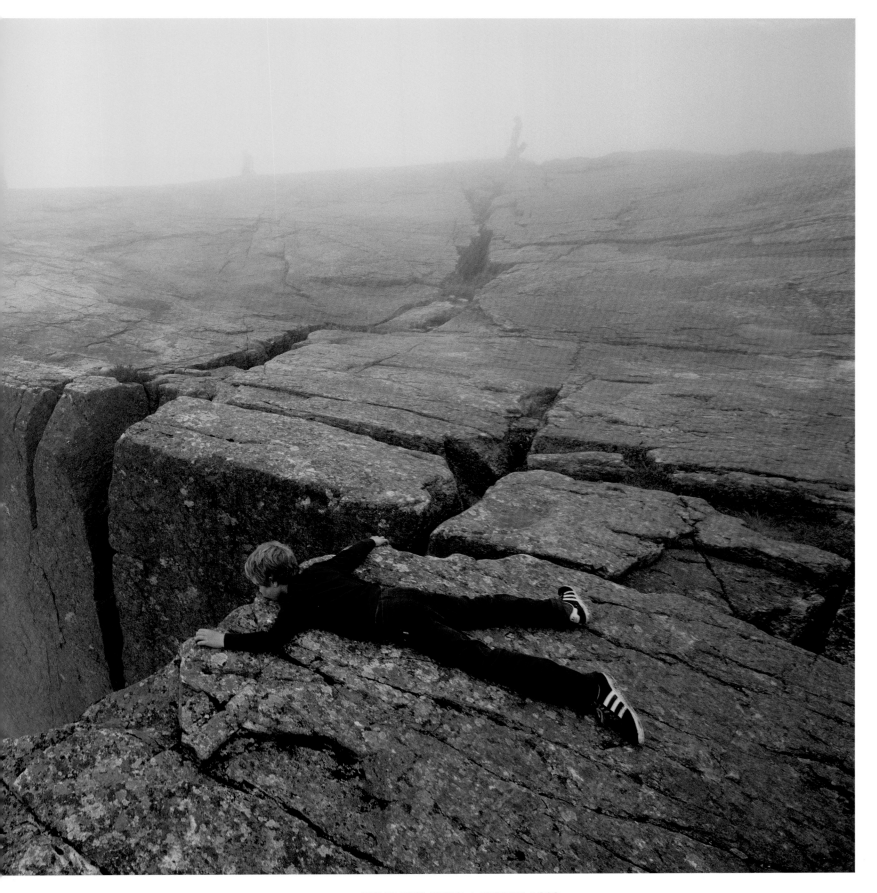

STAVANGER FJORD, NORWAY, 1982

A young visitor peers down into one
of Norway's most photogenic fjords,
hidden beneath a morning mist.

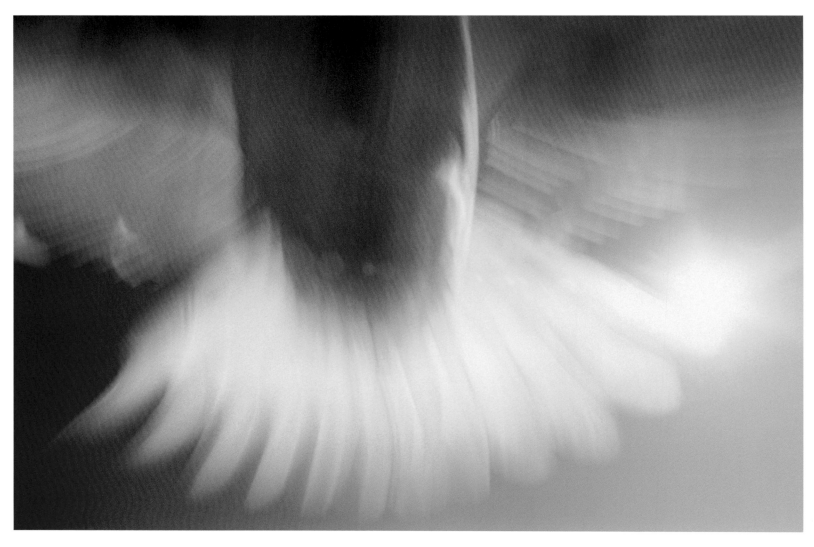

GALÁPAGOS ISLANDS, ECUADOR, 1973

Swallow-tailed gull in flight.

GALÁPAGOS ISLANDS, ECUADOR, 1973

Blue-footed booby at sunset.

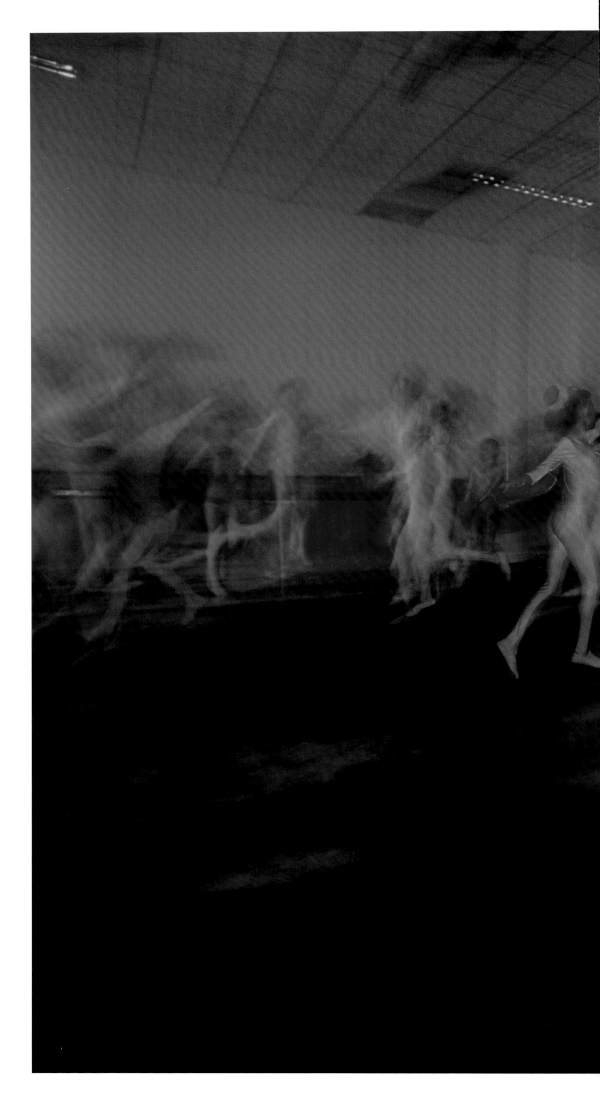

SHANGHAI, CHINA, 1999
Ballet class at Children's Palace, which provides after-school instruction in the performing and fine arts, as well as math and science, to thousands of students.

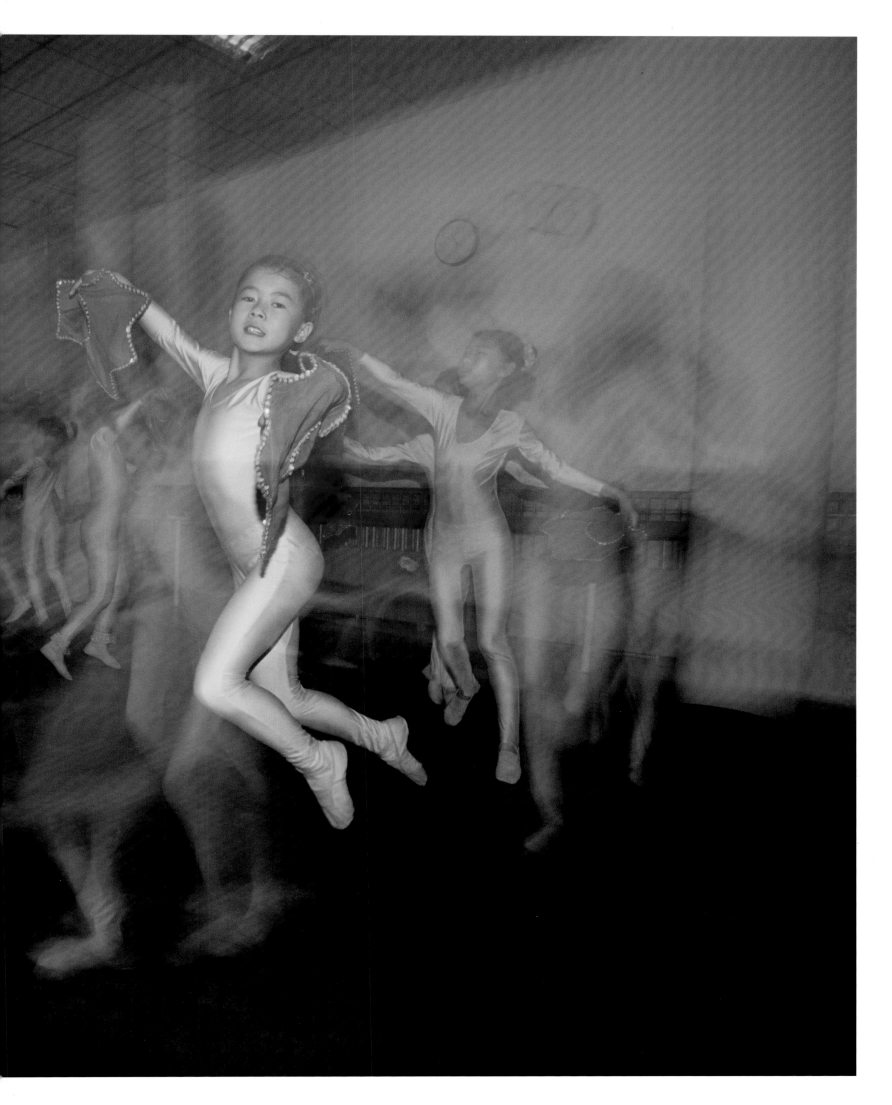

HONOLULU, HAWAII, 1981
The Hee Hing Chinese restaurant, a local landmark in Kapahulu.

THE PEOPLE'S COUNTRY

China

From the ramparts of the Great Wall in the early morning mist, the observer can conjure a vision of Genghis Khan's armies tented to the north eight centuries ago—smoke from camp fires, yak horns sounding reveille, the aroma of grilled meat. Gazing toward the mountainous horizon in the direction of Mongolia, one is led to ponder the infinite passage of time.

Where is this mirage in the glitzy China of today? Few modern-day visitors bother to trek the Great Wall beyond a hundred meters from the tram stop.

Paul first traveled to China in 1989, just before the Tiananmen Square riots. Over the next twenty years, he returned numerous times, photographing many stories in the cities and countryside as the nation went through years of dramatic transition.

The Chinese dynasties are chronicled as far back as 2000 BC, making China home to one of the world's longest-lasting civilizations. To grasp the unfathomable march of Chinese history that is known mainly to the scholar, a visitor must go beyond the urban centers, highways, bullet trains, and vast dam systems—and into the rural villages.

Here is the timeworn China: elders performing tai chi, incense simmering at altars, pigs rooting about in muddy tracks, old men smoking pipes, children with runny noses in quilted jackets, outdoor markets piled with cabbages, a woman working the field with a hoe.

In these regions, where little has changed (other than the advent of cell phones), one can visualize the China of the past.

Go back to Genghis Khan! Imagine hordes of mounted soldiers breaching walls, pillaging cities, overthrowing dynasties. See the vast armadas of Admiral Zheng He—

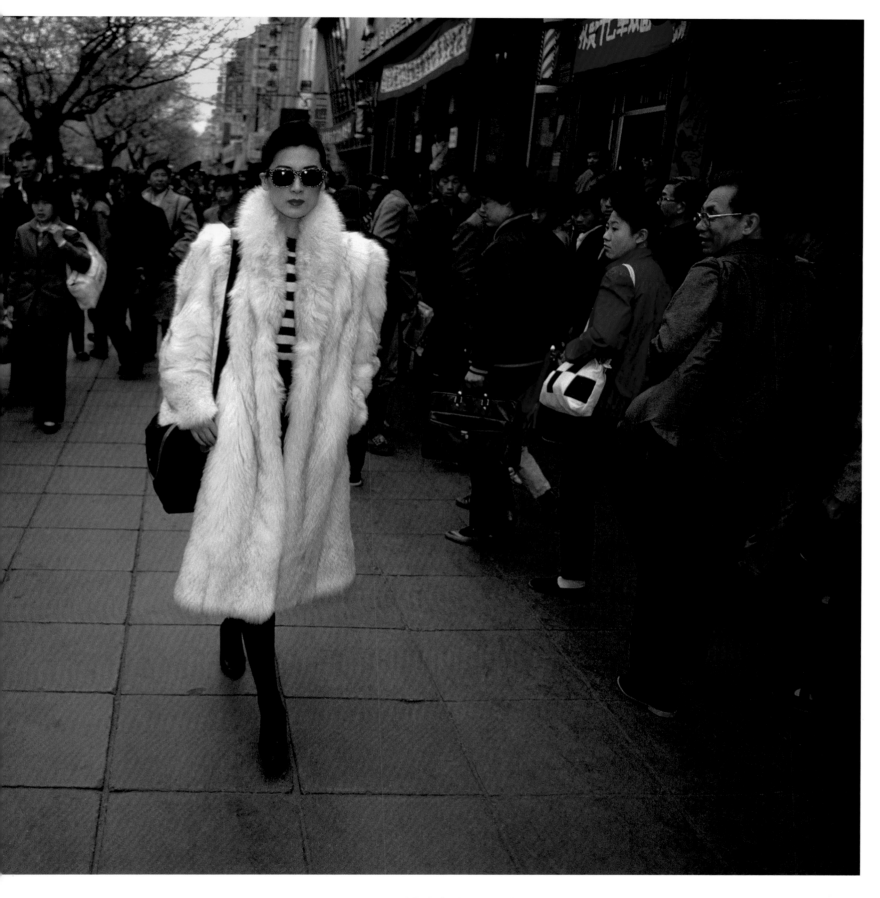

BEIJING, CHINA, 1989

A fashion model surprises pedestrians as
she strolls along Beijing's famous Wangfujing
shopping street.

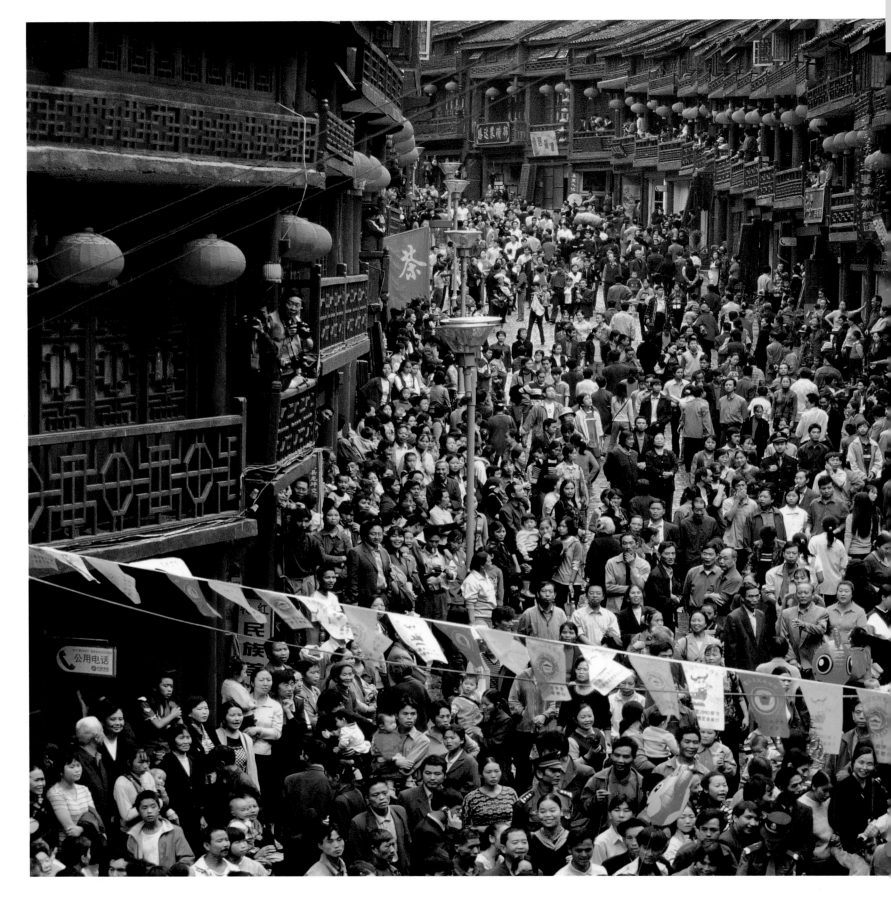

DUYUN, CHINA, 2003

Visitors crowd Shiban Street. Originally built
in the 1300s, the green-tiled roofs and carved,
vermillion balconies are classic examples of
Ming Dynasty architecture.

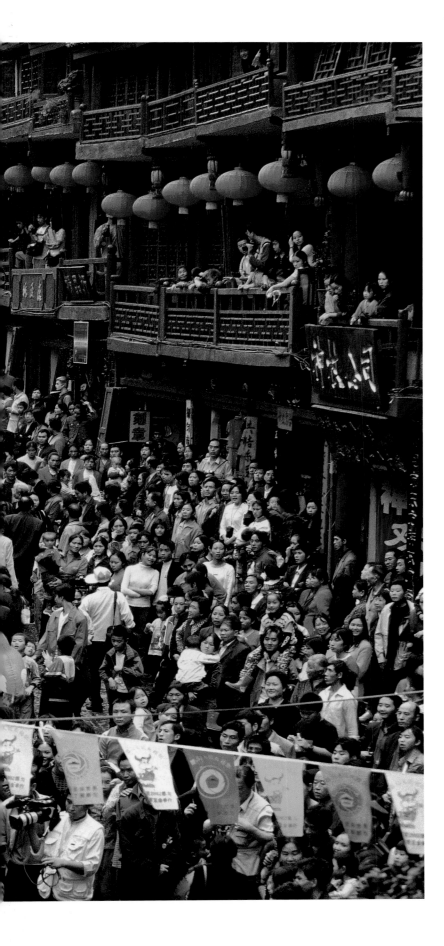

with vessels hundreds of feet long—launched to seek trade in distant seas, to Arabia, India, and Zanzibar. Think of the pavilions in Suzhou by the winding canals, lovers sipping tea; pockets of eunuchs gossiping in the private chambers of the Forbidden Palace.

The panorama dissolves into endless blurred images: Sages are writing poetry under the willow tree by the perfumed moat. Young girls prepare for marriage during the Spring Lantern Festival.

Sadness and hope, fear and peace: Hope is rewarded when the locusts do not come to plague the land with famine; when the Emperor's tax officials detour to another province; when disease takes a leave of absence. Hope is when sons are born; when daughters marry wealthy husbands. Fear returns when an earthquake shakes the land and villages crumble. Peace is sought in the serenity of the garden pavilion listening to the rain.

The eons drift by, like petals caught in a silent eddy. The twentieth century dawns. Internal factions fight for power. Then, overhead, flying machines with red suns on their wings spit death from the clouds. Massacres in Nanjing. White-starred allies arrive to help. The atom bomb devastates Japan.

The World War subsides, and civil war returns. A new leader takes control. Hail the "Great Helmsman"! Millions wave their Little Red Books. A People's Republic (which people?)—though some call it a new kind of empire. Children are unleashed to spy on teachers and parents. The Red Guards! Respect for elders has vanished.

Time passes, and, inevitably, the chairman grows feeble. He withers away.

In 1989, the massacre in Tiananmen Square in Beijing. The clock hands keep turning. A new slogan for the Chinese people is expounded by the government: "Making money is glorious!" exhorts Chairman Deng Xiaoping. The nation responds; the global economy shifts as this sleeping giant awakens to its newly found power.

But did not Master Confucius say: "One who rules by moral force is like the pole-star which remains in its place while all the lesser stars do homage to it."

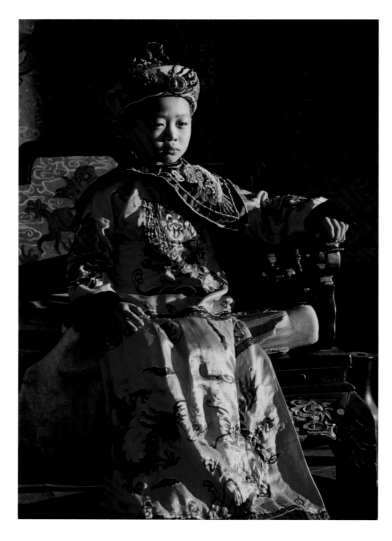

BEIJING, CHINA, 1999
A young visitor to the Forbidden City poses
in the imperial dress of an earlier era.

A verse comes to mind, written on the wind:
The distant boundary of heaven is high.
The sad cicada's cry is heard no more....
Is human life anything but hard?
From earliest time all have to die....
Unstrained wine will serve to cheer me up.
I do not know about a thousand years,
So I had better just prolong today.
 —T'ao Ch'ien

Oh, China, the Middle Kingdom, where are you? —*KL*

BEIJING, CHINA, 1997

A couple strolls through the back streets of the Forbidden City wearing *zhongshan* suits. The tunic was required dress for civil servants in the 1920s, and was worn by many Communist Party cadres until the 1990s.

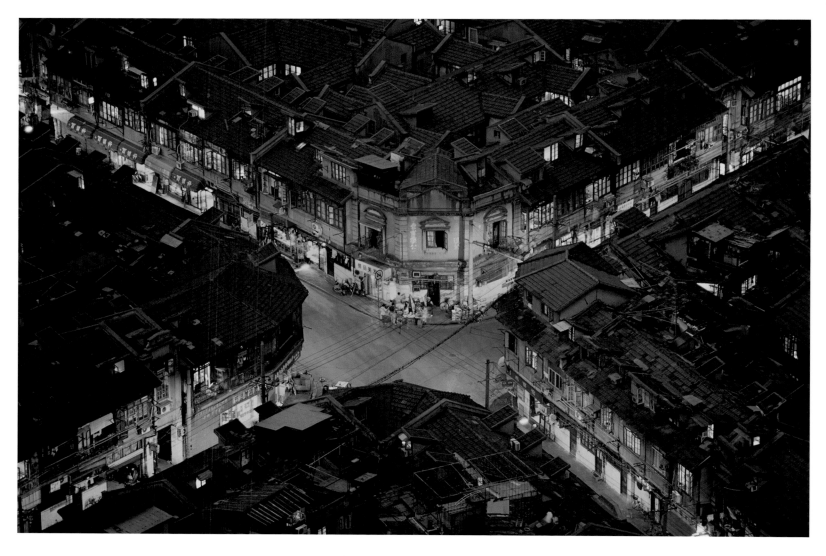

SHANGHAI, CHINA, 1997

Night falls on an old neighborhood near the
Bund, the waterfront area in the city's center.

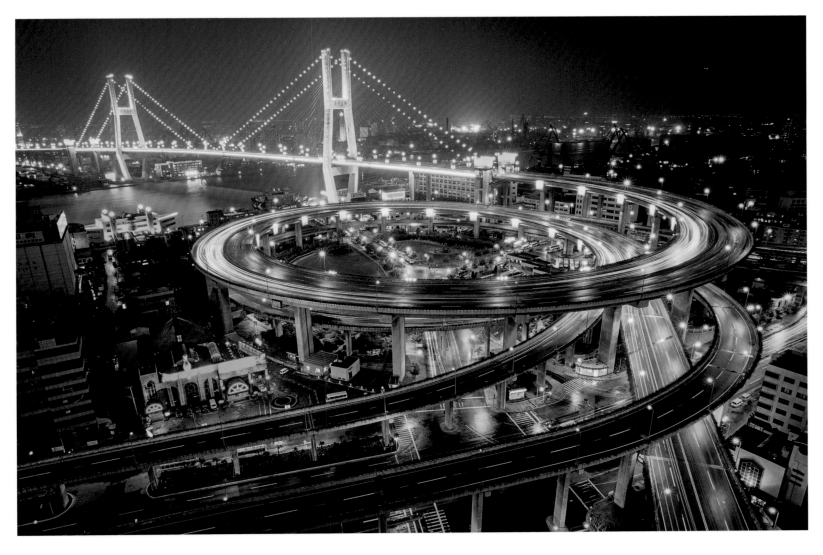

SHANGHAI, CHINA, 1999

The Nanpu Bridge connects Shanghai's historical
district of Puxi to Pudong, its fast-growing financial
and commercial hub.

SHANGHAI, CHINA, 2003
Morning commuter traffic passes near the
entrance to Yuyuan Gardens.

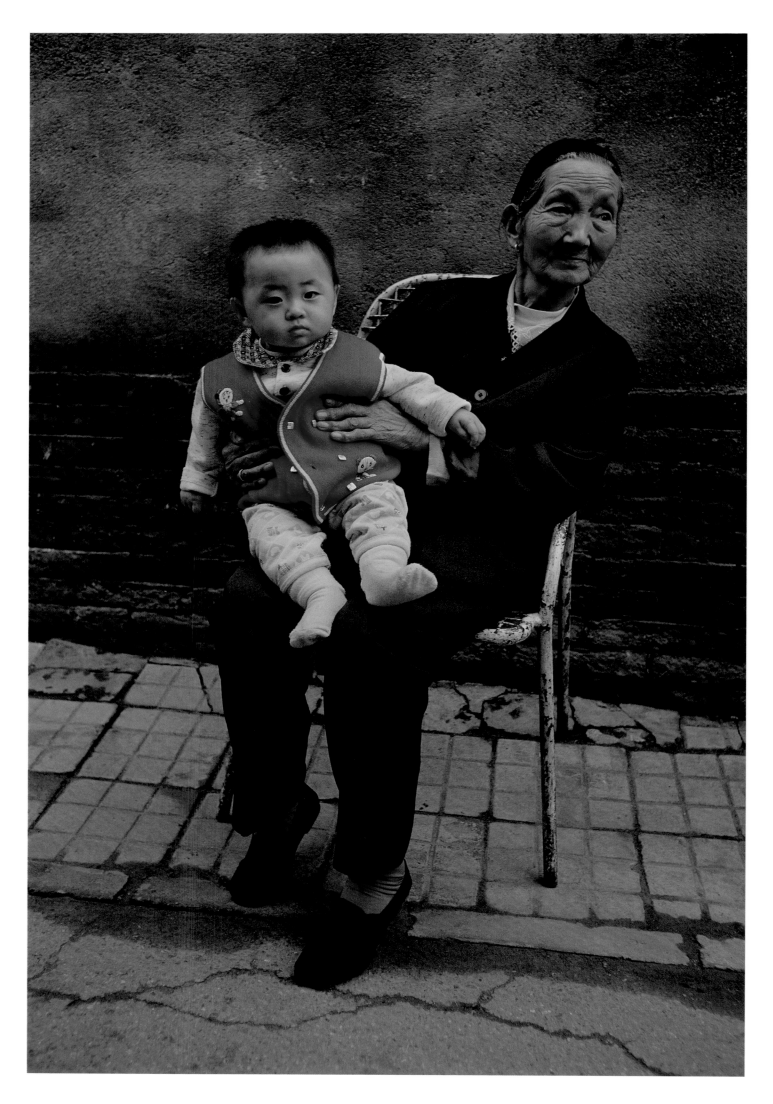

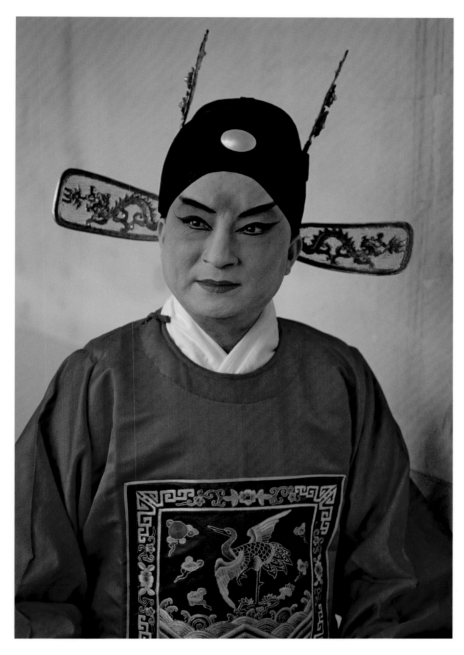

BEIJING, CHINA, 1999

A Chinese opera singer's makeup helps reveal the
character's personality, role, and fate to his audience.
Generally, a red face represents loyalty and bravery;
a black face, valor; yellow and white, duplicity; and
gold and silver, mystery.

BEIJING, CHINA, 1999

A grandmother and child pass the time in a
hutong neighborhood. These older districts of
narrow streets, alleys, and courtyard residences
are rapidly disappearing, giving way to wider
roads and high-rises.

BEIJING, CHINA, 1999

BEIJING, CHINA, 1999

SHANGHAI, CHINA, 1999

BEIJING, CHINA, 1989

A woman protects her face from the springtime dust storms that blow in from the deserts of north-eastern China and Mongolia.

SHANGHAI, CHINA, 1999

Young dancers head home after their lessons at Children's Palace, an educational center that trains more than 5,000 students each year in the arts, including Chinese violin, calligraphic writing, ballet, and drama.

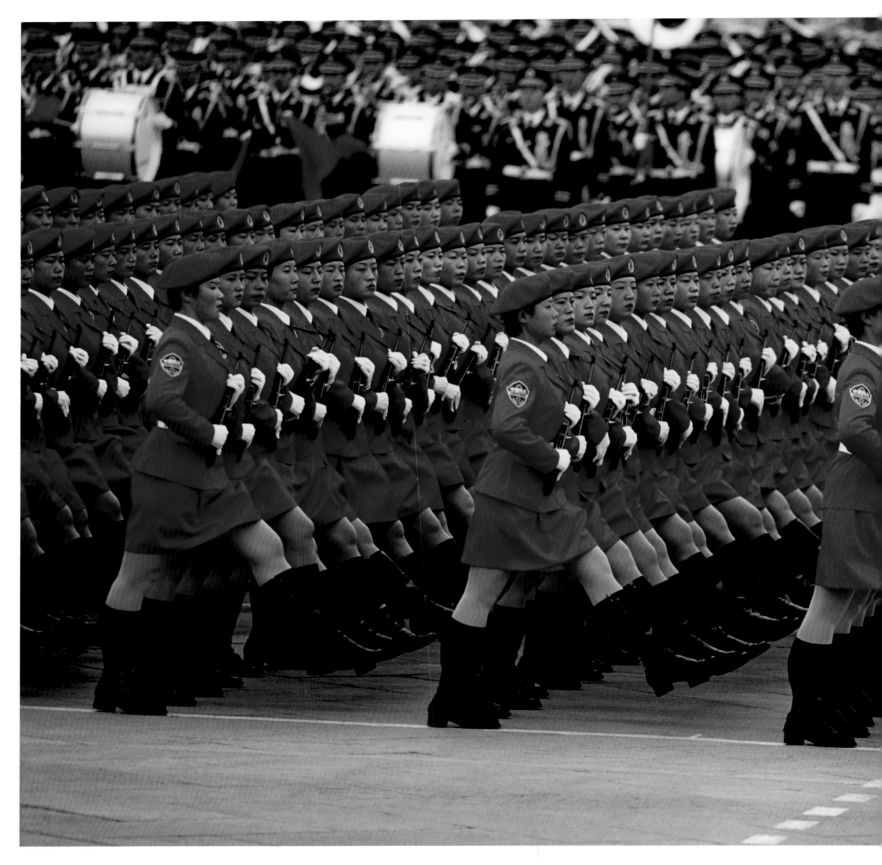

BEIJING, CHINA, 1999

Army soldiers march in the National Day
Parade in Tiananmen Square. More than 300
million women serve in the Chinese military.

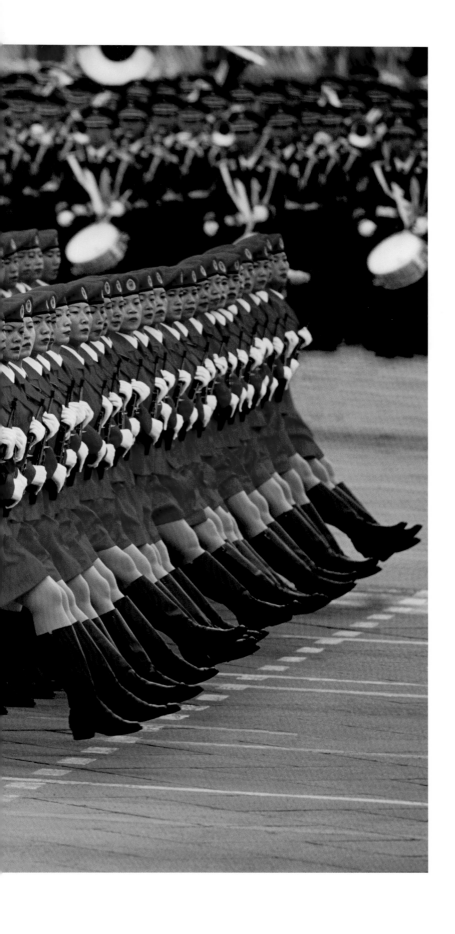

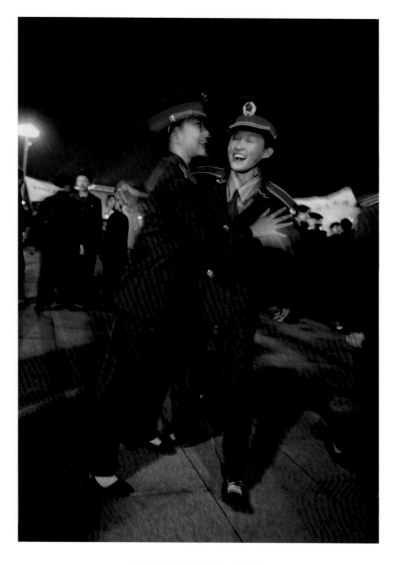

BEIJING, CHINA, 1999

As the official events of the National Day
Parade come to an end, soldiers share a
spontaneous moment of celebration.

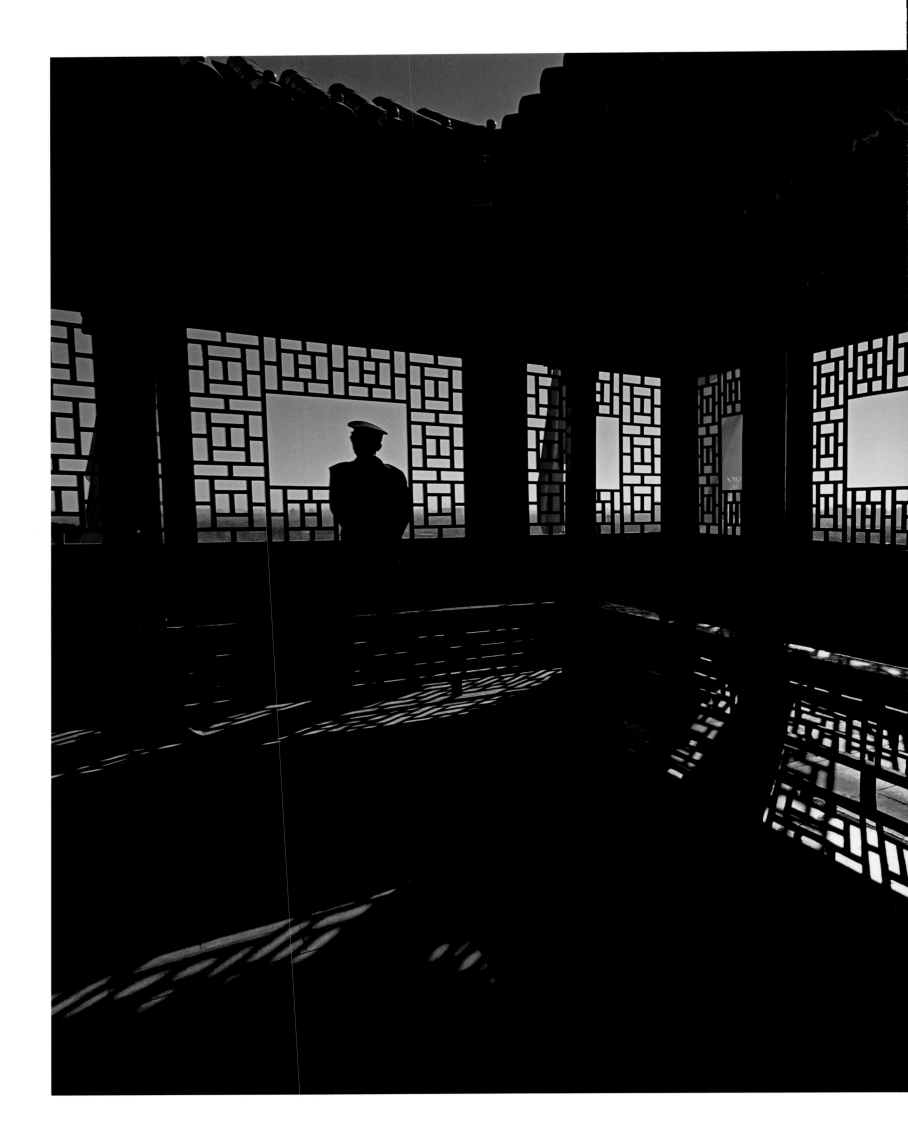

BEIJING, CHINA, 2001

A soldier stands watch over the grounds of the Summer Palace, a residence of the emperors of China from 1750 until the early twentieth century.

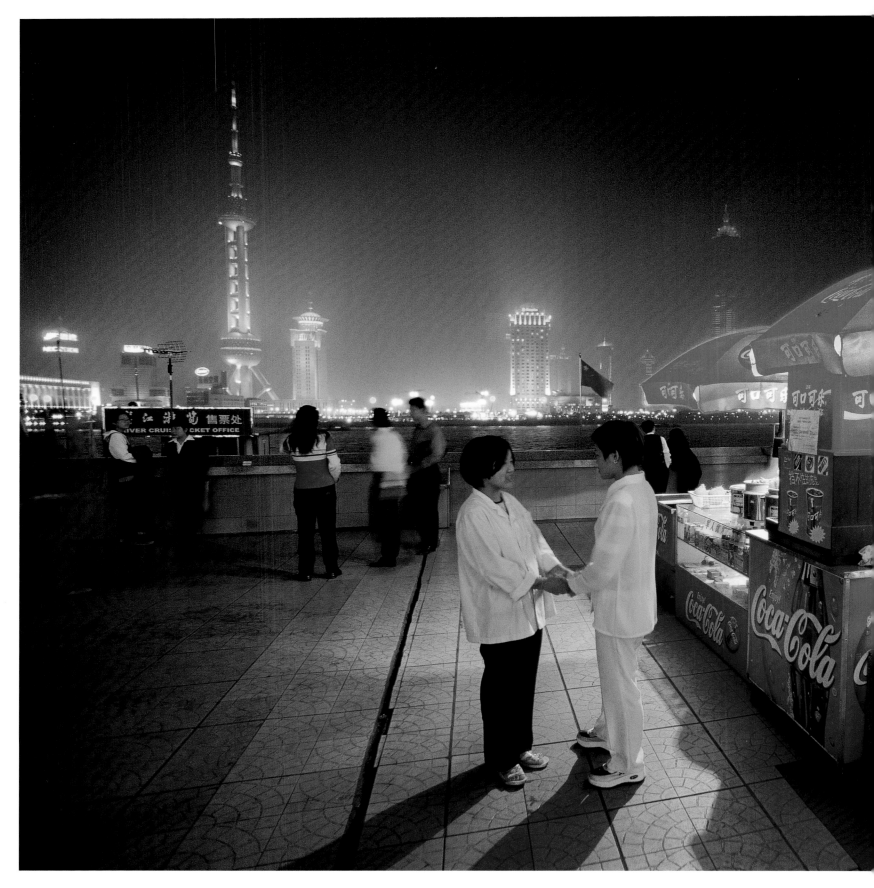

SHANGHAI, CHINA, 2001

Locals spend an evening along the waterfront
of the Bund district. Across the Huangpu River,
the city's financial center lights up the night sky.

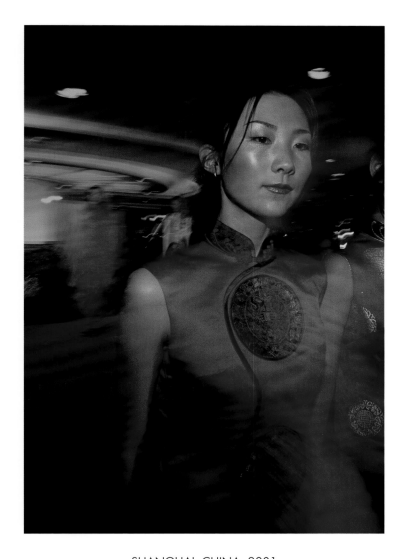

SHANGHAI, CHINA, 2001

At a boutique on Nanjing Road—one of the world's busiest premiere shopping districts—a model displays a modern take on the classic Chinese *cheongsum*.

BEIJING, CHINA, 1999
Fireworks frame a portrait of Sun Yat-sen,
first president and founder of the Republic
of China, at the National Day Parade in
Tiananmen Square.

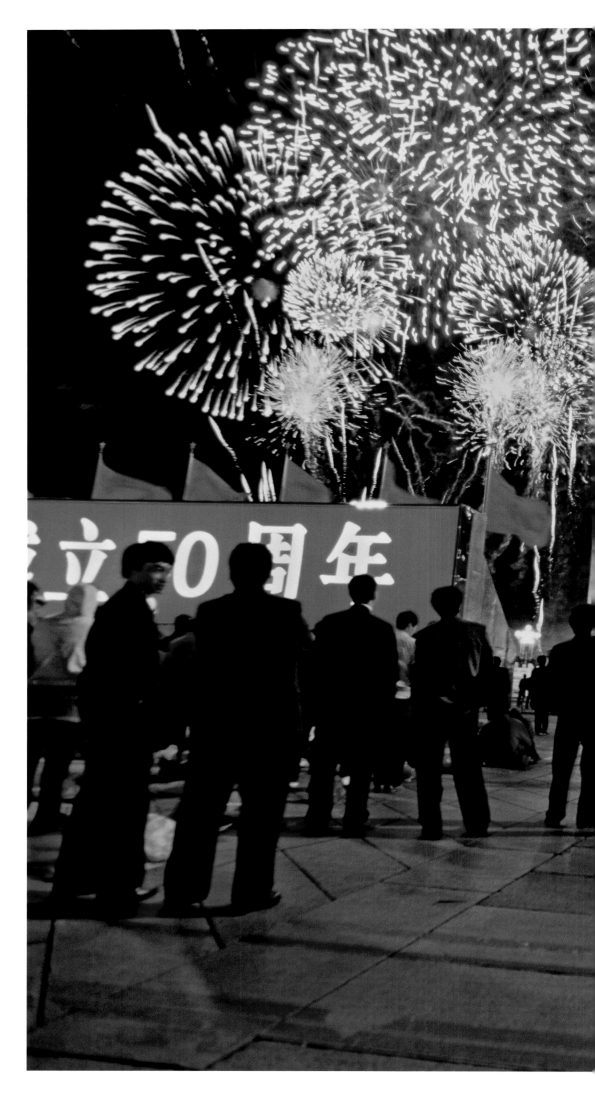

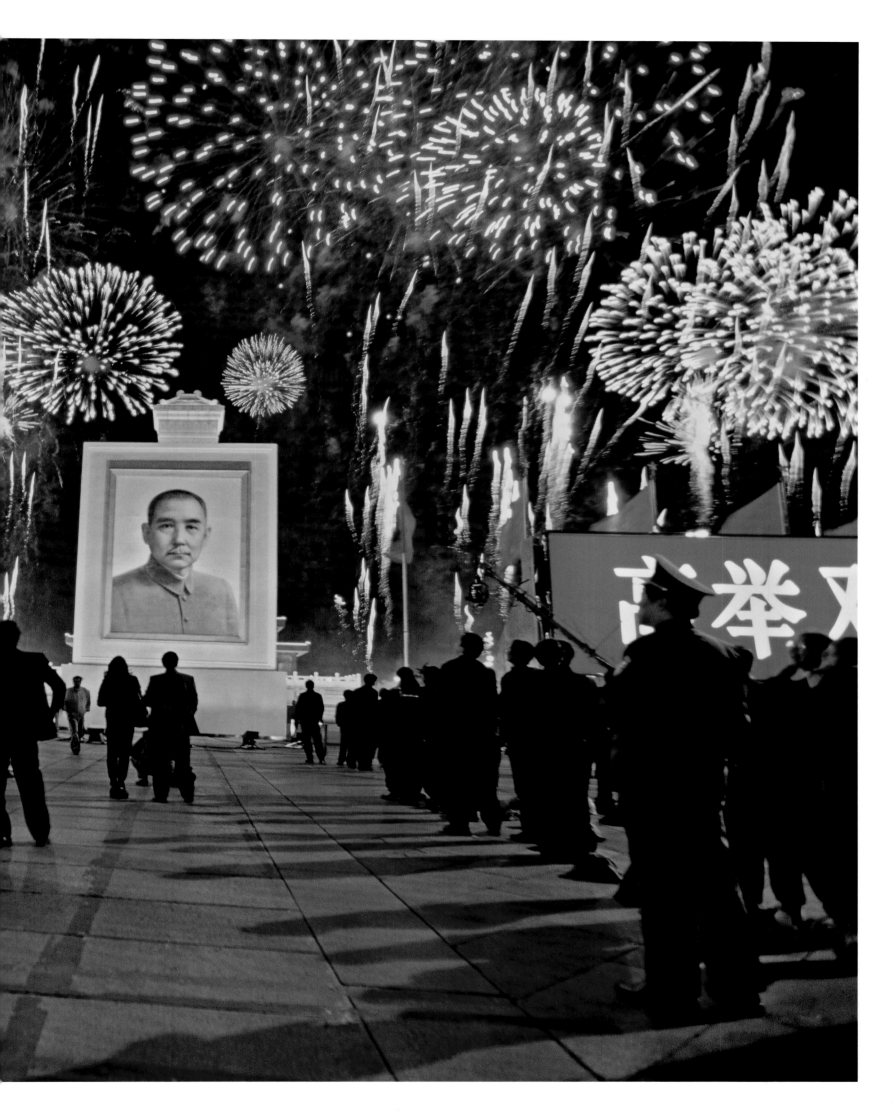

CAPTURING BEAUTY

The Nature of the Galápagos

Darwin never returned to the Galápagos Islands, but his writings shook the world.

In the early 1970s, Paul had the chance to go to Ecuador—his first shoot overseas. He accompanied his photography school classmate Nicholas deVore III, who was already down in Quito on one of his first assignments for *National Geographic*. The street life was as colorful as anywhere in Latin America—outdoor markets, tribal costumes, burros, and pyramids of fruit for sale. And then to Vilcabamba, nestled in a lush valley, famous for the old age reached by its inhabitants, many well over 100 years old—the faces of an ancient race.

On to the ageless Galápagos. Paul and Nicholas traveled there on their own dime, planning to spend three or four days—but they were fortunate to meet a Canadian family with a yacht. In exchange for photography lessons for the family, Paul and Nicholas were able to spend three more weeks traveling the islands, room and board included.

Charles Darwin would be shocked to learn that today over 25,000 persons are living on the archipelago—many more than the handful of misfits scrounging a living when his survey vessel, *HMS Beagle*, anchored there for five weeks in 1835.

The Galápagos—600 miles off the coast of Ecuador—was first discovered by a Spanish ship blown off course in 1535, and first mapped in 1570. This island group, once teeming with species not seen elsewhere, has been dramatically affected by numerous marauders, both two- and four-legged. English buccaneers once used the islands as a base to prey on Spanish ships. Yankee whalers dropped anchor, slaughtering wildlife for food. Fur seal hunters wreaked havoc.

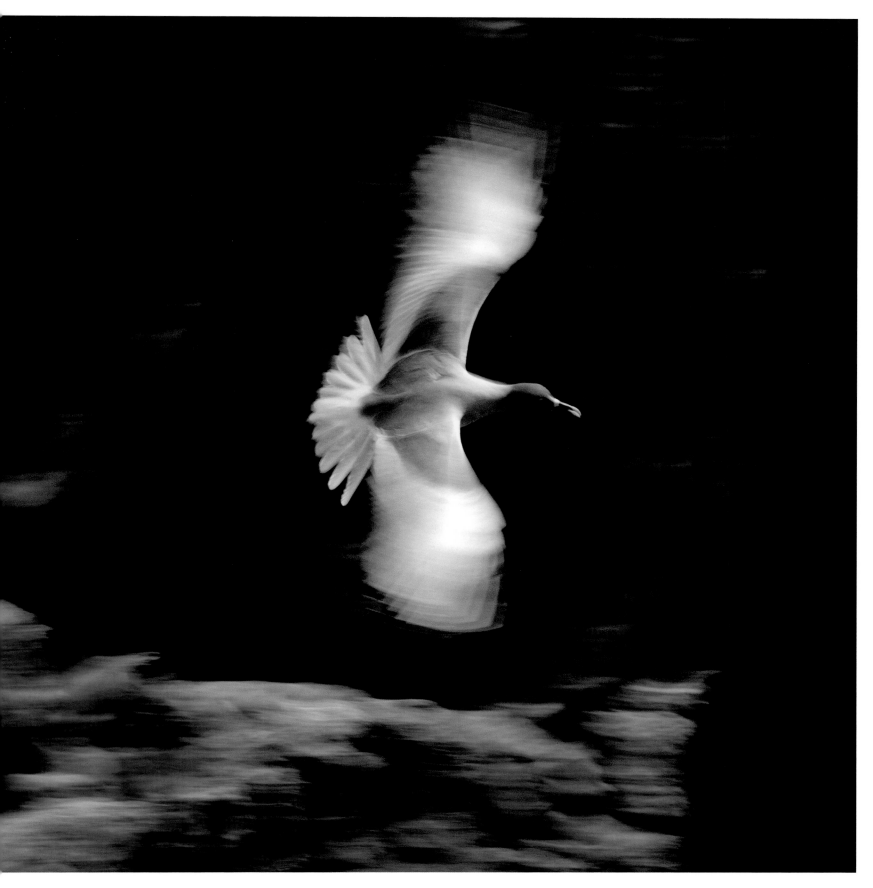

GALÁPAGOS ISLANDS,
ECUADOR, 1973

A swallow-tailed gull takes flight from a
cliffside on the small island of Baltra.

The government of Ecuador annexed the Galápagos in 1832. They encouraged migrants to plant sugar cane, and even set up a penal colony. In World War II, the U.S. established an air base here to guard the Pacific approaches to the Panama Canal. Japan actually had a plan to bomb the canal from this vicinity.

With each incursion on the Galápagos, the numbers of the famed giant tortoises have been reduced, on some islands to the point of extinction. Foreign species—goats, pigs, wild dogs, rats, and cats—have ravaged the nests and breeding places of the tortoises, as well as marine iguanas, swallow-tailed gulls, and blue-footed boobies. In recent years, global tourism has steadily grown. Numerous well-to-do visitors arrive by plane and cruise ship. Now confined to roped paths, they stand and stare at lava lizards, tropical penguins, pelicans, sea lions, flightless cormorants, albatrosses, and fur seals. Meanwhile these puzzled creatures stare back in even greater wonder.

Mail is no longer left in a wooden barrel on Santa Maria for sailing ships to pick up. In the distant past, visiting sea captains could learn who had been marooned there when they emptied the barrel of its moldy contents. It was Darwin, through his later writings, who brought fame to these islands that he visited as a young man in 1835. He never returned in old age. This is the place where Darwin compared the beaks of finches on the various islands, noting how they were shaped differently according to environmental circumstances and needs. "I never dreamed that islands, about fifty or sixty miles apart...formed of precisely the same rocks, placed under a quite similar climate, would have been differently tenanted," wrote Darwin in *The Voyage of the Beagle,* ten years after his journey.

From here he would make his giant leap of understanding about the evolution of man—a theory that has not made the Creationists happy, but changed the world's ideas about where we came from and how it happened. In *On the Origin of Species,* Darwin wrote, "I have called this principle, by which each slight variation, if useful, is preserved, by the term Natural Selection." —KL

GALÁPAGOS ISLANDS,
ECUADOR, 1973

On Santa Cruz Island, a frigate bird hovers in the air—one of the more than two dozen surviving bird and animal species that are found only in the Galápagos.

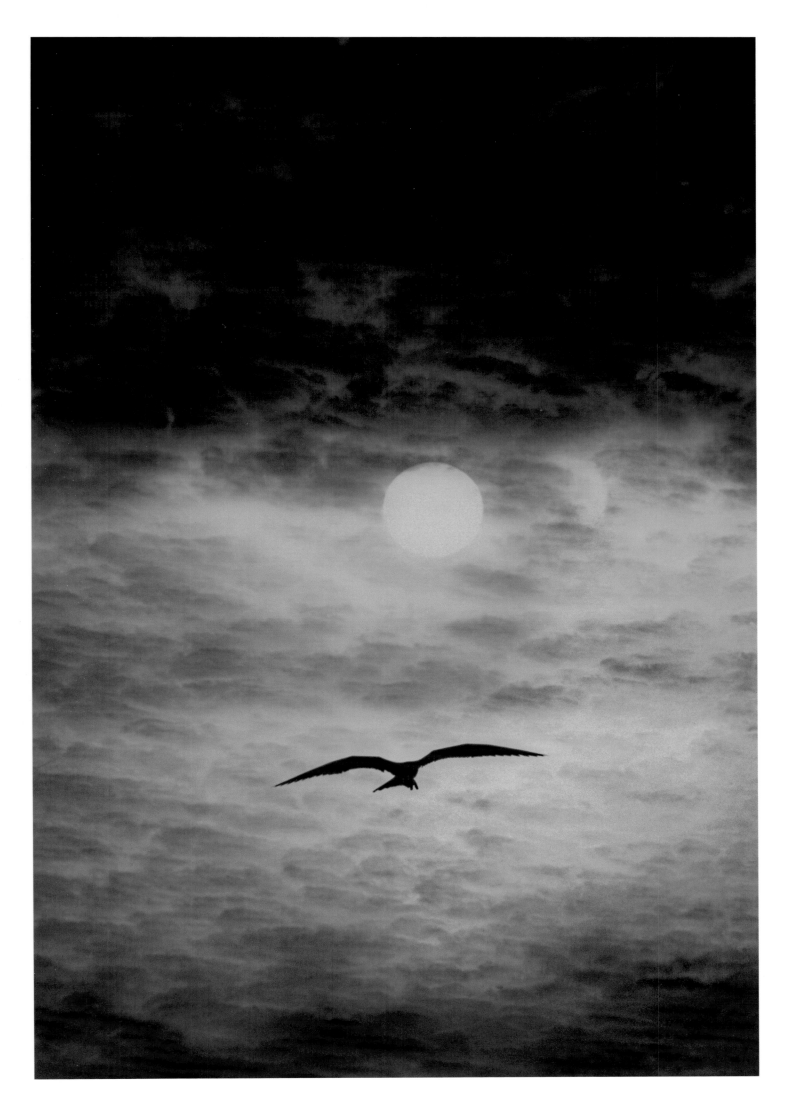

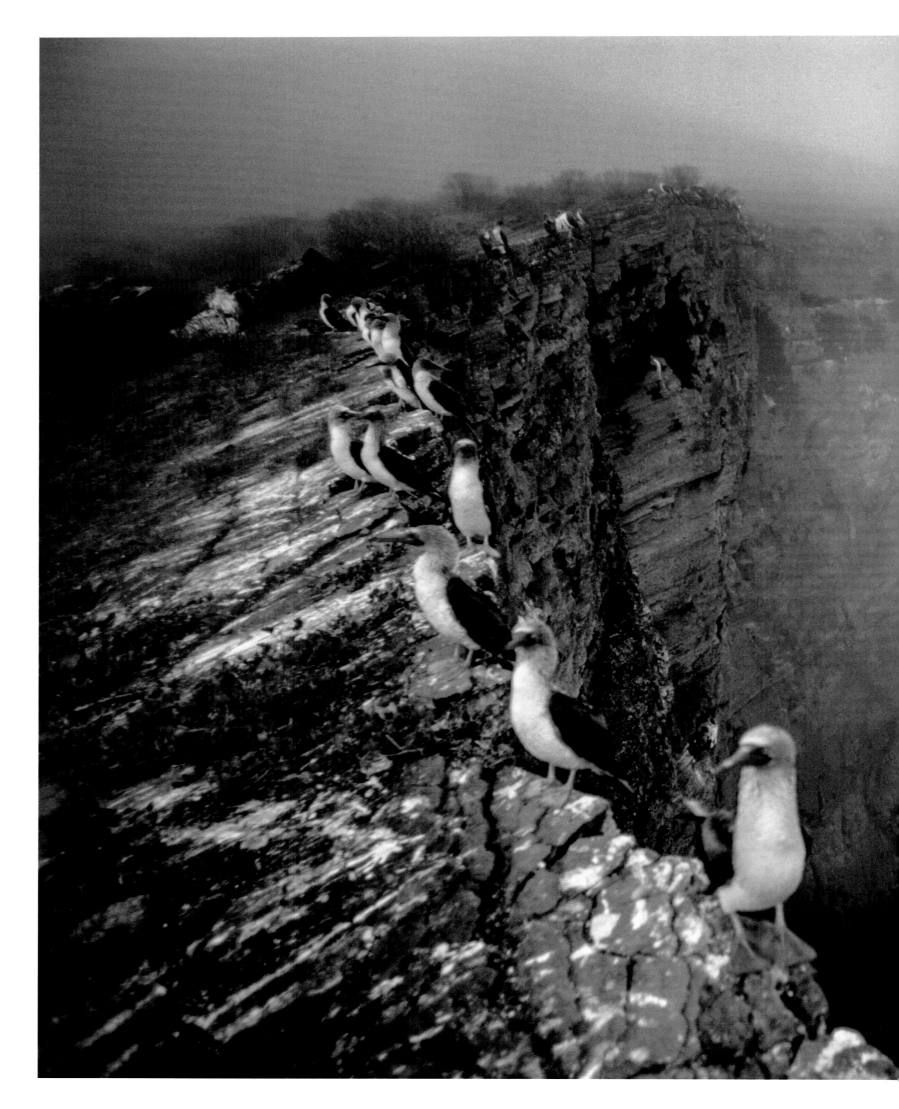

GALÁPAGOS ISLANDS,
ECUADOR, 1973

Blue-footed boobies perch comfortably
on the edge of a sheer drop to an inner
lagoon. The island of Isabela is one of the
most volcanically active places on earth.

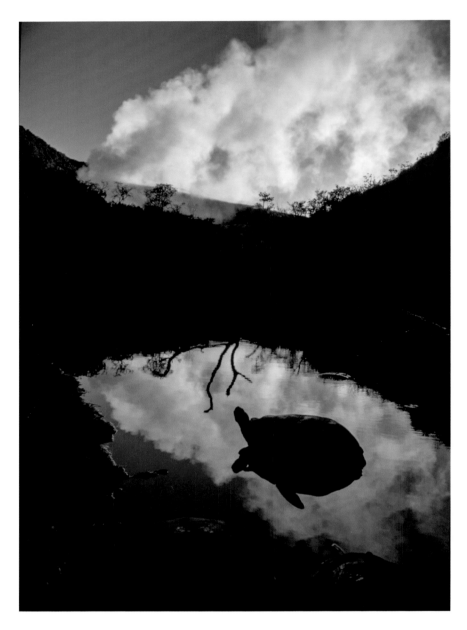

GALÁPAGOS ISLANDS,
ECUADOR, 1973

Seen in the crater of the Alcedo Volcano on
Isabela Island, the endangered Galápagos
tortoise is the largest species in the tortoise
family and can live to be over 150 years old.

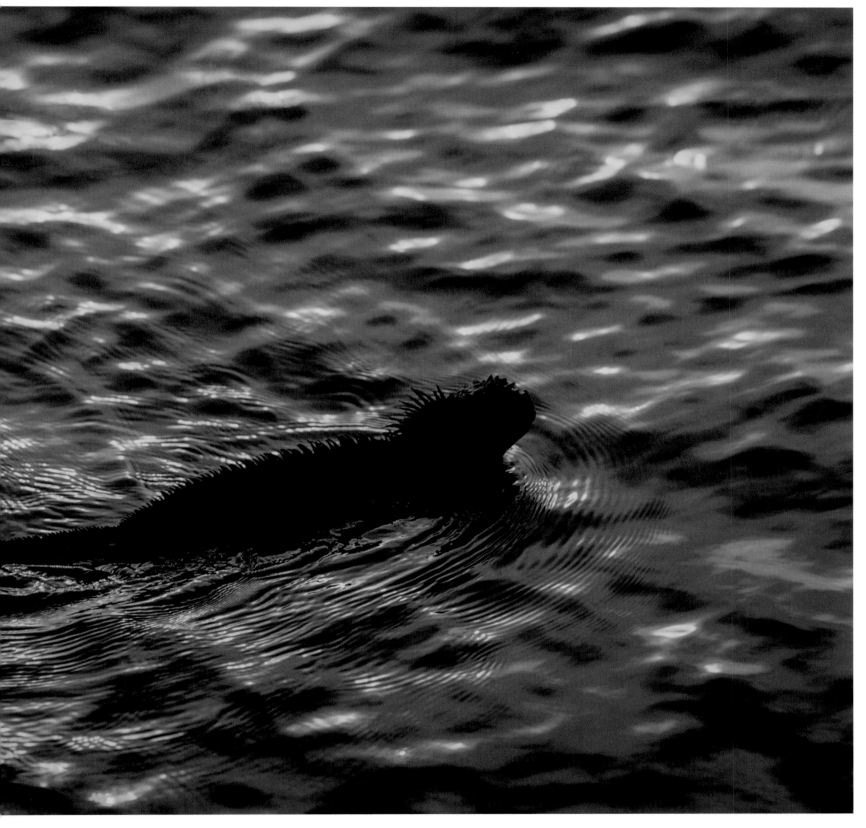

GALÁPAGOS ISLANDS,
ECUADOR, 1973

Marine iguanas are the world's only seafaring
lizards, and are unique to the Galápagos.

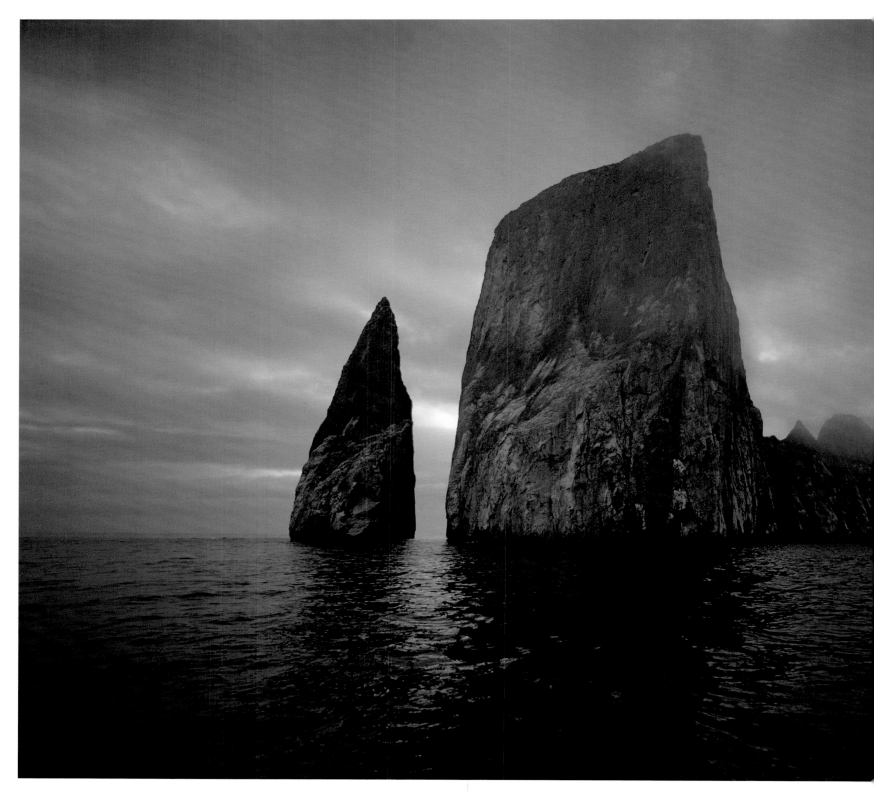

GALÁPAGOS ISLANDS,
ECUADOR, 1973

Rising 500 feet from the ocean, the famous land-
mark Kicker Rock is also known as *León Dormido*
(sleeping lion).

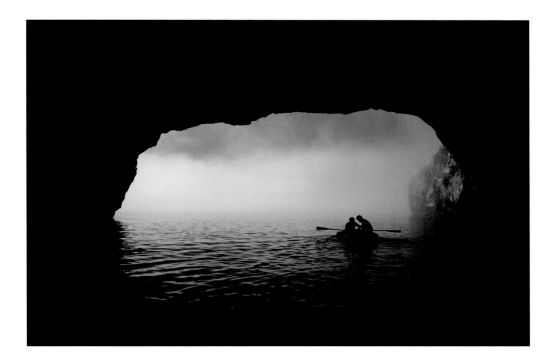

GALÁPAGOS ISLANDS,
ECUADOR, 1973

Boaters explore the sea caves of Isabela Island
near Tagus Cove, a sheltered haven that provided
refuge to pirates and whalers for hundreds of
years before the area was colonized in 1893.

GALÁPAGOS ISLANDS,
ECUADOR, 1973

A flock of boobies alights from Fernadina
Island, one of the most pristine regions in
the Galápagos.

*"We must, however, acknowledge...that
man with all his noble qualities, with sym-
pathy which feels for the most debased,
with benevolence which extends not only
to other men but to the humblest living
creatures...with all these exalted powers,
man still bears in his bodily frame the
indelible stamp of his lowly origin."*
 —Charles Darwin,
 Epigraph for *The Descent of Man*

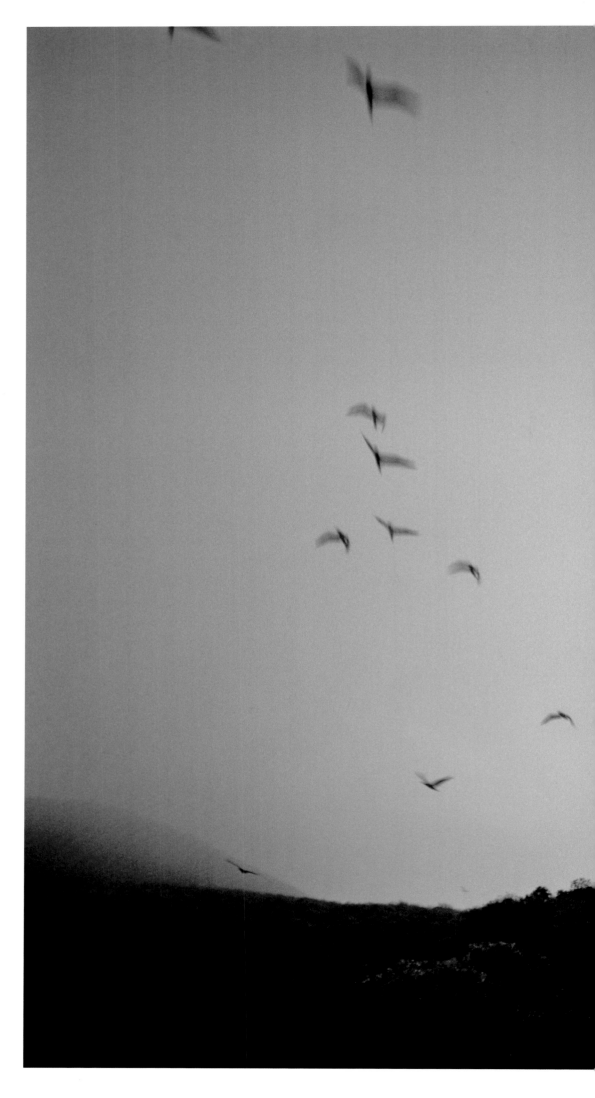

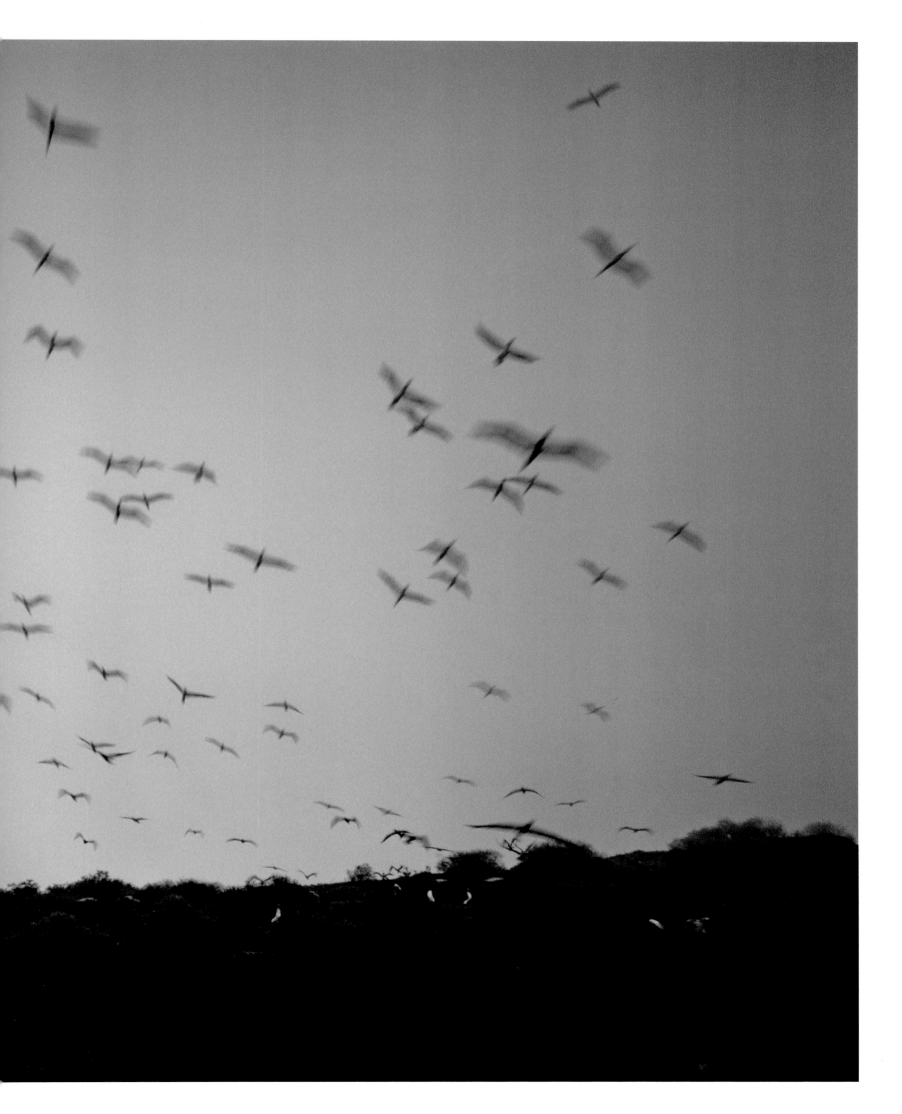

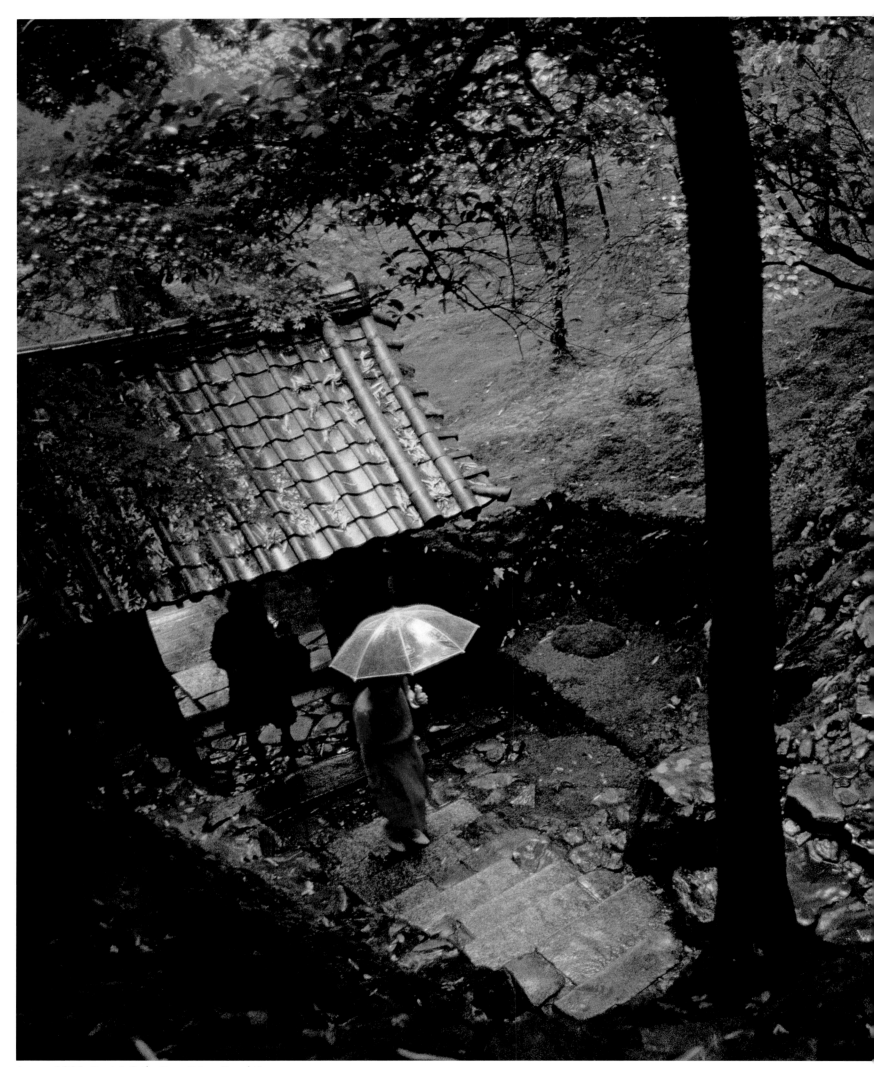

Japan, 1988, Kyoto's Saiho-ji, or "Moss Temple"

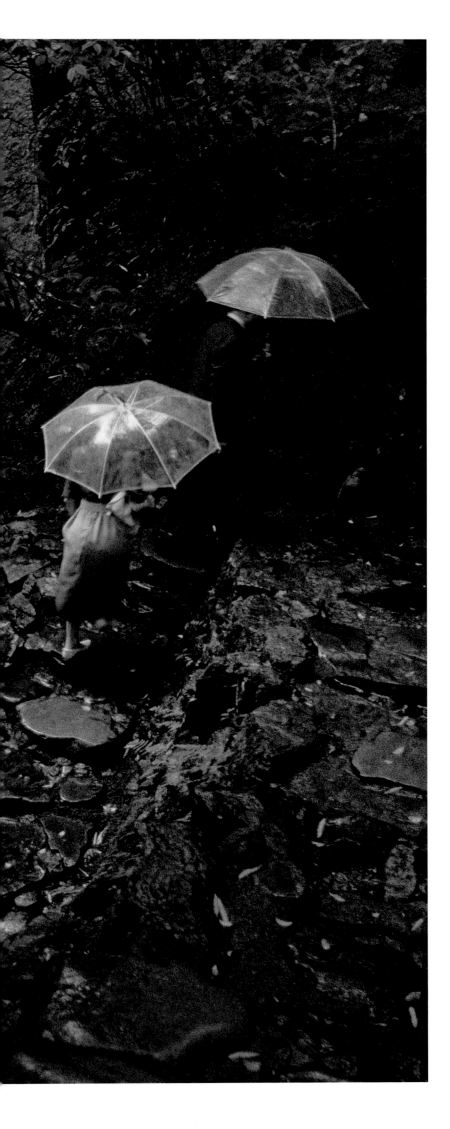

THE FLOATING WORLD

Japan

In an earthquake zone, prone to volcanic eruptions and tsunamis, the Japanese people live on the edge. Is this what also makes them deeply Japanese? In the twelfth century, the monk Kamono Chomei, having witnessed an earthquake that reduced a city to a flaming ruin, retreated to a "Ten Foot Square Hut" in the mountains. Living the life of a hermit he wrote: "In the stately ways of our shining capital, Kyoto, the dwellings of high and low raise their roofs in rivalry...but few indeed there are that have stood for many generations.... And this man that is born and dies, who knows whence he came and whither he goes? And who knows also why with so much labor he builds his house, and who knows which will survive the other?"

We are reminded of the recent tsunami that roared in so close to Tokyo. The brevity of life—as the Japanese call the "Floating World"—pervades the art and culture of these island people. In haiku verse, the essence of man's fleeting days is expressed in tiny details. Yoshida Kenko, a fourteenth-century Buddhist priest, reclusive scholar, and poet, wrote on impermanence. "Truly the beauty of life is its uncertainty," he penned in *Essays In Idleness*.

There is the way of Zen, and the way of tea. You will be served by a geisha seated on a tatami after a Shiatsu massage in an *onsen*. Then it's time to watch a sumo or jujitsu match that you can reach by rickshaw. Take a photo of Mount Fuji, or try to climb it. Stay in a *ryokan*. Go to Kyoto. Enter a temple. Perhaps you will find the spirit of Amida through the repetition of devotional phrases. Take a bullet train to the Inland Sea, visit the memorial at Hiroshima, watch cormorants catching fish by torchlight as shown in Keisai Eisen's woodblock prints from the Edo period. Be confused by a Noh play or Kabuki. Struggle through the neon wilderness of the Ginza, lost in translation. Hello Kitty!

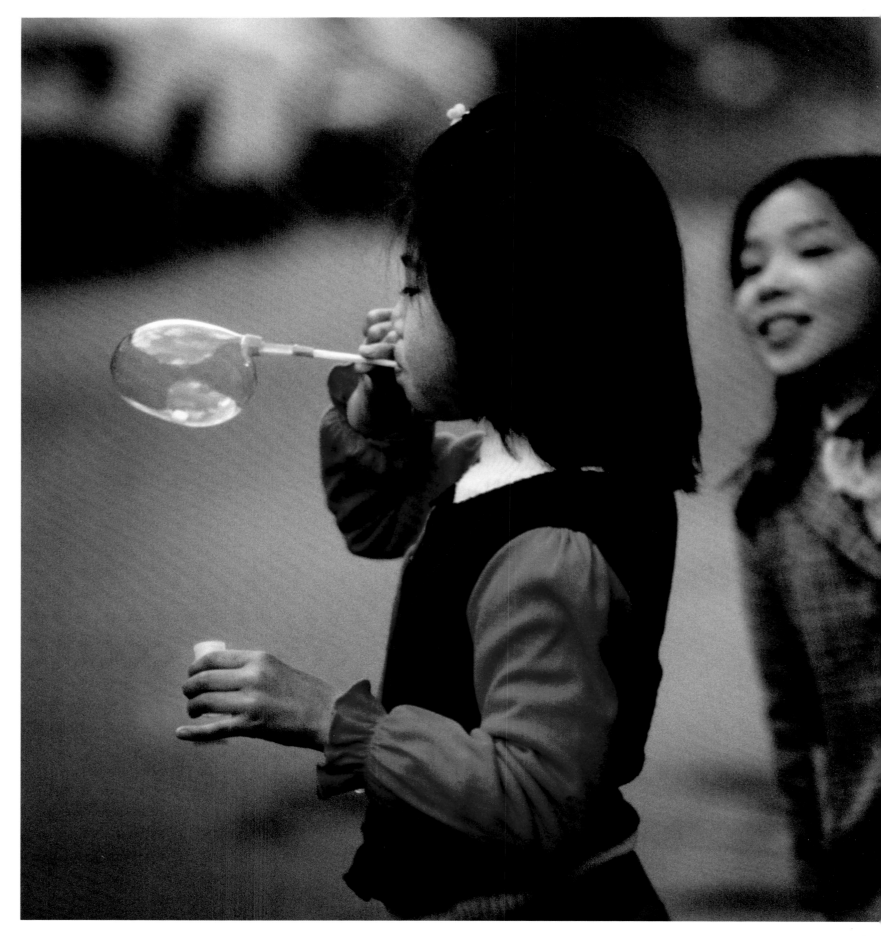

SAPPORO, JAPAN, 1974

Odori Park, a nearly mile-long strip of greenery
cutting through central Sapporo, provides city
residents with a space for play and relaxation.

For centuries, the Japanese succeeded in keeping their civilization isolated and self-ruled, while many other Asian nations were held in check by colonial landlords. The *daimyo* (feudal lords) ruled the land, with an iron hand and a samurai sword. There was some trade with "barbarians of the south"—the Dutch, Spanish, English and Portuguese. But by the mid-1600s, except for trade with China, the country largely remained off limits— foreigners were subject to the death penalty.

Then in 1854, Commodore Perry forced Japan out of hiding, bringing this mysterious nation onto the international stage—where it has firmly remained. No longer hidden behind a silk veil of its own making, Japan invaded China forty years later. In 1905, the country vanquished the Czarist fleet over the fight for Korea and Manchuria. During World War II, Japan spread its might over Southeast Asia and the Pacific, shocking the world with its attack on Pearl Harbor.

Defeat and devastation would follow in 1945, but Japan would soon rise from the ruins. As the new millennium dawned—less than 150 years since it opened its gates—this small nation had embraced globalization and boasted the world's third-largest economy. Japanese culture has spread worldwide. Japanese words, once so foreign, pepper the international tongue. Japan has always presented something of a riddle to the Western mind. Its culture is built on a thousand-year history of brutal feudalistic control; and an equally long tradition of meditation, tranquil ceremony, and celebration of nature. Their Buddhist teachings, influenced by Confucius, Taoism, and Shintoism—the indigenous spirituality and religious beliefs practiced in Japan—may bring clarity to the local inhabitants, but oft times breed confusion in the uninitiated.

Chotto matte kudasai! One moment please! You hear it in the shops and stalls of Shinjuku and the temples of Kyoto. With a deep bow if delivered by an older person, a traditional courtesy lost on the young—it has now gone the way of the samurai! The individual runs off to find a requested book, to clarify directions, or to locate an English-language menu. Perhaps he or she returns with what you were hoping for, perhaps not, perhaps only to answer your question with another question. Is that not the way of Buddha? And which way is that? —*KL*

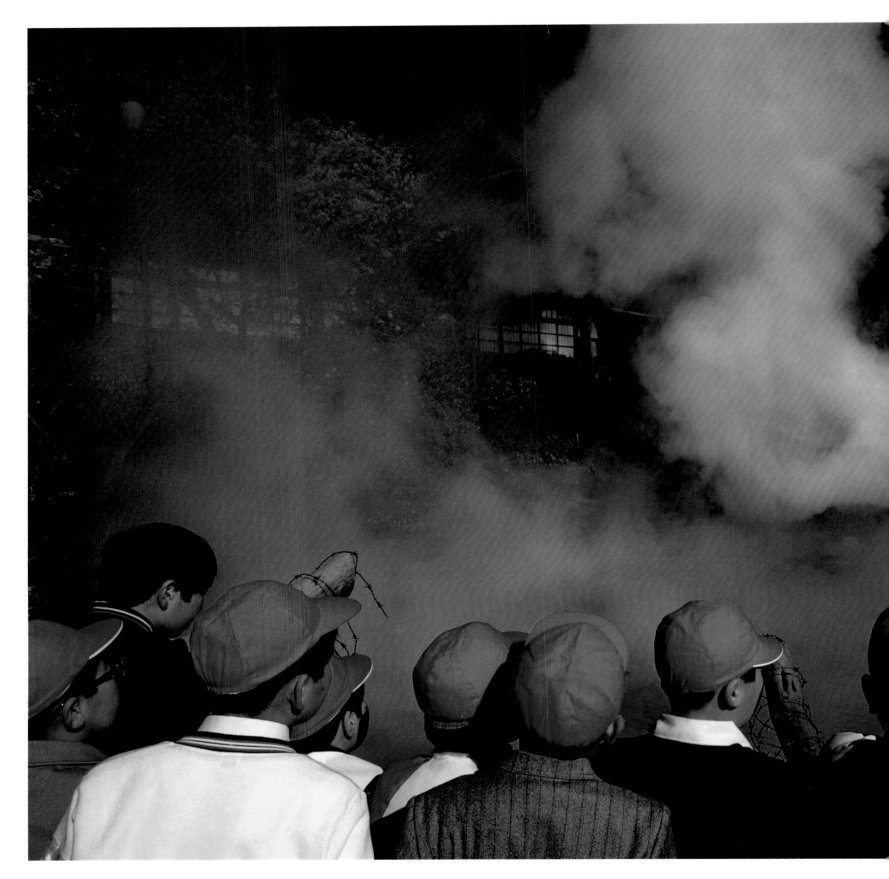

BEPPU, JAPAN, 1974

Students watch the steam rise from a thermal
pool in Beppu, one of the most famous hot
springs sites in the country.

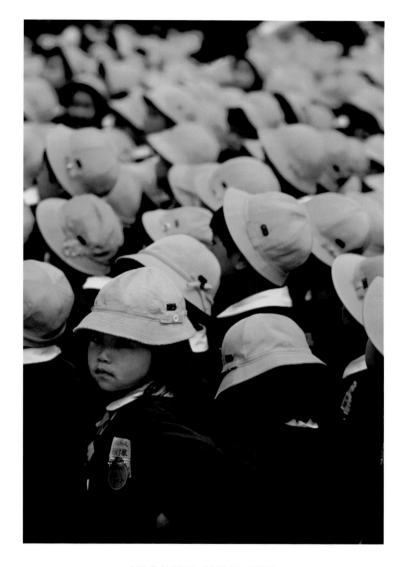

HIROSHIMA, JAPAN, 1974

Children on a school trip crowd to view
a Buddhist temple.

The Geisha

Long shrouded in mystery, the "flower and willow world" of the geisha has rarely been experienced by foreigners. Using his *National Geographic* credentials and his connections within Japan, Paul became one of only a handful of photographers who have been allowed to photograph the geisha behind the scenes—at an *okiya* in Kyoto, where they live and learn their craft as hostesses, musicians, and entertainers.

Paul had anticipated that, as a six-foot-tall American man, he might have some trouble blending in when he entered the private domain of the geisha. But as he would learn, these women were professionals. Once the house-mother gave her approval, the young *maikos* (geisha apprentices) were quite comfortable having him follow and document their every movement throughout the day.

Now only about 1,000 to 2,000 geisha practice their trade in Japan, down from the almost 100,000 at the beginning of the twentieth century. Modern culture has taken its toll on the geisha. They were hit particularly hard by World War II, when most women were expected to work in factories to support the war efforts. Today, as more Japanese women move into the mainstream work force and up the corporate latter, the geisha are increasingly becoming an anachronism.

So how does the geisha—in her stiff lacquered hair, many-layered kimono, and wooden *getas*—survive in a culture that unabashedly embraces Hello Kitty and Harajuku girls? Some geisha launch websites, take English lessons, and tour overseas—slowly lifting the veil of privacy over a facet of the Japanese culture that has long appeared mysterious and been misunderstood in the West.

"I felt like I had stepped into another world, another century," Paul remembered."But as one geisha boarded the bullet train to go to an appointment at a restaurant, I realized that is exactly what is so fascinating about Japan in general—how it simultaneously keeps one foot in the past while it moves at light speed headlong into the future."

KYOTO, JAPAN, 1988

Young geisha, known as *maiko*, arrive at their *okiya* (geisha house), to prepare for the evening's entertainment, which includes singing, playing music, games, and conversation with their clients.

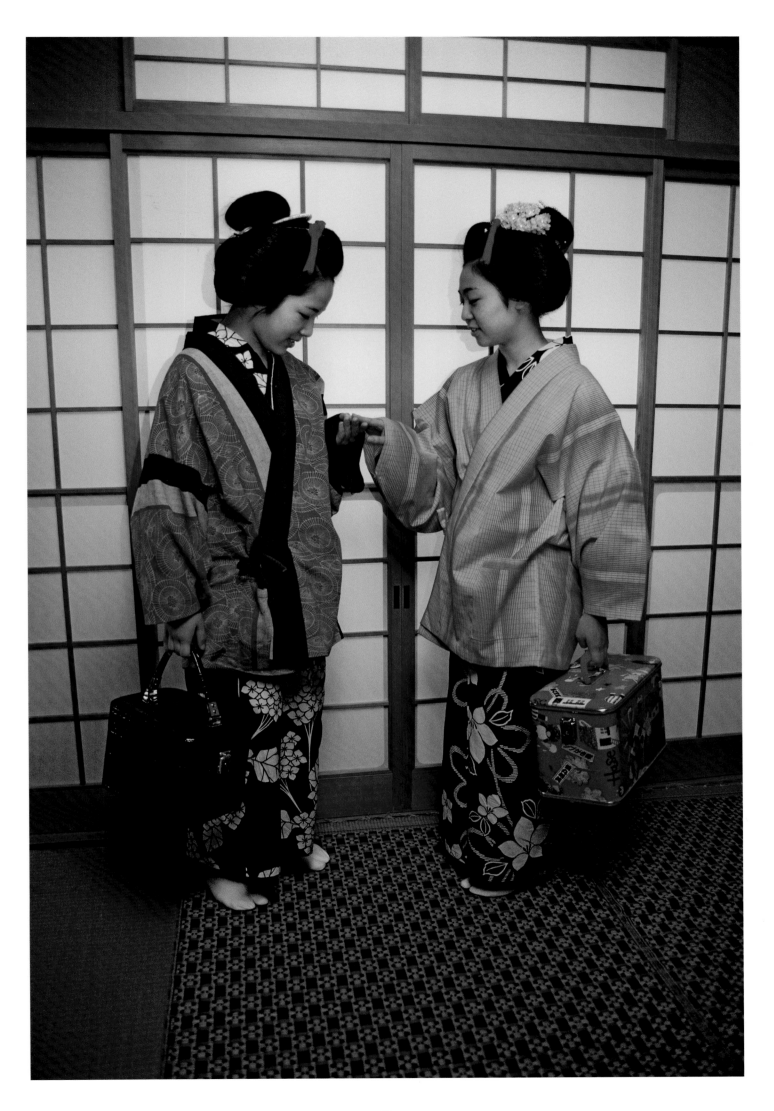

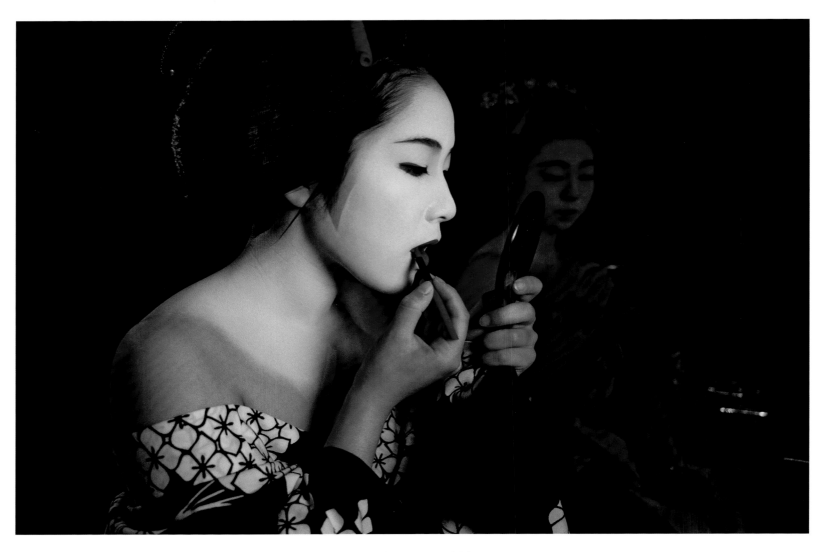

KYOTO, JAPAN, 1988

The geisha's stylized makeup dates back over
800 years, and is typified by thick chalk-white
face paint, pursed red lips, and red eyeliner.
Originally the teeth were blackened with oxi-
dized iron, but this practice was abandoned
in the late 1800s.

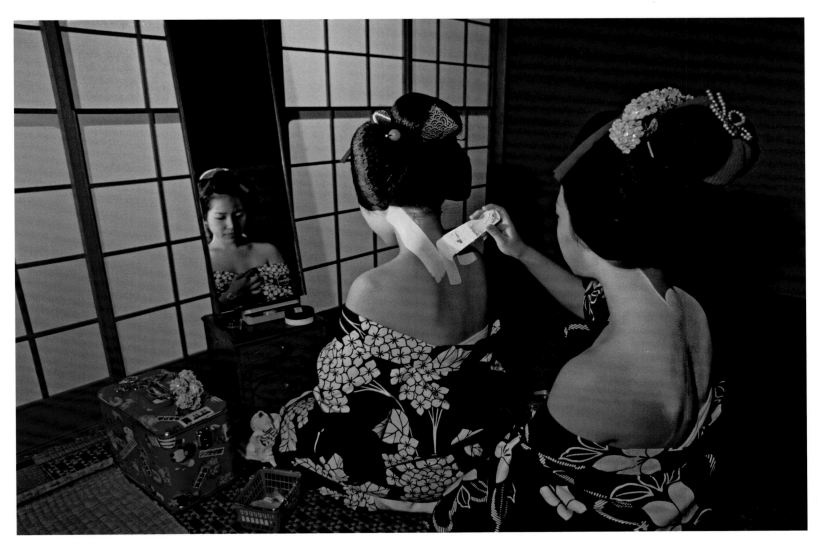

KYOTO, JAPAN, 1988

The back of the neck has always been considered a sensual area in Japanese beauty standards. Geisha leave this small patch of skin bare to heighten the illusion and mystery created by their white makeup.

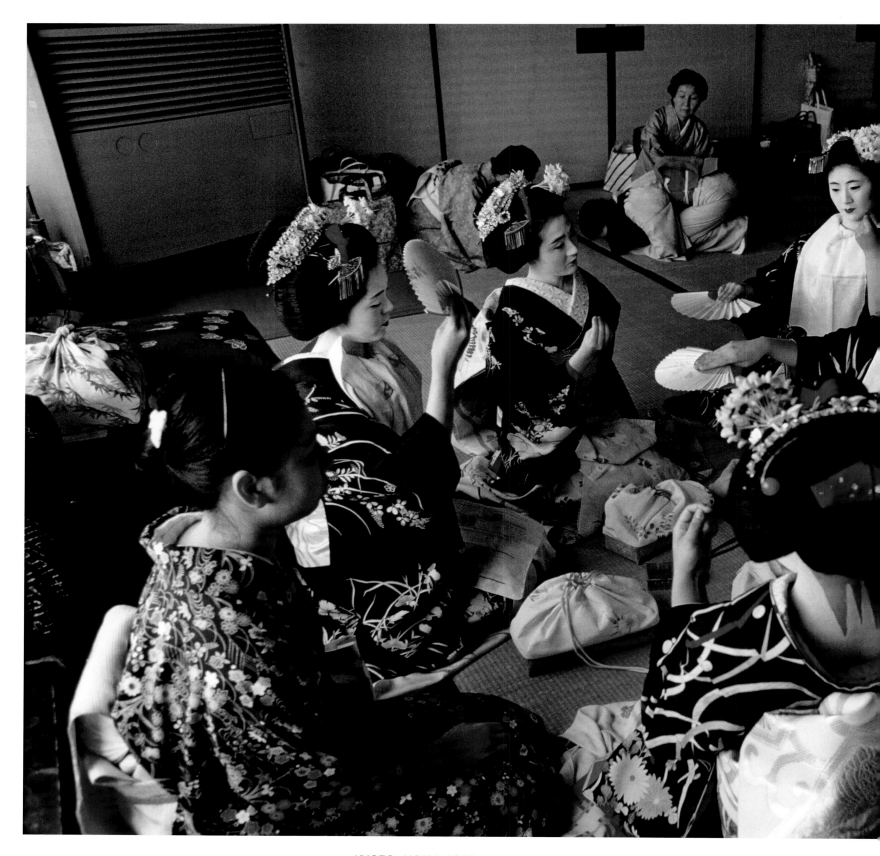

KYOTO, JAPAN, 1988

The elaborate costumes and accessories of the geisha
tradition—including fans, kimonos, and obis—involve many
assistants and hours of preparation. Modern geisha often
wear wigs rather than have their hair lacquered weekly—
which required them to sleep on wooden supports instead
of pillows in order to preserve their hairstyles.

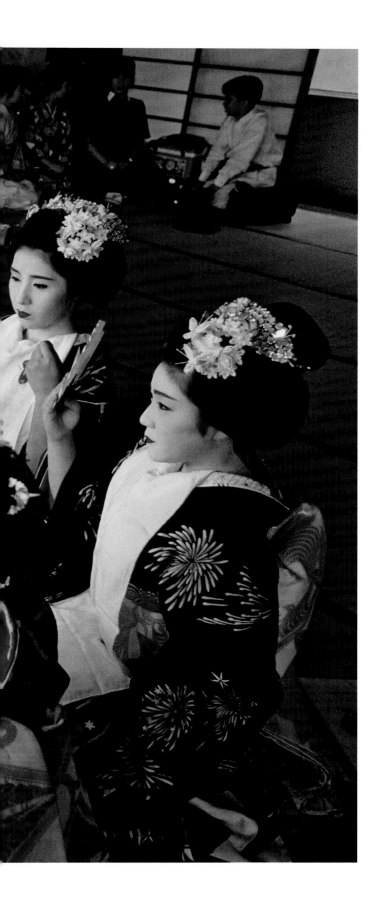

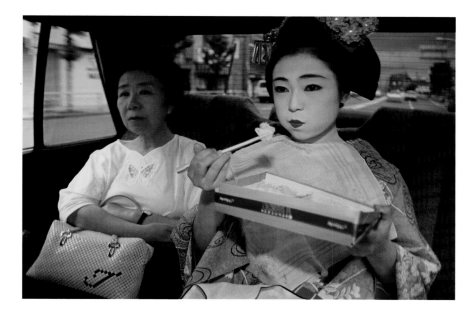

KYOTO, JAPAN, 1988

The young *maiko* works as an apprentice to
her *oka-san*, or housemother, who provides
all her costumes and training, and serves as
both her business manager and mentor.

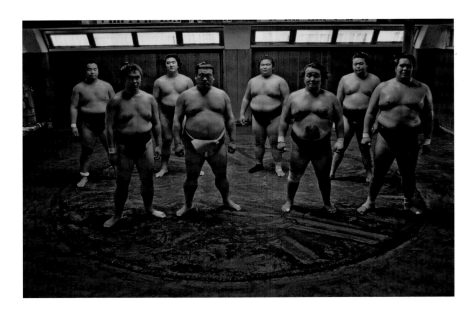

TOKYO, JAPAN, 1988

Sumo wrestlers pose for Paul's camera in their *mawashi* (loincloths) and *chonmage* topknot hairstyle—similar to that worn by the samurai of the Edo period.

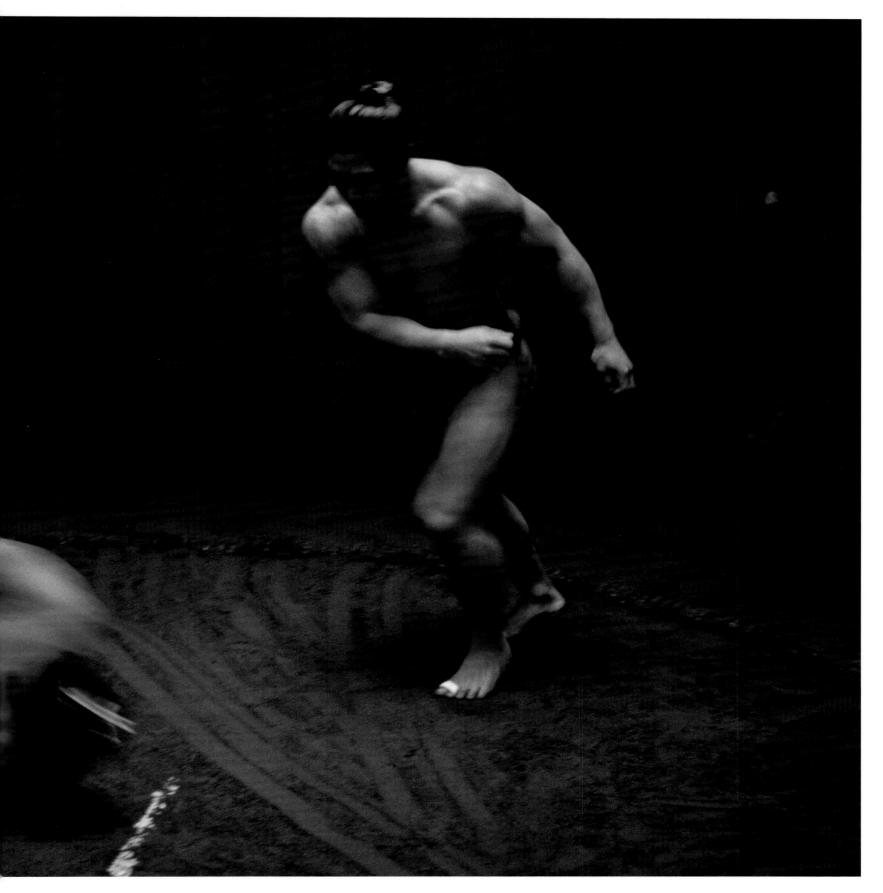

TOKYO, JAPAN, 1988

The winner of a sumo wrestling match is the first
competitor to force his opponent to either step
outside the *dohyo* (wrestling ring) or to touch the
ground with any part of his body other than his feet.

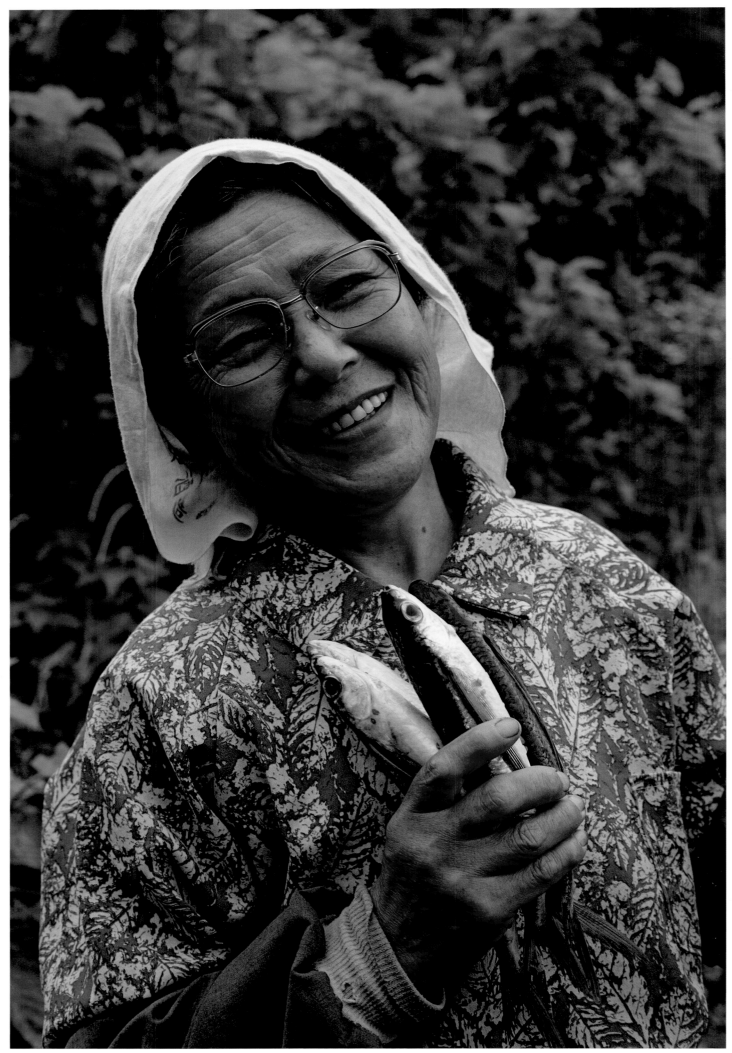

OITA, JAPAN, 1983

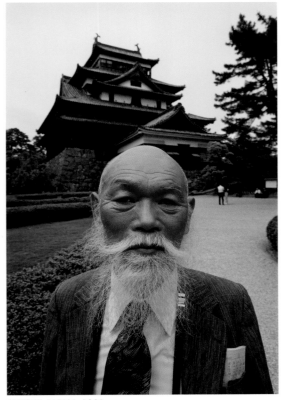

MATSUE, JAPAN, 1981

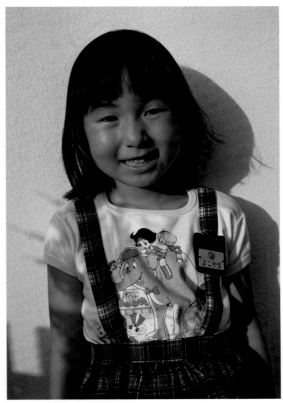

NAGOYA, JAPAN, 1974

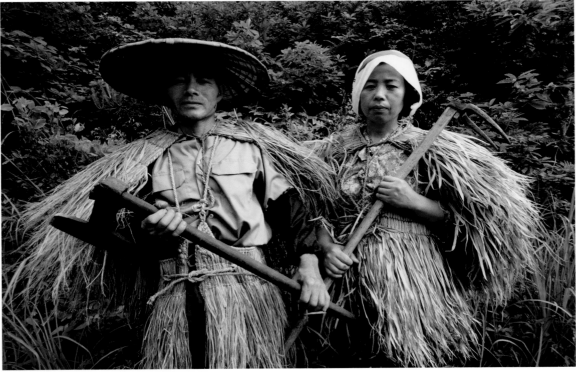

HAMAMATSU, JAPAN, 1981

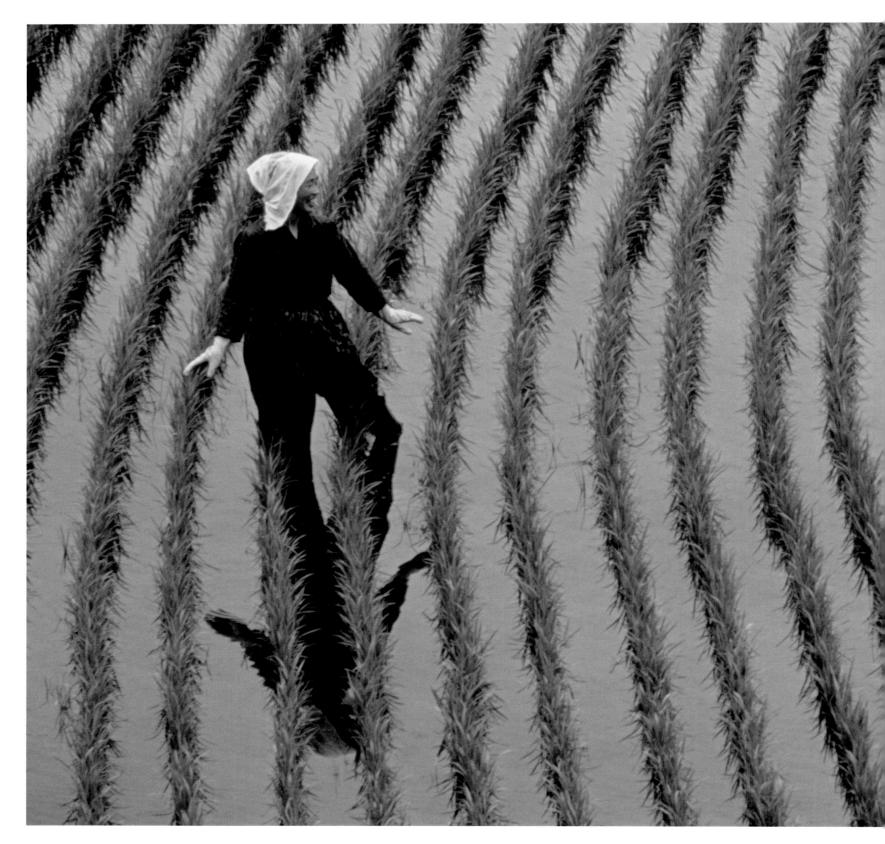

YOSHIDA, JAPAN, 1981

Field workers take a break from tending
rice patties and exchange a little gossip.

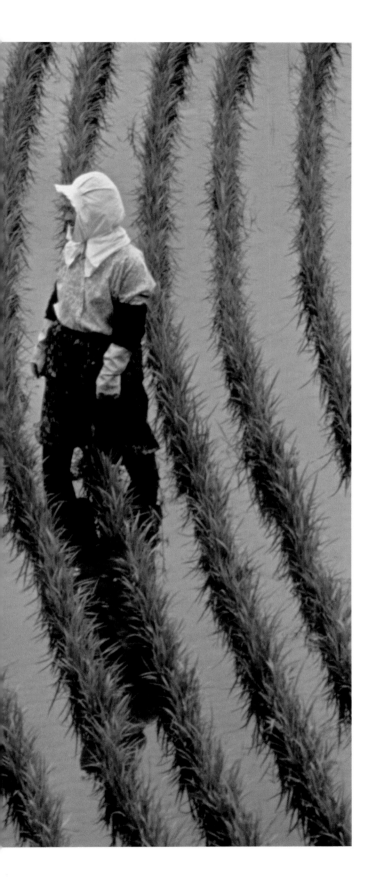

YOSHIDA, JAPAN, 1981

A farmer heads back toward her thatched-roof country house, after clearing weeds from her newly sprouted field.

.

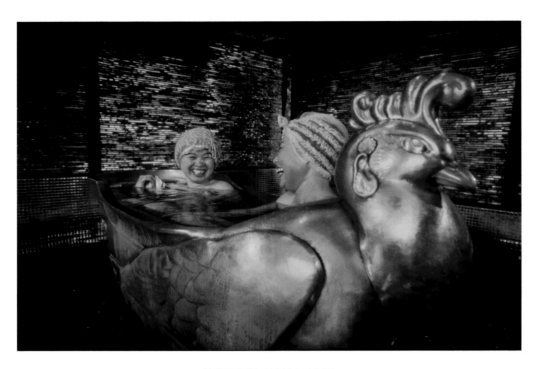

SHUZENJI, JAPAN, 1979

At the Shuzenji Onsen, friends relax in the
famous "Gold Bath," said to be the world's
largest single intact piece of solid gold. The
geography of Japan abounds in natural mineral
springs, making the *onsen* (hot springs) one of
the nation's most popular pastimes.

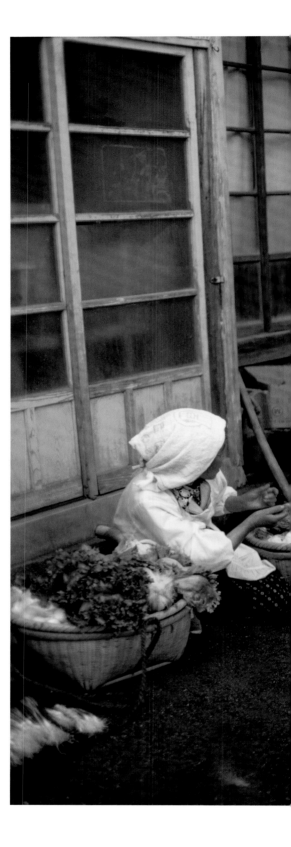

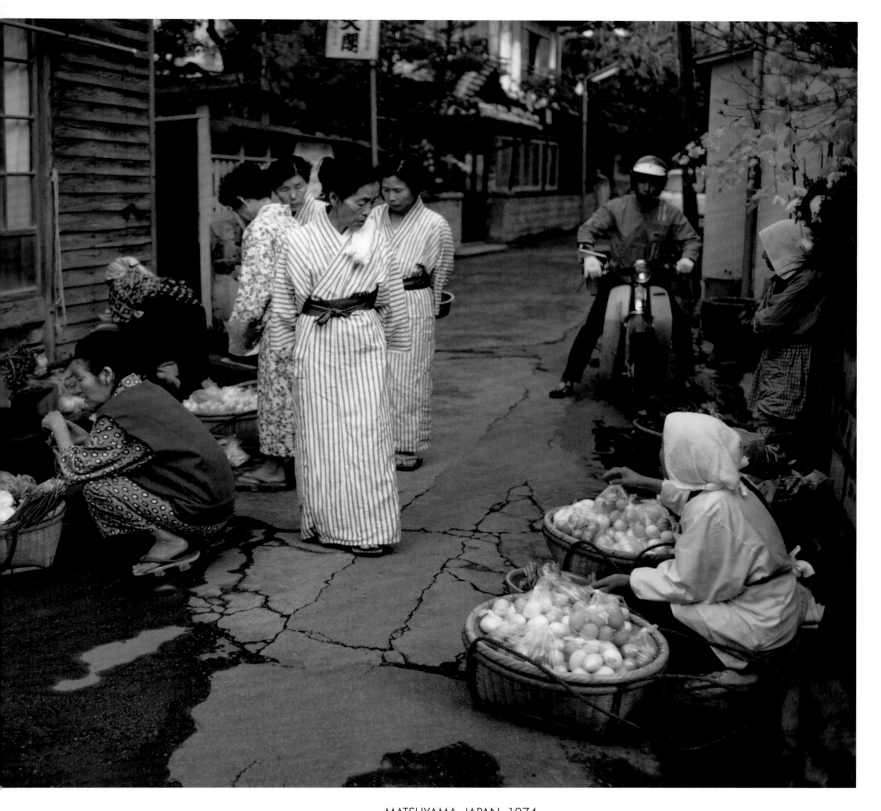

MATSUYAMA, JAPAN, 1974

After a visit to the Dogo Onsen—one of the oldest spas in Japan—women explore the nearby streets dressed in light summer robes called *yukata*.

TURBULENT KINGDOMS

*The Sacred Landscapes of
Vietnam, Cambodia, Laos,
Thailand, and Burma*

The mainland countries of Southeast Asia saw their share of conflict in the mid-twentieth century. Paul began his many trips to the region in the 1980s, photographing the resilient and spiritual peoples of these nations during decades of recovery.

In this infinitely diverse area are highland peoples and river peoples, plateau dwellers and jungle nomads, rice growers and fishermen, coastal traders and mountain recluses. Tribes of every conceivable origin populate sweeping regions of varied geography.

Across tribal and national lines are Buddhists, Mohammedans, Hindus, Confucianists, Christians, and animists. Hundreds of tongues, dialects, and languages can prevent even the simplest attempt at communication. Endless stories of miracles and myths are told, from hamlets in the Mekong delta to caves in the chilly mountains of Laos near China's border. Smoke rises from incense sticks at temples and spews from active volcanoes. Puppet dances and shadow plays are reminders of ancient combat, of rivalries, of loves and losses.

The advent of white colonial invaders is but a recent ripple in time. Long before the Spanish, Portuguese, English, French, and American conquests, an infinite number of traders, explorers, and marauders from the Mongolian steppes and Persian heartlands were absorbed. When twentieth-century colonial regimes were shattered by a fleeting Japanese empire, new entities were formed, unformed, and reformed under the anvil of insurgency and revolution.

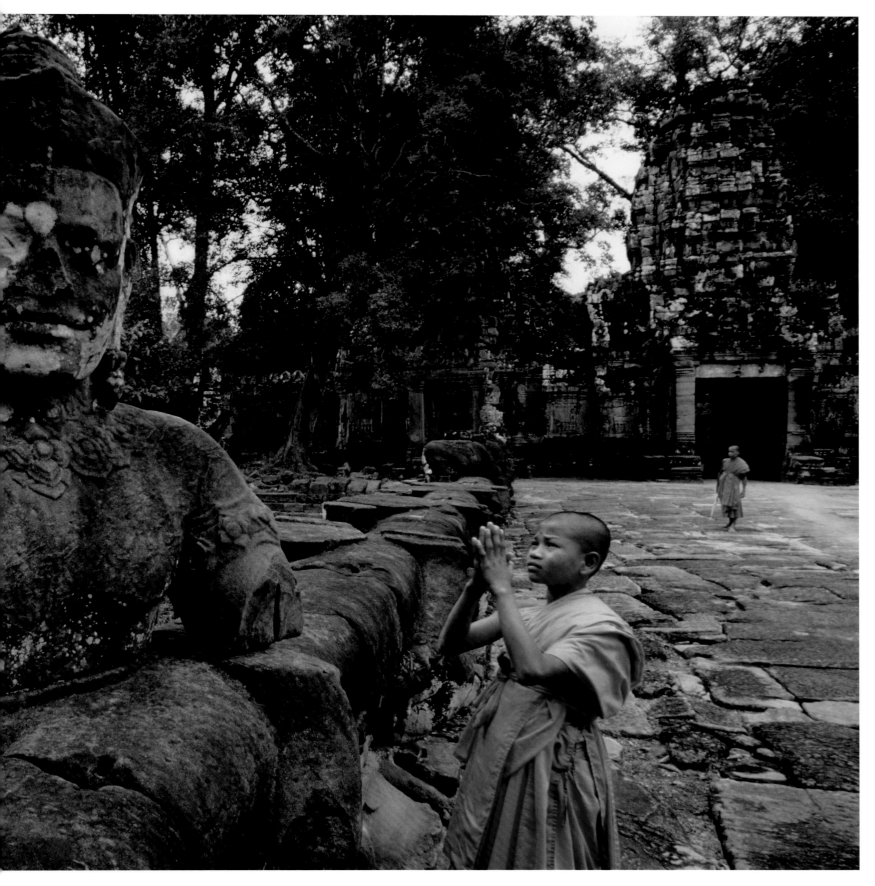

ANGKOR, CAMBODIA, 1996

A young Buddhist monk prays at one of the many
stone statues adorning the Preah Kahn Temple, built
by the Khmer monarch Jayavarman II in 1191.

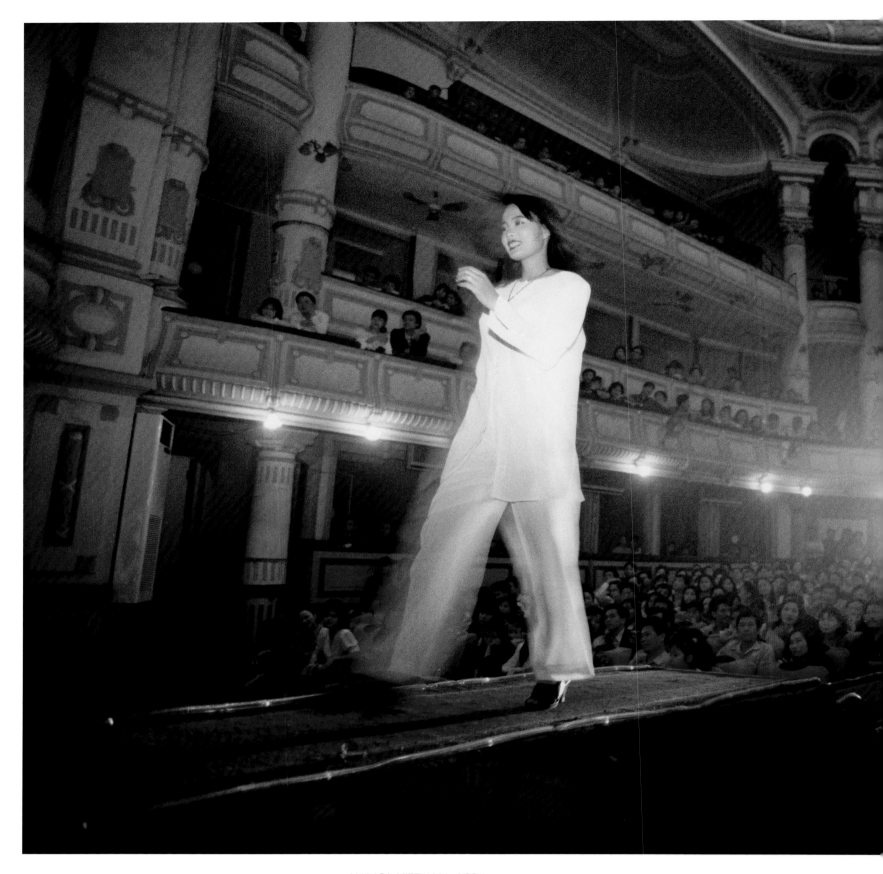

HANOI, VIETNAM, 1994

A model strolls the catwalk in a fashion
show at the Hanoi Opera House.

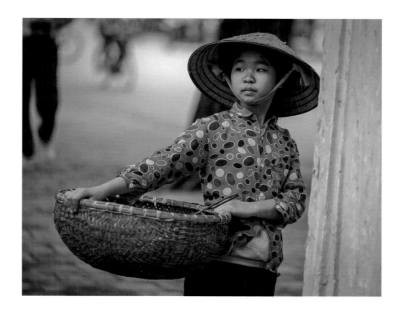

HANOI, VIETNAM, 1994
Shopping basket in hand, a teenage girl
heads home from the market.

All the while, the basic needs of nameless milllions continue the same as ever, since the beginning of time. Decolonization has rarely affected the remotest inhabitants. Postwar treaties, pacts, and conventions design a superficial veneer over the unending reality of planting, tending, harvesting, trading, marketing, and survival.

Alliances and associations in our twenty-first century supposedly represent the best interests of this array of migrants, refugees, longhouse dwellers, and sea gypsies—but do they? As far as the vast populace is concerned, are these resolutions not etched in the sand or traced on the lily pad?

These people have never heard of the World Bank, the U.N.'s Universal Declaration of Human Rights, the Association of Southeast Asian Nations, the World Trade Organization, or the pact for Asia-Pacific Economic Cooperation.

Ah, but the Lords of Poverty (as the aid donors to the Third World have been called) are insatiable crusaders. They must be taken seriously! Gratitude will be paid by lighting joss sticks. —KL

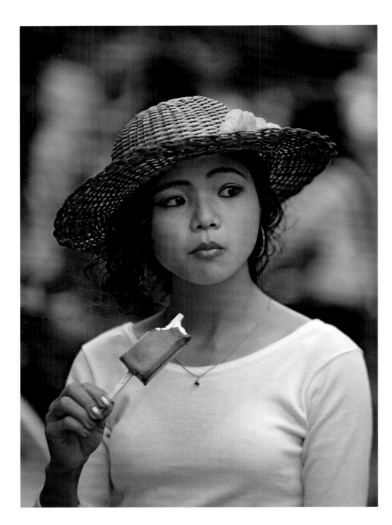

HO CHI MINH CITY, VIETNAM, 1994

In this tropical city with an average temperature
of 82°F, ice cream is a welcome treat.

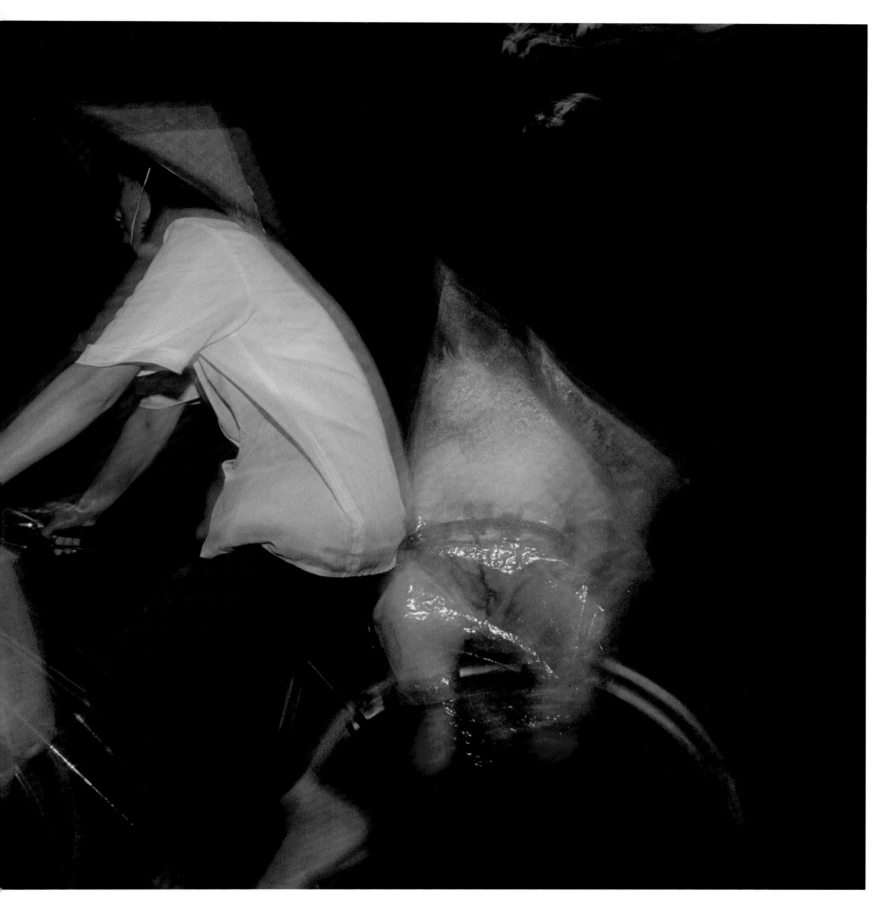

HANOI, VIETNAM, 1995

Running errands on her bicycle, a mother keeps
her child under wraps to protect him from rain.

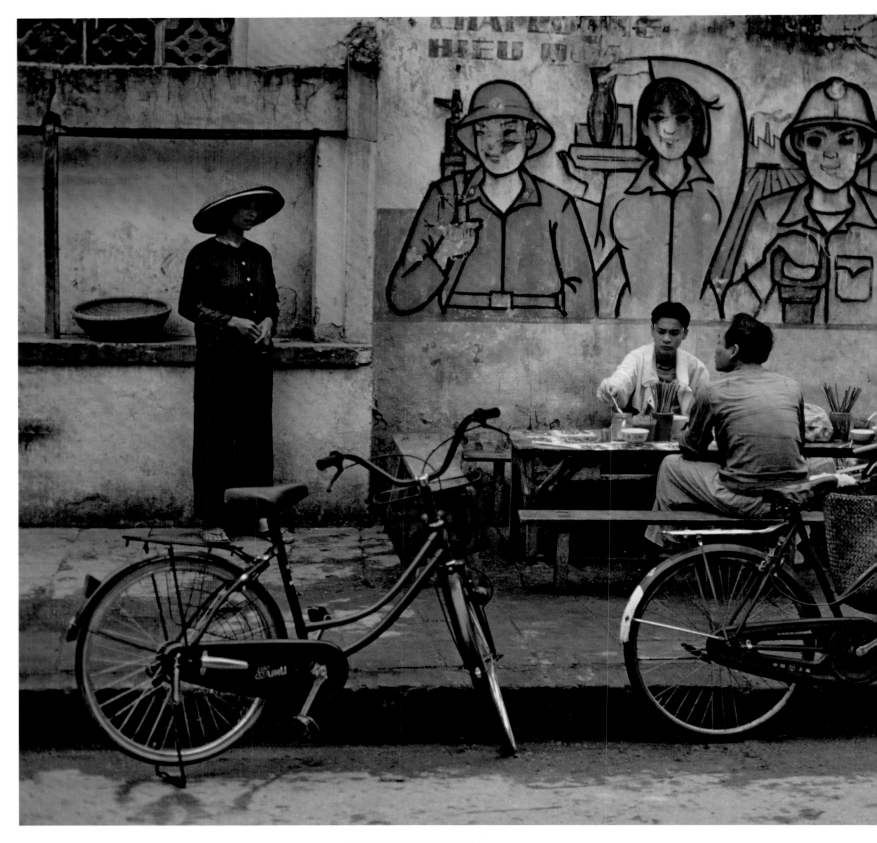

HANOI, VIETNAM, 1994

Citizens break for a quiet afternoon meal under
the gaze of the soldiers in a propaganda mural.

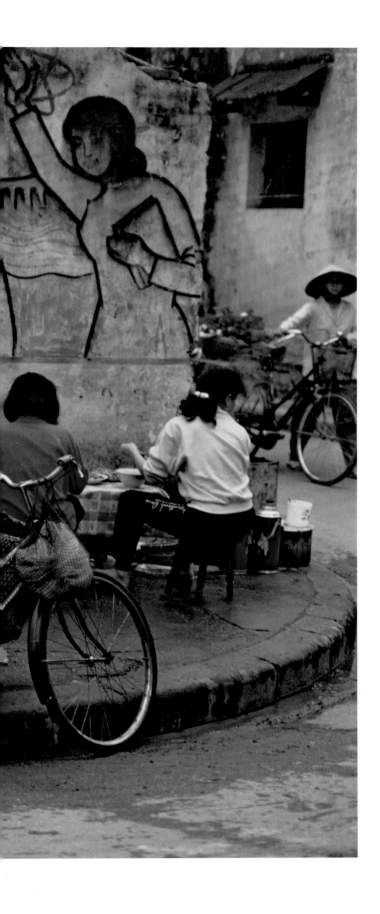

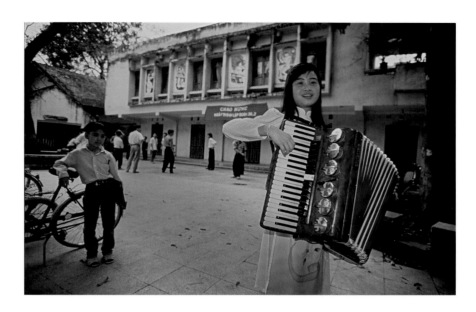

HANOI, VIETNAM, 1994

A young woman entertains passersby
with her musical talents.

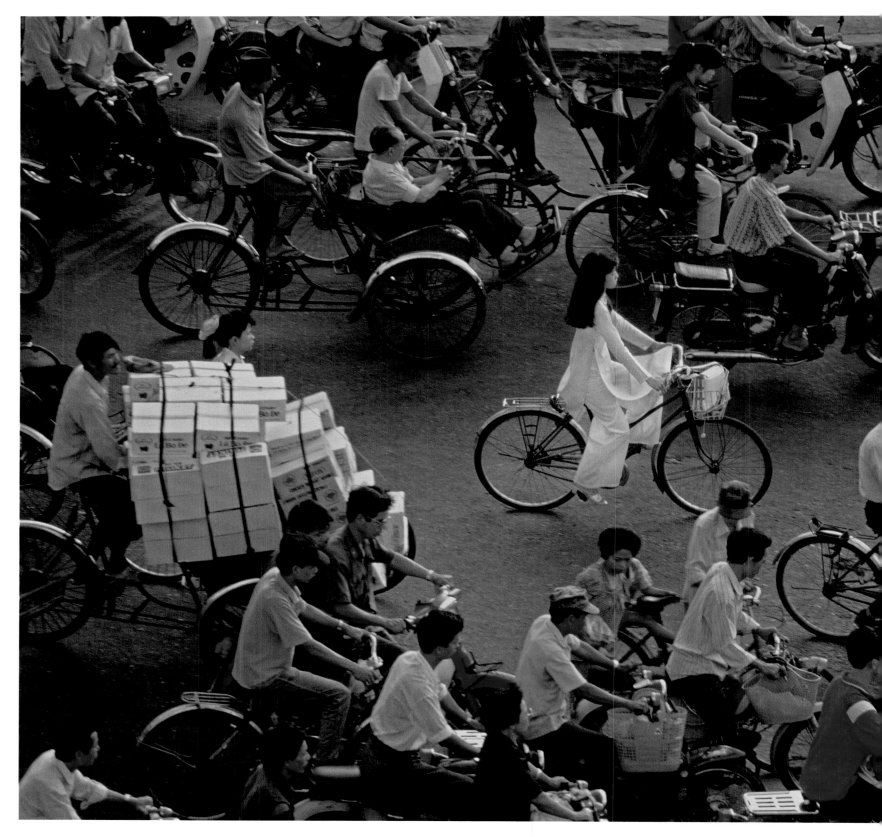

HO CHI MINH CITY, VIETNAM, 1994

Morning commuters slowly navigate the city traffic.
At the time of this photograph, Vietnam was just
opening to the outside world: cars were a rarity, and
the streets were filled with the sounds of bicycle bells.

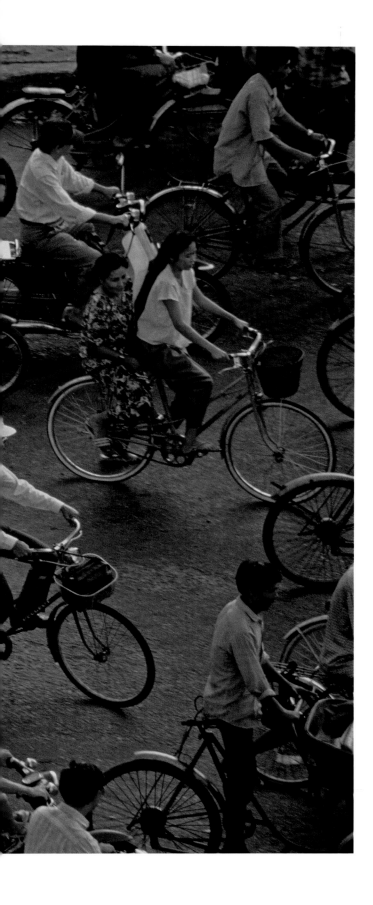

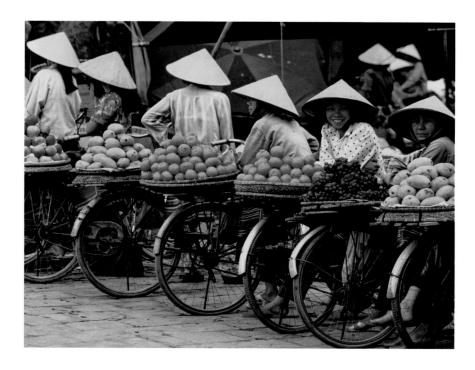

HANOI, VIETNAM, 1994

Vendors hawk their produce at a morning
market in Vietnam's capital.

The Lost War

When I was a poor student in Paris in 1959, I discovered a tiny *foyer* on the narrow rue Git-le-Coeur off place St-Michel that served *pho* to Vietnamese students at the Sorbonne. There was a map of North Vietnam and a picture of Ho Chi Minh on the wall. The girl students wore the flowing national dress, the *áo dài*. They wore metal-rim eyeglasses and carried identical worn book bags. I thought of them as porcelain moths, fluttering for an instant then vanishing. Hungry, I sometimes finished the noodles they left behind in the bottom of their bowls. Many years later, I wondered how many of them, attired in camouflage green, had fought and perished along the trail named after their Uncle Ho.

Recently I saw a photo of an elderly, bemedaled North Vietnamese army veteran. She had first taken up arms at sixteen, and fought the French, the Japanese, and the Americans. She had taught women to make their own weapons, dig tunnels, and steal guns. In 1994, she recited, "In the words of Ho Chi Minh, we shall forget the past and greet the future with open arms."

Little did I imagine that in 1963, I would fly into Saigon and sip a Pernod at one of those same tables at the Continental where Graham Greene wrote his prophetic novel *The Quiet American*. A few blocks away, saffron-robed monks were setting fire to themselves in protest of the Diem regime—which was supported by the American government. What Greene had written a decade before, just prior to the Battle of Dien Bien Phu, had come true. The Americans had now climbed into the snake pit vacated by France. They were up to their ears.

Vietnamese history is long and bloody: The Trung sisters, who fought the Chinese in the first century AD; dynasties rising and falling throughout millennia; the Tay Son "peasant" rebellion of 1771. The arrival of the French in 1859; the Japanese occupation during World War II. Finally the Americans, with their democracy, their Domino Theory, their "hearts and minds," the Cold War.

Those delusions came to an end on April 30, 1975, with the final helicopter exit. Graham Greene once noted, "Maybe America has simply so much goodwill for the rest of the world that she just doesn't know what to do with it." —KL

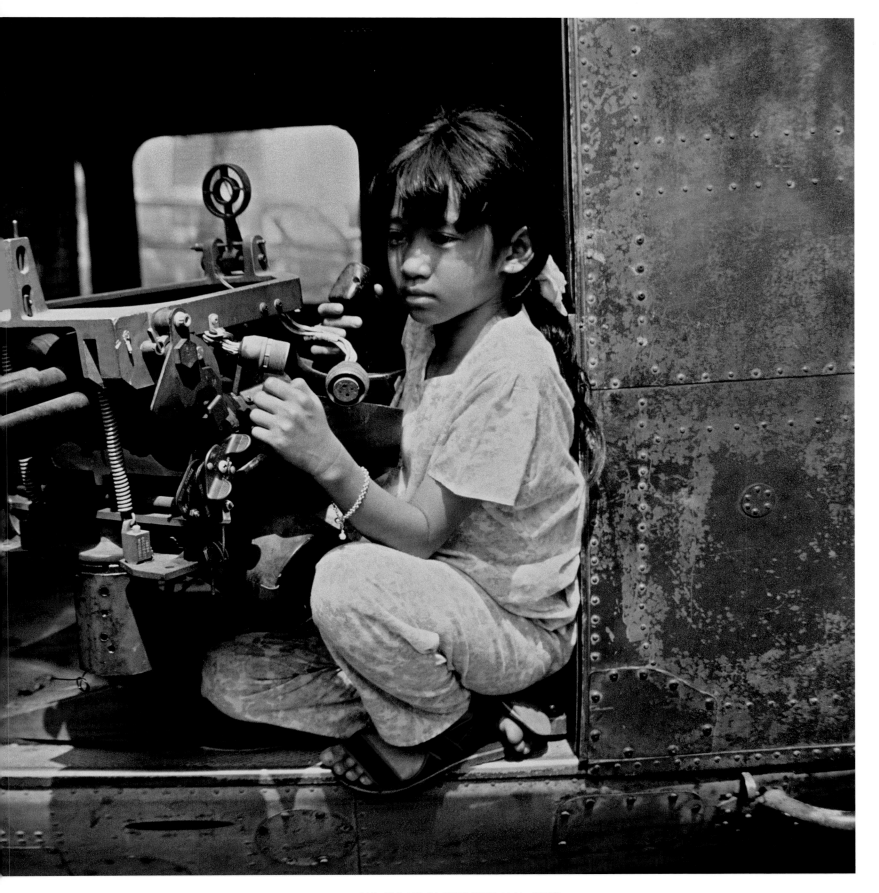

HO CHI MINH CITY, VIETNAM, 1993

At the Vietnam Military History Museum, a young Vietnamese takes aim from a U.S. helicopter, part of an array of captured weapons, bombs, and aircraft on display.

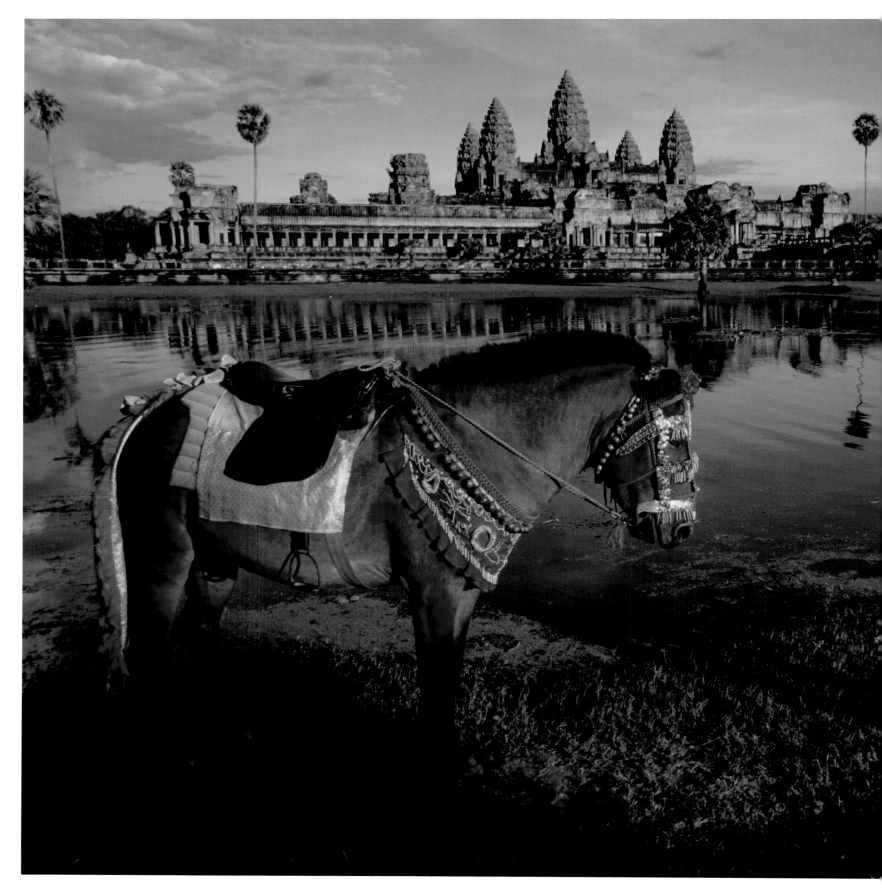

ANGKOR, CAMBODIA, 1996

Staking a prime position near the temples of the
Angkor Wat, a young entrepreneur offers rides to
tourists on her father's horse.

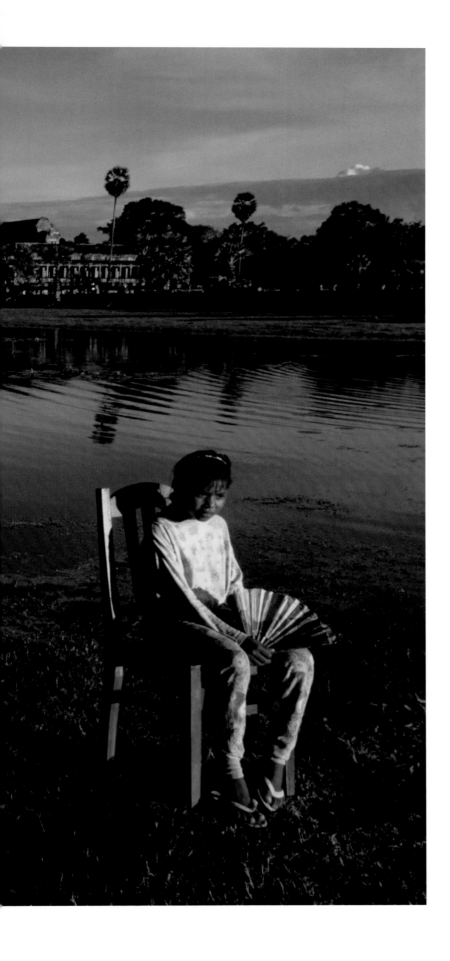

The Haunted Country

On my first visit to Cambodia in 1963, I stopped over in Siem Reap on my way from Saigon. Walking through the jungle-clad ruins of Angkor Thom and Angkor Wat, totally alone, I came upon impassive stone faces strangled by great roots. Their expressions told me nothing. Monkeys shrieked in the treetops and showered me with twigs. A stone dancer with round breasts assumed her enticing pose. Masked demons and monkey gods stared out from cracked passageways. There was time to reflect on the passing of empires and the deaths of kings.

When Paul visited the ruins thirty-five years later, he preferred the Ta Prohm temple—which was still unrestored—to Angkor Wat, which had been rescued for tourism and was a challenge to photograph due to all the visitors. Ta Prohm had retained its overgrown, ghostly appearance.

Who are the Khmer people, who created these enduring monuments? The Khmer Empire first emerged about AD 802, when the young leader, Jayavarman II, declared independence from Java, and proclaimed himself a *devaraja*, or "god-king." His followers then proceeded to conquer surrounding areas for the next seven centuries, and to create the most expansive city in the preindustrial world.

The most powerful symbols of this dynasty are the nearly 1,000 temples found throughout the Khmer capital region of Angkor. Built in the early twelfth century, Angkor Wat is the largest religious monument on earth. Originally a state temple, it was dedicated to the Hindu god Vishnu, but later became a Buddhist shrine.

The Khmer Empire waned and in 1431 Angkor was sacked by the Siamese. The Khmer princes retreated to smaller city-states, and various local and neighboring forces fought for control of the region, until Cambodia became a protectorate of France in 1863. This lasted ninety years, until 1953.

Prince Norodom Sihanouk ruled as a constitutional monarch until March 1970, when he was overthrown by a right-wing coup instigated by his generals and probably helped by Washington.

I immediately flew to Cambodia from my residence in Singapore to report on the erupting war. A communist

offshoot of the North Vietnamese People's Army, called the Khmer Rouge, had emerged, and was rapidly encircling the capital, Phnom Penh.

The drill for the press corps was to motor out of the capital during the day and try to assess the shifting combat perimeter. A large number of reporters, cameramen, and photographers were captured, killed, or disappeared. Friends from CBS, NBC, and UPI were never seen again. By dusk if they had not returned for drinks at Le Royal, one could only suspect the worst.

The bloodbath began in April 1975, when the Khmer Rouge assumed power. The rest is history. Cambodia would return to the Year Zero. The next year, I was back in New York working at United Nations Radio. One day I sat a few feet away from Ieng Sary, who was the Kampuchea delegate and one of the top three Khmer Rouge leaders, after Pol Pot and Khieu Sampan. He was known as Brother Number Three. He had a round baby face. I said, "Bonjour, Monsieur." In 2007, Sary would be arrested by the Cambodia Tribunal for crimes against humanity; he died before the case reached a verdict.

Today Cambodia, under a former Khmer Rouge cadre, carries on: the red-and-yellow robed monks make their rounds; chanting is heard in the temples; rice fields glimmer. Land mines are still being cleared, as amputees from the long years of war beg on the sidewalks. Tourists flock to restored Angkor Wat by the thousands; restaurants, nightclubs and four-star hotels serve the well-to-do.

Meanwhile, two million ghosts from the Khmer Rouge holocaust, bones long bleached in the killing fields, haunt the corners of this troubled land. Like the impassive stone faces in Angkor, it is hard to fathom the past when you return the stare of any older Cambodian today. The eyes do not tell it. —KL

ANGKOR, CAMBODIA, 1996
Monks walk through the south gate entrance to the ancient royal city of Angkor Thom.

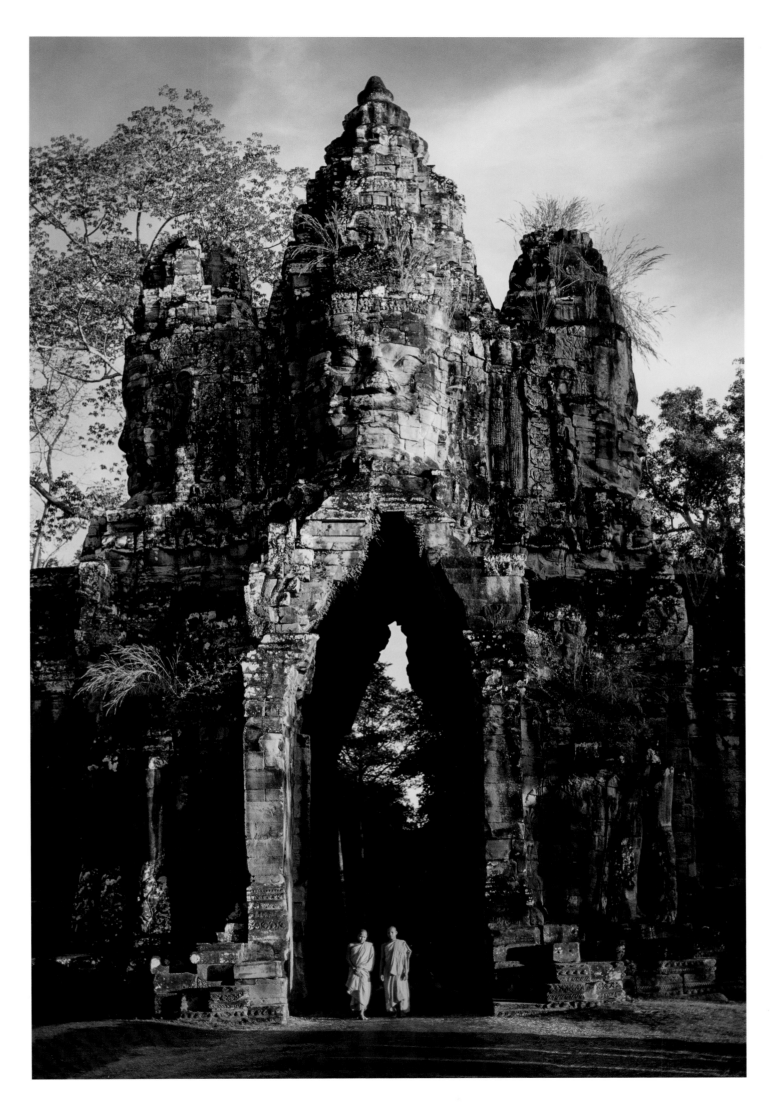

ANGKOR, CAMBODIA, 1996

Khmer Rouge forces occupied much of the region around Angkor through the mid-1990s. Visitors are advised not to wander too far beyond the immediate temple grounds, due to the land mines that still exist in the area.

ANGKOR, CAMBODIA, 1996

In Preah Kahn, a largely unrestored 800-year-old temple that was once the religious center for 15,000 teachers and students, young monks explore one of many age-old passageways.

LUANG PRABANG, LAOS, 1998

Students take a break between classes in the
former royal capital of Laos.

On the Far Side of the Mekong

Time passes so slowly in Laos that you can hear the rice grow. So say the Lao, a graceful people.

In the 1890s, France rescued Laos from a Chinese invasion and began to administer the region as a part of its "protected" Indochina territories. In 1953, under pressure after World War II, Paris declared Laos an independent constitutional monarchy.

The people wove beautiful clothes and erected exquisite temples. The monks answered to everyone's spiritual needs. Up in the mountains, the Hmong tribes revered their guardian spirits and pursued their ancient rituals. Everybody was happy in this serene kingdom. Then, war came.

I began reporting the shifting fortunes in Laos in the 1960s, as the Cold War crept into Southeast Asia. In the capital, Vientiane, at the seedy Hotel Constellation, I joined a cadre of news stringers who were paying their bar bills by sending out reports of the rumored war between the U.S.-supported Royal Lao Army and the communist Pathet Lao. The hotel manager, Maurice, a money exchange dealer, was assisted by his three lovely daughters, counting stacks of currency in plain view.

If Vientiane was quiet in those days, Luang Prabang, the royal seat of Laos, was asleep. The mists lingered through the crooked lanes and temple courtyards until the sun rose over the surrounding hills. In the cool of the early morning, the markets came alive; in the distance you could hear the aircraft of Air America, the CIA subsidiary, bringing in guns and taking out opium.

As the conflict heated up, more journalists flocked to the Hotel Constellation. Maurice's three daughters married foreign correspondents and got out of the country—in the nick of time.

Pulled into a Cold War power play, Laos was subjected to more bombing per capita than any other nation in history—by the U.S. After the communists took over in 1975, the Hmong people, who had fought on the American side, were subjected to harsh treatment. A quarter-million Hmong refugees were resettled abroad.

Today, Laos's principle export is electricity to Thailand. More dams are planned. But for now, life continues to move at the pace of a donkey cart. —KL

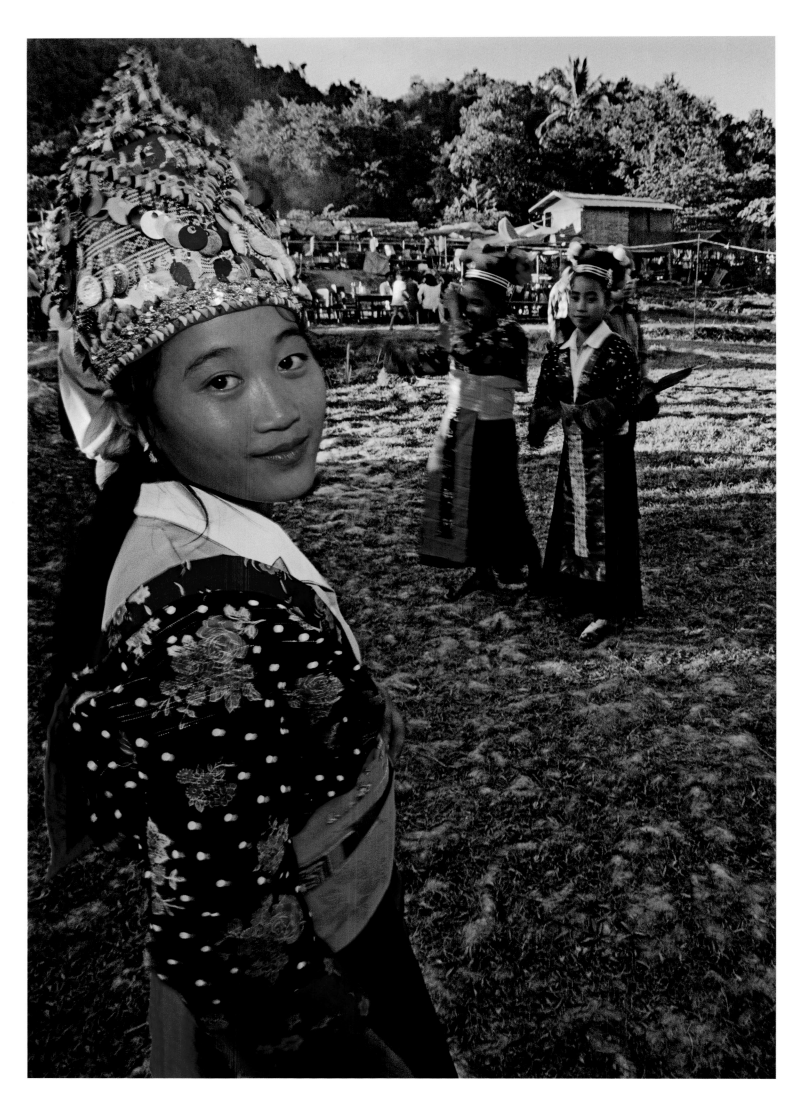

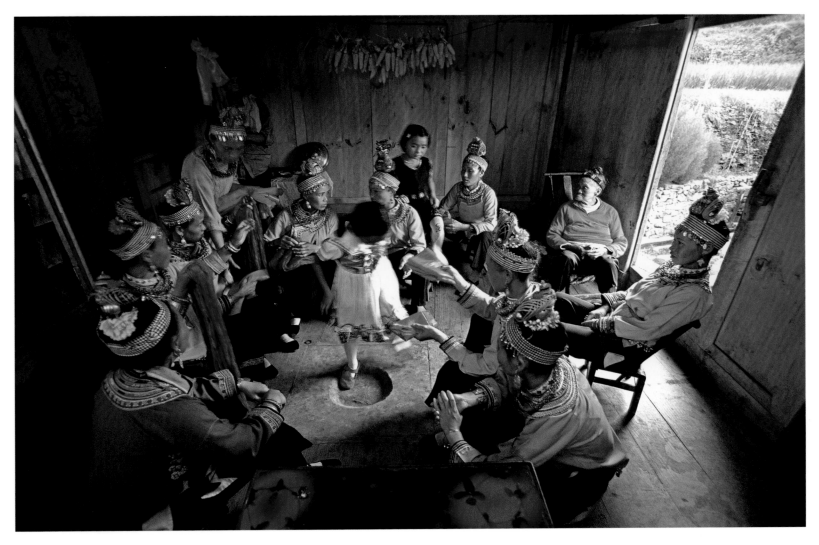

LUANG PRABANG, LAOS, 1998

A troupe of Hmong performers encourages a young
dancer. These hill tribes prefer their highland home,
but come down to the lowland towns for trading.

LUANG PRABANG, LAOS, 1998

Hmong girls attend a festival in the distinctive
costumes of their people—known for their bril-
liant colors and intricate embroidery.

BANGKOK, THAILAND, 1993

Students at a boys' school play with their digitally
enabled toys—a harbinger of worldwide trends
to come.

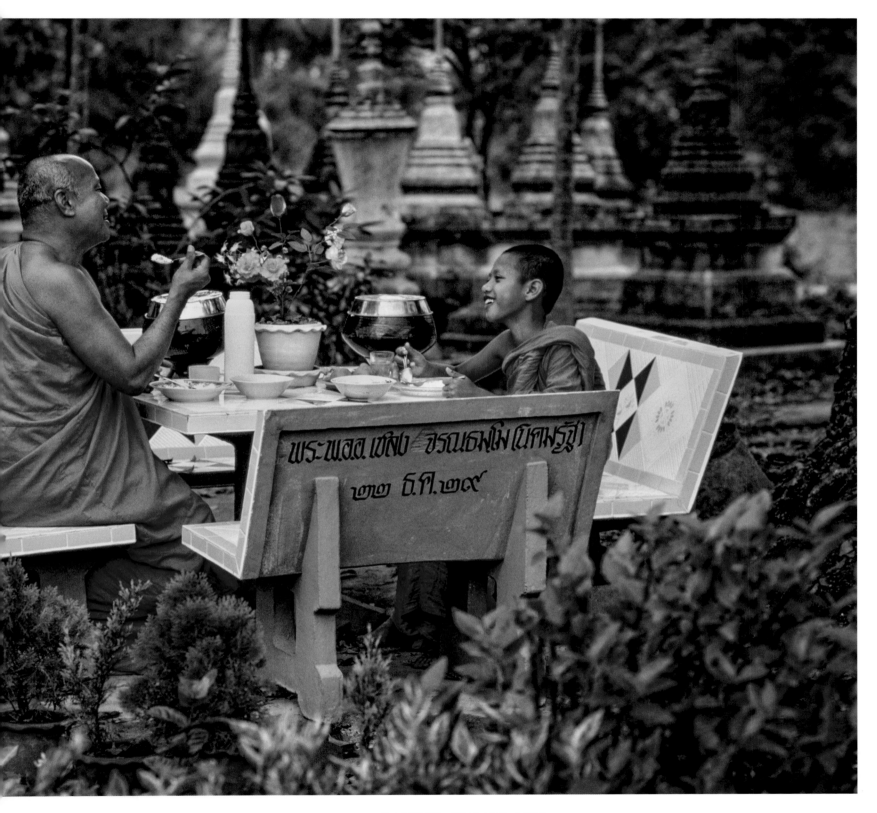

AYUTTHAYA, THAILAND, 1993

A novice receives etiquette lessons from an
elder monk in the kingdom's ancient capital,
founded in 1350.

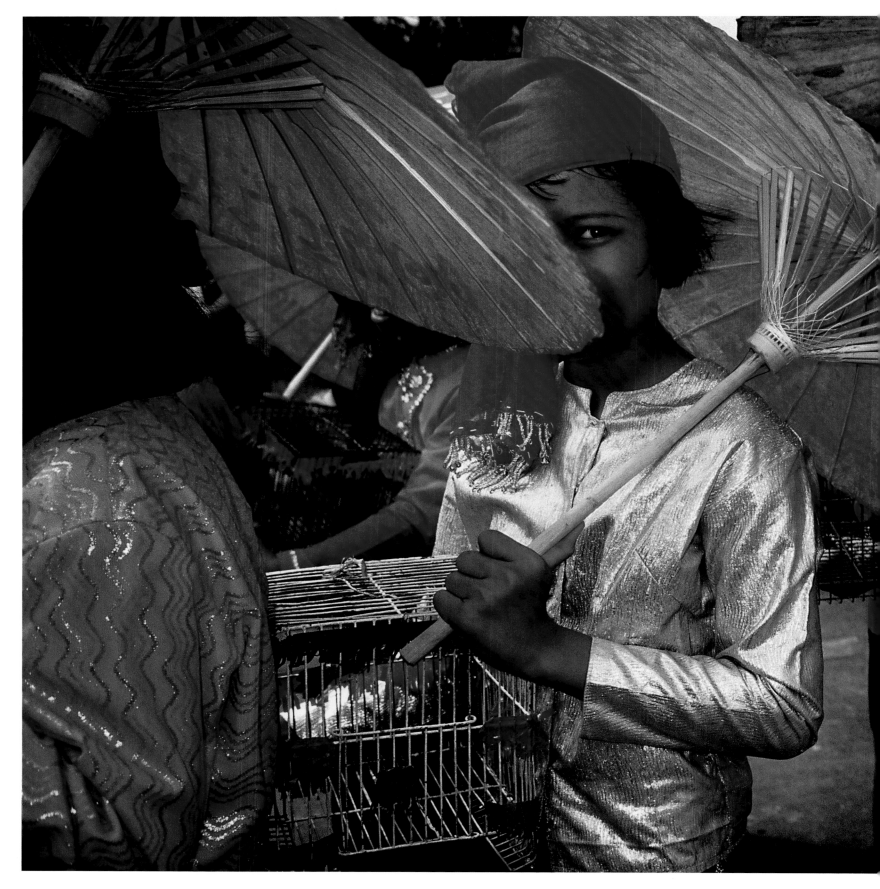

BANGKOK, THAILAND, 1988

Women carrying birdcages parade to a Buddhist
temple on New Year's Day. Upon arrival, the birds
are released as an offering to bring prosperity.

The Thai Smile

The Thai people, once characterized as frustratingly easy-going, have moved with the times. They have joined the international consumer economy, and yet, for the most part, retained their graceful and hospitable nature. The Thai culture reflects a miraculous balance supported by three pillars: monarchy, religion, and state.

This delicate act, although not always perfect, has nevertheless saved the country from the horrors of its neighbors: the Cambodian holocaust; the ethnic cleansing in Burma; and the massive conflicts in Vietnam and Laos. It is also the only land in the region to have skillfully avoided Western colonization.

I was fortunate enough to land in Thailand in late 1961. Jobless, in a rooming house in North Beach, San Francisco, I got an invitation from a school friend. He was already working with Pan Am in Bangkok and he wired me a one-way ticket. With no expectations, no visa, and thirty dollars in savings, I embarked a few days later, with a single valise. My friend put me up in the servants' quarters behind his villa—and there began my introduction to Thai idiom, Thai food, and the pleasurable Thai attitude toward life.

Over the years, I saw Thailand transform from a relative backwater with few paved roads; to a bustling hub for the American war in Vietnam; to a major manufacturing, transportation, financial, and tourist base for the region. I witnessed many military coup d'états, some with vicious side effects, others bloodless, and watched the country proceed slowly toward democratic values.

Paul often used Thailand as a base for his magazine and book projects in Southeast Asia. He has also photographed many assignments in the kingdom, including his collaboration with the renowned writer William Warren on a 1995 book entitled *Bangkok*.

We *farangs* (or expats) provide constant amusement, as well as currency, to the welcoming Thai people, who gracefully forgive our clumsiness. Many foreigners make Thailand their permanent home. It is even said that few get out of Thailand alive.

Take the case of Jim Thompson, perhaps the most famous expat in postwar Thailand, and long referred to as the American "Thai silk king." I had an introduction to Thompson; we both had gone to St. Paul's, a prep school in New Hampshire. Sometimes we chatted by the pool at the Royal Bangkok Sports Club, his lunch-time hangout. He was famous for reintroducing the bright colors of Thai silk, commissioning villagers in remote provinces to return to their looms, and essentially saving a vital national industry.

At the same time, Thompson was also carrying out intelligence duties for the OSS (Office of Strategic Services)—which morphed into the CIA after World War II. It is said that by 1967, he was deeply disillusioned by the succession of right-wing dictators in Thailand, their cronies at the U.S. Embassy, and the American war machine in Indochina. That year he went for a walk while on vacation in Malaysia and vanished without a trace.

Thailand's greatest gift to the world comes quite naturally. It is the Thai smile. Looking deeper, observers try to peel away the Siamese veil. Stay in Thailand long enough and you may conclude that you have bought a ticket to a performance in which the script changes moment to moment, depending on your own reactions.

Today, wrinkled abbots may whisper about the demise of the monarchy. After all, His Royal Highness is now aged. They foretell the end of the Chakri dynasty. New factions will angle for power. Venerable astrologers scribble daring predictions on banana leaves that they wrap around sticky rice and throw down to the "pariah dogs." Nothing lasts. The seduction of Thailand lies in its impermanence, and in its patience, like the persistence of those tiny red ants in a stealthy column, waiting for the ripe mango to fall, once again. *Sanuk!* —*KL*

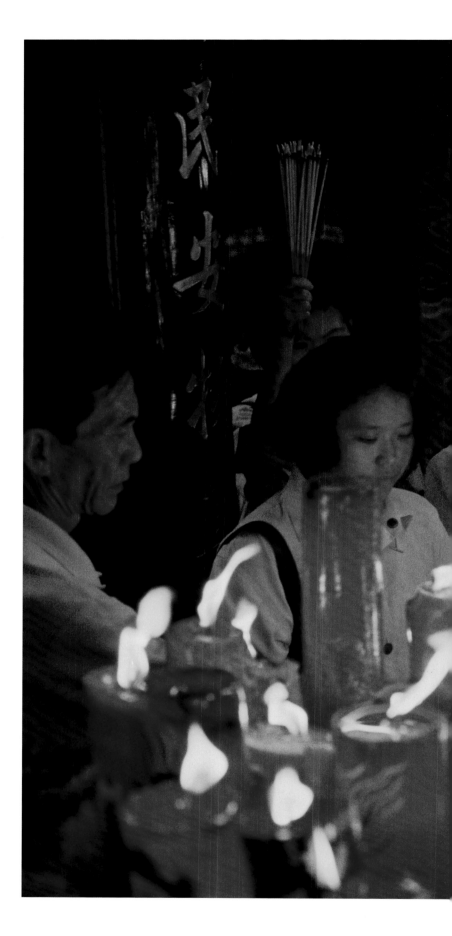

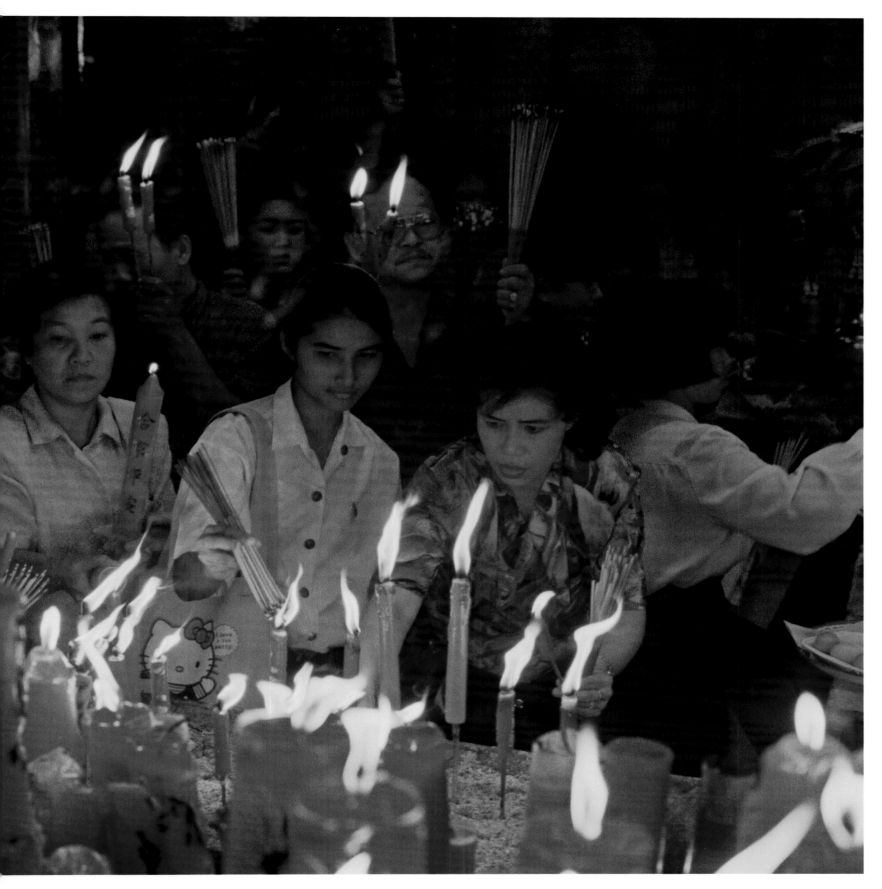

BANGKOK, THAILAND, 1995

Buddhist worshippers light incense and candles
at the Sanjao Pho Suea Shrine in Bangkok's
crowded Chinatown.

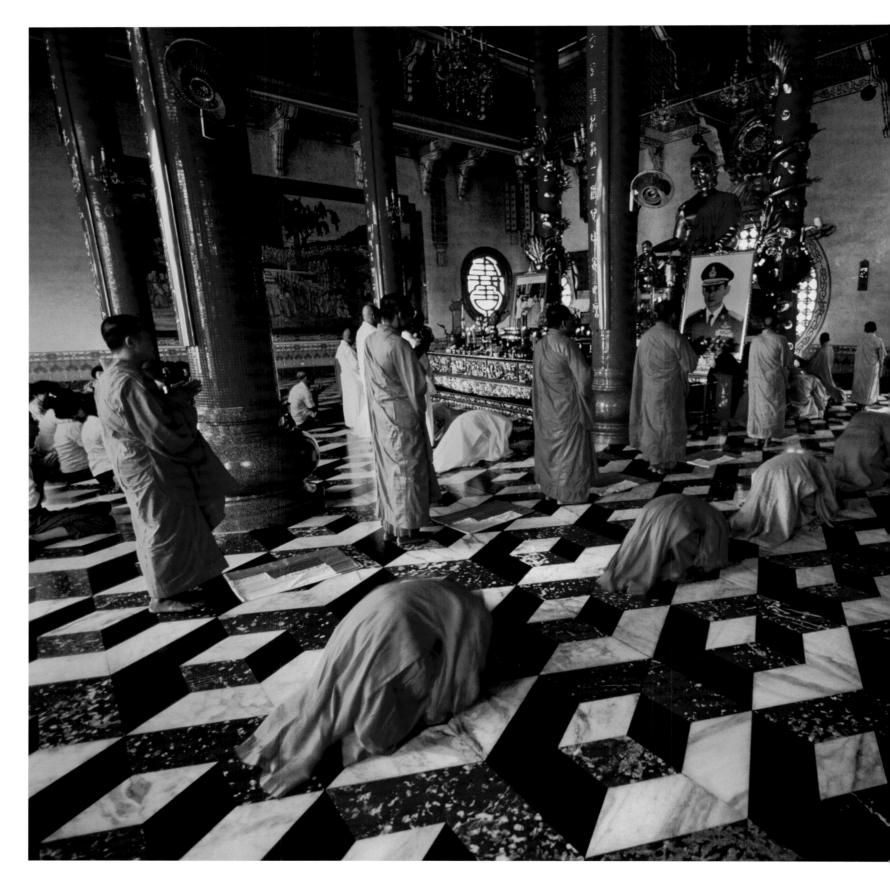

BANGKOK, THAILAND, 1993

Monks conduct their daily prayers before a
portrait of His Royal Highness, King Bhumibol
Adulyadej (Rama IX). Currently the world's
longest-serving monarch, he ascended to the
Thai throne in 1946.

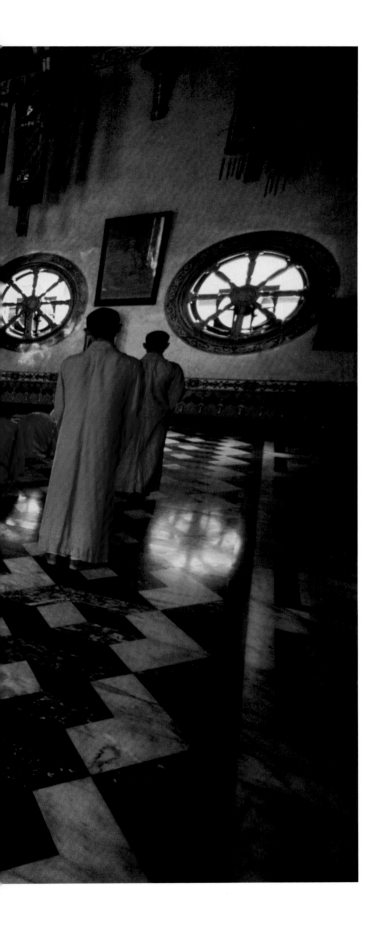

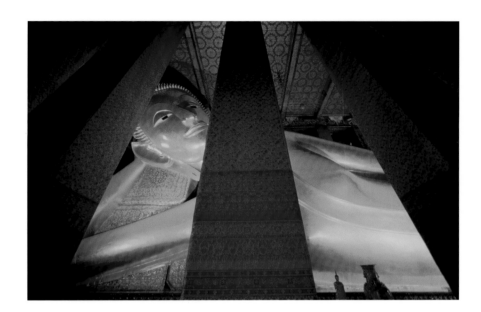

BANGKOK, THAILAND, 1995

Wat Pho is the oldest and largest temple in Bangkok, housing the famous 150-foot-long statue of the Reclining Buddha.

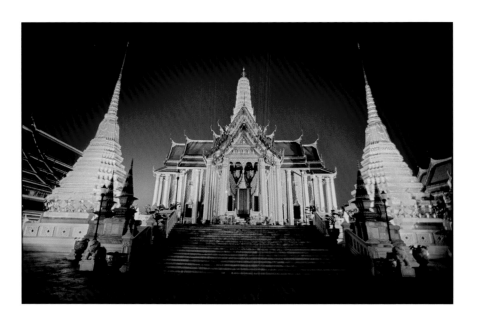

BANGKOK, THAILAND, 1998

The Grand Palace is the seat of the Chakri dynasty, which
came to power in Thailand (then called Siam) in the late
1700s, after the Burmese sacked the old capital of Ayutthaya.

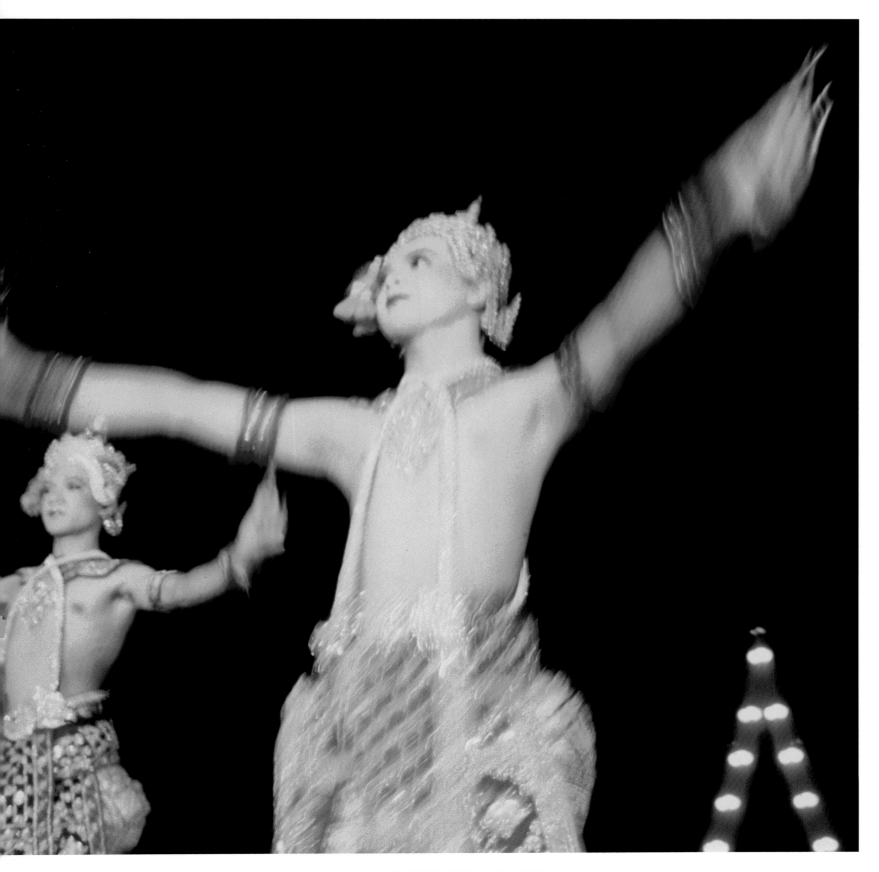

BANGKOK, THAILAND, 1998

Thai dancers recreate Hindu epics that are popular
with local audiences.

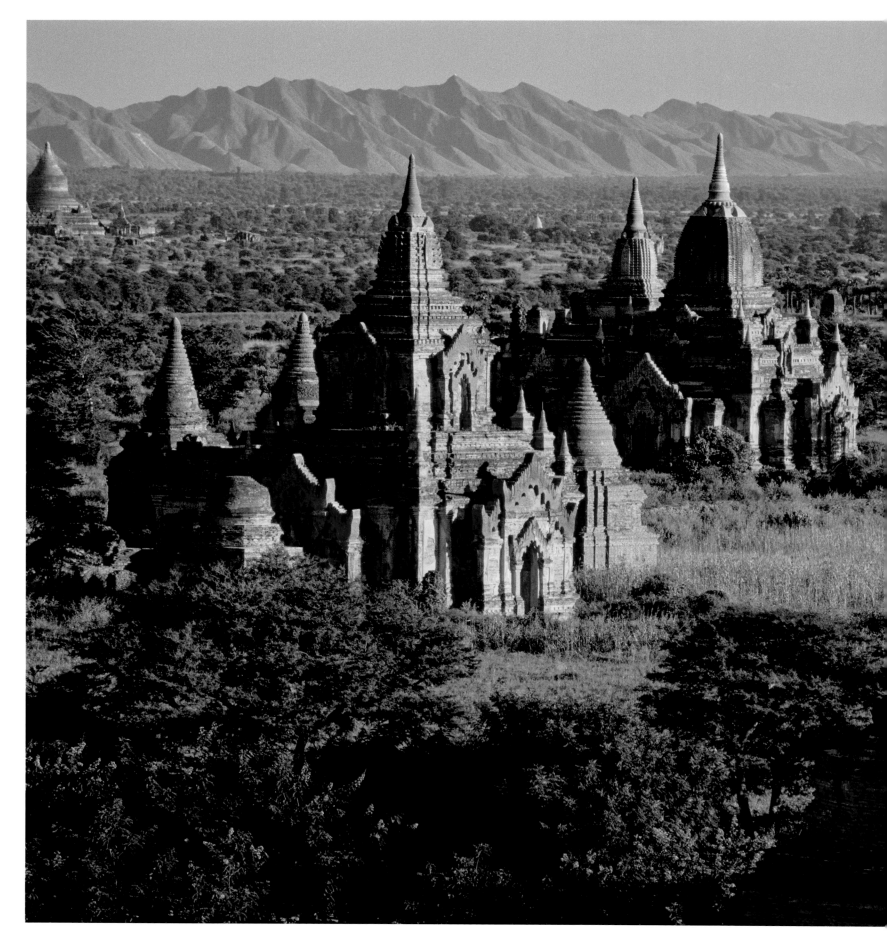

BAGAN, BURMA, 1997

Encompassing more than 10,000 Buddhist temples,
pagodas, and monasteries, Bagan was the political,
economic, and cultural center of the Pagan Kingdom for
over 500 years before the regime's collapse in 1287—
the result of Mongol invasions from the north.

The Road to Mandalay

The curse of Burma turned out to be independence. If only the colonials had stayed on drinking their gin and Rose's lime juice at Rangoon's ornate Pegu Club for another decade, the country might have prospered—no failed economy, no civil war, no state-run drug operations, no terrorism, no ethnic cleansing.

In 1889, Rudyard Kipling was inspired by his evening in the Pegu Club to compose his famous poem "Mandalay." Just four years earlier his drinking companions had overthrown King Thibaw and Queen Supayalat, abolishing the Burmese monarchy. This completed the conquest of Burma, begun sixty years earlier. By World War II's end, Britain was sitting on a powder keg. Multiple groups demanded a stake in the country's future. A council to prepare for independence was headed by 32-year-old General Aung San. He was gunned down on July 19, 1947, with most of his cabinet. Burma began its descent into anarchy and autarchy.

I visited Rangoon in June 1962—in the midst of General Ne Win's military takeover—on a maximum three-day visa from Bangkok. The city was a backwater with rats running in the streets; the population staring vacantly and smoking cheroots. The next month, the army stormed Rangoon University and blew up the student union, killing hundreds.

Today, fifty years after the coup, the government essentially remains under the military fist. Aung San Suu Ky, expected to run for president, has many challenges. At present, a militant nationalism fanned by Buddhist extremists may reverse the limited progress toward democracy, and lead once again to chaos.

The Burmese are held hostage to a cornucopia of superstitions. They have a dreadful fear of *nats*, spirits that haunt every nook. One must propitiate the *nats*, believed to determine one's fate, with candles, incense, and prayer. Maintaining the peoples' addiction to myth has ever been the goal of Burma's potentates.

Through it all, the everlasting spirit of the Burmese people survives and even flourishes in the bazaars, among the stalls and vendors, the teeming, aromatic passageways, the chatter and laughter. And therein lies the incongruity that is Burma, a struggling chimera. —*KL*

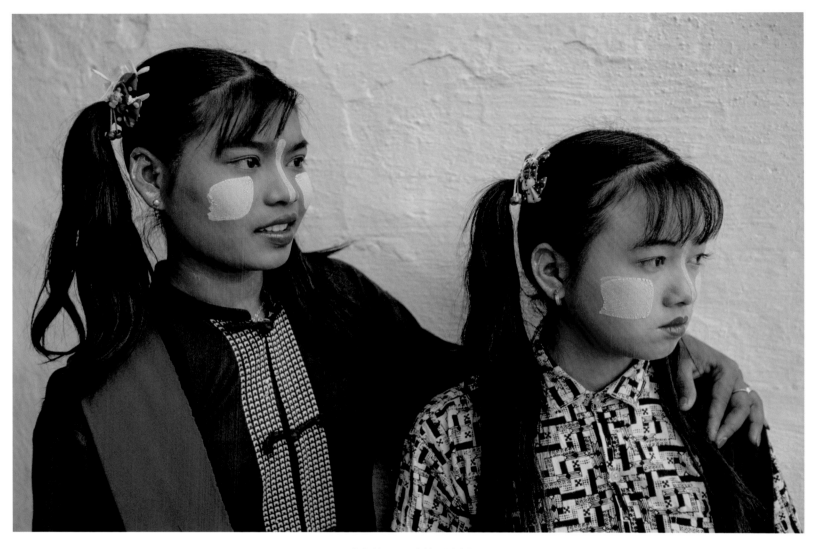

BAGAN, BURMA, 1997

Thanaka paste has been used by Burmese women for more than 2,000 years to cool and protect the skin. It is also applied decoratively to catch the eye of an object of interest.

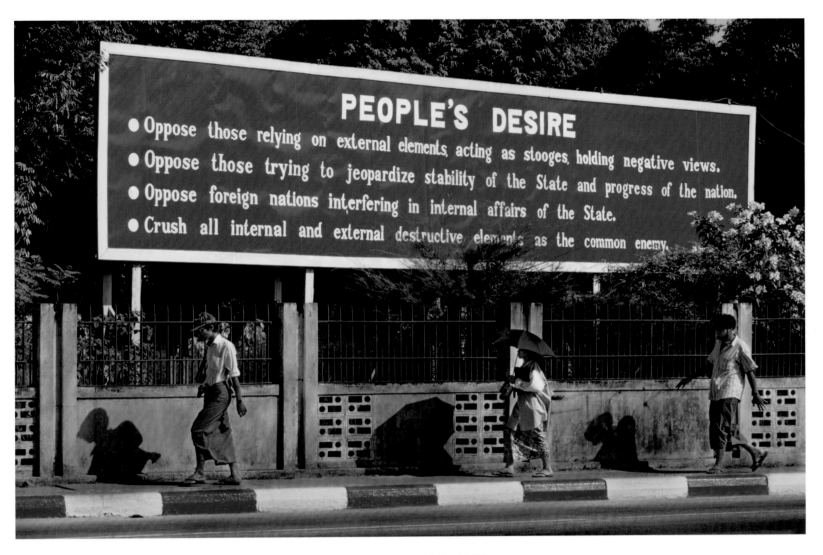

RANGOON, BURMA, 1997

The Burmese are subjected to barrages of propaganda in many forms by the military regime, which has ruled over the country since 1962.

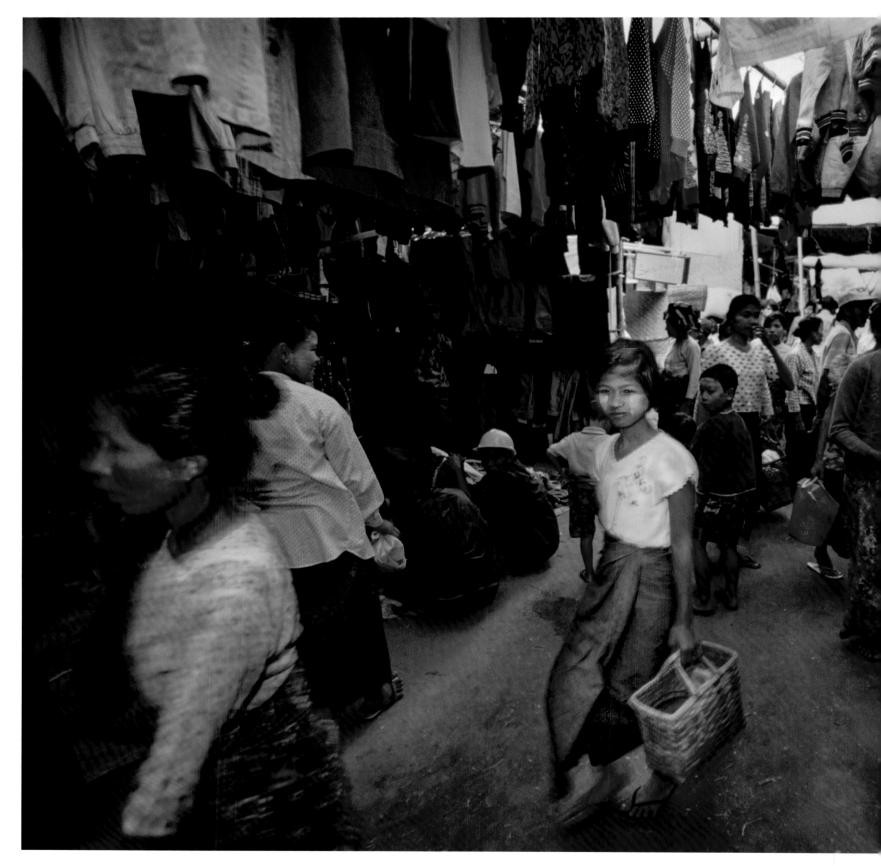

MANDALAY, BURMA, 1997

Wearing *longyi* (characteristic Burmese wrap-
around skirts), women shop at a clothing bazaar.

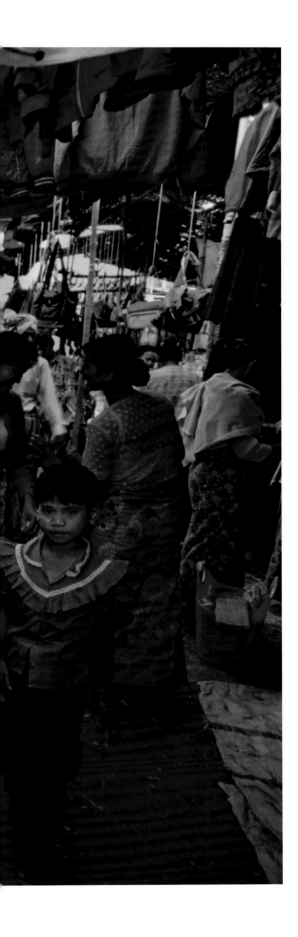

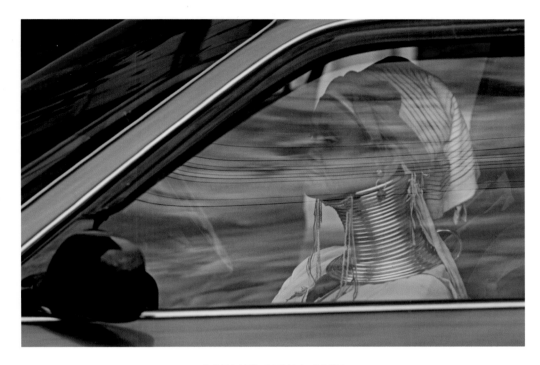

INLE LAKE, BURMA, 1997

A *Kayan* woman waits for a driver to take her back to her village. Traditionally, the women of this hill tribe begin wearing decorative brass coils that elongate the neck from a very early age. The practice has become controversial, but the tourist attention it draws has also helped the tribe sustain themselves.

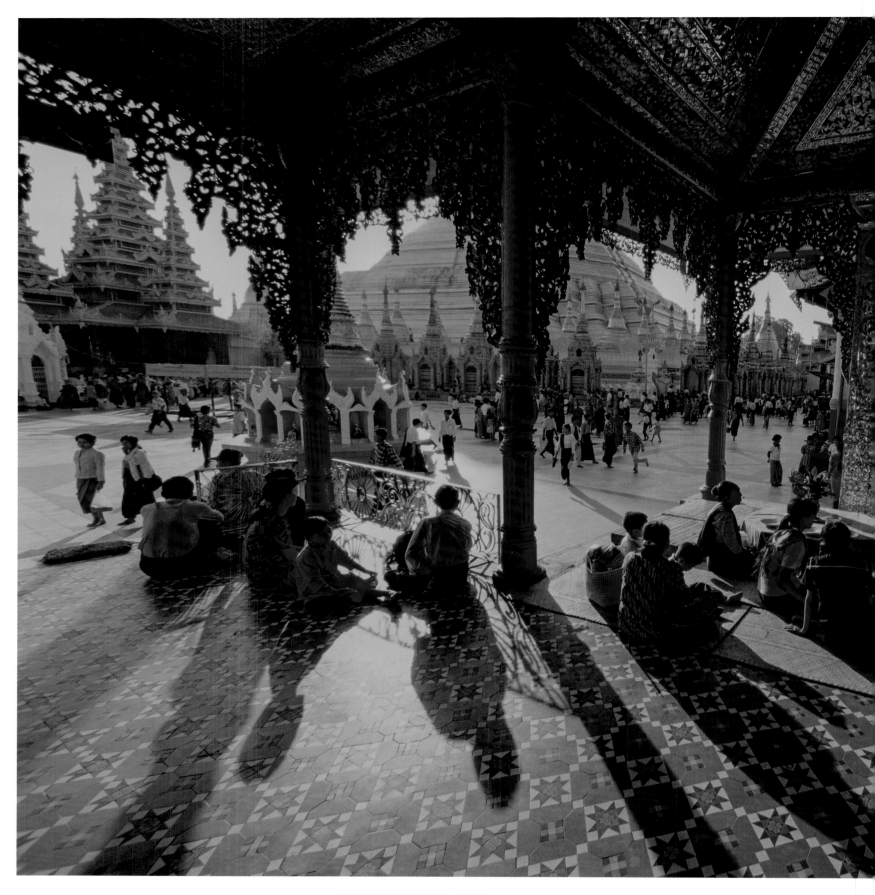

RANGOON, BURMA, 1997

Early morning dawns at the Shwedagon Pagoda,
the most sacred Buddhist temple in Burma, believed
to be over 2,500 years old.

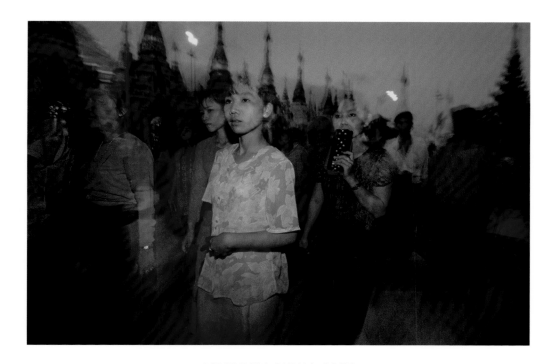

RANGOON, BURMA, 1997

Evening visitors come to worship at the Shwed-agon Pagoda. Most Burmese, in addition to their Buddhism, strongly embrace astrology originating from Hindu Brahmanism, and perform numerous incantations to ensure their well-being.

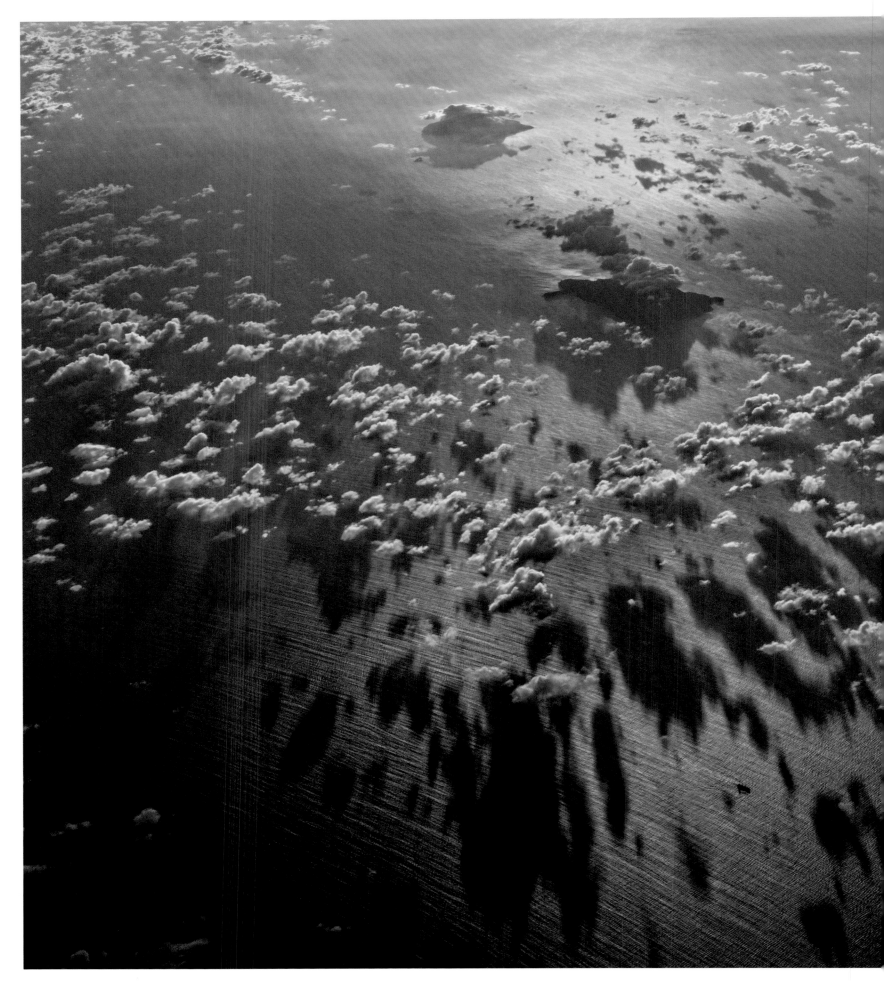

SOUTH PACIFIC, 2010

A freighter passes a smoking volcano
in the middle of the vast open sea.

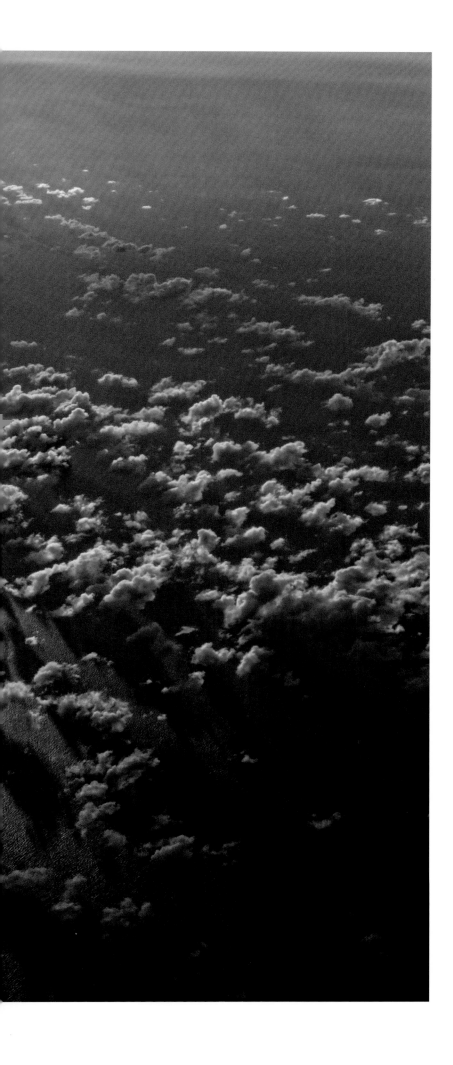

THE VIEW FROM ABOVE

*Aerial Landscapes
Across the World*

Paul was attracted to flying from an early age. He and his father would go on tour in the huge de Havilland Beaver seaplane based at Rock Harbor in Michigan's Isle Royale National Park.

As a photojournalist, Paul took to the sky many times, in tiny Cessnas and helicopters, to get the right perspective. He often felt that a key image for a given photo story could only be captured from an aerial view, noted his longtime project manager Carole Lee Vowell. In later years, sadly, he counted several colleagues who had died in plane accidents while on assignment.

Early pilots saw the world from an angle that was not the privilege of the average mortal. They shared a view that combined an awe of nature's majesty with recognition of their own insignificance. Modesty is ever apparent.

Their flying machines, while providing a unique glimpse of the earth, were an impudent challenge to nature. "I realized that if I had to choose, I would rather have birds than airplanes. In wilderness I sense the miracle of life. Behind it, our scientific accomplishments fade to trivia. Real freedom lies in wilderness, not in civilization," wrote Charles Lindbergh.

Beryl Markham, who in 1936 was the first woman to fly solo across the Atlantic from east to west, shared a similar belief in her memoir, *West with the Night*: "We fly, but we have not 'conquered' the air. Nature presides in all her dignity, permitting us the study and the use of such of her forces as we may understand." Markham did not forget that the overwhelming odds are in favor of nature, regardless of man's technical genius. A Briton born in Kenya, Markham flew all over East Africa, spotting

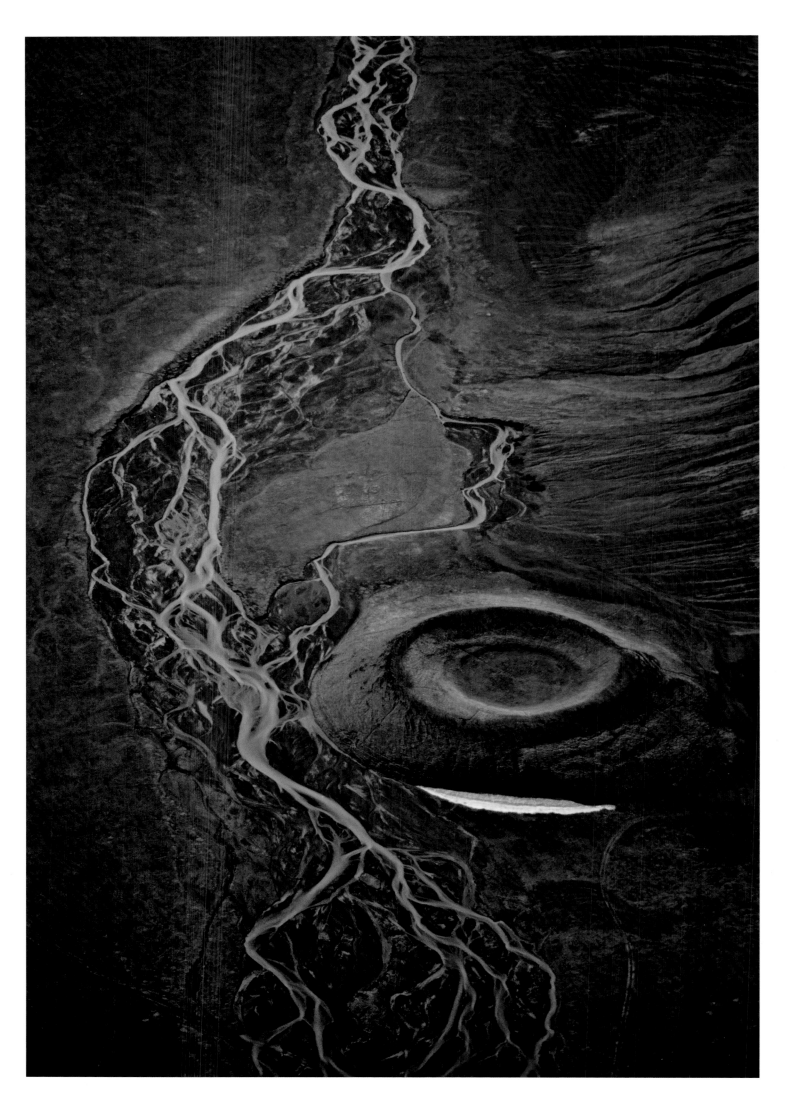

game for wealthy hunting clients and training race horses, and was a member of the "Happy Valley" social set that included Baroness Blixen—author of *Out of Africa.*

In the 1920s, pioneer American pilot Amelia Earhart was ecstatic about her youthful discovery. "As soon as I left the ground, I knew I had to fly." She became obsessed with the grandeur of the air: "After midnight the moon set and I was alone with the stars. I have often said that the lure of flying is the lure of beauty."

Earhart set many records in North America. The search still continues on and off for the wreckage of her plane, which disappeared near Howland Island in the Pacific in 1937. In simpler words she once remarked, "You haven't seen a tree until you've seen its shadow from the sky."

We have not cited the view of the planet that the astronauts shared with us. Perhaps this is just too overwhelming. I prefer what the early flyers of the 1920s and 1930s had to tell us when flight was personal. Their reserve was more apparent before the grand age of NASA.

Yes, the early pilots are gone, but their words remain to inspire us. "I learned what every dreaming child needs to know—that no horizon is so far that you cannot get above it, or beyond it," wrote Beryl Markham.

The French aviator Antoine de Saint-Exupéry, who disappeared over the Mediterranean in 1944—shot down by a German fighter—wrote several books drawn from his experience as a mail pilot in France, Africa, and South America. *Night Flight* and *Wind, Sand and Stars* are two of these classics.

The Little Prince, the angel who appeared to the crashed pilot in the desert in Saint-Exupéry's 1943 novel, is forever emblematic of the mystery and enchantment of the air. Saint-Exupéry wrote, in the voice of this beloved character, "It is only with the heart that one can see rightly; what is essential is invisible to the eye." —KL

ELDHRAUN, ICELAND, 1982

In 1783, a volcanic eruption sent lava flowing across southern Iceland, creating scores of craters and burying an area twice the size of Chicago with lava three stories deep. Two hundred years later, a far gentler landscape had emerged.

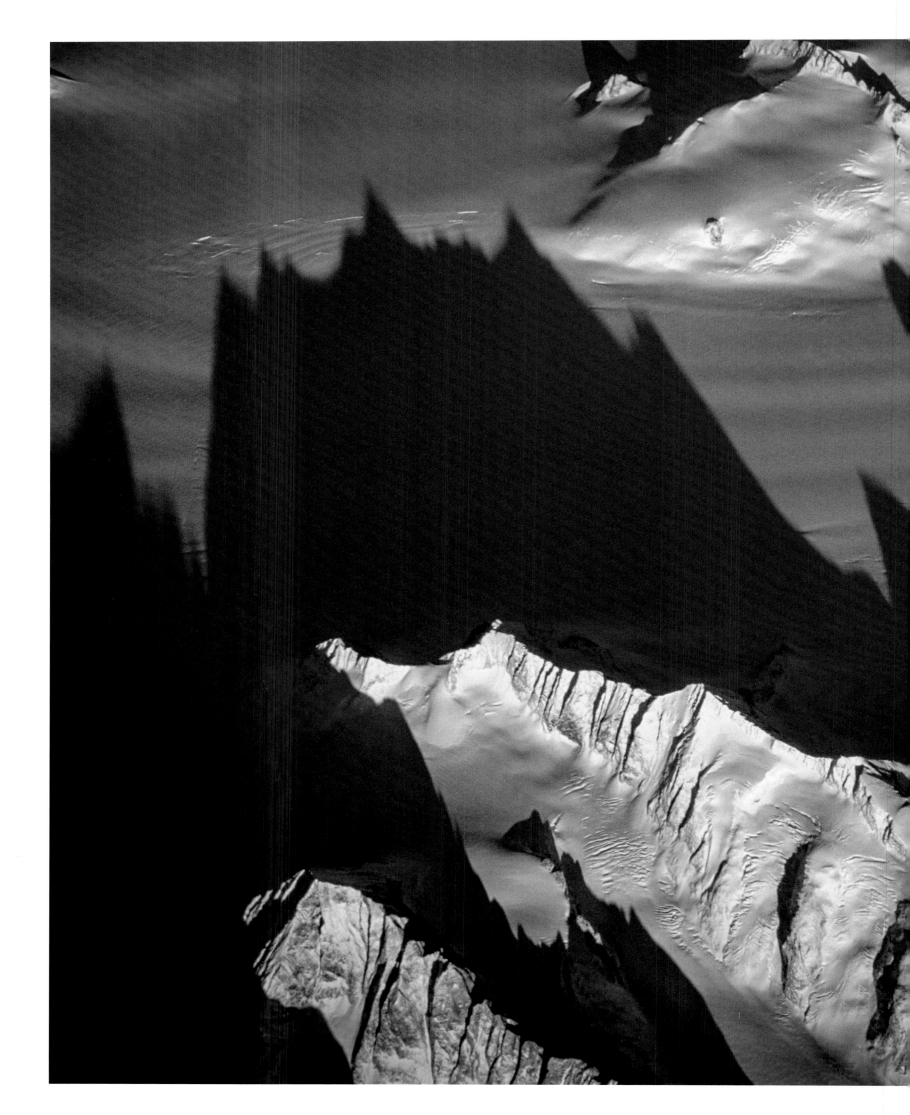

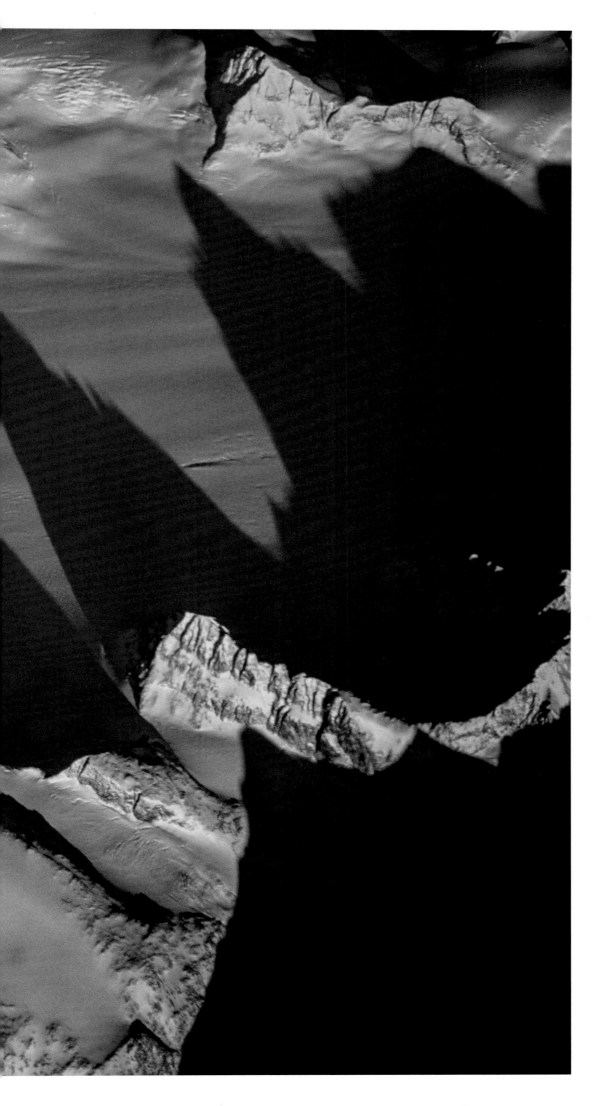

GREENLAND, 2002

On a transatlantic flight on his way home from an assignment, Paul captures the glacial landscapes of this frozen wilderness.

TUCSON, ARIZONA, 1997

The "Boneyard" at Davis-Monthan Air Force Base is home to America's largest fleet of "mothballed" planes. The dry, clear, and virtually smog-free climate of the Arizona desert helps minimize corrosion. More than sixty years after the first Boeing B-52 Stratofortress flew its maiden flight, B-52s are still used in modern-day conflicts.

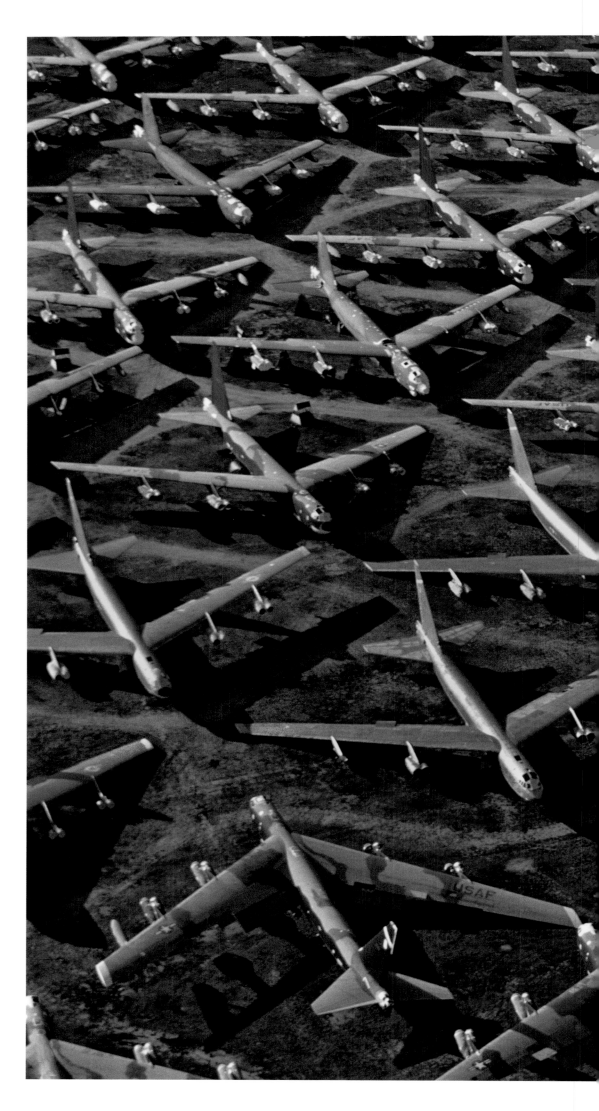

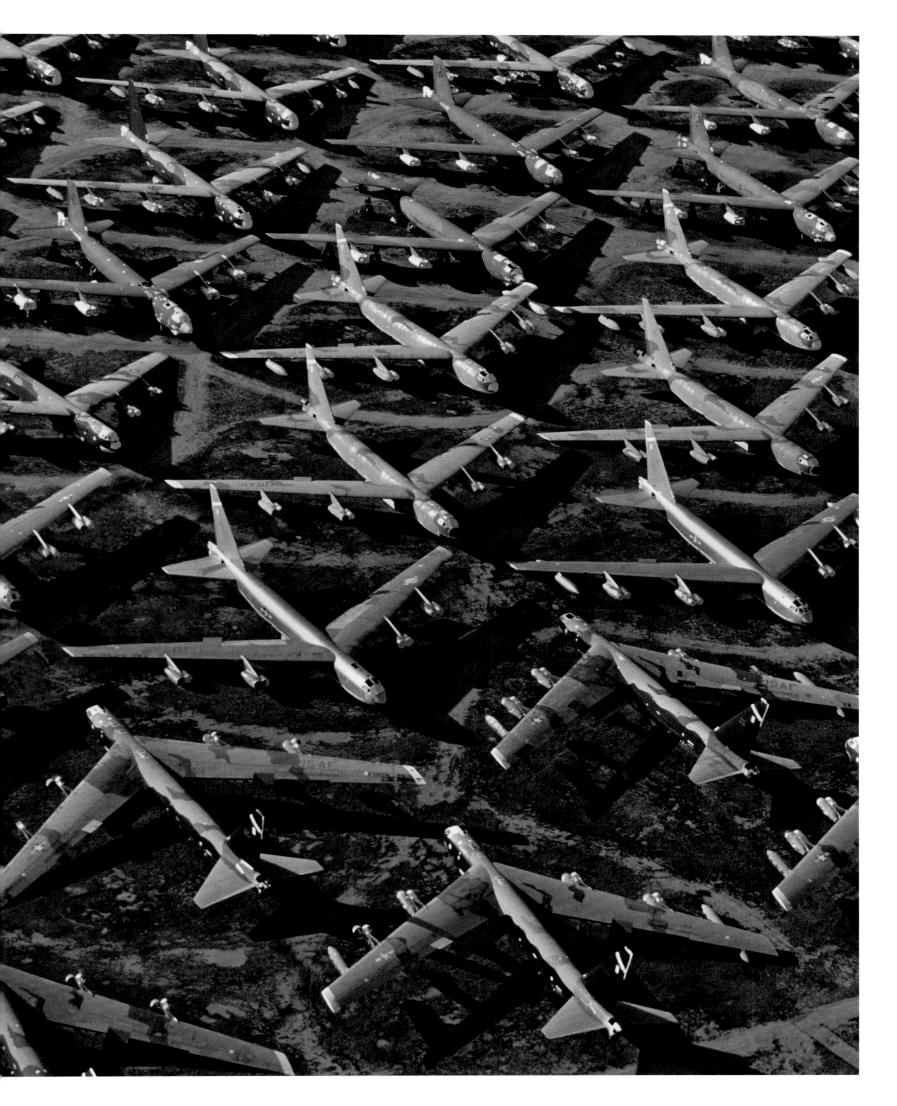

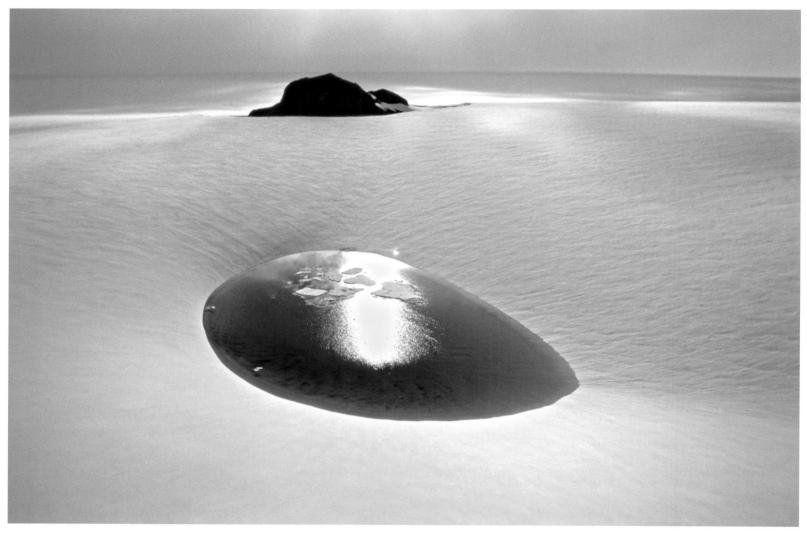

VATNAJÖKULL NATIONAL PARK,
ICELAND, 1987

More than eight percent of Iceland's land mass
is covered by Vatnajökull (the Glacier of Rivers).
Many small lakes are formed on the surface by
volcanic activity beneath the ice cap.

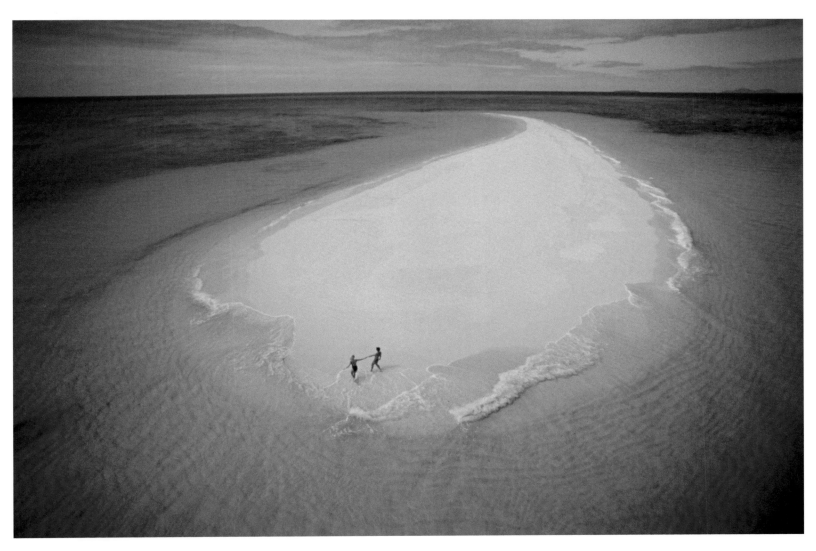

CAIRNS, AUSTRALIA, 1995

Moving sandbars dot the waters along the Great
Barrier Reef—the world's largest coral reef system,
stretching over 2,600 kilometers along Australia's
eastern coast.

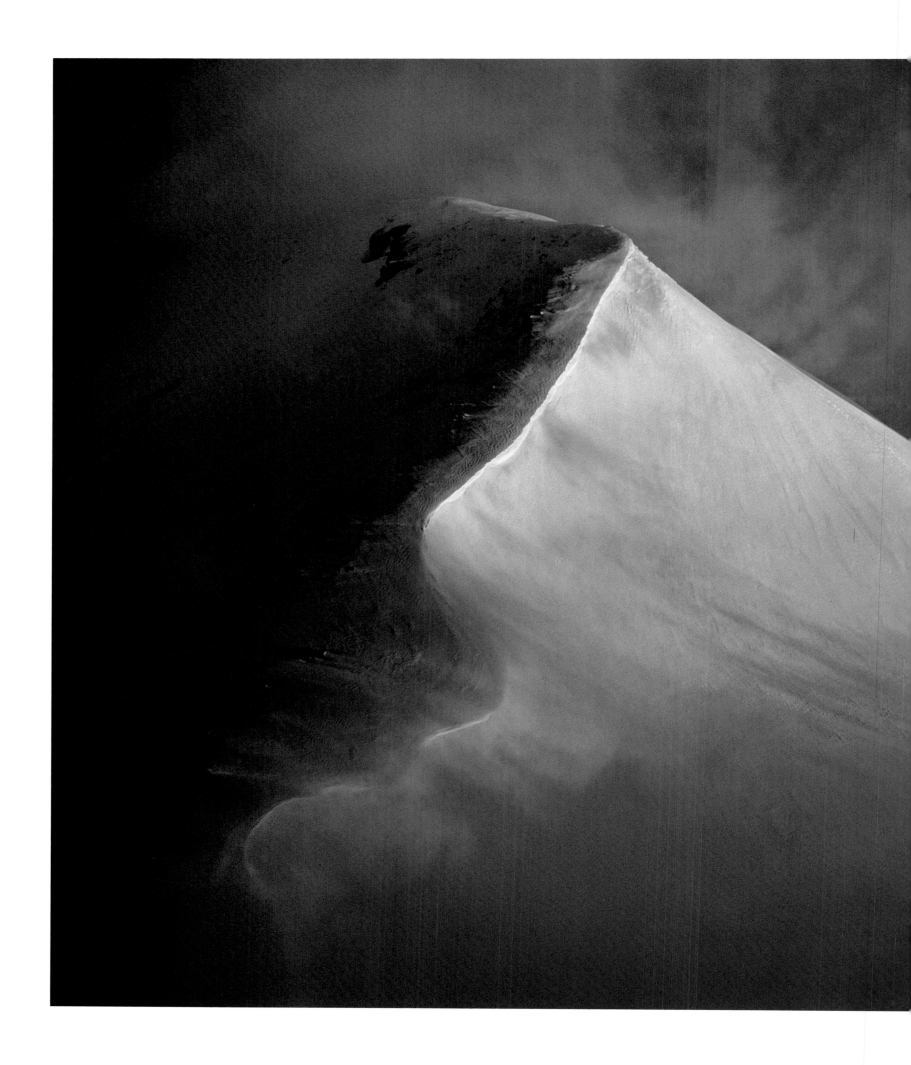

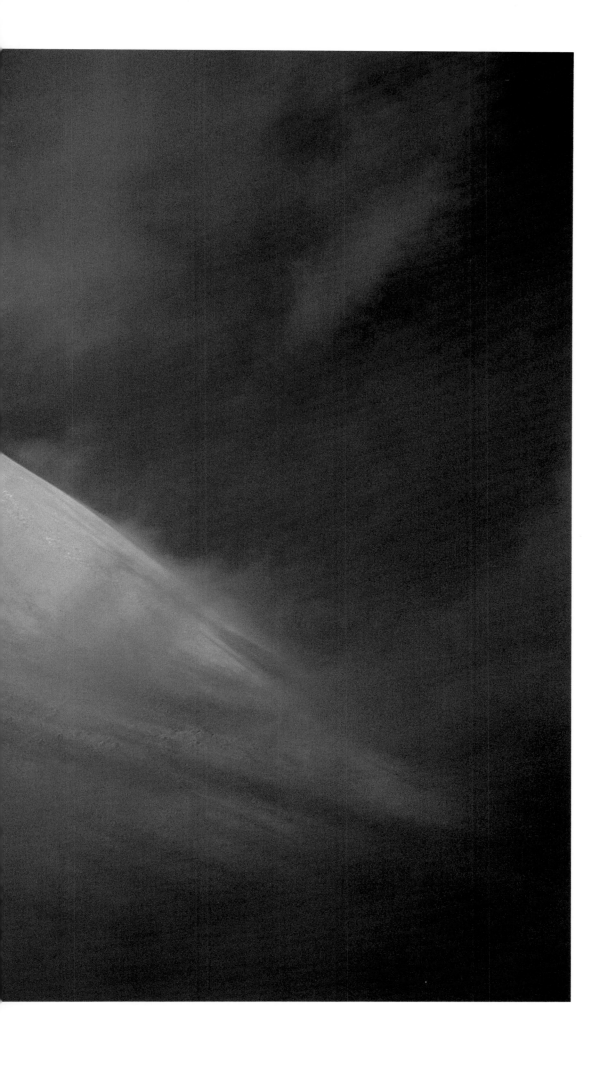

GRAND TETON NATIONAL PARK,
WYOMING, 1982
Morning winds blow ice particles across a
snow-buried spur of the Teton Range.

SHIPROCK, NEW MEXICO, 1982

Rising majestically from the desert floor, the fortress-like Shiprock is revered by Native Americans, and served as a land-mark for early pioneers.

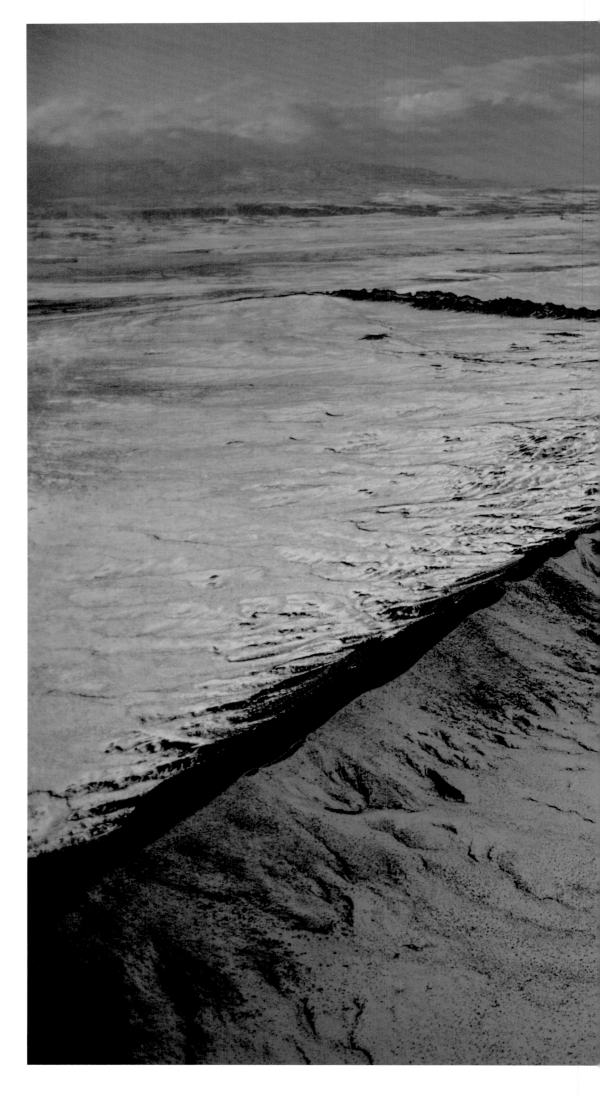

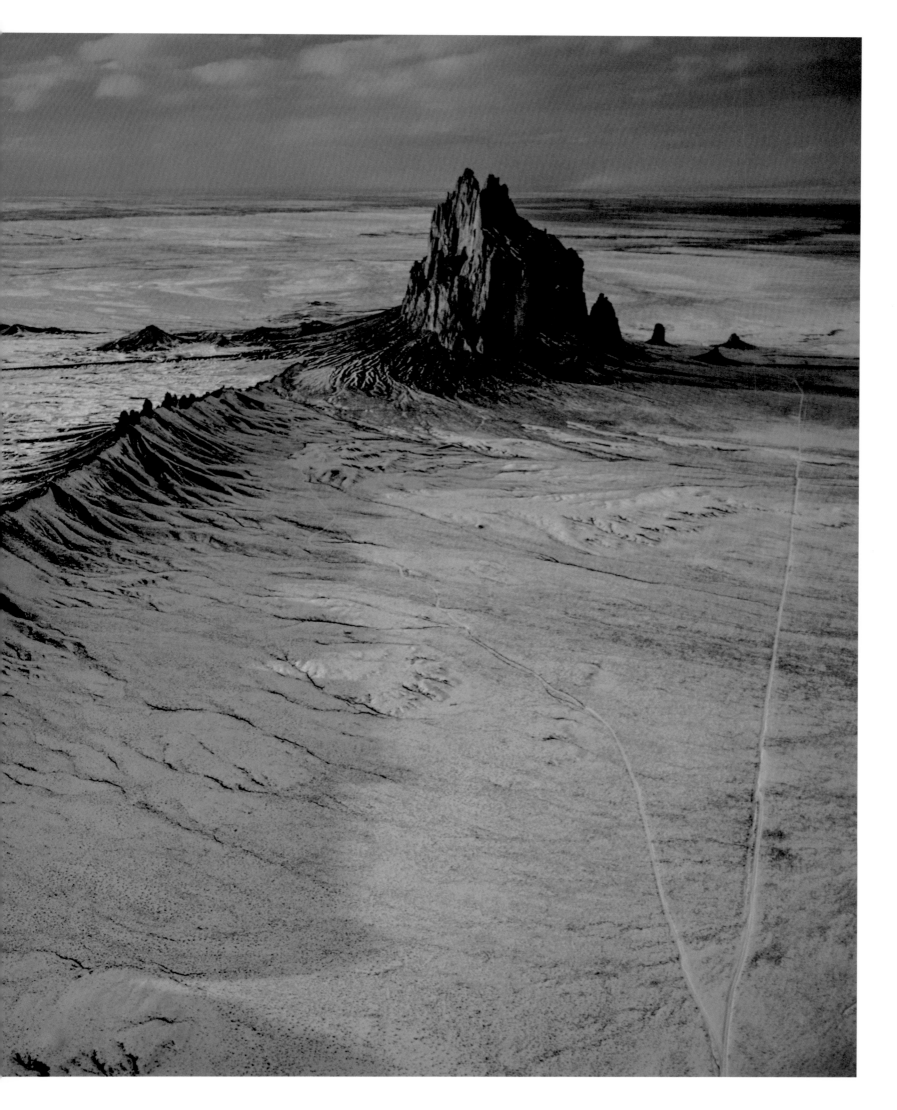

INTO THE SUNSET

The Vanishing Frontiers of
the American West

The call of the past…remote canyons and mesas, buttes and gorges, peaks and arches. The Rockies are eighty million years old. Yet man crossed over the Bering Straits from Siberia only 20,000 years ago.

One of Paul's early assignments was to photograph the 3,000-mile range of the Rocky Mountains from the Rio Grande to Northern Canada for the National Geographic Society. He spent eight months traversing the area by ground and by air.

In New York City when I was young, I was fascinated by articles in *National Geographic* about the West. The Anasazis clinging to canyon rims, the Hohokams digging canals, the Mogollons hunting and farming. The Pueblos, who settled in villages and farmed corn, beans, and squash. They were often raided by warlike tribes, including the Apaches and the Navajos.

Sir Alexander Mackenzie was the first European to cross the northern Rockies, in 1793 on the Oregon Trail, although there are legends of hardy "mountain men"— fur traders and hunters—who found the high passes and river systems before Lewis and Clark arrived a decade later. The Mormons sought their Holy Land, passing over the Rockies in 1847 en route to Salt Lake. In 1869, the transcontinental railroad crossed the country. The Great Northern Railroad, founded by Minnesota's James J. Hill, soon cut through the Rockies at Marias Pass.

I was awed as a youth imagining the vast herds of bison, elk, white-tailed deer, pronghorns, and big-horned sheep; the moose, black bears, grizzlies, coyotes, lynx, and wolverines. One of my favorite authors was Ernest Thompson Seton. I saved my allowance and collected first editions of *The Biography of a Grizzly* and *Wild Animals*

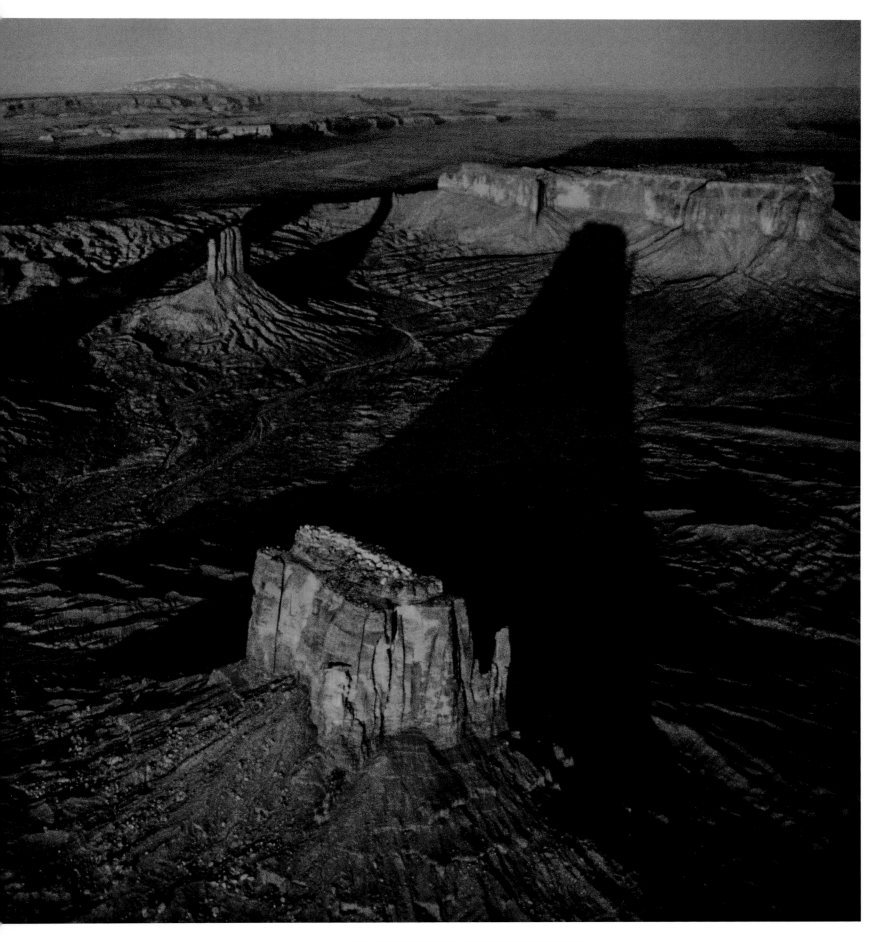

MONUMENT VALLEY NAVAJO TRIBAL PARK,
ARIZONA, 1982

The sandstone plateaus of Monument Valley were
created over the course of a millennium by the erosion
of an ancient seabed.

I Have Known. Thompson tramped the Rockies, chronicling specific animals year after year to the end of their lives. I dreamed of the vast ranges of pines, Douglas firs, hemlocks, and aspens stretching from the peaks down to the Great Plains. And the names of the Indian tribes—Apache, Arapaho, Bannock, Cheyenne, Crow, Flathead, Shoshone, Sioux, and Ute—rang like music.

At the turn of the century, Frederic Remington's sketches and sculptures of cowboys and Indians captured the sunset of the frontier. Remington became a close friend of President Teddy Roosevelt—another great lover of the western outdoor life. It was TR, or course, who was responsible for establishing some of the first national parks.

The great writer on the West, Wallace Stegner, noted: "National parks are the best idea we ever had. Absolutely American. Absolutely democratic. They reflect us at our best rather than our worst."

At the other extreme was the famous 1,100-mile trek over the Rockies of the Nez Percé tribe in 1877. The U.S. government had reclaimed the tribe's six-million-acre Wallowa Valley reservation in Oregon after gold was discovered there. The tribe's leader, Chief Joseph the Elder, resisted—he tore up his bible, shredded the American flag, and cursed the Great White Chief in Washington. After the elder's death, his son, Joseph the Younger—also known as Thunder Rolling Down the Mountain—led the long journey, pursued by the U.S. Army, in an attempt to join Sitting Bull in Canada. The Younger Joseph surrendered his 250 warriors thirty miles from the Canadian border in Montana, announcing: "My heart is sick and sad. From where the sun now stands I will fight no more forever."

The "happy hunting grounds" are dark today. The buffalo are long gone. On the reservation, tourists from Japan and Europe, awed by the sagas of cowboys and Indians inhabiting the boundless West, step off the bus and point cameras at the dignified tribal elders and sacred dancers.

Still, the iconic beauty of the West never fails to overwhelm. The horizons seem endless. —*KL*

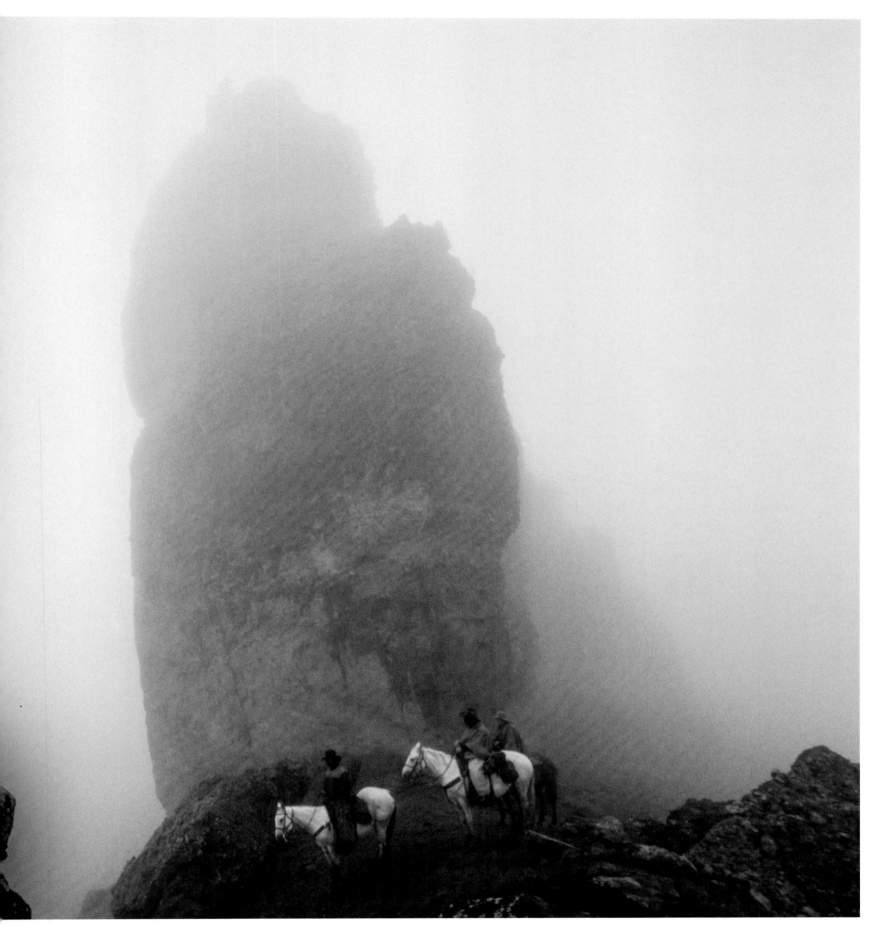

SAN JUAN MOUNTAINS, COLORADO, 1980
Dense fog shrouds the opening of the Window,
a well-known ridge-top formation straddling the
Continental Divide.

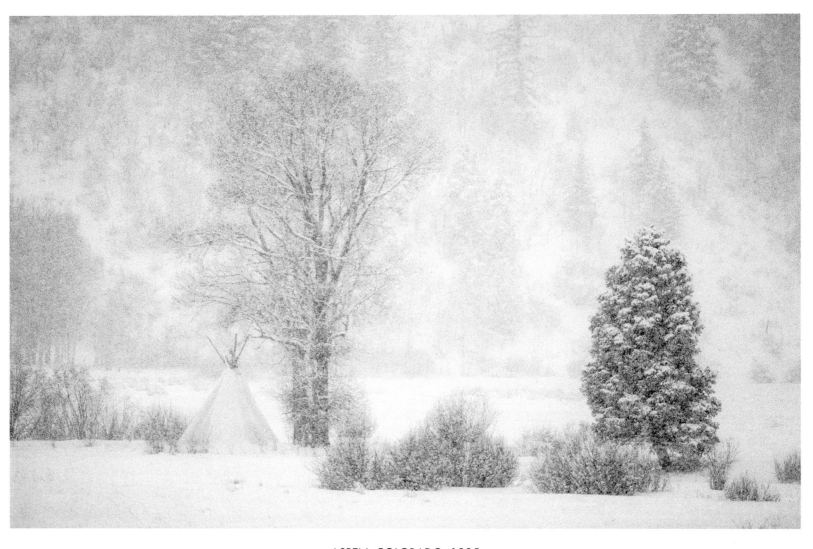

ASPEN, COLORADO, 1995

A snowstorm blankets a tepee in the North
Star Nature Preserve in the Rocky Mountains.

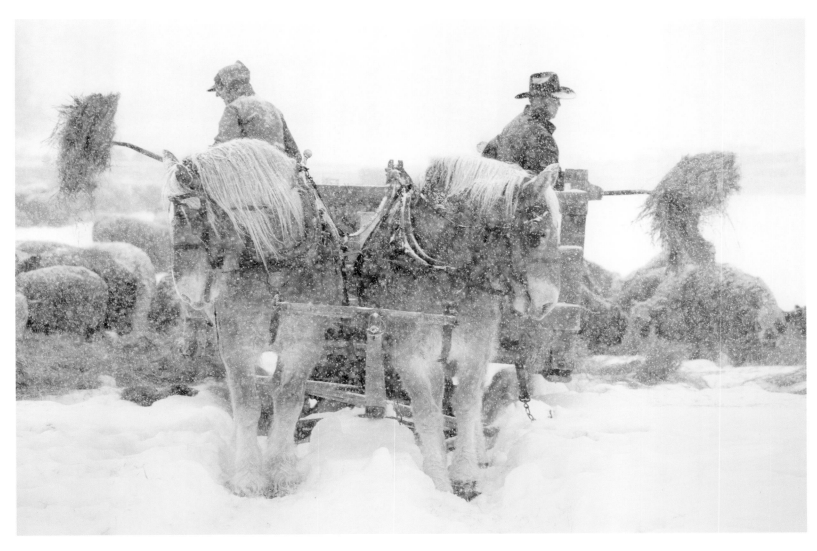

STEAMBOAT SPRINGS, COLORADO, 1995

Ranchers Raymond Gray and John Daughen pitch
hay for their wintering livestock.

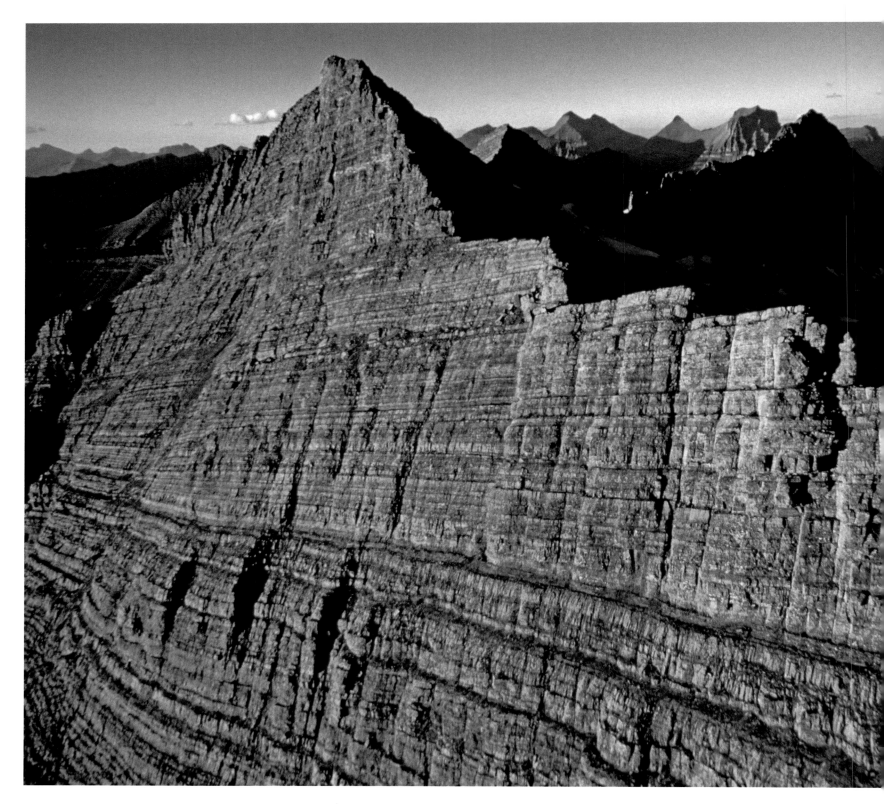

GLACIER NATIONAL PARK, MONTANA, 1980

Sheared by a slow-moving mass of ice during
the glacial era, the Continental Divide stairsteps
to the crest of Gunsight Mountain, within sight
of Saint Mary Lake.

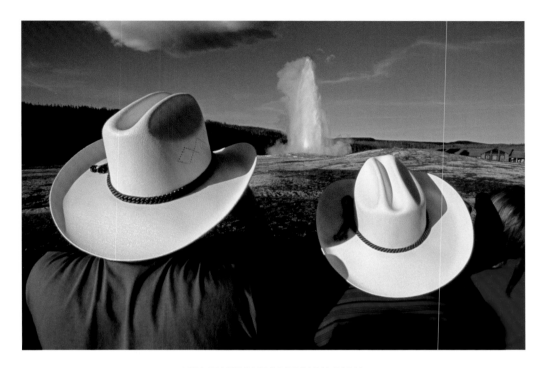

YELLOWSTONE NATIONAL PARK,
WYOMING, 1995

Old Faithful Geyser shoots its ever-predicable
eruption of steam and superheated water in the
world's first national park, established in 1872.

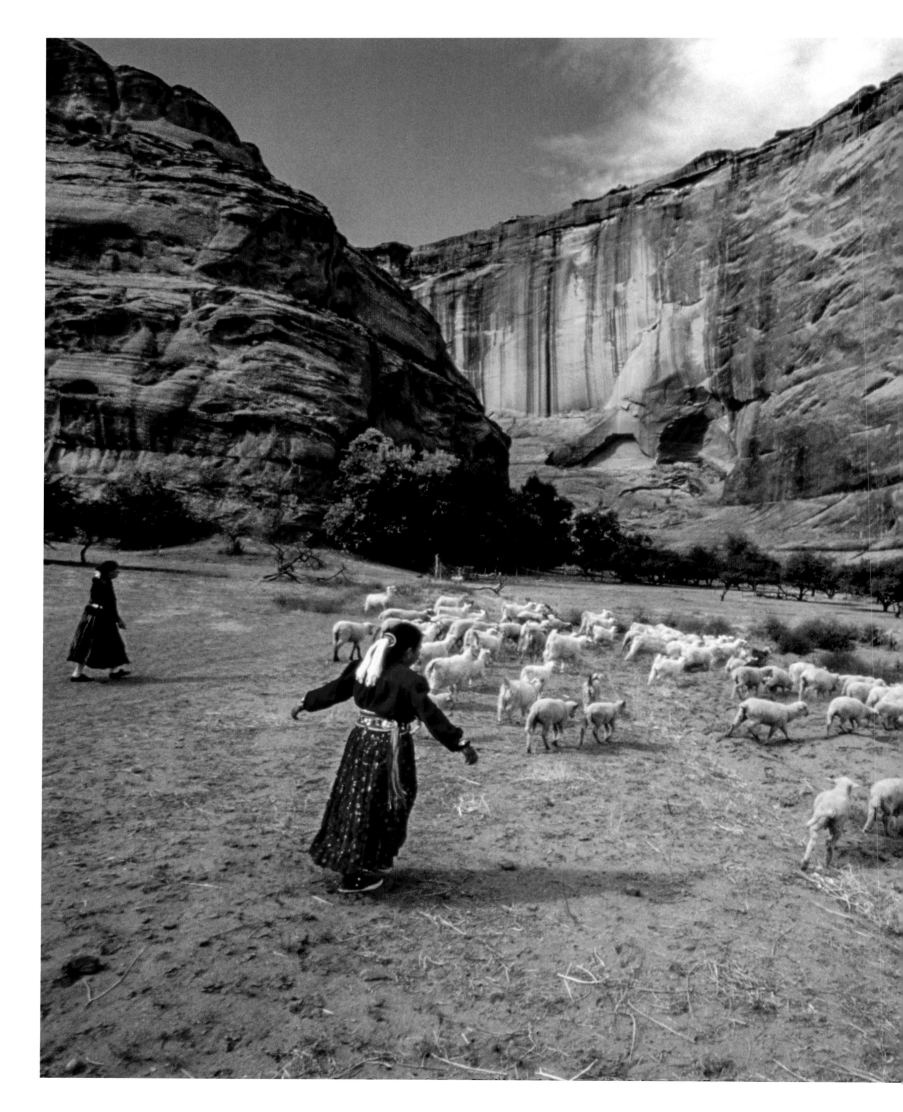

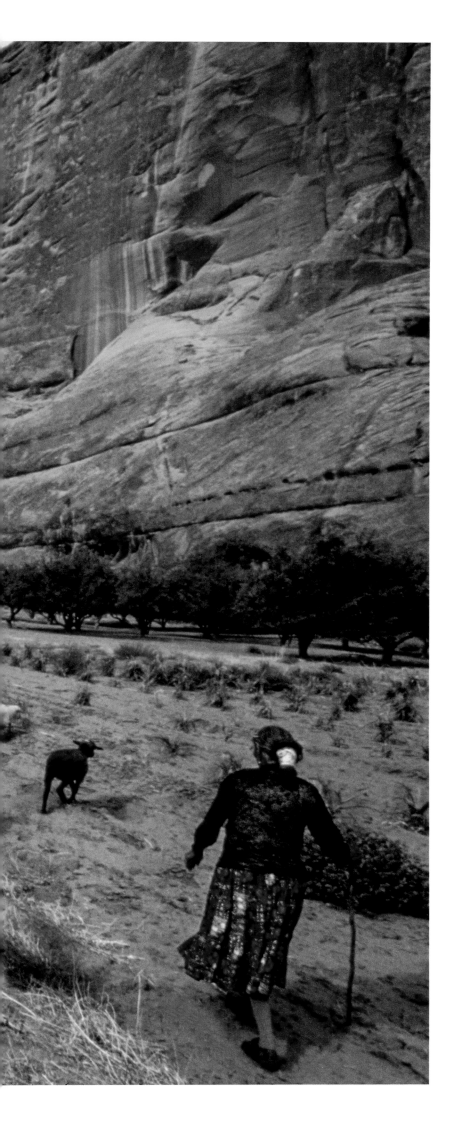

Keeping the Traditions

During my travels with Paul through the northeast corner of Arizona for *The Stories of Mothers & Daughters* book project, we met Sally Sam. She was an independent, agile, petite Navajo grandmother who lived near the towering steep sandstone walls of Canyon de Chelly.

Out of the 131 square miles that make up the canyon, Sally and her family have carved a little niche for themselves. They are one of about forty families who live in the park and have every right to roam freely on this land, which is not owned by the federal government, but rather by the tribal trust of the Navajo Nation.

Sally and her granddaughter brought us on a hike to a beautiful sandstone arch that overlooked the valley where they herded sheep. The sheep were not only a food source, but were also indicators of their wealth, family, security, and social standing. Like many elders in her tribe, she was proud that she taught her grandchildren the Navajo ways of sheep herding, farming, and living in this beautiful valley. —*Carole Lee Vowell*

CANYON DE CHELLY NATIONAL
MONUMENT, ARIZONA, 1997

Navajo tribal elder Sally Sam and her grand-
daughters herd their sheep beneath towering cliffs.

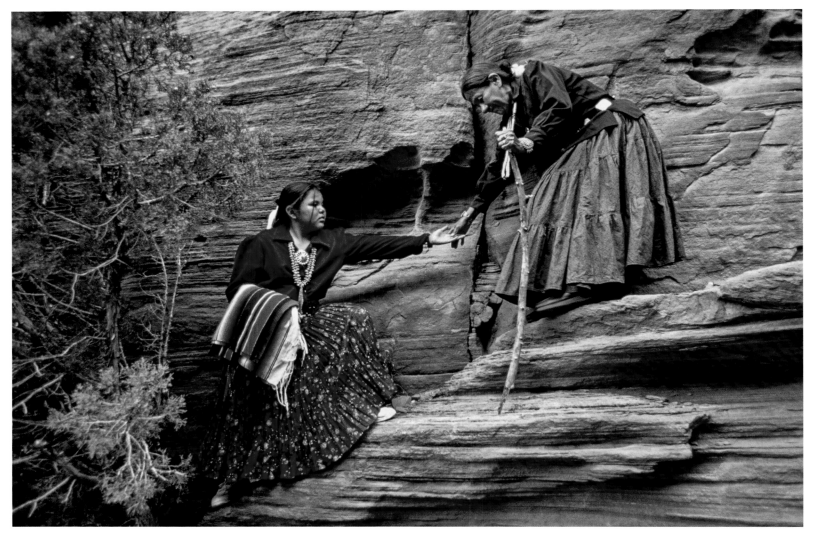

CANYON DE CHELLY NATIONAL
MONUMENT, ARIZONA, 1997

Harriet Sam helps her grandmother Sally down one of
the ancient trails of their ancestors. The canyon is one
of the longest continually inhabited areas in North
America, home to the long-vanished Anasazi. It is now a
part of the Navajo Nation, a semi-autonomous territory.

CANYON DE CHELLY NATIONAL
MONUMENT, ARIZONA, 1997

Window Rock is one of many natural sandstone
formations in the canyon formed by erosion over
millions of years.

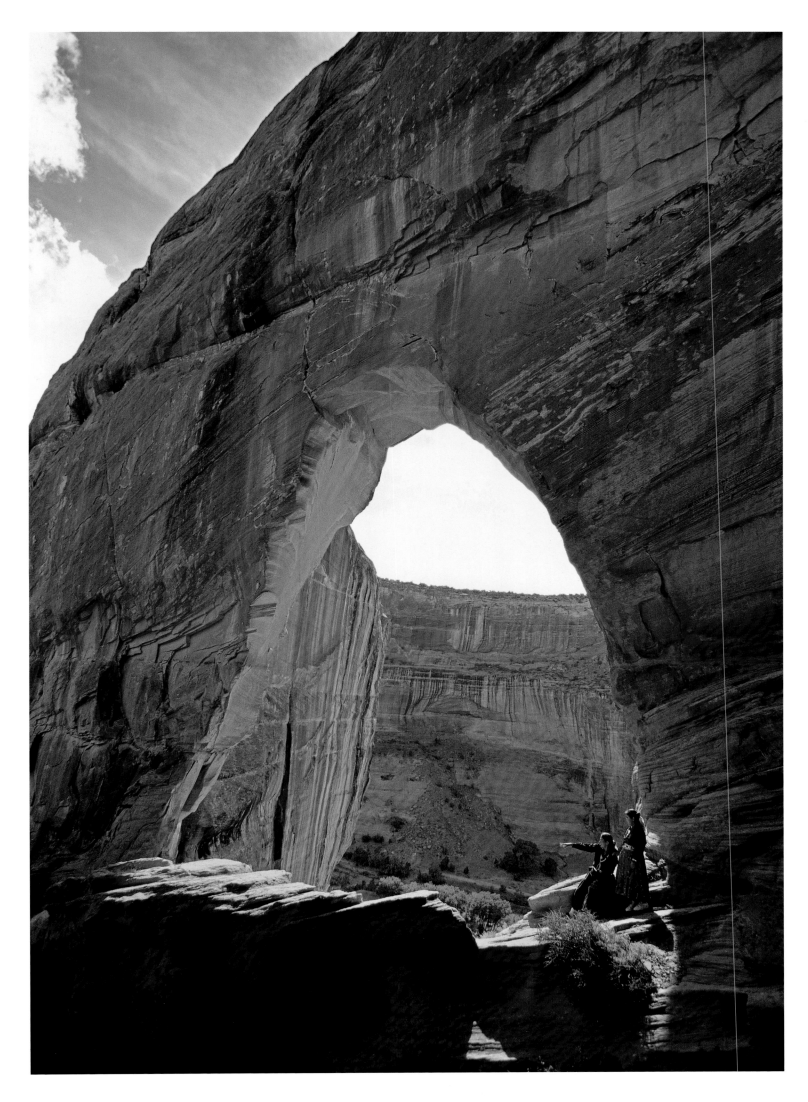

SHIPROCK, NEW MEXICO, 1982

In a one-room sacred hogan, Navajo artist Eugene B. Joe creates a sand painting, working with his aunt, Lillie Joe Hatathley, and his father, James, a former medicine man. Sand paintings are created in healing and blessing ceremonies, but also purely as art.

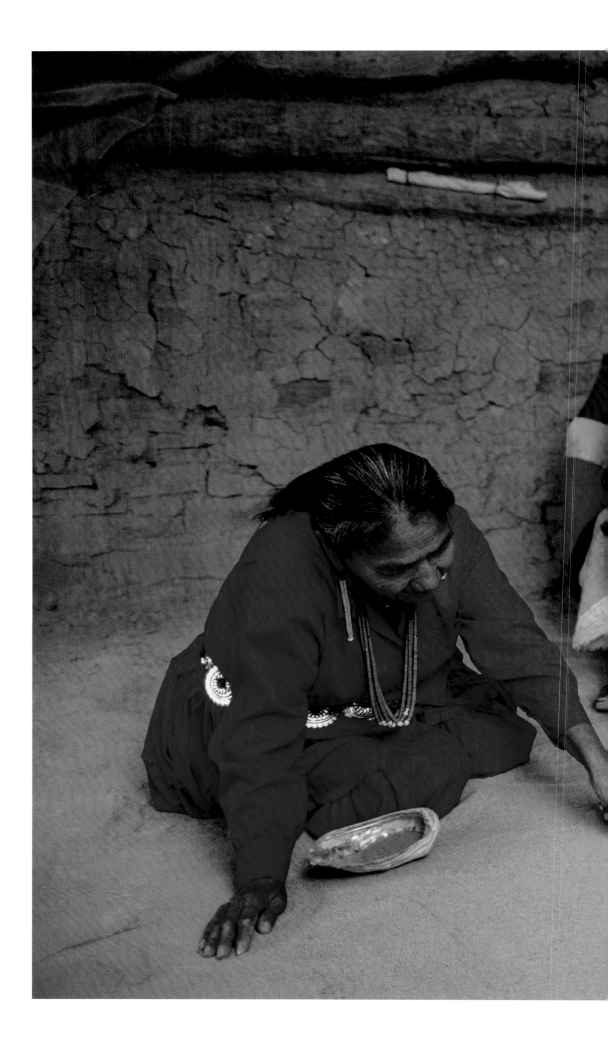

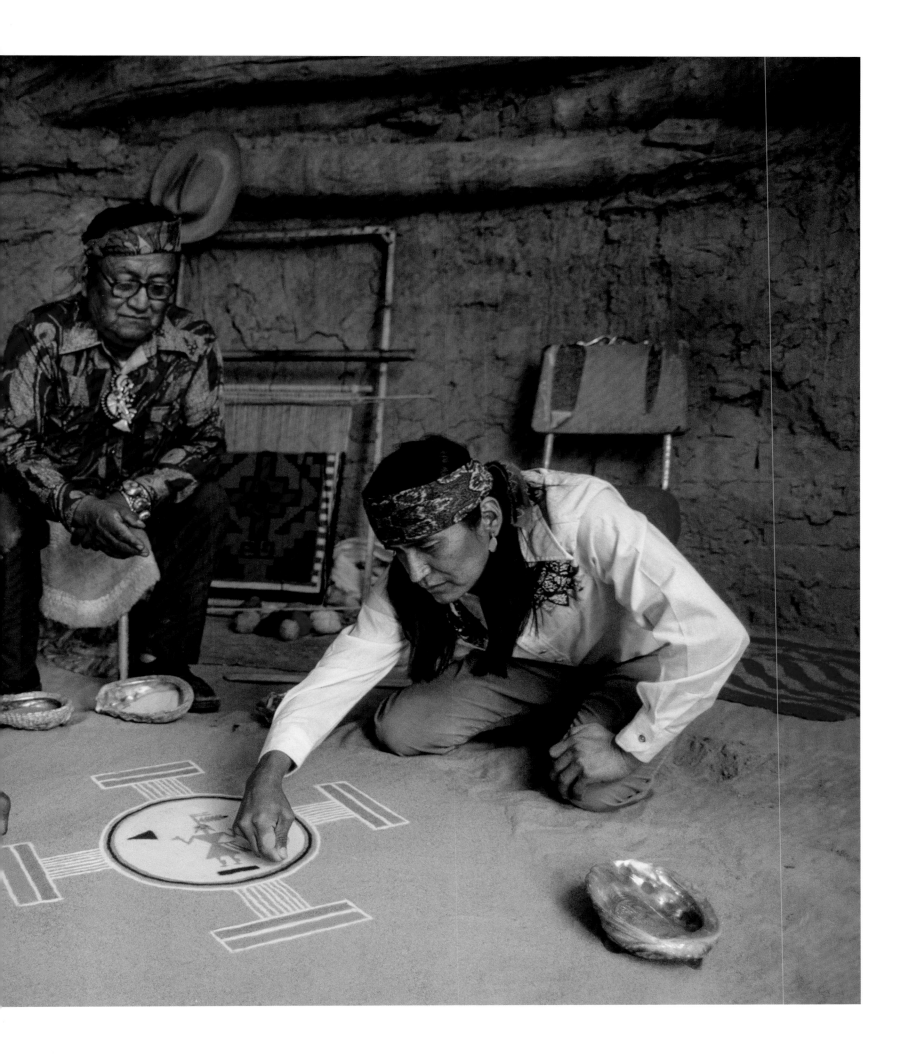

FRUITA, COLORADO, 1997

Keeping it all in the family, competitive barrel racer
and single-mom Gayla Hawks fixes her daughter
Jackie's hair before they ride against each other.
Nine-year-old Tyrell travels the rodeo circuit with his
mother and sister throughout the summers.

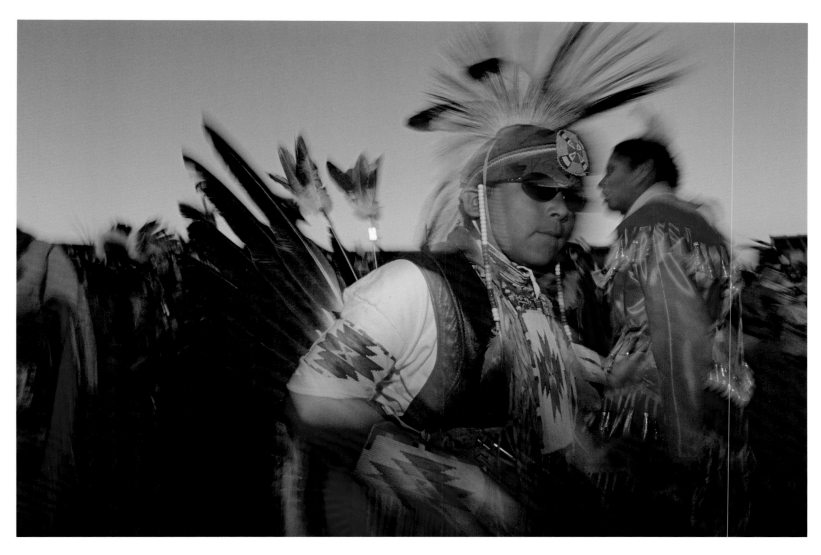

BROWNING, MONTANA, 1995

Wearing the ceremonial dress of his ancestors, a
young Blackfoot dances in the North American
Indian Days powwow—a yearly gathering that brings
together Native Americans from across the country.

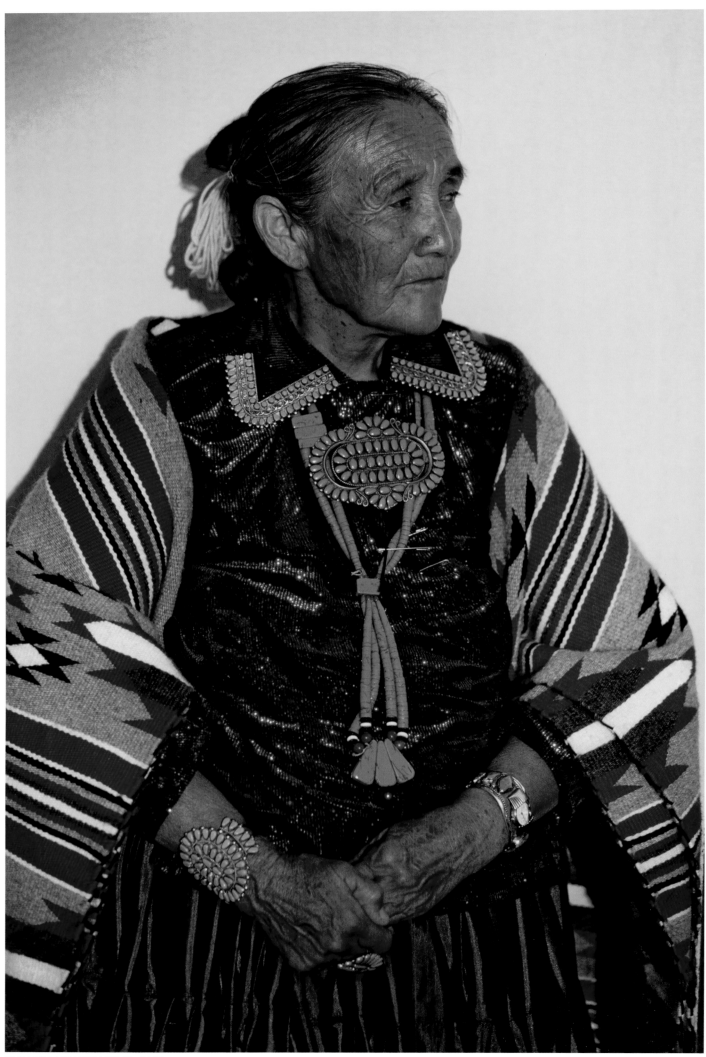

CROWNPOINT, NEW MEXICO, 1995

JASPER, ALBERTA, CANADA, 1995

SILVER CITY, NEW MEXICO, 1980

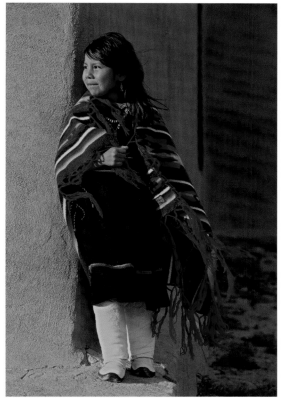

TESUQUE PUEBLO, NEW MEXICO, 1995

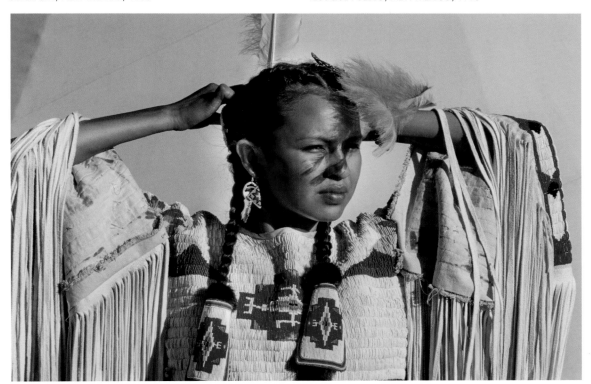

BROWNING, MONTANA, 1995

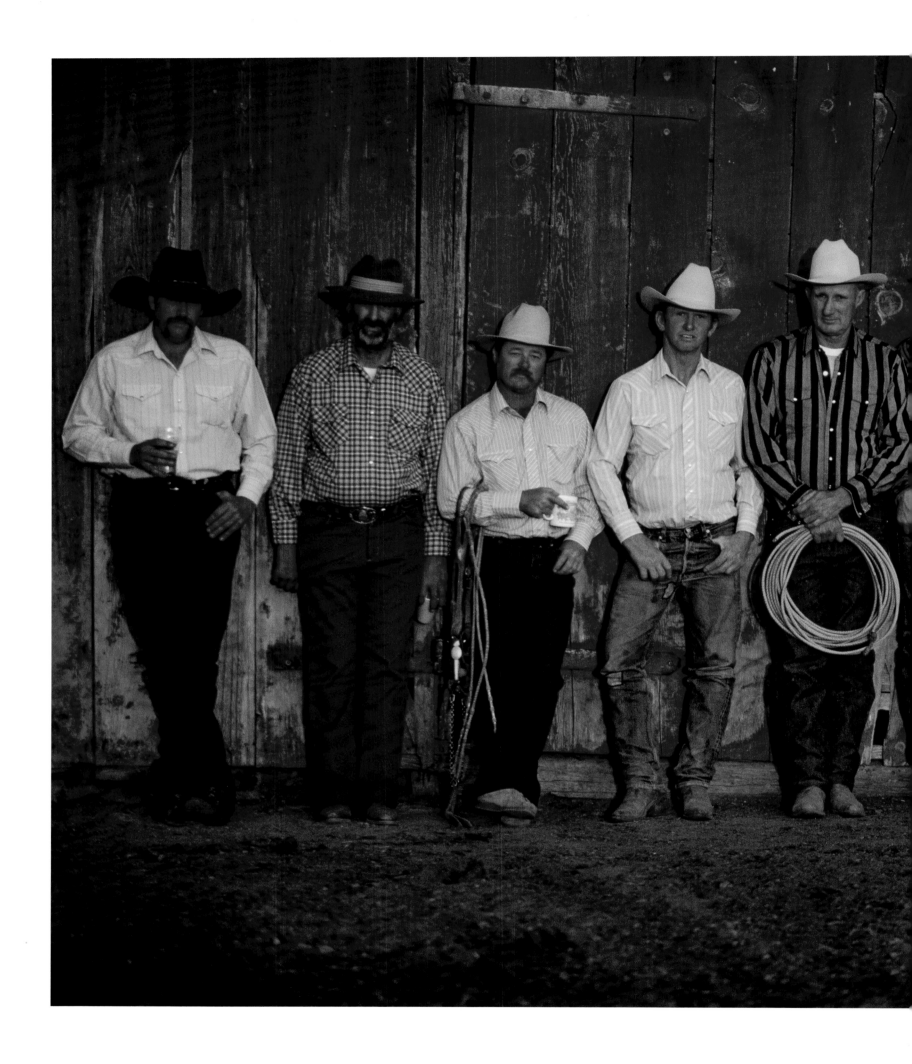

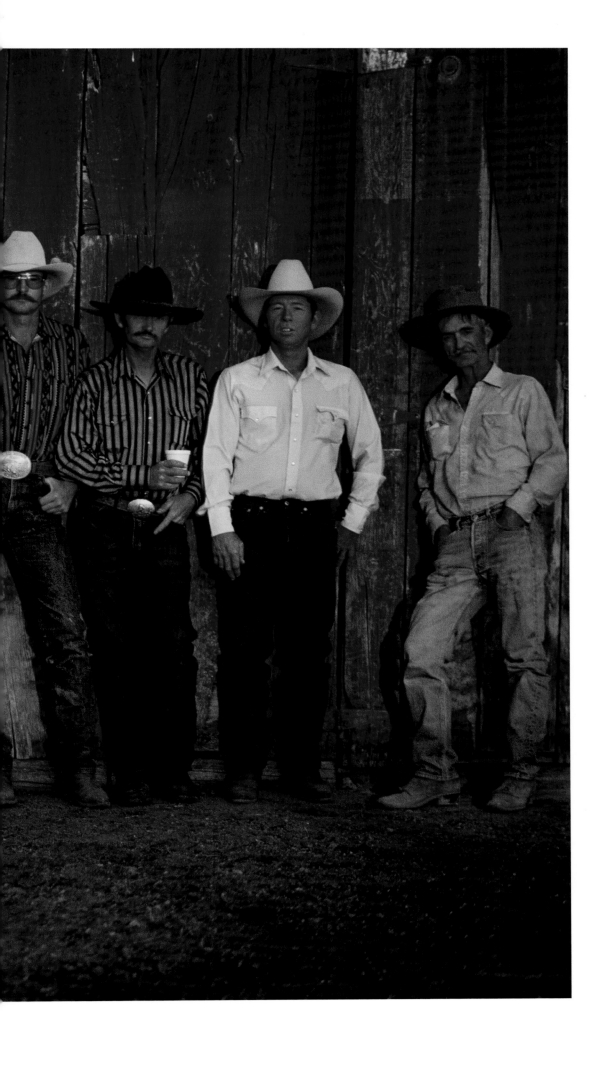

OROVADA, NEVADA, 1991
John Falen (center, with rope) poses for a portrait with the wranglers who work his cattle ranch in far northern Nevada.

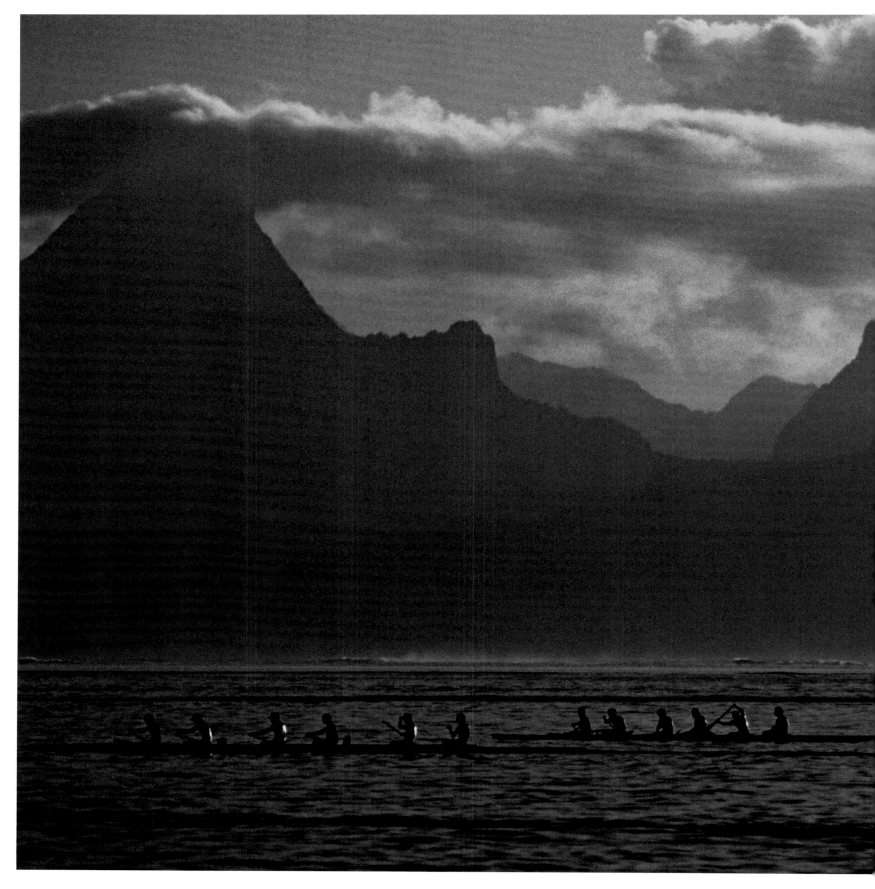

PAPEETE, TAHITI,
FRENCH POLYNESIA, 1987

Outrigger canoe racers practice in the waters
off Papeete, Tahiti's capital. In the distance rise
the volcanic peaks of Moorea.

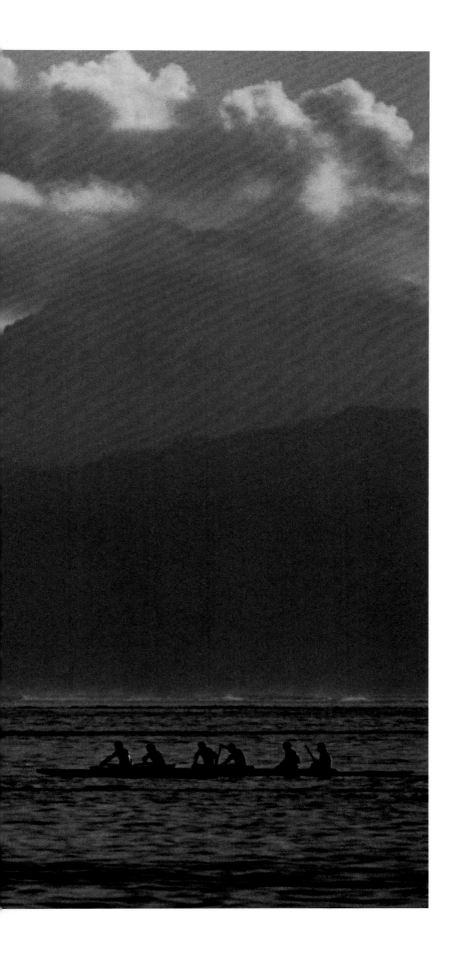

ACROSS THE SEAS

The Islands of Polynesia and Micronesia

Oceania. The scattering of remote atolls and tiny countries over a quarter of the earth's surface has long held a magical attraction for Westerners suffocating from their bourgeois life at home. Yap, Palau, Chuuk, Pohnpei; Tahiti; and even the now-familiar islands of Hawaii: Maui, Kauai, and Molokai.

I was entranced in my youth by writers who had discovered this vast "blue of Capricorn"—Herman Melville, Pierre Loti, Robert Louis Stevenson, Jack London, Somerset Maugham, and James Michener.

Before Paul and I met in Hawaii many years later, we both had traveled throughout the Pacific on numerous journalistic assignments. I suspect that Paul felt the same romantic tug as those famous writers did—and indeed, as did I—on his visits to the pristine Micronesian archipelagos: where time can yet stand still, where even the flies take a siesta, where hospitality and a nonchalance tuned to the ceaseless rumble of breaking surf lulls one into oblivion. In Yap, not long ago, you were still greeted by topless island girls at planeside.

Tahiti has long evoked the most desirable idea of escape from the grime and stress of Western industrialization. Besides its remoteness, it has everything one might dream about. The jagged green carpeted peaks set against shades of an azure sea and surrounded by white surf, the silence of time, an abundance of fruit and fish, breezy tropical climate, friendly people—God's idea of perfection. The Tahitians have successfully blended with British, French, Chinese, Americans, and other foreign seekers of paradise.

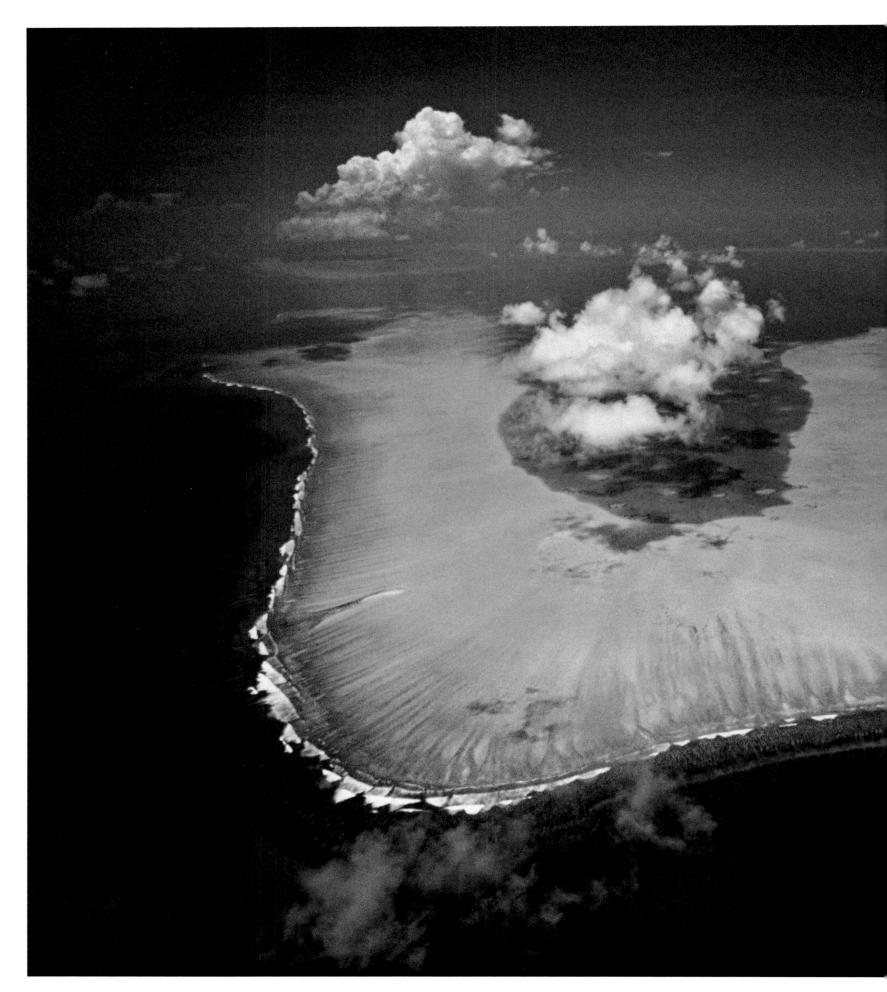

PALAU, 1987

A remote coral atoll near Kayangel is one of
more than over 250 islands and outcroppings
that make up the Republic of Palau.

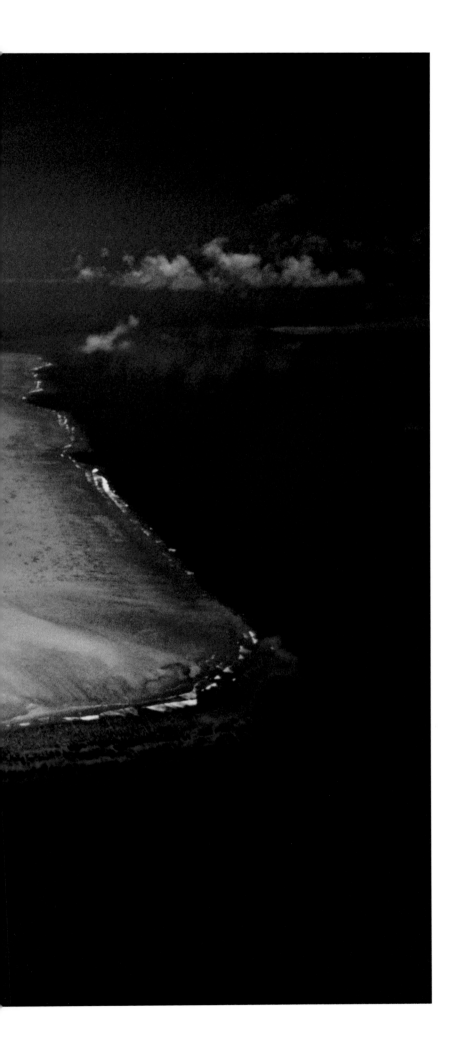

Sadly, modern air travel has robbed Oceania of much of its romance. The Pan Am flying boats of 1930s were a different story. In those days, one could enjoy a pampered, unhurried flight from Australia through the Cook Islands to Honolulu and on to San Francisco. It was a bed and free champagne all the way.

On my own first crossing of the Pacific, in 1966, I flew in slow stages from Acapulco through Tahiti, Samoa, and Fiji to Australia, on Qantas, UTA, and Pan Am. The allure to stay in any one of these ports of call was plainly seductive.

In 1979, I returned to Polynesia, and spent six weeks in the Cook Islands, based in Rarotonga. Again, I was tempted to remain indefinitely. I stopped over in Nuku'alofa, the sleepy capital of Tonga. I set up an interview with King Taufa'ahau Tupou IV. We talked on the breezy veranda of the palace. His Majesty weighed several hundred pounds. He had just enjoyed a hearty lunch and a few minutes into the meeting he fell asleep. He snored heavily. I did not know how to continue the interview. I had been asking him something about foreign investment. Then a fly landed on his nose. He jerked awake, slapping at his face.

"Why, yes," he continued, without missing a beat. "We accept foreign investment from almost everyone. Except China."

The introduction of modern culture has brought a dark side to some of these places. The passage of war, atomic tests, imported diseases, and unhealthy diets—where Spam is a staple—have infiltrated these lonely atolls. They have left their marks and reminders in the form of rusting battle wrecks, physical deformities, juvenile delinquency, drugs, diabetes, and dependency. Like everything, paradise comes with a price.

The Pacific still conjures up a sense of joyous remoteness. In these vast spaces you will come face to face with your overwhelming insignificance. You can feel queasy. You may even have to rethink the very meaning of your brief moment on this planet. As sure as the coconuts fall, your footprint on the sand will be washed away in the evening tide, the trade winds will rise, and the stars will shine. —KL

ROCK ISLANDS, PALAU, 1987

A snorkler explores one of the many Japanese Zero fighter planes from World War II that rest in the shallow lagoons of the Rock Islands. The Battle of Peleliu lasted more than two months and resulted in over 2,000 Americans and 10,000 Japanese killed, with the Americans taking control in November 1944.

ROCK ISLANDS, PALAU, 1987

Largely uninhabited, the Rock Islands get their unique mushroom shape as a result of erosion, grazing fish, and tiny marine mollusks that scrape at the coral outcroppings.

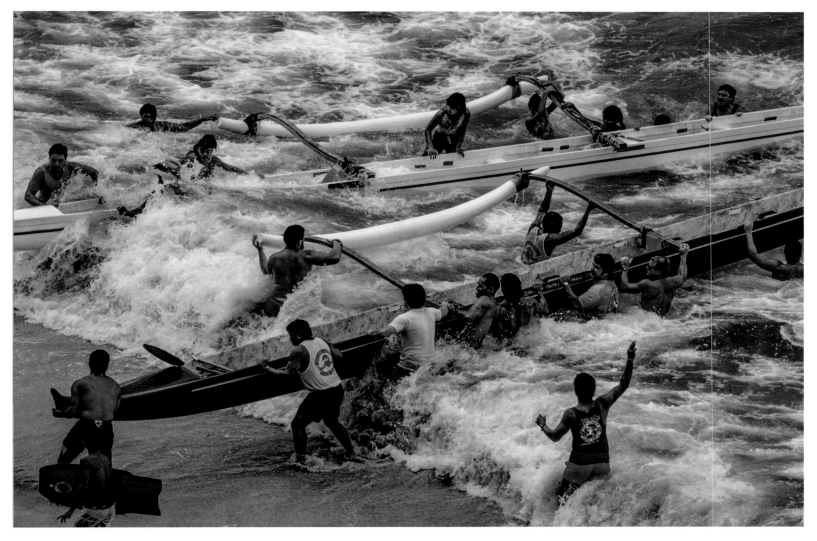

HONOLULU, HAWAII, 1984

Crews struggle against the high surf after the
annual Molokai to Oahu Outrigger Canoe
Race. Begun in 1952, it is the world's oldest
and most prestigious outrigger competition.

TAHITI, FRENCH POLYNESIA, 1987

Six-man canoe teams compete in the famed
Tahiti Nui Va'a race. The 100-mile course
around the main island of Tahiti takes three
days to complete.

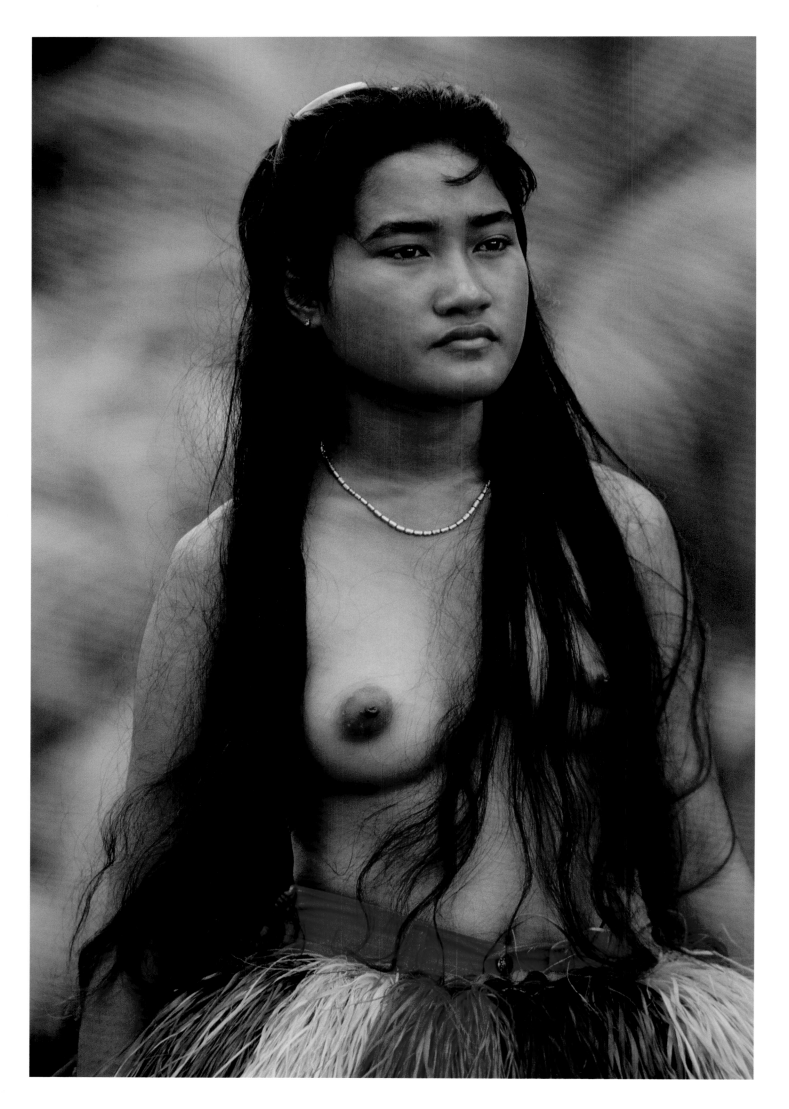

Love in the South Seas

As an outpost of French culture, Tahiti's city of Papeete exuded romance. Paul Gauguin fled to this capital of French Polynesia in the 1890s, later moving to the Marquesas Islands to seek further isolation. His paintings of indolent women in *pareus* lounging along the beach side are etched into our consciousness. A Tahitian woman with a *hinano* blossom tucked behind an ear. A horse painted in bold colors. A family sitting on straw mats. Gauguin hardly sold a painting during his time in the Pacific.

It was in Papeete, in 1966, that I met a Swedish artist named Peter Heymann. He passed his days at the Café Vailma on the waterfront, sketching visitors. Heymann told me an interesting story. After thirty years in Tahiti, he had decided it was time for him to return home to his native Sweden to die. Heymann sailed away. In Stockholm, on a cold winter afternoon, he passed a cinema house that was showing a film about Tahiti. He paid the price of a ticket and went inside. Midway through the film, Heymann saw himself on the screen sketching a tourist at a table at the Café Vailma. He left the theater feeling miserable. Overcome with nostalgia, he bought a passage back to Papeete, and now intended never to leave again. We drank to that!

I also met Bengt Danielsson, who lived in Faaa, a short distance from Papeete. He was a writer and had been a member of Thor Heyerdahl's famous Kon-Tiki expedition, which sailed on a balsa raft from Peru to Tahiti in the late 1940s. They were trying to prove that ancient Polynesians had sailed westward to the Society Islands instead of eastward from the Indonesian archipelago. The world was convinced of it for a time.

I was thrilled when I read Heyerdahl's book at the age of twelve. Later the theory was proved wrong when someone sailed the other way. Never mind. Danielsson enjoyed his life in Tahiti. He signed for me a book he had written. It was called *Love in the South Seas.* —KL

YAP, CAROLINE ISLANDS,
MICRONESIA, 1987

Wearing a straw skirt over her jeans, a teen-age performer takes part in a *churu* dance, a form of storytelling and oral history similar to the Hawaiian hula.

KOROR, PALAU, 1992

Although Palau is home to fewer than 20,000 residents, the culture of urban teens looks not unlike many more populous areas of the world.

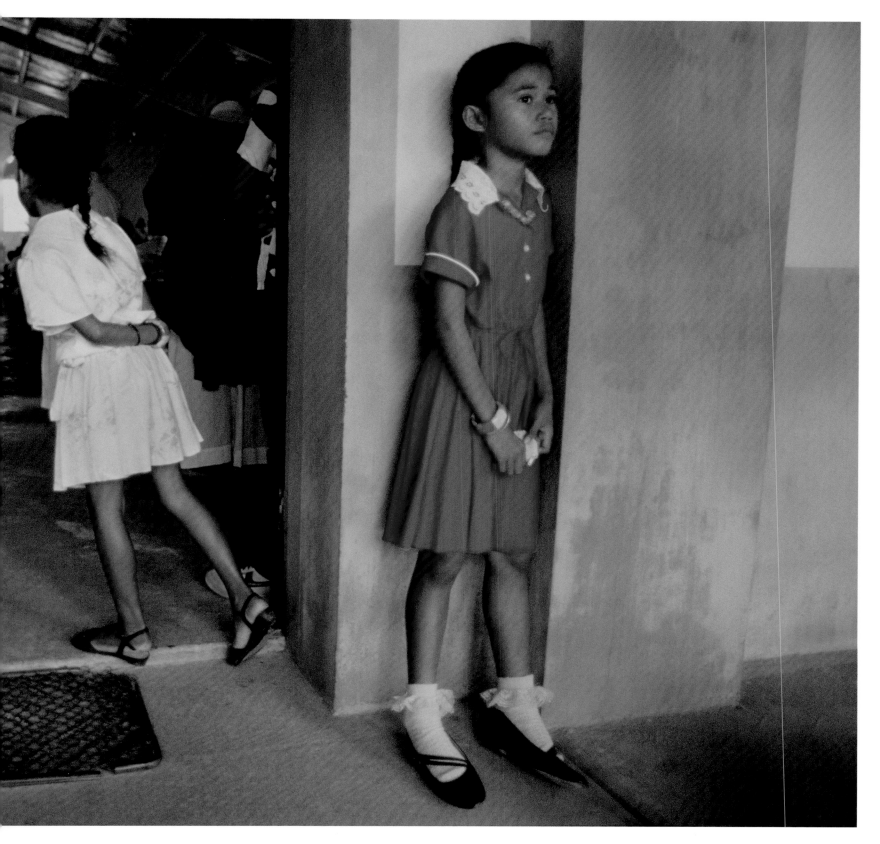

KOROR, PALAU, 1987

The Republic of Palau is a predominantly Christian
country, influenced by hundreds of years of missionary
expeditions and occupation, first from Spain and later
Germany and Japan.

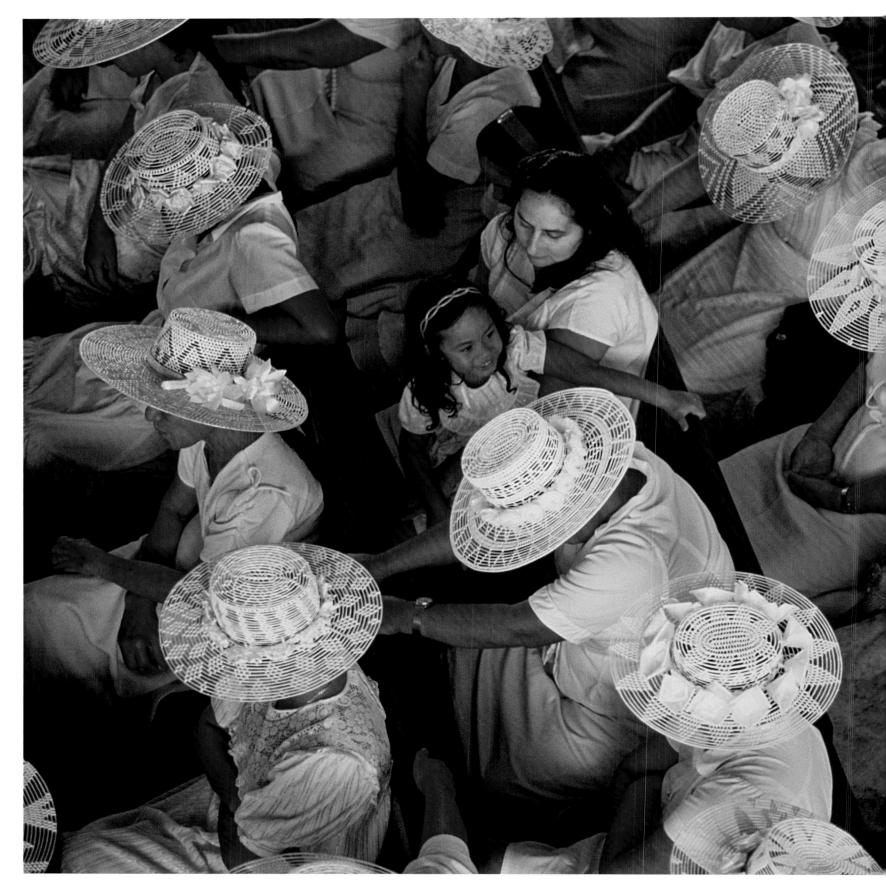

PAPEETE, TAHITI,
FRENCH POLYNESIA, 1987

Churchgoers in Tahiti wear their trade-
mark Sunday whites to church services
year-round.

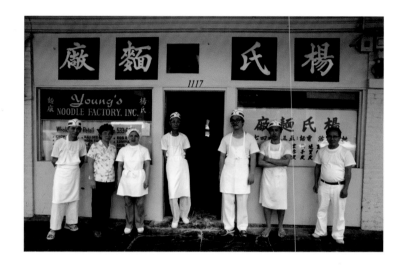

HONOLULU, HAWAII, 1983

Workers at Young's Noodle Factory in Chinatown pose for a portrait.

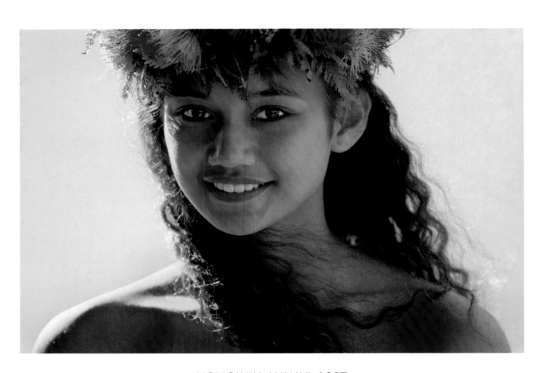

HONOLULU, HAWAII, 1987

Seventeen-year-old Kaui Dalire wears a
traditional *haku* lei of braided flowers.

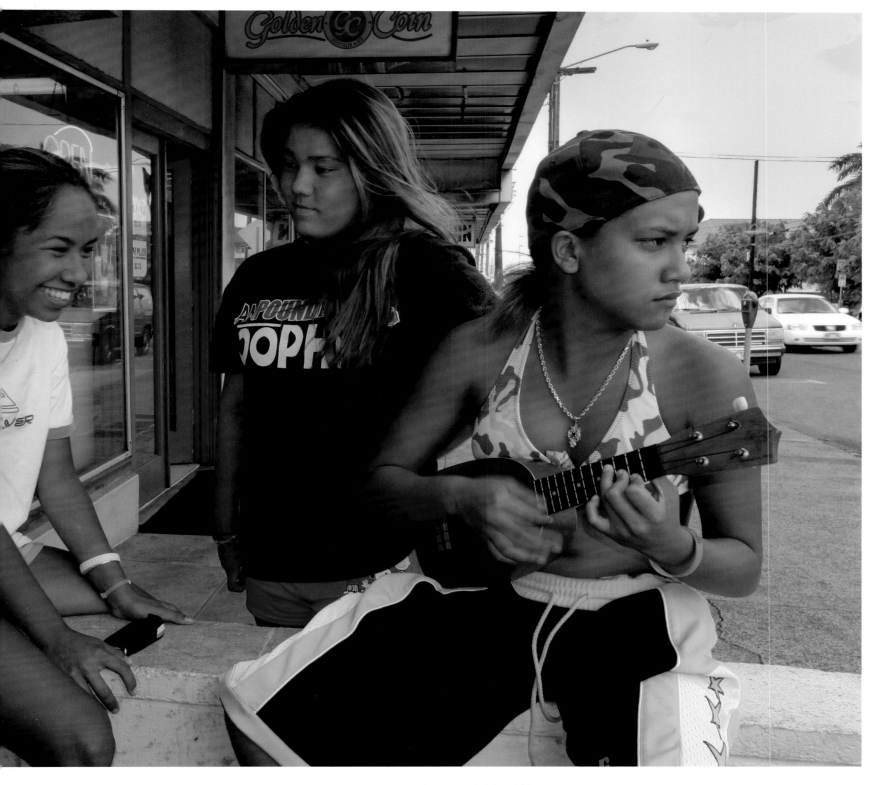

HONOLULU, HAWAII, 2007

Teenagers on Liliha Street seamlessly embrace
both modern and traditional culture, including
the ukelele, a longtime island favorite recently
regaining popularity.

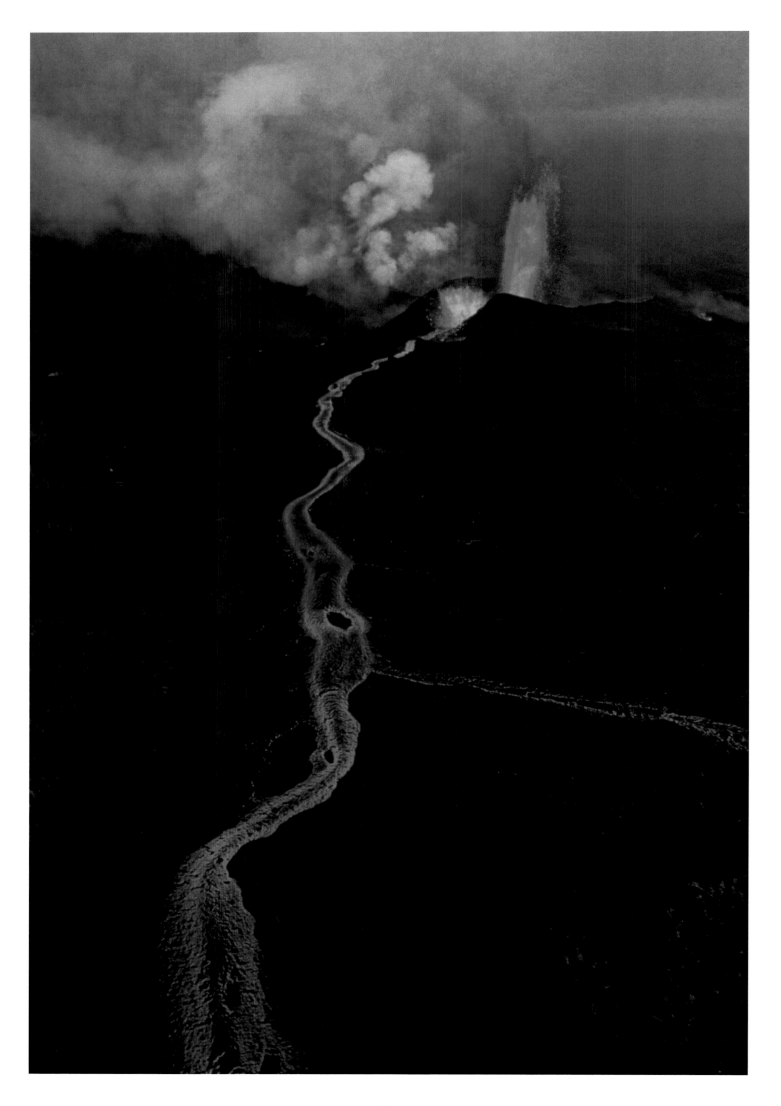

MAUI, HAWAII, 1984

The coastline of the Ke'anae Peninsula was formed
centuries ago by hot lava meeting the cold sea.

HAWAII VOLCANOES
NATIONAL PARK, HAWAII, 1984

The Kilauea Volcano spews molten rock
across the landscape of Hawaii's Big Island.

Pearls in the Deep Blue Ocean

Seen from space, the Hawaiian Islands resemble a strand of pearls in the vast deep blue ocean. How did the ancient seafarers ever find this sanctuary?

It is astonishing to recall that Hawaii was only "discovered" as late as 1778. The same year that George Washington and his Continental Army were shivering in Valley Forge, Captain Cook arrived in Hawaii, traveling from Tahiti in search of the Northwest Passage. He was soon followed by whalers, sandalwood traders, and missionaries. With the fall of the old idols, Hawaii would never be the same.

We residents of the Hawaiian Islands live on a few minuscule dots tossed up millions of years ago from the earth's core, far from all the continents. And Hawaii is still being formed. Lava has been spewing from Kilauea's Pu'u 'O'o cone since 1983. Hawaiian legend has it that Kilauea is the "body of Pele," a volcano goddess who is in active conflict with the rain god, Kamapua'a. The unlucky residents who have lost their homes nearby must be victims of a scorching lovers' quarrel.

As molten lava streams down to the coastline—enlarging the Big Island of Hawaii by just a mote—the human population increases, arriving from distant shores in search of a better future, as did their ancestors: Polynesians, Europeans, and Asians. Hawaii has transitioned from a government of tribal chiefs, to a monarchy, to a republic, to a U.S. territory, to finally becoming the fiftieth American state.

With its multi-ethnic, talented population, its array of international specialists, and its unique geography, Hawaii will always remain an indispensable strategic location. How many Asia-Pacific specialists—at the U.S. Pacific Command, the University of Hawaii, the East-West Center, the Asia-Pacific Center for Security Studies, and other think tanks—can dance simultaneously on the head of a pin? Plenty!

The beat goes on. The tourists come and go. The weather remains, but what about climate change? How many years before Waikiki will be under a few feet of water? The experts are making their calculations. Meanwhile, the natives strum their ukuleles under the Honolulu moon. —KL

OAHU, HAWAII, 1984

Honolulu peeks out through the clouds as
the morning sun hits the 1,200-foot cliffs
of the Ko'olau Range.

HONOLULU, HAWAII, 2006

A memorial statue is posed in reverence
in Nuuanu Valley's Oahu Cemetery.

HONOLULU, HAWAII, 1984

Located near downtown Honolulu in the
ancient Punch Bowl volcanic crater, the
National Memorial Cemetery of the Pacific
commemorates men and women who served
in the United States Armed Forces.

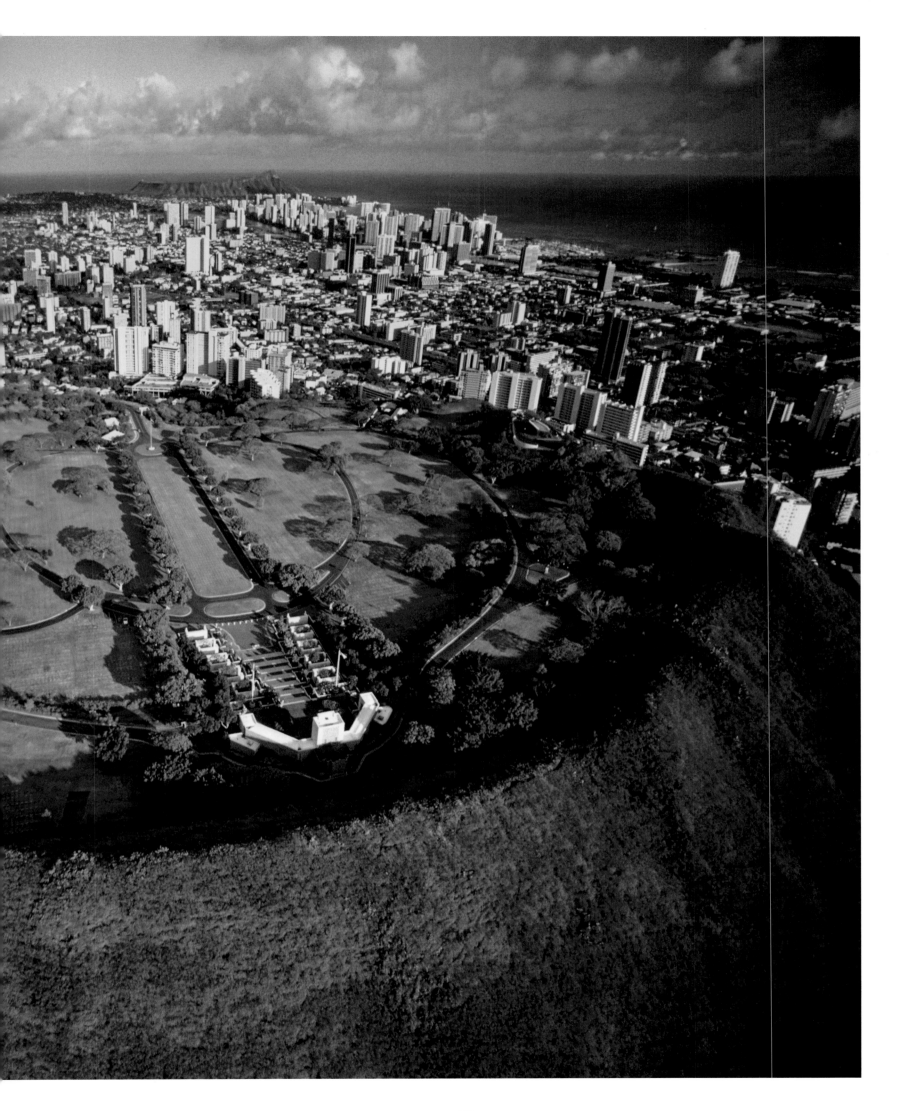

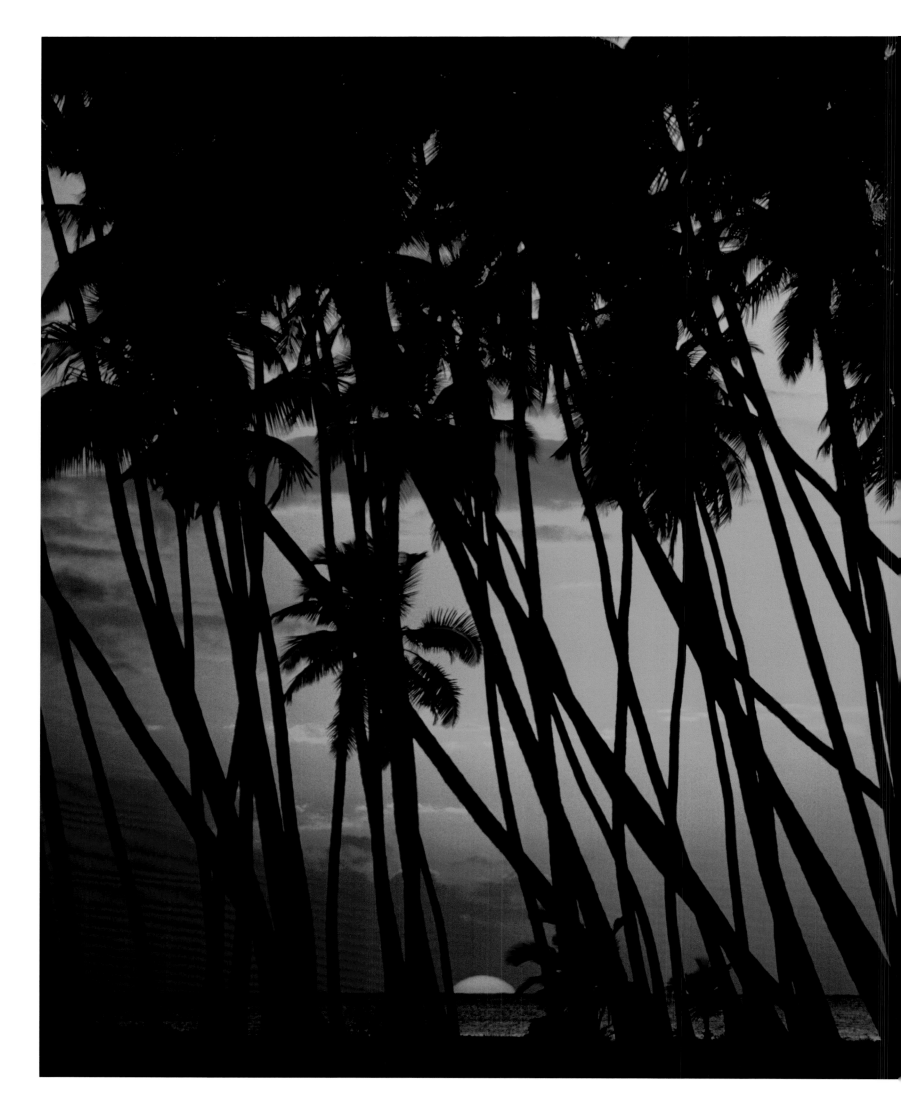

MOLOKAI, HAWAII, 1984

The sun sets on Kapuaiwa Coconut Beach
Park. Although often associated with
Hawaii, coconut trees are not indigenous
to these islands, but were brought here by
early Polynesian settlers.

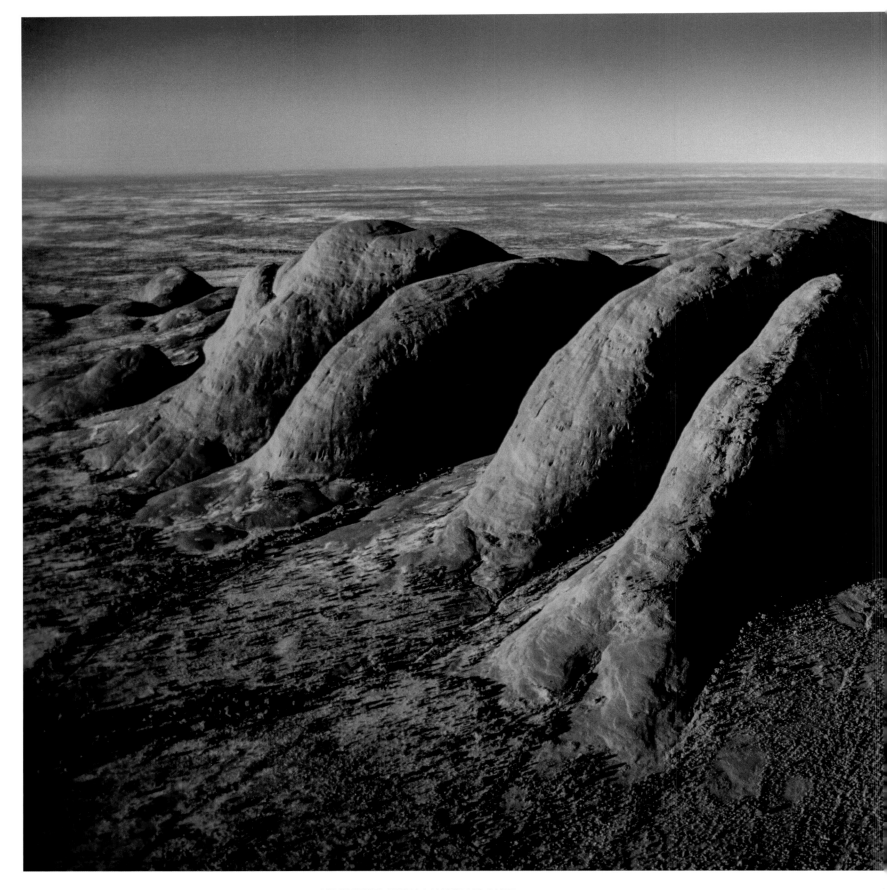

ULURU-KATA TJUTA NATIONAL PARK,
AUSTRALIA, 1990

Thirty-four miles southwest of Ayers Rock, the
Olga Mountains are known to the Aborigines
as Kata Tjuta, and are closely related to their
Dream-Time legends.

A PEOPLE DOWN UNDER

The Aborigines of Australia

The gentleness of the Aboriginal people was what first touched Paul when he spent several weeks photographing them in northwestern Australia in the 1990s. As he became better acquainted with some of the members of this ancient race, he began to appreciate the significance of Dream-Time, core to the beliefs of these indigenous people.

Dream-Time recalls a sacred era when the totemic spirits of ancestors created the world. In Dream-Time, the structure of society, the rules for social behavior, and law were established. Knowledge is preserved in the Songlines, which provide an oral history of a given local area. This history is chanted by individuals as they make their away across the terrain. Songlines also include Dreaming Tracks across the sky, as in astronomy. On the ground, landmarks, such as water holes, depressions, and other natural phenomena, are embedded in the songs to enable navigation. The songs must be continually sung to keep the land alive, as all land is sacred.

What is known about the origins of these people? Various studies have attempted to determine the genetic roots of the so-called Aborigines, a term that is gradually being replaced with "Indigenous Australians." Researchers now believe that their ancestors migrated to this southern continent as long as 50,000 years ago. This theory is based on archaeological discoveries of human remains near Lake Mungo in southeastern Australia. The Aborigines apparently split off from the ancestors of European and Asian populations about 75,000 years ago, long before those two populations separated from each other. The Aborigines have lived in the same territories on the Australian continent longer than any other human population has occupied its ancestral area.

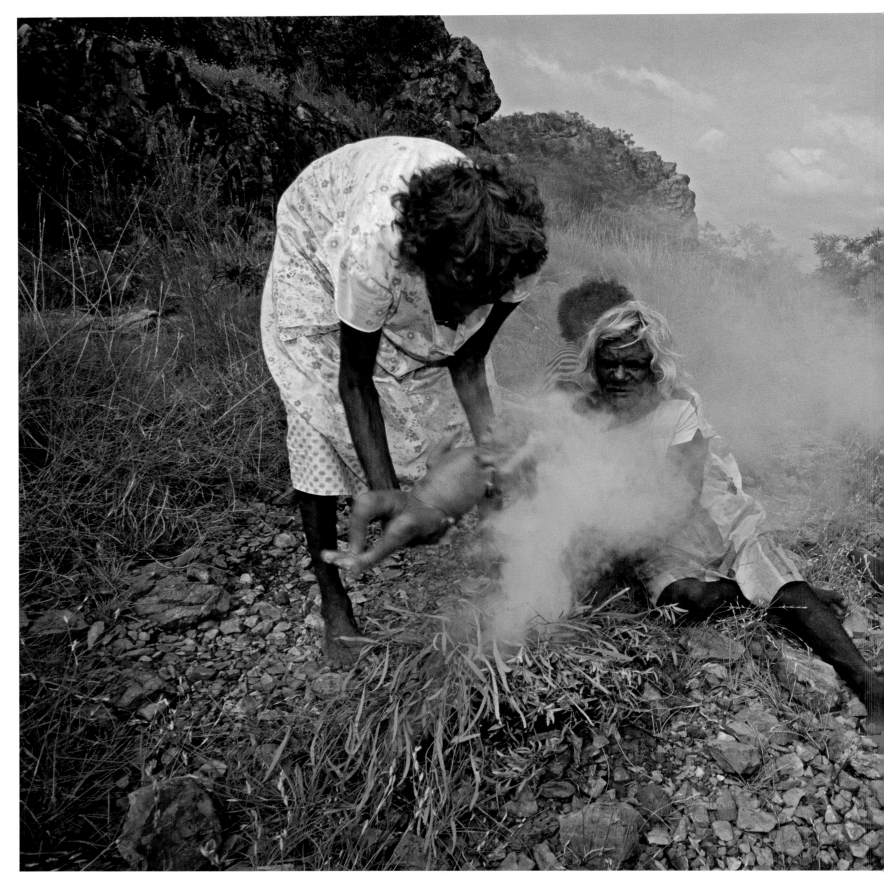

KING LEOPOLD MOUNTAINS,
AUSTRALIA, 1991

An Aboriginal mother prepares a ceremonial
"smoking" of sacred herbs and plants to ensure
her baby's good health and long life.

In 2008, the Australian government made a formal apology for the past wrongs made by successive governments toward the indigenous population. The prime minister regretted those laws that "inflicted profound grief, suffering, and loss." This apology endeavored to close the book on generations of prejudice against the Aborigines. It followed on the heels of a report in 2000, by the prestigious human-rights group Survival International, that noted, "The Australian government seems hell-bent on doing everything it can to deny Aborigines their internationally recognised rights, especially their land rights."

Much is hidden from sight in Australia, both socially and geographically. In America, some Old Families trace their ancestors to the Pilgrims who came over on the Mayflower. In Australia, it is oddly prestigious to be a descendant of English purse thieves and debtors who were shipped off to the penal colony in New South Wales in the late 1700s. These cantankerous descendants claim a kind of Australian aristocracy today.

Many traditional Aussies want no part of fancy British ways, titles, and tea parties. Some would prefer to cut the old dominion ties. On the other hand, in the past fifty years Australia has opened its doors to a wide mélange of immigrants, admitting more Asians, Greeks, Italians, and various Balkan peoples (following the conflicts in that region). The result is a much more cosmopolitan Australia.

Most Australians love the legend of the ingenious rebel Ned Kelly, an Aussie version of Billy the Kid or Jesse James. Kelly's life has been retold in song, story, and cinema. His father was an Irish convict deported to Australia for stealing two pigs. Kelly was brought up poor. Disputes occurred with the authorities. Kelly shot down three policemen and became an outlaw. His gang robbed banks. In a unique strategy to outwit his pursuers, he dressed in metal armor and a helmet. Bullets bounced off him for a time. However, in 1880, he was captured, tried, and subsequently hanged in Old Melbourne Gaol. His defenders have always asserted that "Kelly was a political revolutionary, and a figure of Irish Catholic and working-class resistance to the establishment of British colonial ties."

There is something likable in the Australian character that favors rebels. —KL

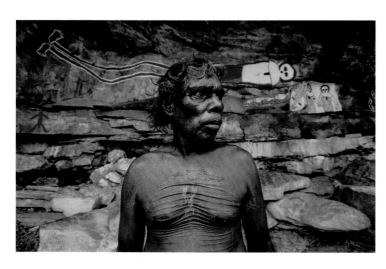

KING LEOPOLD MOUNTAINS, AUSTRALIA, 1991

David Mowaljarlai (1926-1997) was a poet, author, and longtime activist for the return of tribal lands to the indigenous peoples. David accompanied Paul on an assignment to Aboriginal lands in the outback of Australia.

"You got country as far as the eye can see, and it's yours. Because of this consciousness, you are going through it reverently, quietly—through the middle of all this nature. What will happen? Well, every contact you make with the eye— perhaps you don't bother to look at it—but everything is present for you to see. What you go for are the things you want to understand on this day."

—David Mowaljarlai

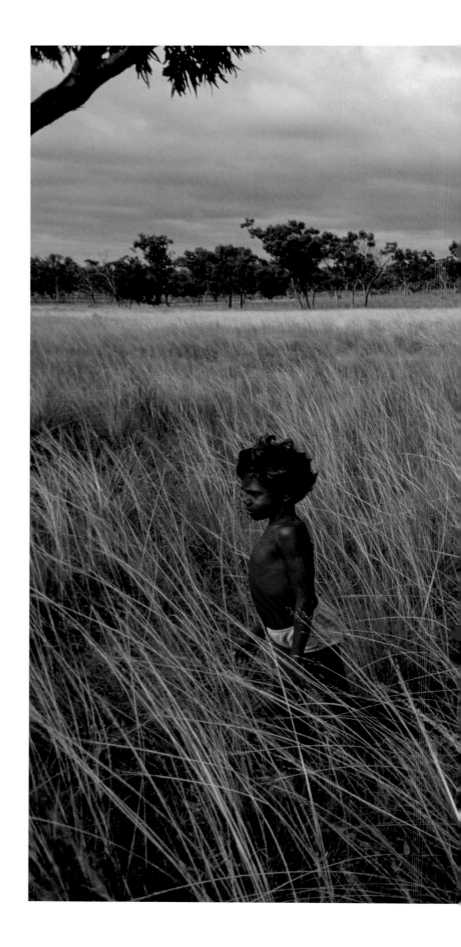

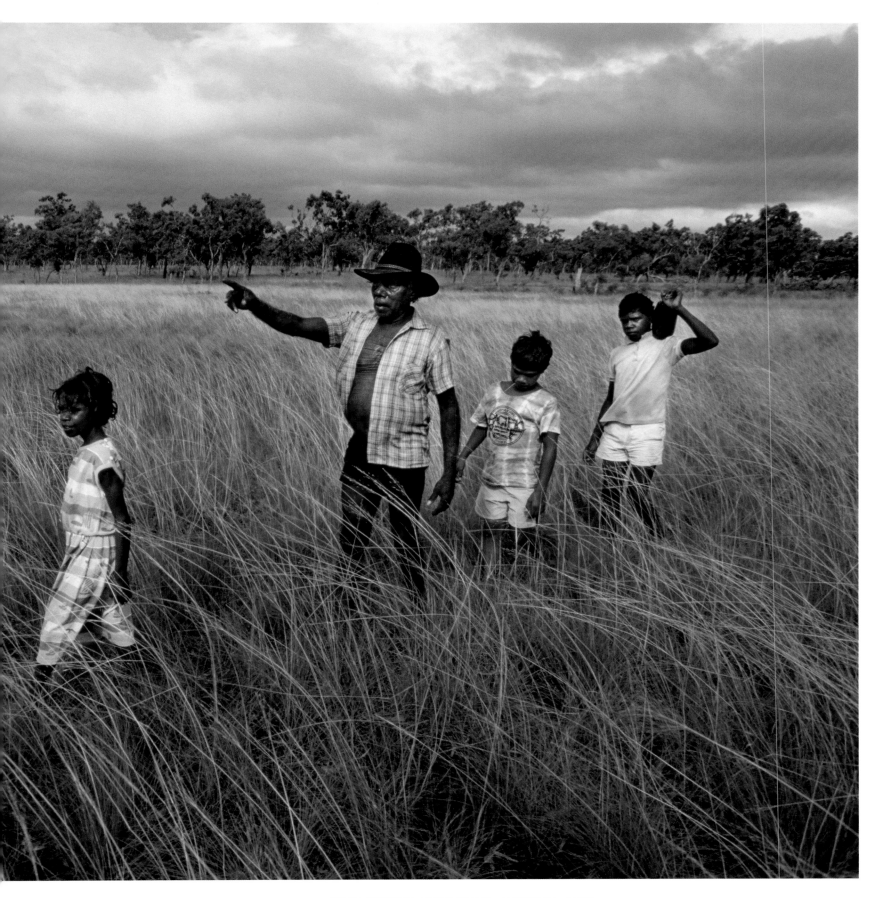

KING LEOPOLD MOUNTAINS, AUSTRALIA, 1991

David Mowaljarlai guides local children to nearby Aboriginal rock art caves. The caves are so secret and protected that the youngsters had never seen them, even though they live only several miles away.

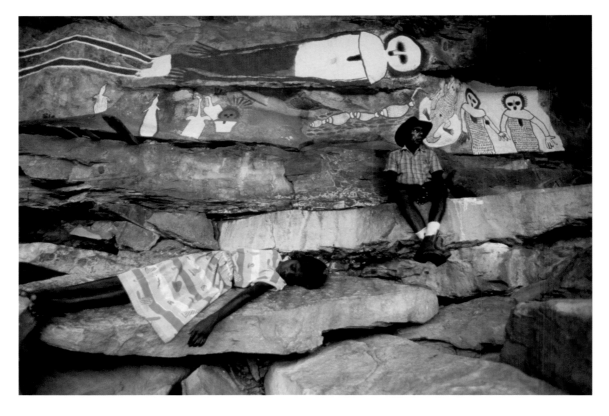

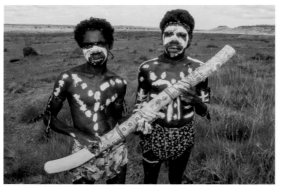

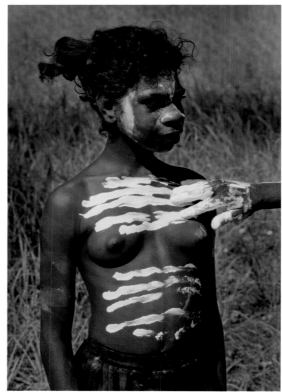

KING LEOPOLD MOUNTAINS,
AUSTRALIA, 1991

Many of the Aboriginal traditions reflect back to the
early legends of the Dream-Time, including their rock-
cave paintings, and chalk-white body paint, applied
by elders for ceremonial dance and rituals.

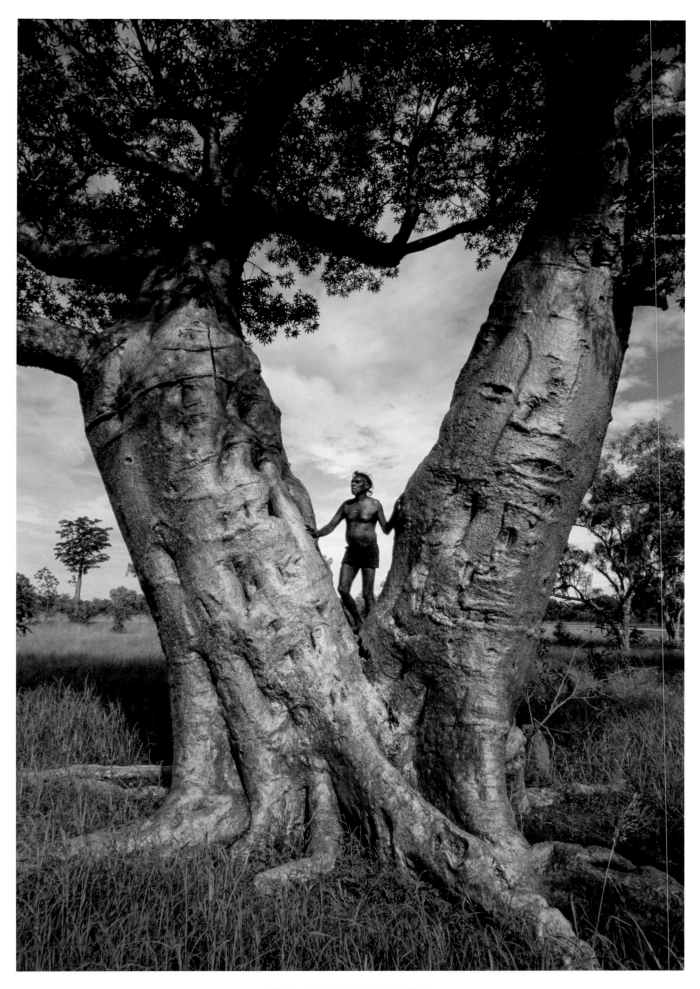

KING LEOPOLD MOUNTAINS,
AUSTRALIA, 1991

David Mowaljarlai surveys the landscape from a
boab tree, some of which live over 1,500 years.

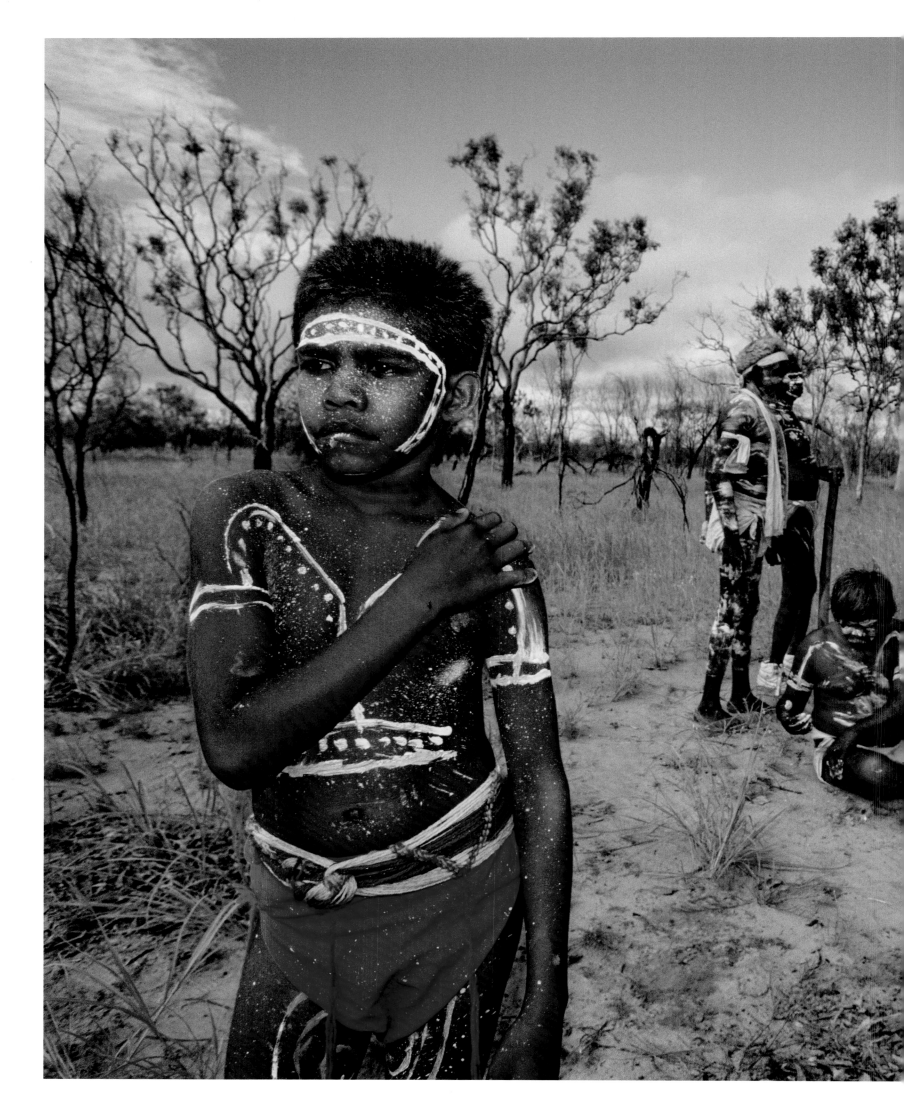

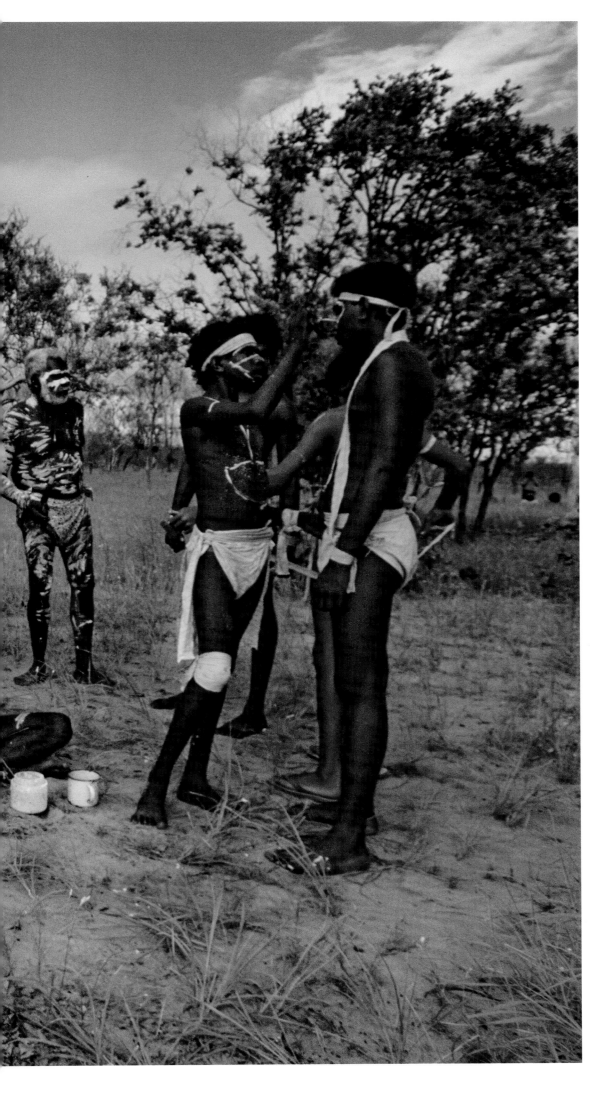

HALLS CREEK, AUSTRALIA, 1991

The modern Aborigines are directly descended from migrants who arrived in Australia as long as 50,000 years ago, according to current scientific findings.

THE HIDDEN REALM

Bhutan

Bordered by Tibet, closed off for centuries from the outside world, remote Bhutan has retained a medieval society to the very present. Serfs were indentured to feudal estates until 1959. Printed money was only introduced in the late 1960s. The yak is still the basis of livelihood, providing hide for rough clothing; meat, cheese, and butter for food or trade; and dung for fertilizer. *Chang* (barley beer) is an instrument of barter.

The tribes living along this southern rim of the Himalayas have long remained culturally intact due to mountainous barriers. They represent a splendid array of Hindu and Buddhist, Lamaist and animist, and highland and valley. A mere handful of European explorers penetrated this hidden realm before World War II.

In the late 1980s, Paul was fortunate to visit Bhutan for a month, photographing for a National Geographic book. Paul was struck by the primitiveness of the trip compared with modern standards of travel. It took three attempts to fly in from Calcutta in a twin-engine prop because of the weather in Bhutan—the first day's delay was because of fog, the second day snow. On the third day, he made it in, landing on a grass runway in Paro, the kingdom's only airstrip. The first planes had been able to land there just a few years earlier.

Soon after arriving, Paul set off on a two-week jeep trip with a guide and driver, from the capital of Thimphu to Bhutan's far eastern reaches. These tribal villages had no hotels or grocery stores or restaurants—so Paul and his crew slept on the floor of the local *dzongs* and carried all their own food. They were rewarded with the chance to experience a way of life previously unknown and undocumented by outsiders.

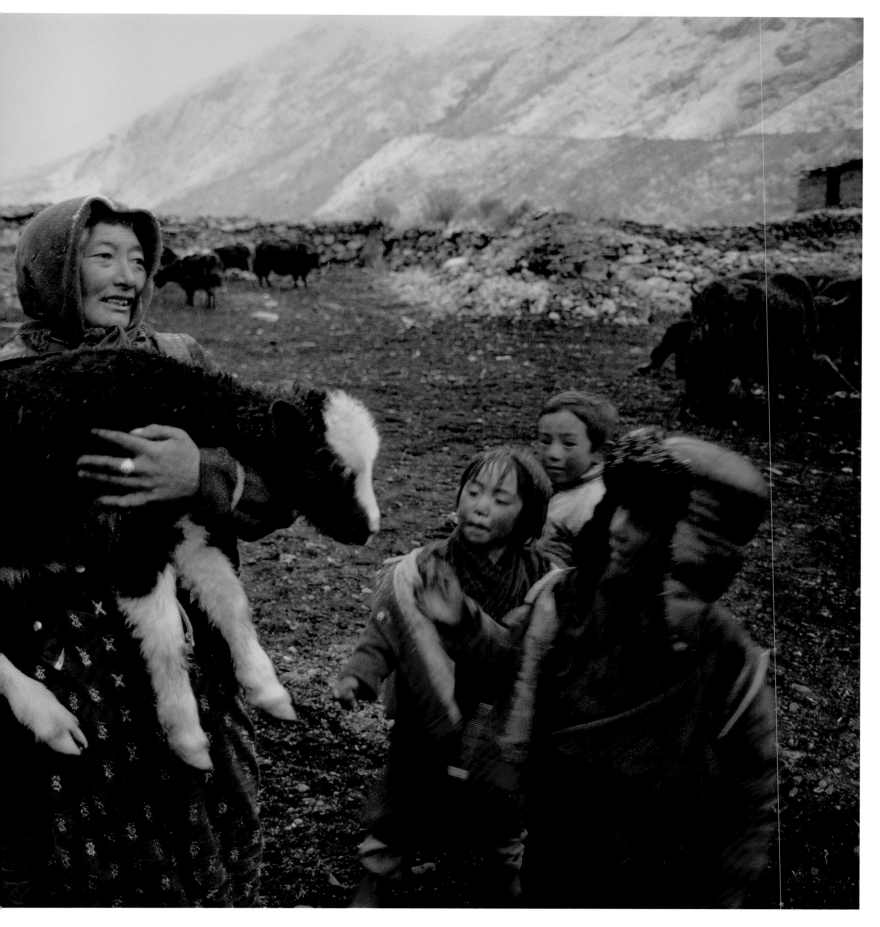

BHUTAN, 1987

A woman attends to the daily chores of
caring for her family's herd of yaks in the
far western region of the country.

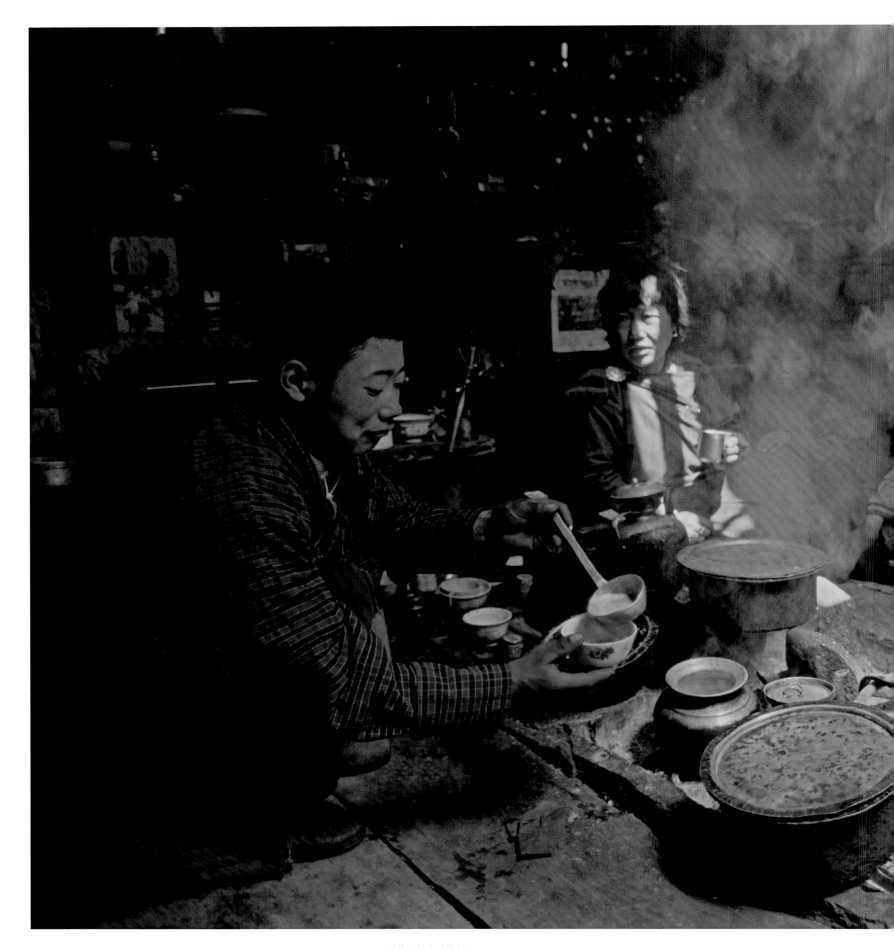

BHUTAN, 1987

A rural family prepares a simple afternoon
meal of rice, barley, chilies, and tea.

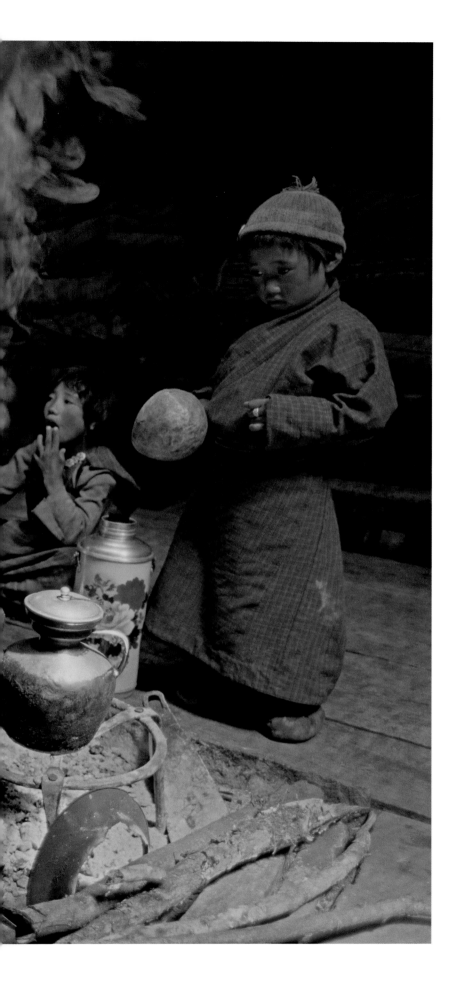

It is evident to any visitor that Buddhism represents the core of life in this realm. The clergy traditionally control the education. Monks, old and young, are omnipresent. White pennants—prayer flags printed with Buddhist incantations—flutter from the ridge tops. In the main towns, the most imposing structure is the *dzong*—a combined religious and administrative center.

The Bhutanese are nurtured from an early age to have faith in a supreme spiritual force that is far, far greater than their own inconsequential selves. The aim of every Bhutanese is to escape the cycle of births and attain Nirvana. The depiction of the spiritual "wheel of life" is ever present in art forms, tapestries, pennants, walls, and sacred *thangkas* (embroidered paintings prized by art collectors). Masked dancers at festivals constantly reinforce this perception of life's transitory state.

The royal family of Bhutan made a decisive move a few years ago when it stepped aside to make way for a legislative assembly mandated to pursue a democratic style of government. King Jigme Singye Wangchuck determined there were now enough educated people in his realm who knew how to navigate between the rampant capitalism knocking on his outer walls and the traditional simplicity that is characteristic of the Buddhist path. Most dramatic was the decision to allow satellite television into the reclusive country. Now numerous channels blare out the consumer excesses of the West.

The present rulers have come up with the idea that, rather than focusing on the nearly universal economic objective of ratcheting up the GNP (Gross National Product), it is more important to attain what they have dubbed GNH, Gross National Happiness.

It seems a noble objective. But at the same time, the number of tourists permitted to enter the remote country each year is increasing exponentially, which means bigger airports, more hotels, wider roads, larger tour buses, more fuel, and more foreign exchange, all contributing to the dilution of Bhutan's unique, isolated culture—one of the last on this consumption-driven planet.

What happened on the Way to Shambala? Whither the "jewel in the lotus"? Paul got there just in time. —*KL*

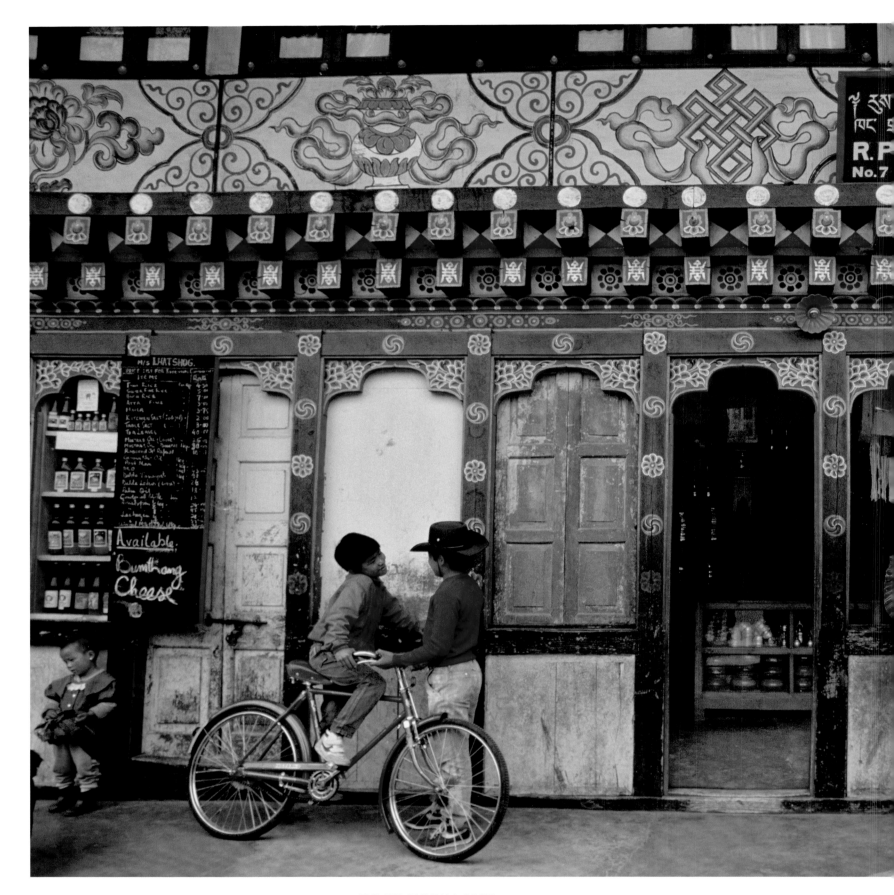

THIMPU, BHUTAN, 1987

Storefronts adorned in traditional archi-
tectural designs line a main shopping
street in the capital city of Bhutan.

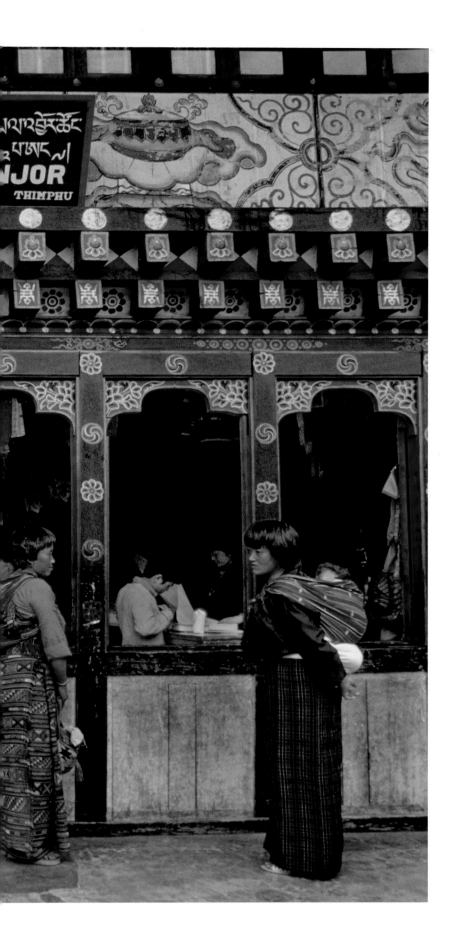

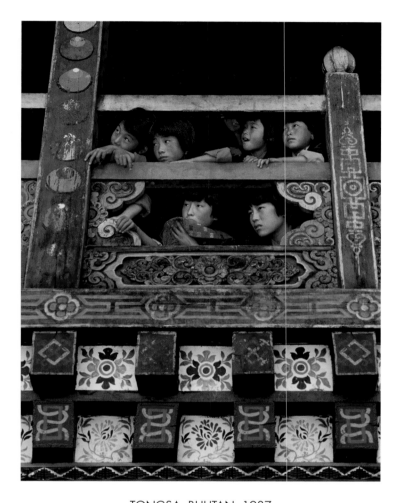

TONGSA, BHUTAN, 1987

Children watch the annual spring
dance festival from the upper levels
of the Rinpung Dzong.

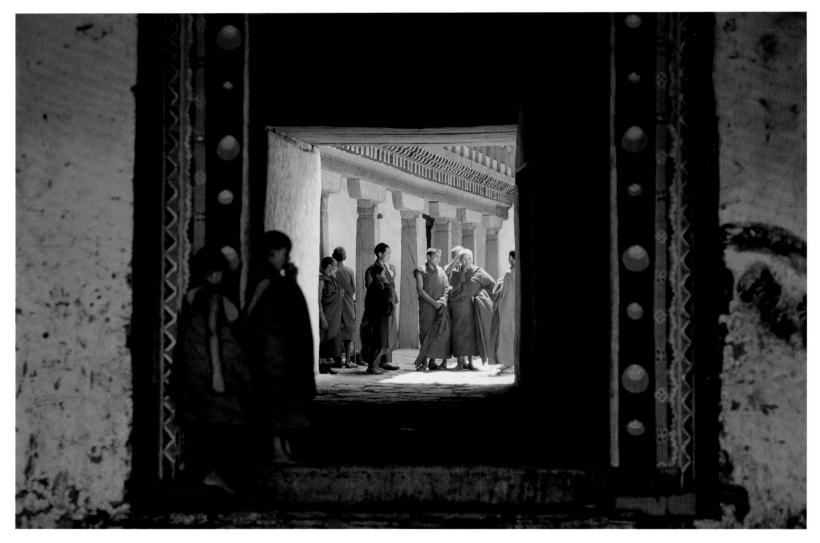

TRONGSA, BHUTAN, 1987

Over forty *dzongs* serve as both religious
and administrative centers across Bhutan.
Buddhism is the primary religion in this
country of 700,000 people.

TRONGSA, BHUTAN, 1987

Depictions of fierce animals—like this fresco of
a tiger inside the fortress-like Trongsa Dzong—
are meant to guard the monasteries.

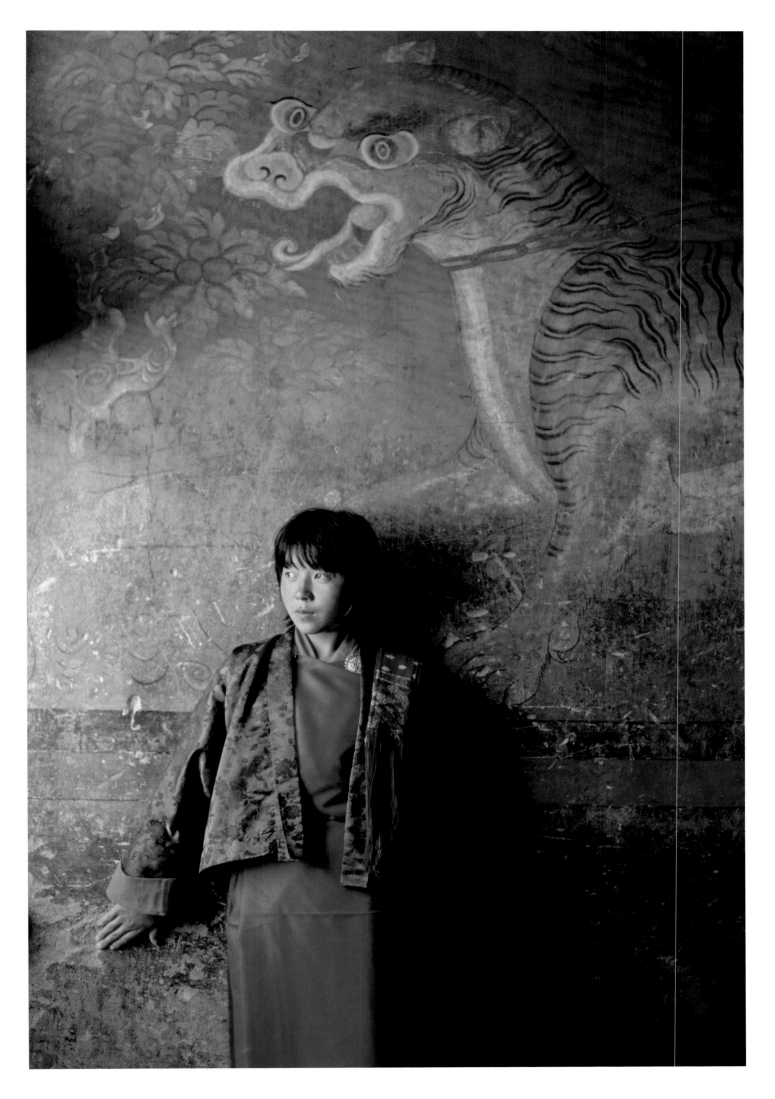

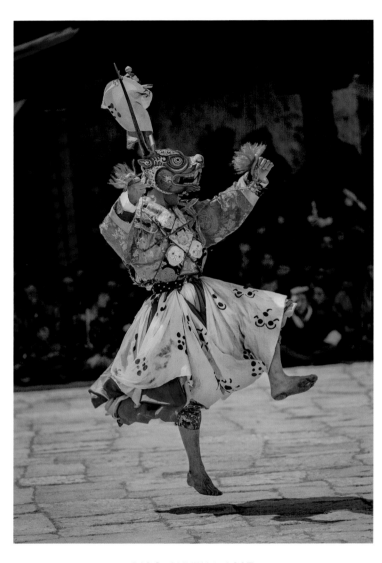

PARO, BHUTAN, 1987

A dancer plays the part of a *raksha*—
a mythological being—as part of a local
religious festival.

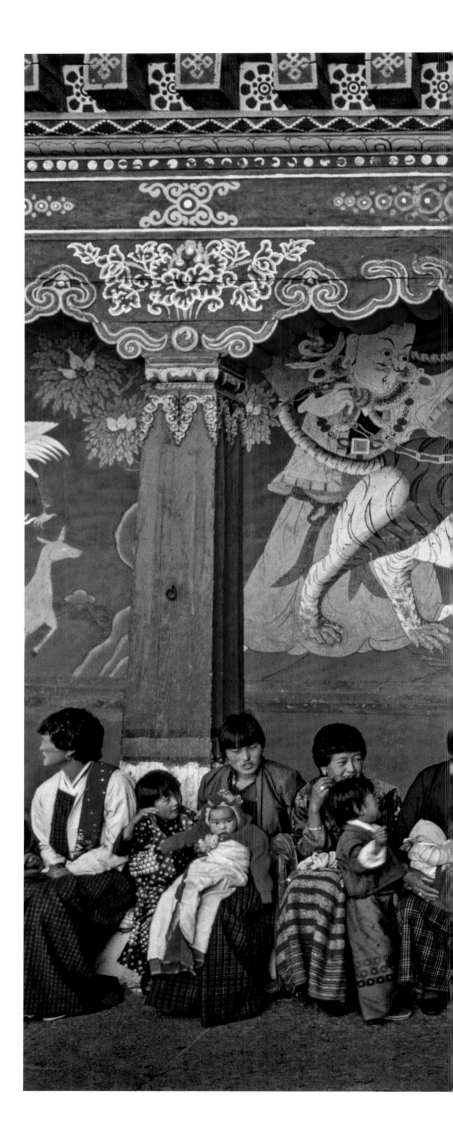

PARO, BHUTAN, 1987

Waiting for festival activities to begin,
women watch over their children in an
inner courtyard of the *dzong*.

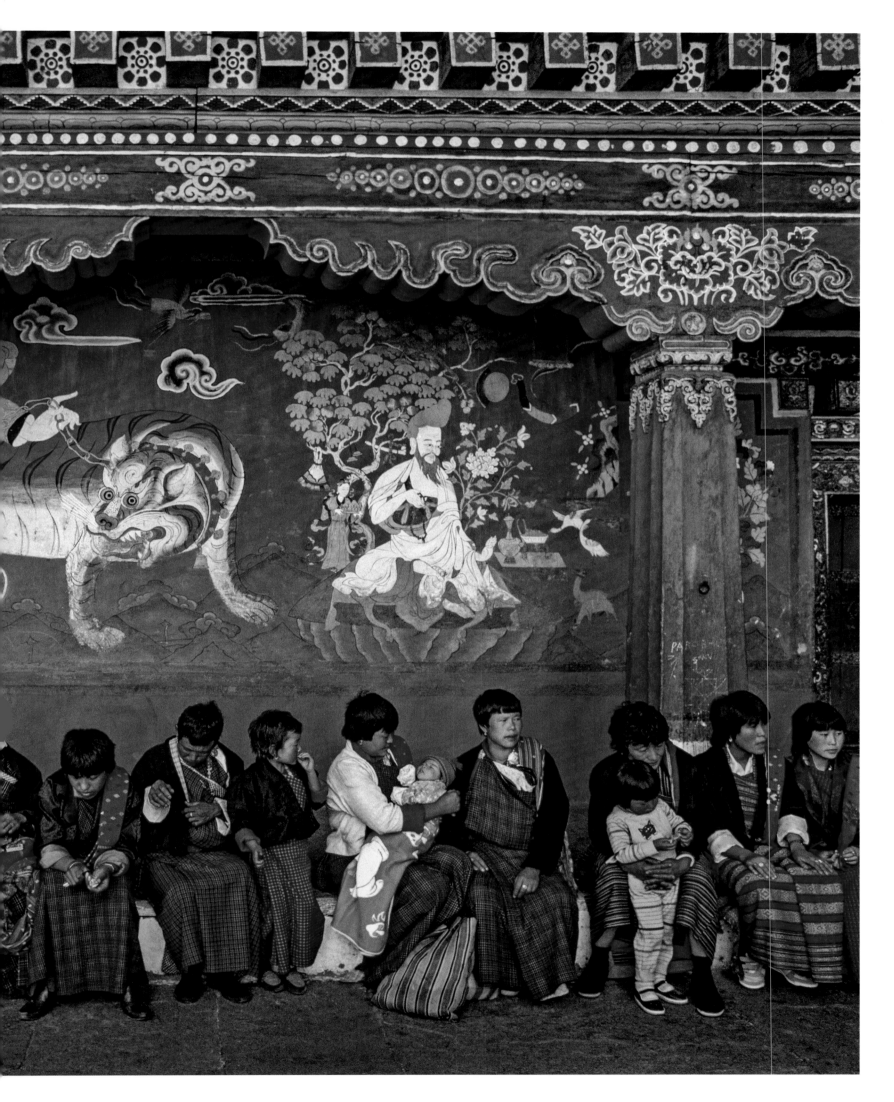

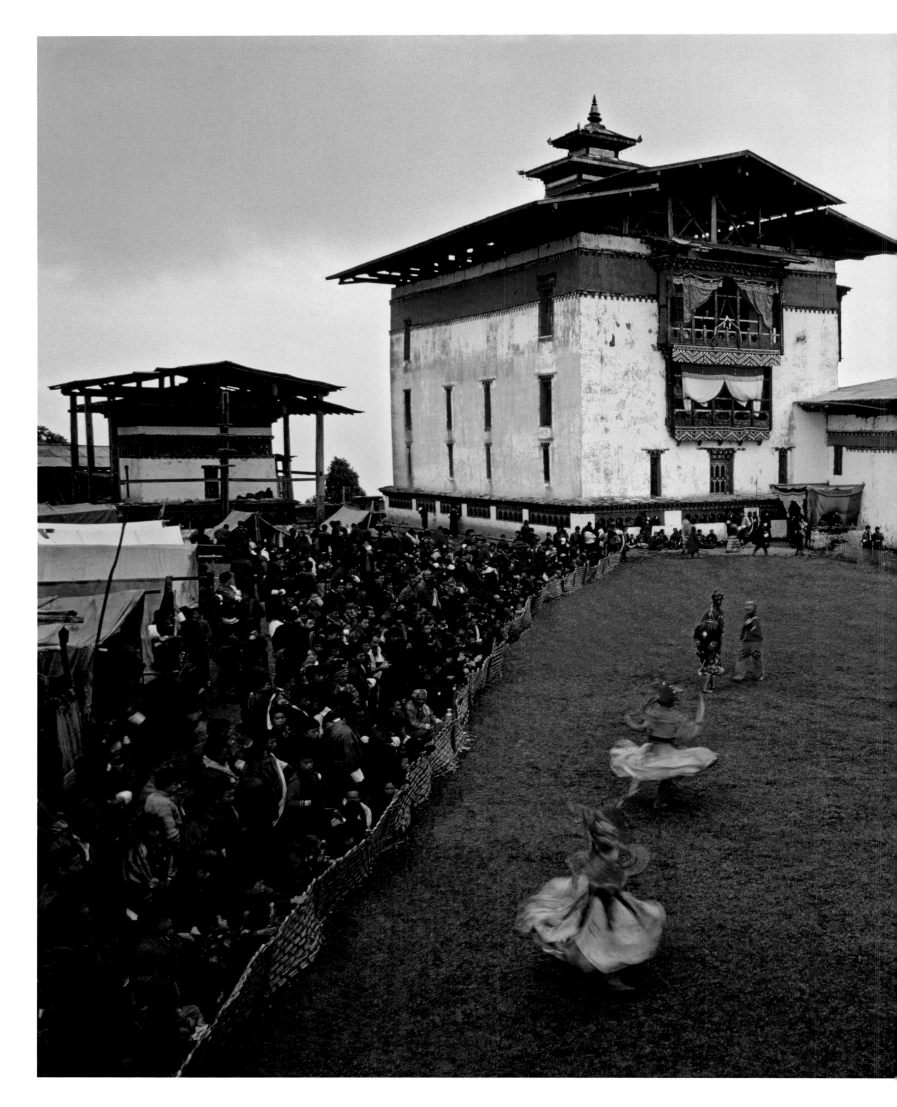

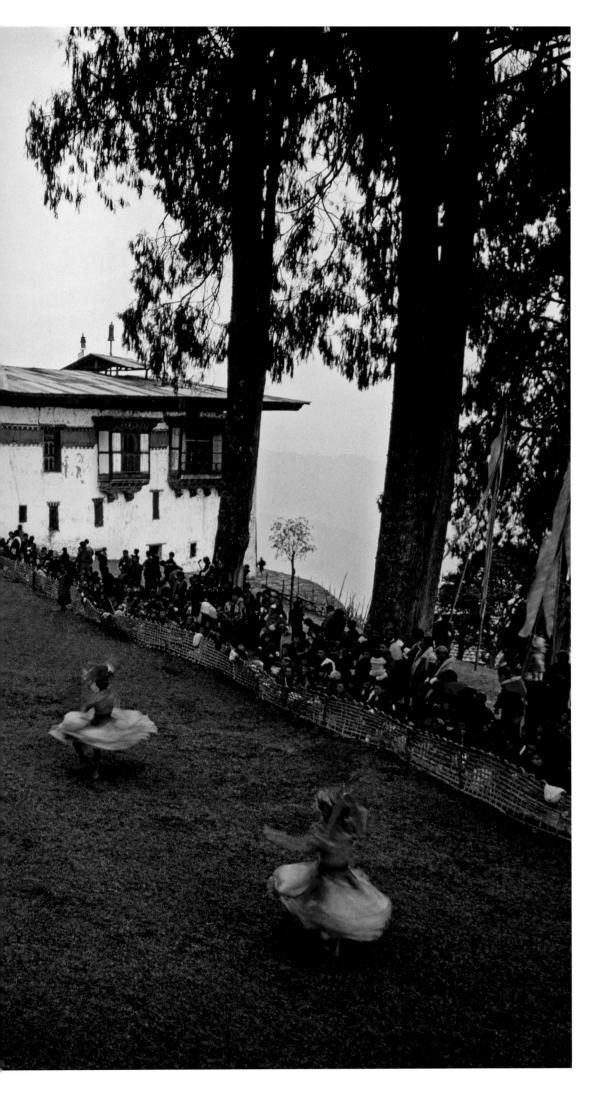

TALO, BHUTAN, 1987

Performing the sacred drum dance at the yearly festival, monks act out the triumph of good over evil to ensure the welfare of the community.

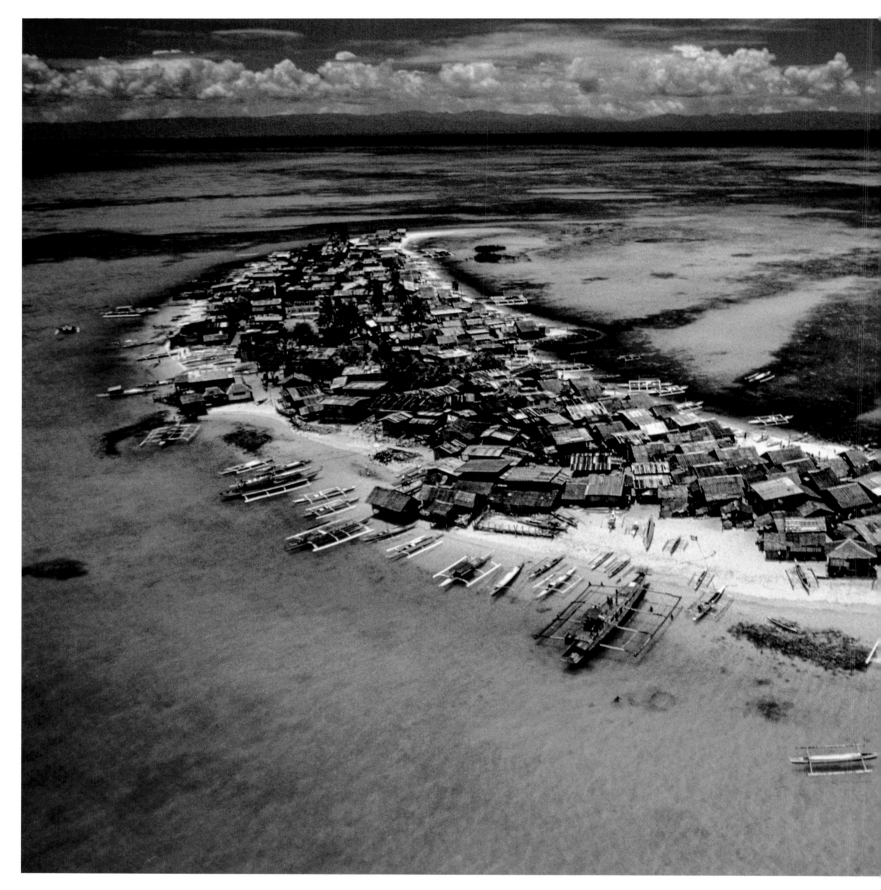

BOHOL STRAIT, PHILIPPINES, 1989

On one of many crowded island villages,
inhabitants endure a precarious life at the
mercy of typhoons.

ISLAND NATIONS

Indonesia, Malaysia, the Philippines, and Sri Lanka

Time is running out for the orangutans in Borneo. Their habitats are being turned into furniture for the Japanese. In Malaysia everything is oil-palm plantations now. The national parks in the Philippines, Indonesia, and Malaysia are fighting for their lives along with the animals.

Meanwhile, in Singapore—once a sleepy town where one could relax under the slow-moving paddle fans at the Raffles and enjoy a nice Pimm's Cup—the city-state has managed to turn itself into a high-finance capital with its own stock exchange. Sixty years ago, it had the tallest building in this region—the Cathay building, over fifteen stories high! Today Singapore has more than 4,000 high-rises and is one of most densely populated countries in the world.

Scattered across the azure waters of the Indian Ocean and the South Pacific, these once-remote archipelagos are changing with the times. Paul made several visits to these countries on assignment in the 1980s and '90s, capturing moments of spiritual celebration as well as crowded streets and markets, as the people of these nations kept to their old traditions and invented new ones.

The industrial and economic success of the region has come with a cost. The European colonial powers are gone; now the pressure is from Asian superpowers and internal politics. Local wars that are seemingly about religious and political issues are also being fanned by the competition for land and resources.

One can be forgiven for a bit of nostalgia for the good old colonial days. I remember the Tudor-style Royal Selangor Club in Kuala Lumpur, a favorite of planters and the import-export crowd in the 1960s. Back then, the club was nicknamed the "Spotted Dog" because for many a year a British tea planter from the Cameron

Highlands had tethered his Dalmatian outside while he enjoyed his whiskey at the Long Bar. I met a ruddy Englishman dressed in baggy khaki shorts. Oliver Milton was a jungle man whose mission was to save the Asian rhino. He had tramped all over the steamy interior looking for rhino footprints. During World War II, he had worked with the Kachin guerrillas in northern Burma, ambushing Japanese patrols and rescuing downed American pilots, earning a medal or two in the process. "To the Empire," he chortled, and quaffed his Johnnie Walker.

Life continues to evolve on these many islands, some with crushing urban populations, others still supporting almost Stone Age cultures. The once lonely beaches now have the best hotels, and often the worst slums. The super-rich live in the skyscrapers, while on stick jetties on remote islands in the Celebes, laborers still hump sacks of rice on their backs and drop them into sailing junks, and infants swing in hammocks.

A century ago, Joseph Conrad and Somerset Maugham captured in their tales of this region the disparity between luxury and poverty, from the European point of view. *Plus ça change, plus c'est la même chose?* Well, in the new Asia, the "posh" life is no longer reserved for European expatriates idling in the Raffles listening to violin strings. Today the new millionaires seldom sport hyphenated Anglo-Saxon names. —*KL*

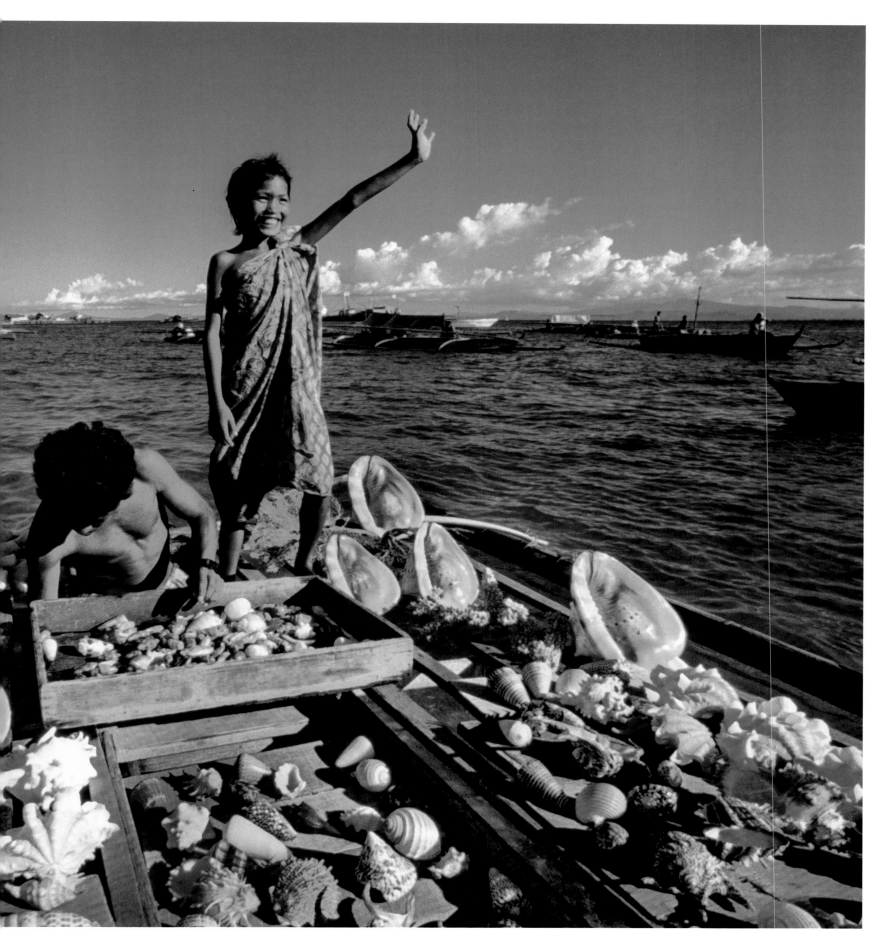

ZAMBOANGA, MINDANAO,
PHILIPPINES, 1989

Stocked with a cornucopia of shells from the
surrounding seas, two young entrepreneurs
ply the waters around tourist areas in hopes
of selling their bounty.

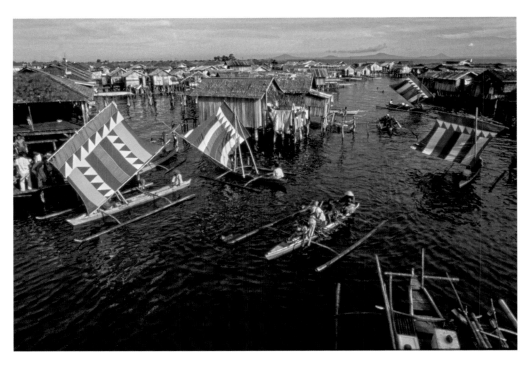

ZAMBOANGA, MINDANAO,
PHILIPPINES, 1989

Fishermen in outrigger canoes head
to sea under bright sails on festival
and ceremonial days.

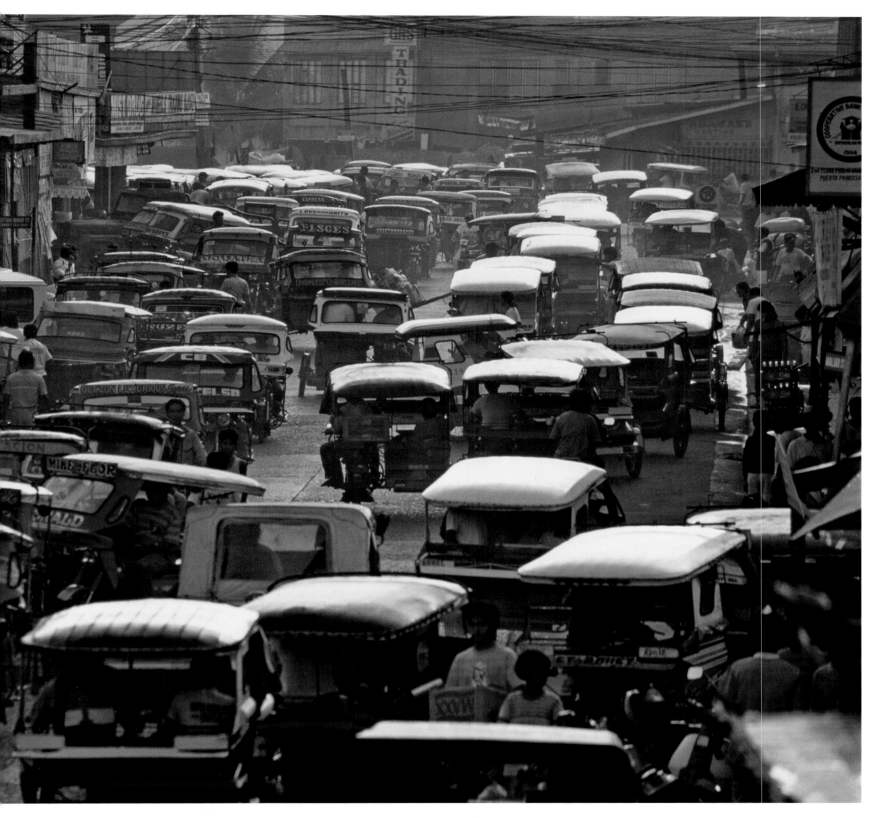

PUERTO PRINCESA, PALAWAN,
PHILIPPINES, 1989

Pollution and tricycle taxis choke the
streets of Palawan's provincial capital.

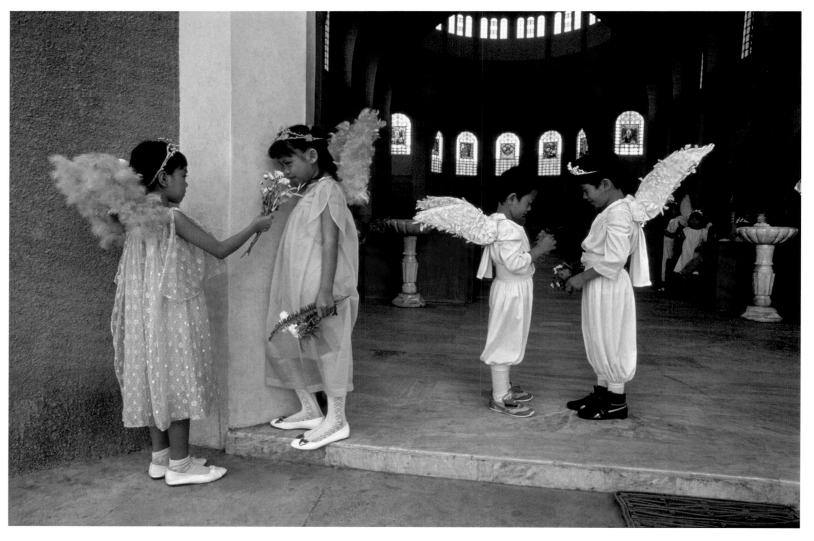

CEBU, PHILIPPINES, 1987

Due to the influence of Spanish colonizers, the Philippines has been predominantly Roman Catholic for the past 350 years. The country is famous for its colorful saints-day celebrations, which include rich music, elaborate cultural displays, and banquets of aromatic foods.

MANILA, PHILIPPINES, 1986

Everybody loves a beauty contest in the Philippines—and many a country girl has soared to brief stardom from village obscurity. The most famous was Imelda Romuáldez, who won a few crowns before catching the eye of the future Philippine president Ferdinand Marcos.

BOHOL, PHILIPPINES, 1989

The Chocolate Hills are named for the rich cocoa color that their lush carpeting of grass takes on each summer. The more than 1,200 hills were formed by erosion and the uplift of coral deposits.

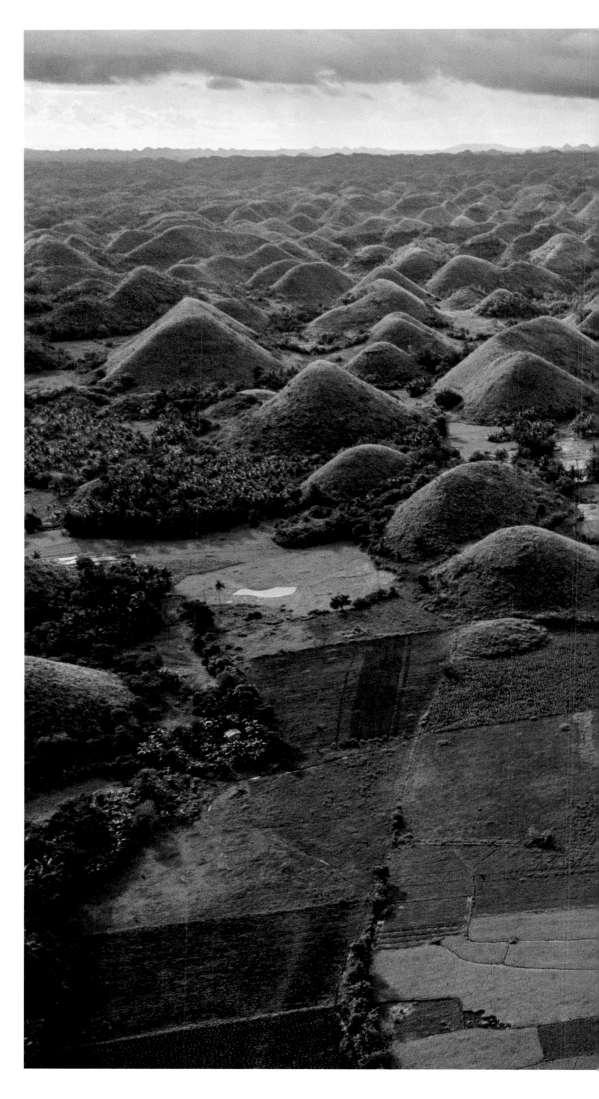

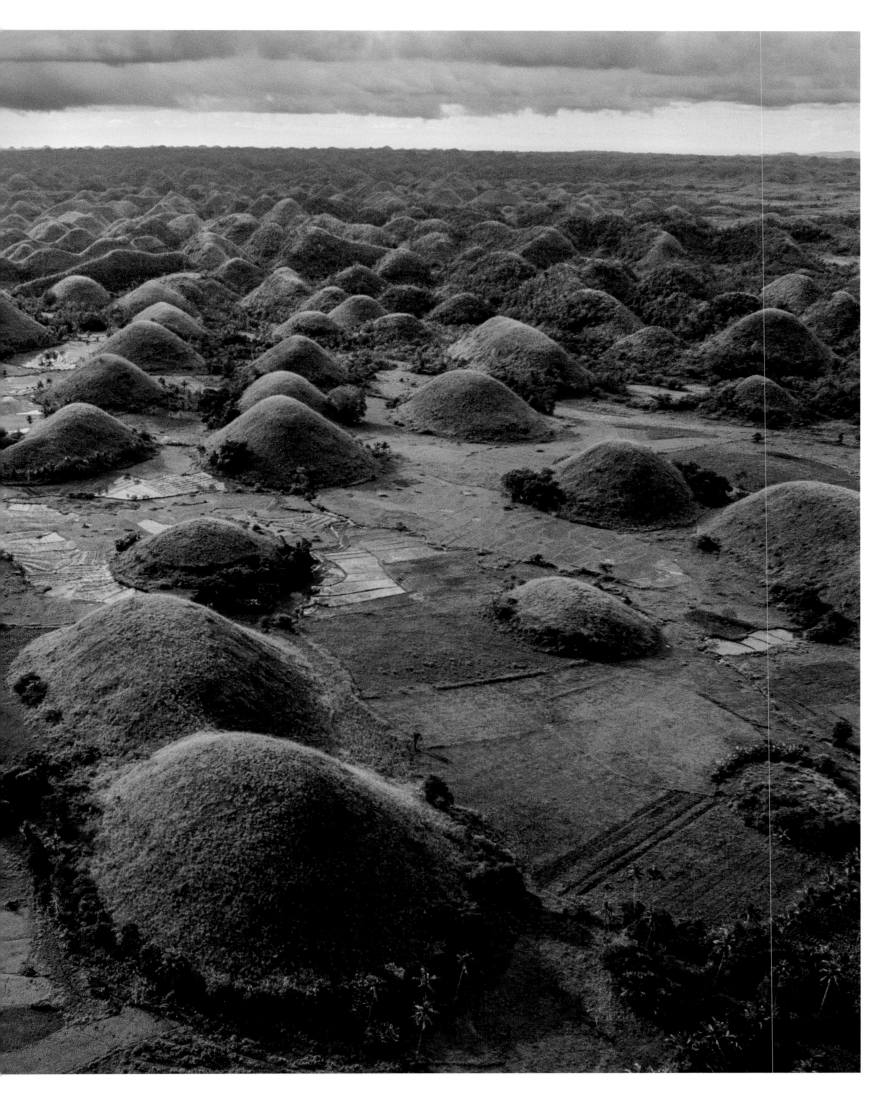

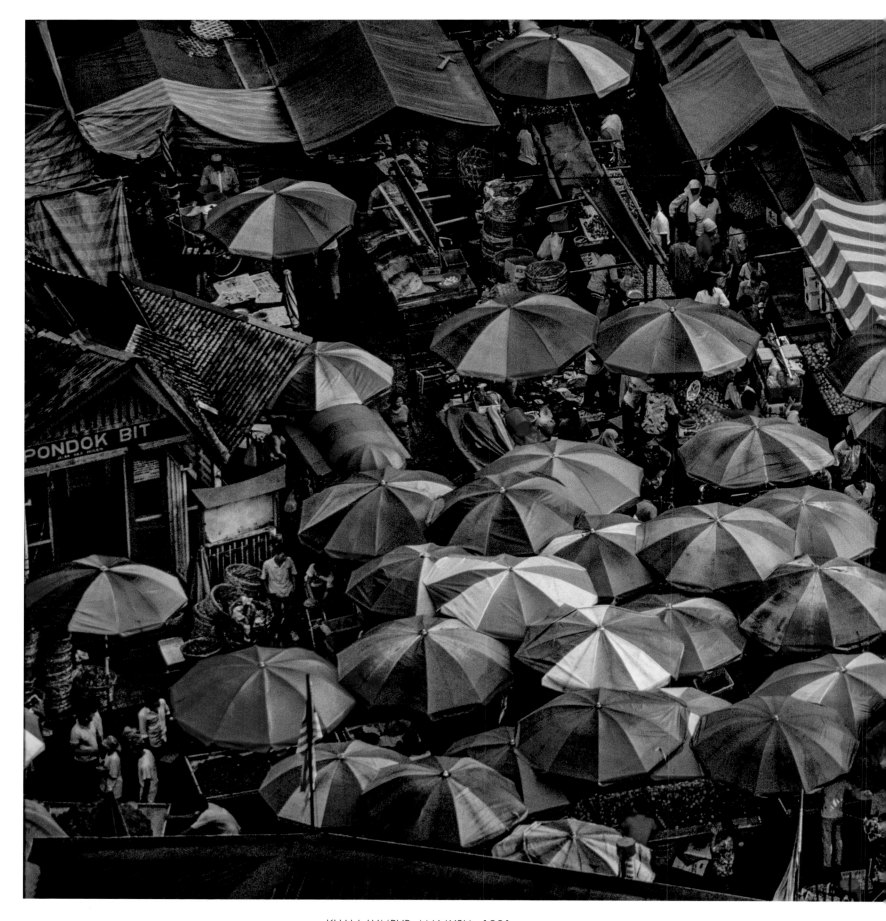

KUALA LUMPUR, MALAYSIA, 1991

Merchants and shoppers in Malaysia's
crowded capital are shielded by umbrellas
from the rain and the hot tropical sun.

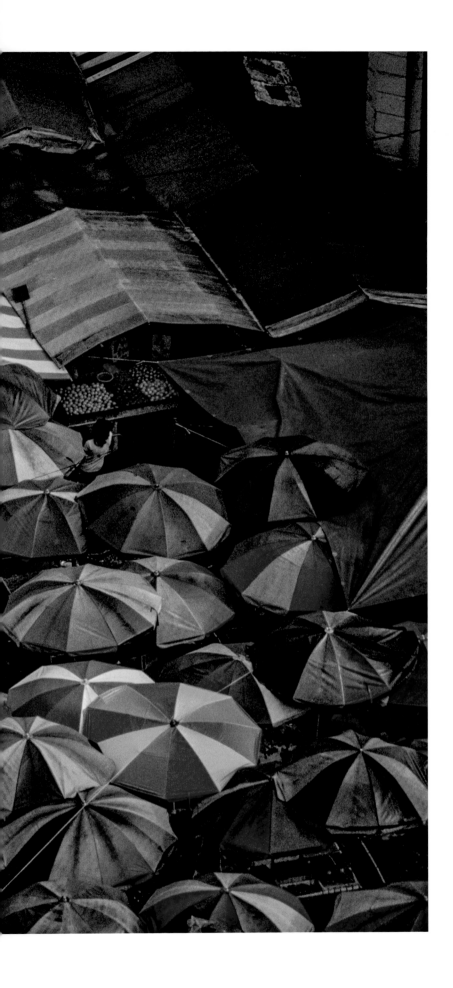

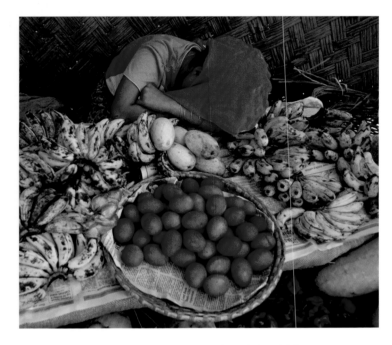

DENPASAR, BALI, INDONESIA, 1989

At one of many street markets in Bali's largest
city, produce vendors begin the day early.

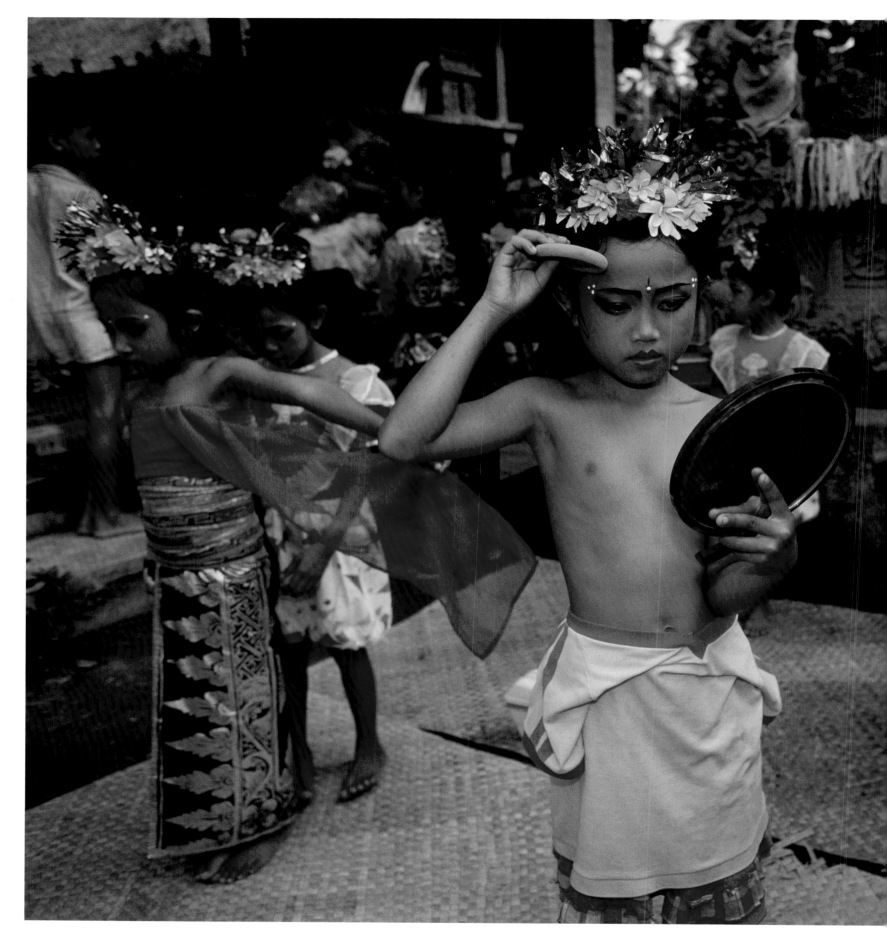

UBUD, BALI, INDONESIA, 1989

According to legend, the prestigious *legong* dance
originated from the dream of a nineteenth-century
Balinese prince. Girls chosen for the honor of
performing begin rigorous training at the age of
five, and are replaced when they reach puberty.

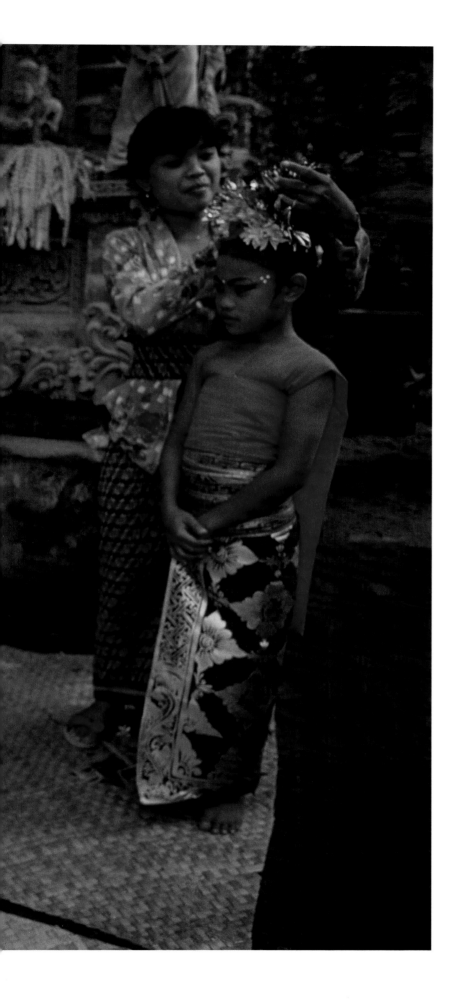

Bali Reverie

Sweet sounds of the gamelan tinkled in the darkness near Ibo's Yasa Samudra bungalows where I was staying in Kuta Beach. At dusk, a graceful girl came by to light candles. It was 1969 and there was not yet electricity. A baby cried, a rooster crowed, a dog barked—such were the only sounds of the night. The next morning, the sun rose over an endless deserted beach, surf rolled in tranquilly, brilliant pink flowers shone in the dune grass. In the afternoon, a purification ceremony made its way to the shoreline, women carrying flower and fruit offerings on their heads, banners fluttering, gongs and cymbals breaking the silence…the Gods were happy.

One day I chatted with the aging Tjokorde Agung, the king of central Bali, in his wooden palace in Ubud. We sat cross-legged in a pavilion and he showed me his faded guest book with signatures of Charlie Chaplin, Ho Chi Minh, and Robert Kennedy. He frowned when asked to predict the future of the island. "When there are too many tourists, and the hotels dot the landscape, and the villagers have neglected their rituals, then the Gods will become angry. Mount Agung will erupt, and the Gods will return Bali to Bali."

He explained to me that art and dance in Bali are religious acts performed in a constant cycle in order to entertain and propitiate the invisible forces controlling man's destiny.

When I visited Bali over the years, I always dropped in to see the lovely Ni Pollok at Sanur Beach—from there you could view the dominating volcano. In 1933, at age fifteen, this exquisite *legong* dancer met the Belgian artist Jean Le Mayeur, who was fifty-two. They married two years later. The Belgian had been inspired by Gauguin's life in Tahiti. His paintings of his dancer wife—bare breasted— sold well in staid British colonial Singapore in the 1930s. After her husband's death in 1958, Ni lived in their home in Sanur for another thirty years.

Back in the 1940s, when Le Mayeur was questioned by a visiting reporter about why he lived on the island, he replied: "Bali has the three things in life that I love: beauty, sunlight, and silence." —KL

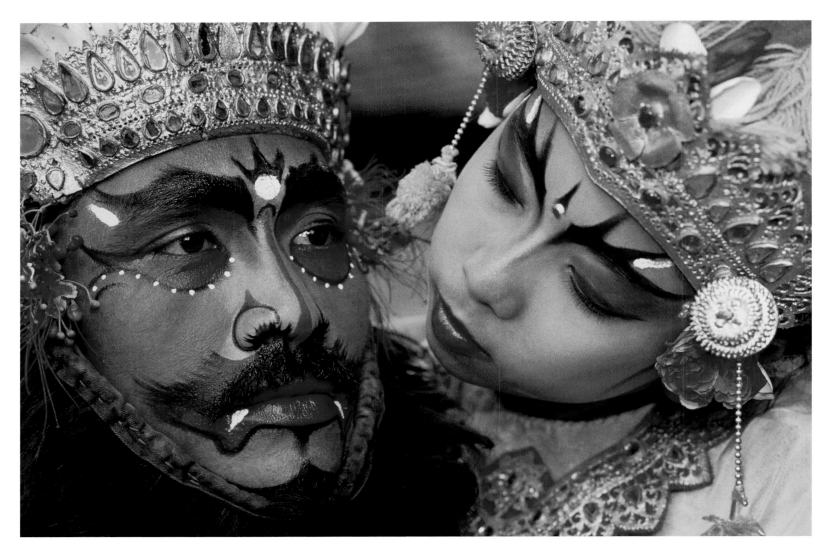

BATUBULAN, BALI, INDONESIA, 1989

Exquisitely costumed dancers represent
mythical characters in performances based on
Hindu classics such as the *Mahabharata* and
the *Ramayana*.

BATUBULAN, BALI, INDONESIA, 1989

The famous *kecak* dance, in which a band of men
chatter like a horde of monkeys, is a relatively new
creation, based on a traditional Balinese trance
ritual and adapted in the 1930s.

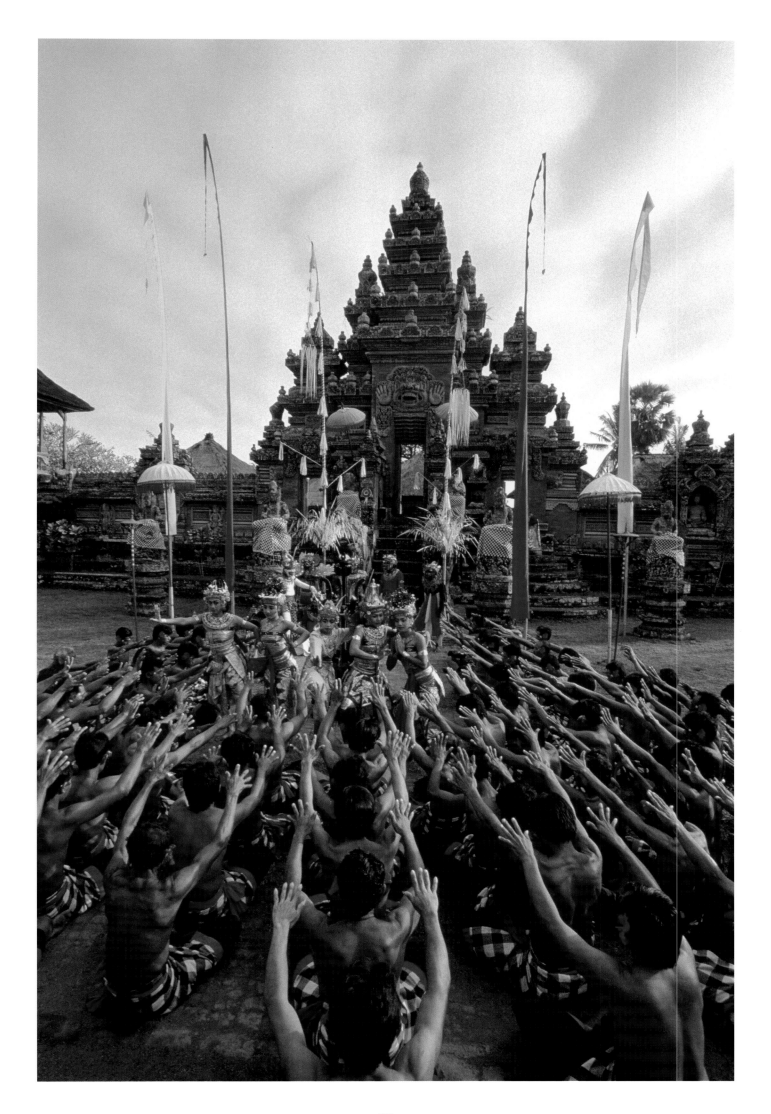

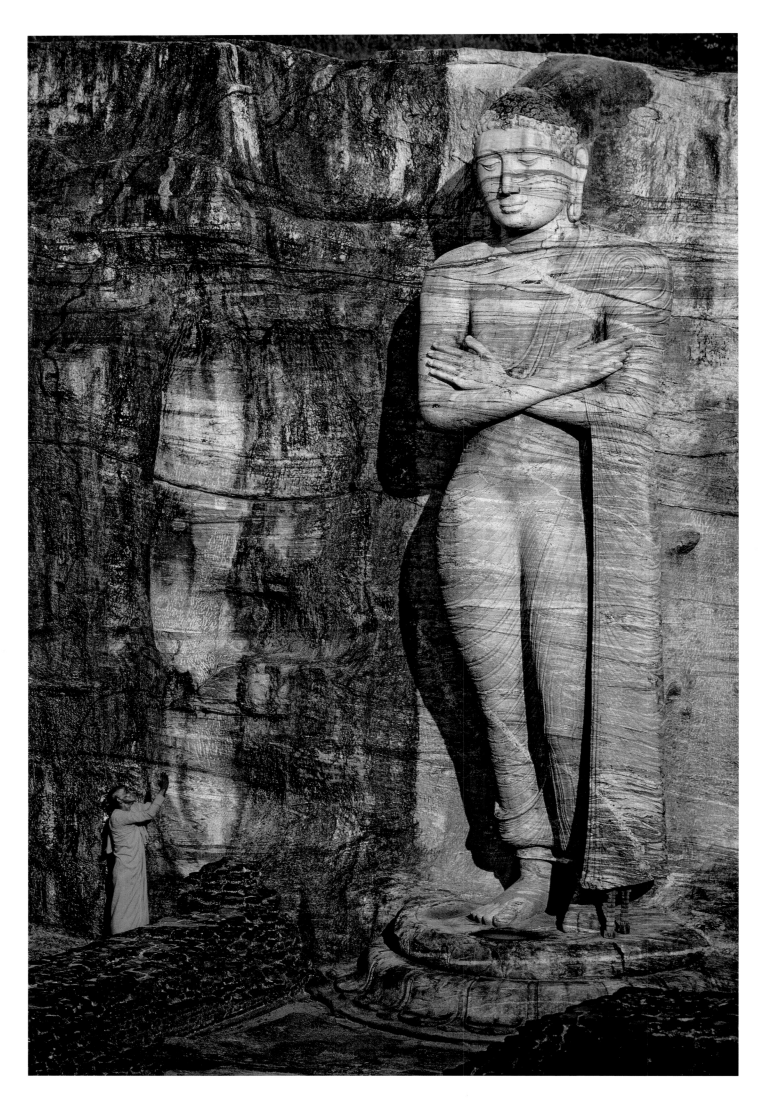

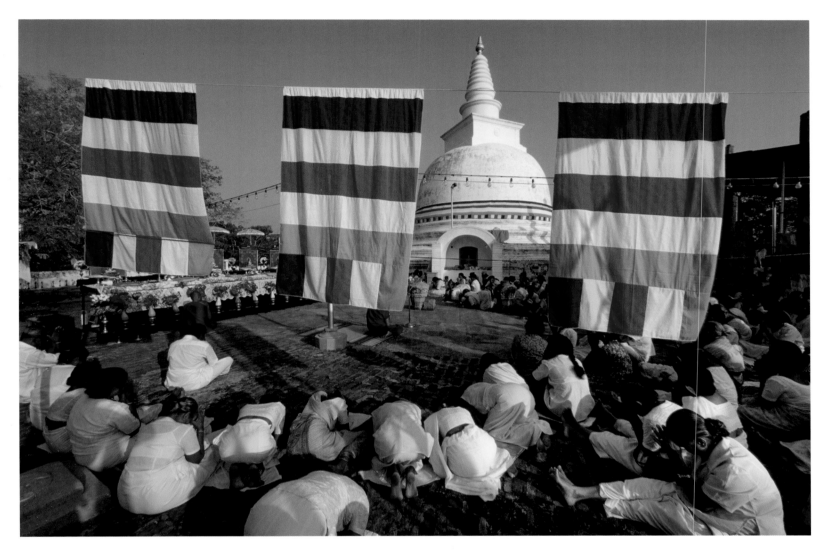

ANURADHAPURA, SRI LANKA, 1994

Worshippers pray during the annual Vesak Festival, commemorating the Buddha's birth. Celebrated for centuries, the official date for the holy day was agreed upon in Sri Lanka in 1950, at the first conference of the World Fellowship of Buddhists.

POLONNARUWA, SRI LANKA, 1994

A UNESCO World Heritage Site, the city of Polonnaruwa dates back a thousand years and contains many of Sri Lanka's most inspiring temples and Buddhist statuaries.

COLUMBO, SRI LANKA, 1994
The Galle Face promenade, with its old
fortifications and cannons, reflects centuries
of European occupation.

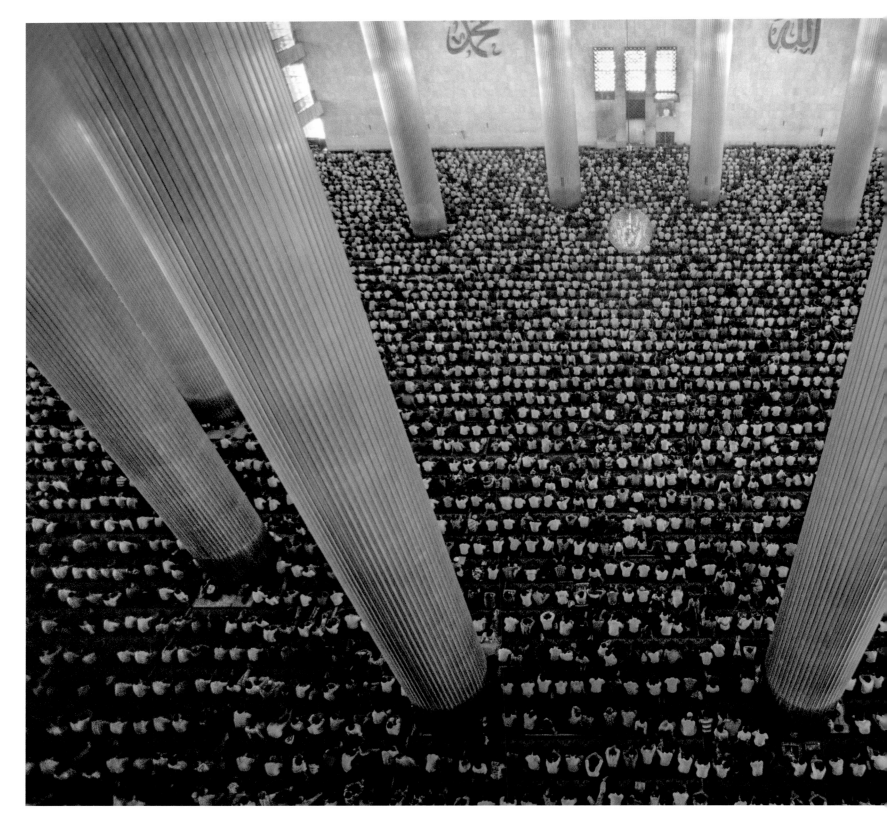

JAKARTA, INDONESIA, 1990

The main hall of the Istiqlal Mosque, the largest
in Southeast Asia, can accommodate 16,000
worshippers. Indonesia has more Muslim adherents
than any other country.

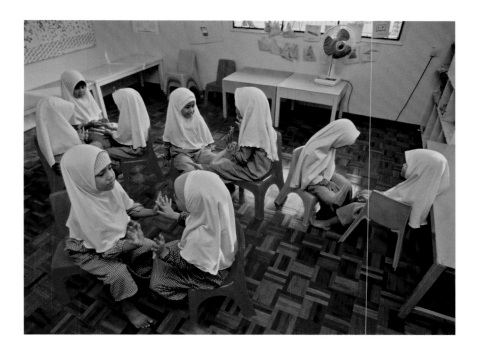

KUALA LUMPUR, MALAYSIA, 1991

Kindergarten girls engage in morning games
at their school.

SHAH ALAM, MALAYSIA, 1991
The distinctive blue-and-white Sultan Abdul
Aziz Mosque, built in the 1980s, is the world's
largest religious dome.

KUTA, BALI, INDONESIA, 1989

Kuta is renowned for its spectacular sunsets—
as well as its wide pristine beaches.

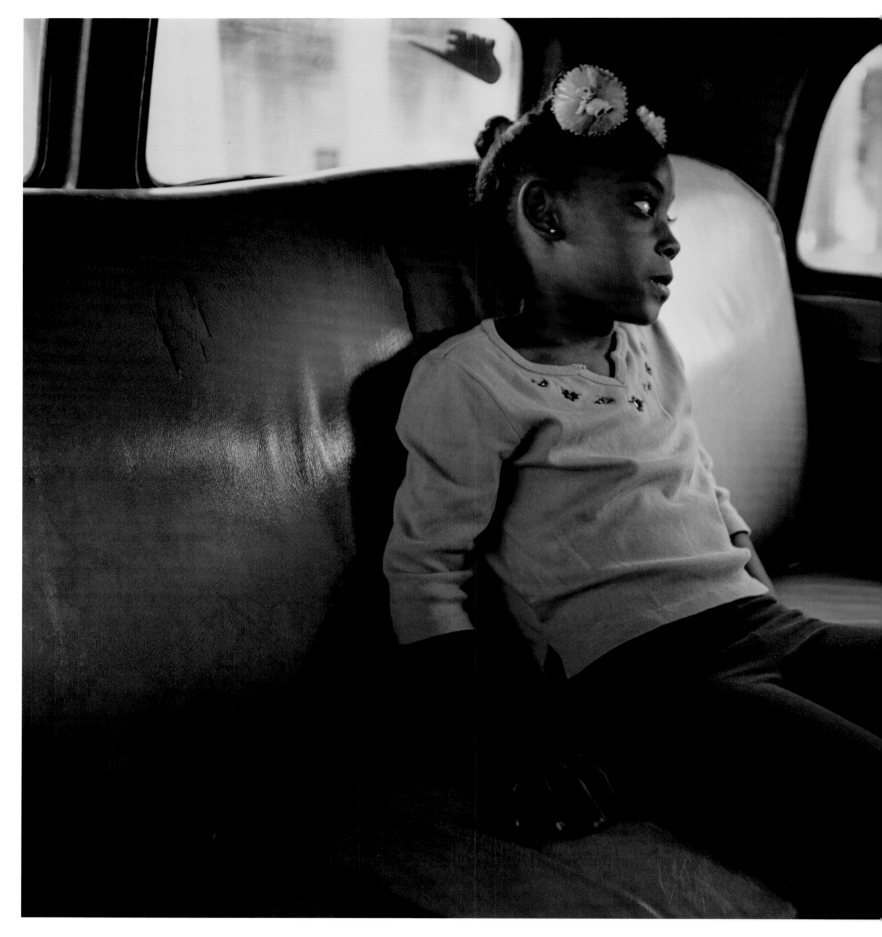

HAVANA, CUBA, 2002

The first on board, a young girl waits for the
taxi to fill with additional passengers and
head to their homes in the countryside.

REVOLUTIONARY DREAMS

Cuba

In the early 2000s, Paul had a longing to go Cuba. After shooting many stories in Russia and Southeast Asia, photographing peoples who had survived highly regimented societies or the devastation of war, he wanted to see how the Cubans were living after forty years under "El Jefe's" rule. After an assignment for *Fortune* magazine on the North Korean border, Paul decided to make his own way to Cuba, which was still off-limits to Americans.

I had been captivated by Cuba since I was teenager in New England. The café creme flavor of the culture, the guitars, the warm salty breezes, and the decaying Spanish architecture were all seductive. I resolved to get down there one day.

In October 1957, I had the opportunity. I had heard that a certain Fidel Castro was fighting up in the Sierra Maestra, about 500 miles east of Havana. Should I go AWOL and join him? I took a ten-day Army leave and hitchhiked from my base at Fort Gordon, Georgia, where I was ticking off the days of my two-year military tour. In Key West, I bought a round-trip ticket to Havana for twenty dollars on a Q Airways DC-3. Only five passengers were on the flight—including Ernest Hemingway and his wife. I recognized him by his beard. His novels *The Sun Also Rises* and *The Old Man and the Sea* had been assigned to us in prep school.

Now I had to think of something to say to him. As the plane descended toward Havana I eased myself into a seat across from him. He looked pretty grizzled. He was tippling from a silver flask. I decided to ask what he thought about Castro's guerrilla war against the sleazy President Batista. I had read the Herbert Matthews articles in the *New York Times*.

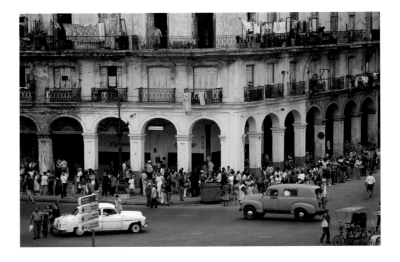

HAVANA, CUBA, 2002
The warm climate and small living
spaces of Havana have contributed
to a lively public street culture.

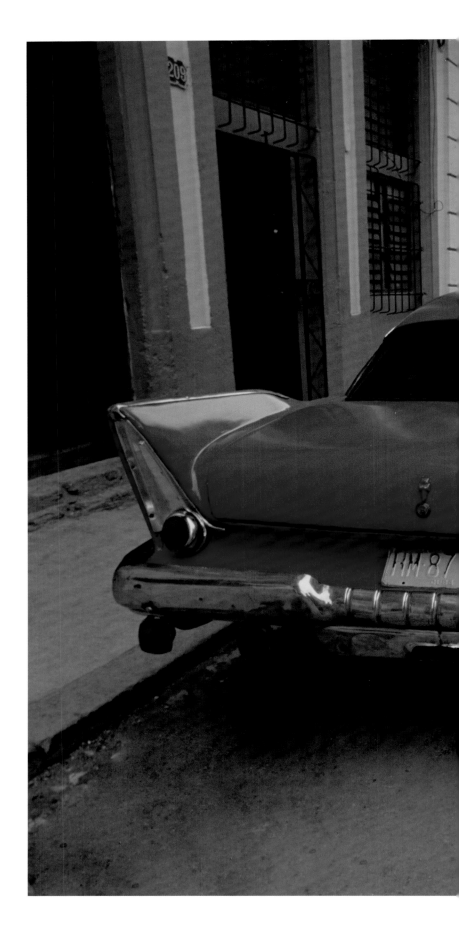

Hemingway looked annoyed. He mumbled, "Well, as long as it doesn't interrupt my fishing."

Encouraged, I thought of another question. "What about the American mafia in Havana?" I asked. "Do they get away with murder over there?"

Hemingway winced, and said, "Depends where you're drinking."

I didn't quite get it. I had read that he drank at a bar called La Floridita. Would I dare to ask one more question? "Say, Mr. Hemingway. I'm on leave from the Army. Have you any advice for a young man going over to Havana for a week with limited funds?"

He winked. "Follow your nose, Old Sport. Just follow your nose."

I returned to my seat for the landing.

Years later, I was reminded of the date that I had arrived in Havana. It was October 6, 1957. The next morning, the Cuban newspaper that I was reading in a coffee stall had a front-page diagram of the Soviet Sputnik satellite just launched into space. More Cold War stuff. But I was thinking of other things. Cigars, sweet coffee, guitar sounds, rum, and vulgar perfume were enticing me into Old Havana. Who gave a damn about space?

Sputnik is long gone, and Russia had been reinvented by the time Paul arrived in Cuba in 2002, but the

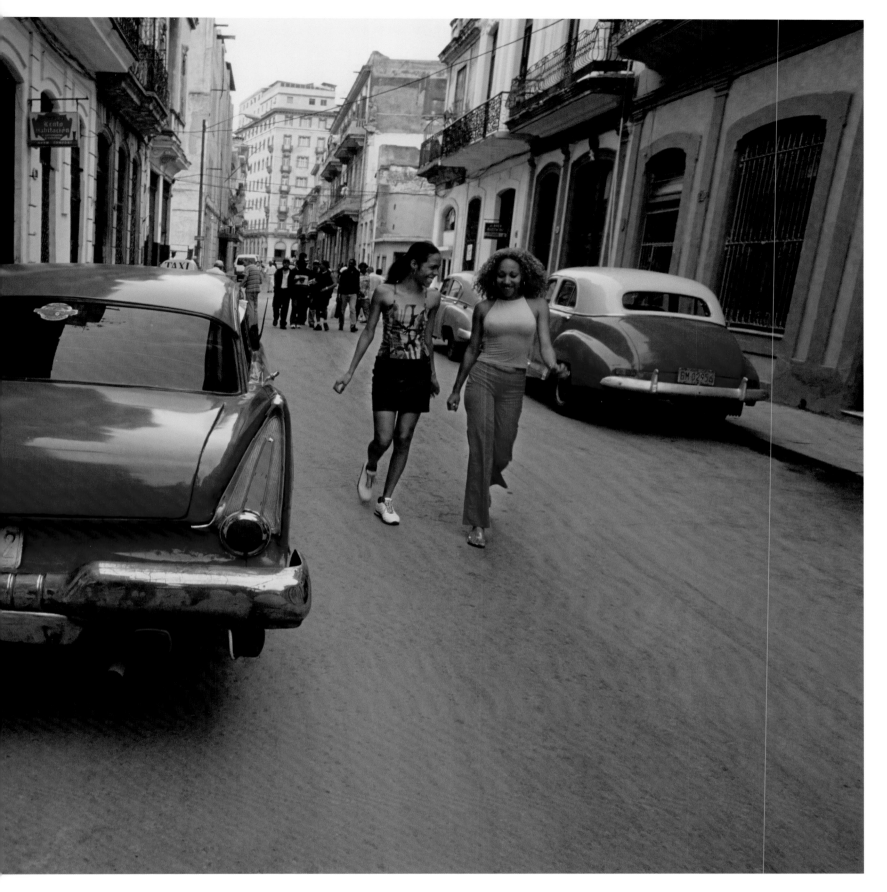

HAVANA, CUBA, 2003

Trade restrictions imposed for five decades left much of Cuba stuck in the 1950s. As a result of few automotive imports, vintage American cars have been carefully maintained, and are now considered national treasures.

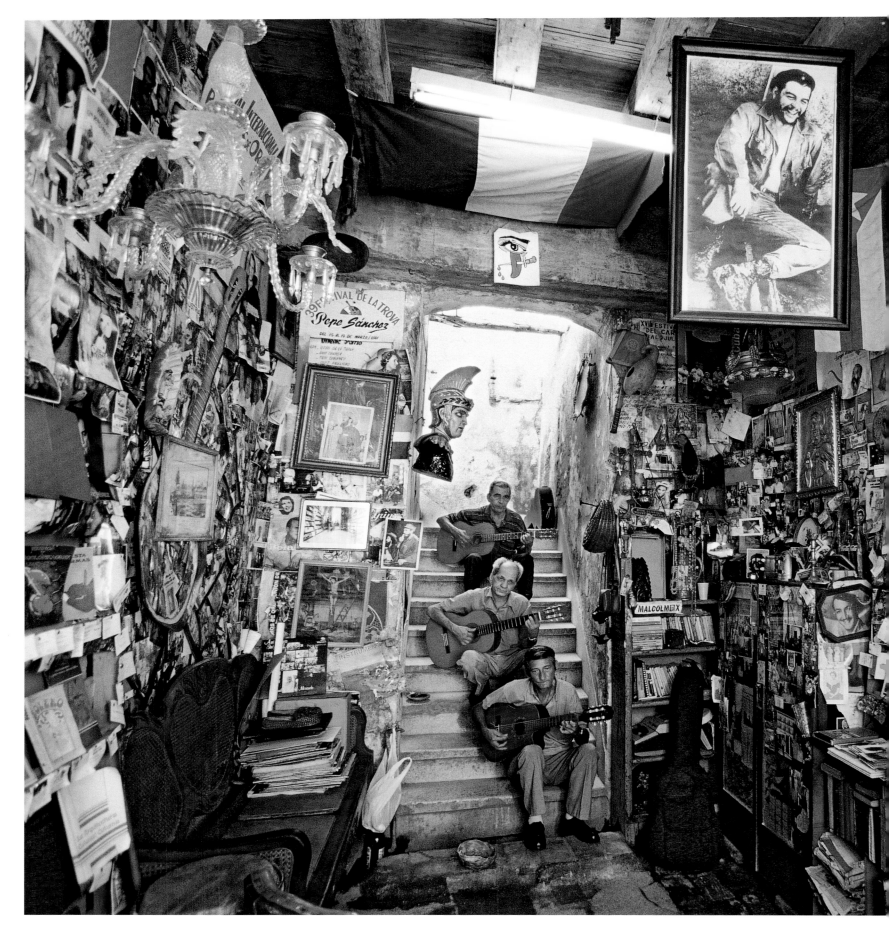

SANTIAGO, CUBA, 2003

Che Guevara, a major figure in the Cuban
Revolution, is still an omnipresent figure in
many local shops in Santiago.

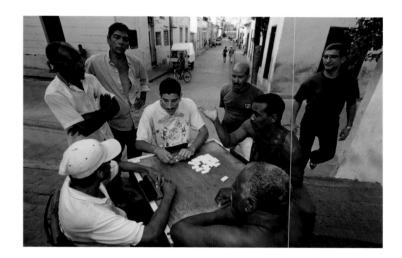

HAVANA, CUBA, 2003
Dominoes, as well as card games,
are popular pastimes in Cuba.

effects of the Cold War could still be felt in the streets of Havana. The embargo by the U.S. and Castro's austerity policies had halted the country in time. The fall of the Soviet Union had ended Moscow's generous subsidies. Still, Cuba held some of its old enchantment for the discerning traveler not merely in search of the decadence of the old Batista regime.

Inspired by the music of the Buena Vista Social Club and visions of old Havana from the movies, Paul explored the city streets, day and night. Then he hopped on an old Russian Tupolev and flew to Santiago, on the eastern end of the island, where Castro had launched his revolution back in the 1950s. Paul has been back twice since then, and hopes to return, even as the country slips rapidly into the future.

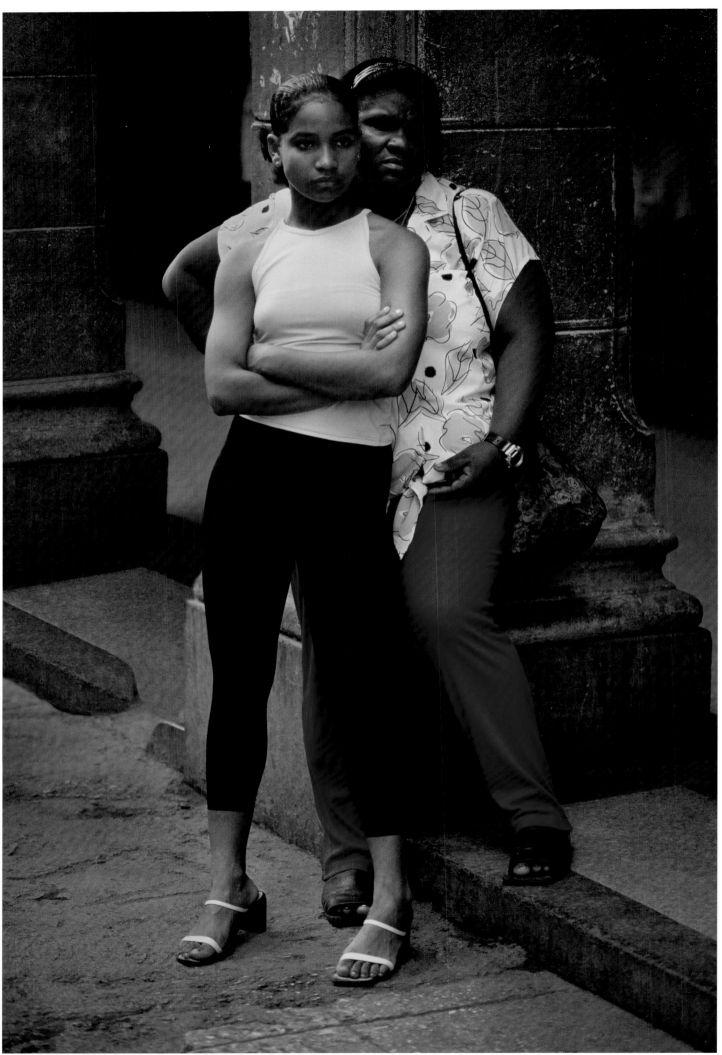

HAVANA, CUBA, 2002

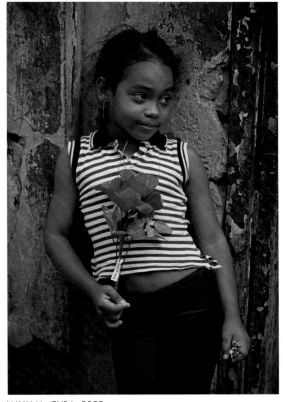

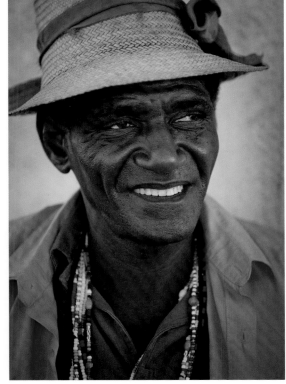

HAVANA, CUBA, 2003

HAVANA, CUBA, 2002

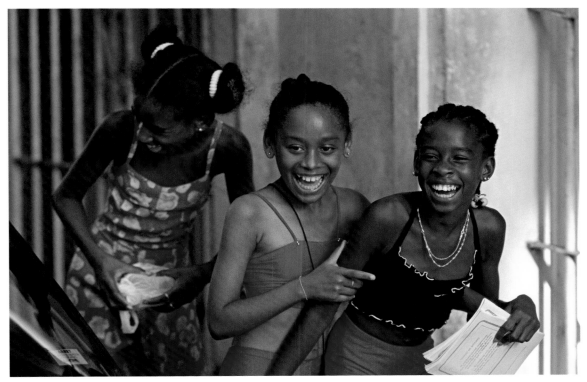

HAVANA, CUBA, 2003

CIENFUEGOS, CUBA, 2002

A resident rides through the historic port
town, established in 1819 and known as
the "Pearl of the South."

CIENFUEGOS, CUBA, 2002

Harkening back to another era, a man
on a horse-cart delivers milk in the early
morning hours.

HAVANA, CUBA, 2002

Twilight descends over a colonial-era cathedral in central Havana.

"Now is no time to think of what you do not have. Think of what you can do with what there is."
—Ernest Hemingway,
from *The Old Man and the Sea*

VATICAN CITY, 2002

The "double staircase" leading into the
Vatican Museum was designed by Giuseppe
Momo in 1932; the Vatican's unparalleled
collection of European and worldwide art
was founded in the early 1500s.

THE GRAND TOUR

Europe

Paul was thrilled to hear the news when the Berlin Wall came down in 1989. Europe had been cast in a murky shadow-and-light play since World War II. Time for a change. The Iron Curtain had for too long determined the price of everything from ski vacations, perfume, caviar, and spying equipment. Had not Winston Churchill predicted this in his famous 1946 speech that launched the Cold War? "From Stettin in the Baltic to Trieste in the Adriatic, an iron curtain has descended across the Continent."

Paul was eager to head for the new Berlin, to Checkpoint Charlie at the Brandenburg Gate, to photograph the graffitied Wall before it got chopped to pieces and sold to collectors. But fate—in this case, an assignment—intervened. Paul was diverted to the holy city of Lourdes in France, where the Catholic faithful have made pilgrimages in hope of healing for hundreds of years. When he arrived, he found the revered site nearly empty—it seemed everyone in Europe had other priorities that week.

Over the next decade, Paul documented the aftereffects of the Wall's demise, along with several other European assignments for National Geographic. After a shoot in Chamonix, France, and before heading out for a month in Iceland, he had time to enjoy a ski vacation in the Alps. Nothing like an après-ski hot cocoa, trading stories with the international set. For Paul, comparing the Alps to his home territory of the Rockies was an inevitable topic of conversation.

Paul had a strong nostalgia for Europe. He recalled his visit to the prehistoric caves of southern France in 1965 with his parents and their close friend Jean Vertut. A gifted engineer, Vertut was equally known for exploring and photographing the cave art in places such as

Lescaux, Arcy-sur-Cure, Montespan, Cougnac, and Niaux. These engravings, paintings, and reliefs of ancient animals and people "reflected how the first art of the world was born and developed," noted Vertut's close collaborator, André Leroi-Gourham, director of the Musée de l'Homme in Paris.

This experience as a teenager made Paul vividly aware of the frail passage of human evolution on our planet—a concept further reinforced on a trip to the Galápagos Islands early in his career.

As the 1990s progressed, Paul became increasingly focused on Russia. The baton had been passed from the Soviet Union to...who knew what, exactly? Where was Russia going? Political risk analysts in the West earned huge consultancy fees trying to figure it out.

The Old World, east of the Danube, was becoming chic. Russian millionaires using U.S. dollars vacationed on the Red Sea and constructed villas on Cyprus. Paul began tracking the faces of new Mother Russia: wealthy oligarchs, faithful worshipers, fashion models, and rock bands....

It wasn't all roses. The Balkans exploded. Bosnian Muslims were massacred by Christian Serbs and vice versa. The UN was unable to prevent ethnic cleansing. Time was galloping toward the century's end. Was anybody still alive who could remember the assassination of the Hapsburg Archduke in Sarajevo that launched World War I? Would the millennium go out with a bang or with a whimper?

Meanwhile, the European Union struggled to create one unified entity in Europe. A World Government must find a solution to chronic poverty! The World Trade Organization was crowned in Genoa amid street riots.

One by one, countries were falling into bankruptcy. The heavy debt burden was killing them. The euro was not going to boost millions up into the middle class. Ireland, Greece, Spain—the dominoes were falling. Whatever happened to Voltaire's "best of all possible worlds?"

Perhaps it is found on the banks of the Seine—at a little brasserie on the Île St. Louis, where Paul fondly remembers sharing wine and stories with fellow photojournalists David and Peter Turnley.

"We must cultivate our own gardens," Candide declared. For Paul, that modest pursuit is the irresistible lure of the next assignment. —KL

CHAMONIX, FRANCE, 1994

Climbers descend from the Aiguille du Midi
on the start of their two-day assent of Mont
Blanc, Europe's highest peak.

MILAN, ITALY, 1982

Visitors and locals gather in Milan's central
piazza, seen here from atop the Duomo,
the fourth largest cathedral in the world.

CHAMONIX, FRANCE, 1994

From the gondola station above Chamonix,
passengers can view of the grandeur of
Mont Blanc and the French Alps.

ROME, ITALY, 1990

The Pantheon and its famous *oculus*—
an opening to the sky representing the all-
seeing eye of heaven—was originally built
in AD 126 as a temple to the Roman gods,
and converted to a Christian church in the
seventh century AD.

MOSCOW, RUSSIA, 1987

Members of the Young Pioneers, a communist youth group, gather in front of the Kremlin in Red Square, in what was at that time the Soviet Union.

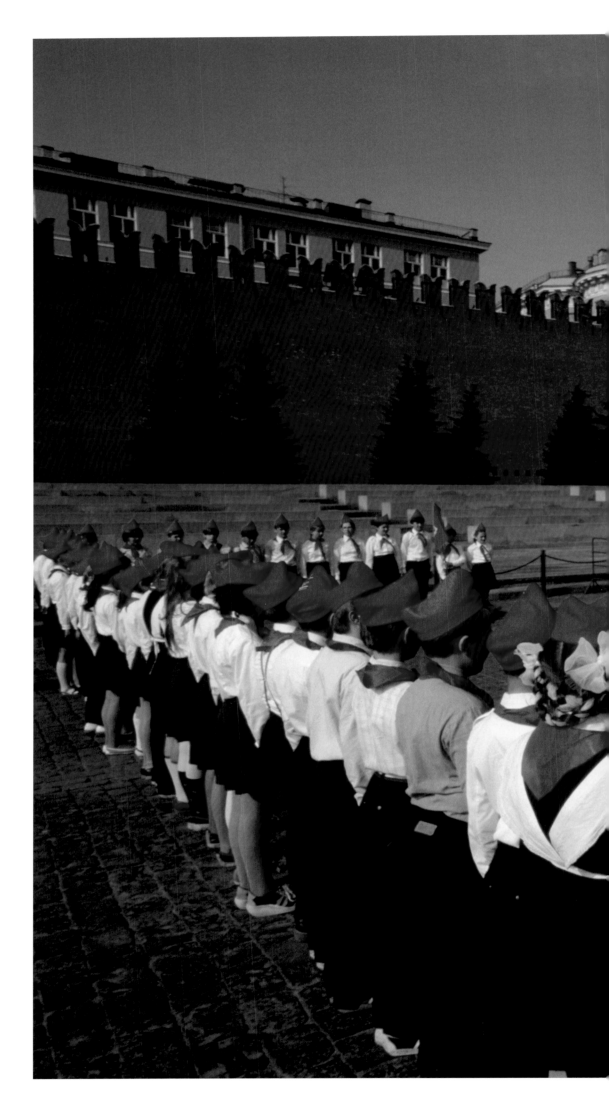

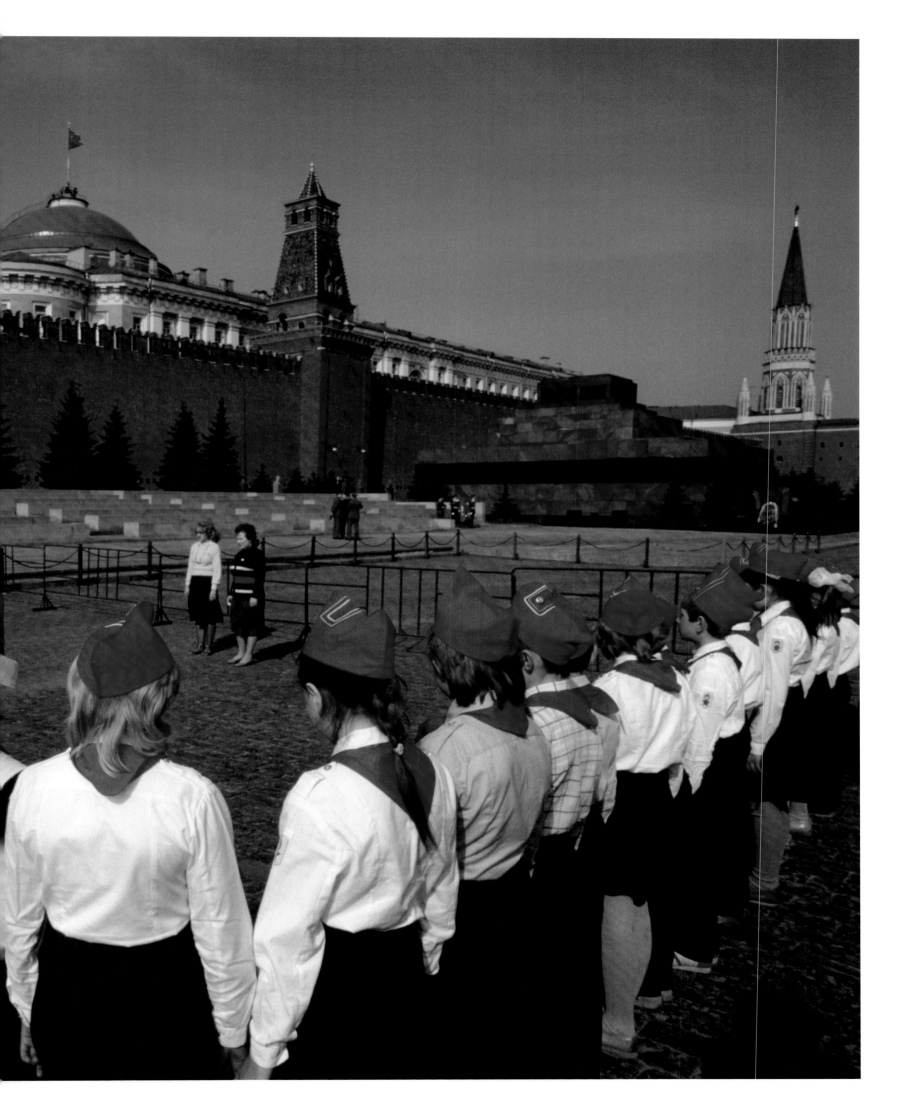

PARIS, FRANCE, 2002

Late-night vendors cater to tourists outside the Palais de Chaillot, built in 1937 for the World's Fair to take advantage of the views of the Eiffel Tower.

Behind the Camera

A street artist's sketch of Paul Chesley and Carole Lee Vowell, Hanoi, Vietnam, 1994.

A PHOTOGRAPHER'S LIFE

I was born in 1946 in Red Wing, Minnesota, a small town on the Mississippi River, and grew up nearby on my grandfather's farm. My earliest childhood memories are of that farm, the now-antiquated machinery, and the animals so beloved by us all. We lived in a rural corner of the world, yet in a family filled with explorers, inventors, travelers, and artists.

My mother's father, Alexander P. Anderson—known as AP—was born in 1862 of Swedish immigrant parents. He worked hard on their pioneer farm and later taught in a one-room school-house. In his late twenties, he studied botany and plant physiology at the University of Minnesota, where he received a scholarship, and later received his doctorate in plant pathology at the University of Munich in 1896.

While at his first academic position in Clemson, South Carolina, he met my grandmother, Lydia McDougall, an immigrant from Scotland. He went on to become a researcher at the New York Botanical Garden. There he conducted experiments with starches that resulted in the inventions of puffed rice and puffed wheat cereals, later acquired by the Quaker Oats Company. In 1916, at the age of 54, he established a laboratory and home on farmland not far from his parents' homestead—the same farm where I grew up. My mother, Jean, the youngest of AP and Lydia's four children, was born in the same year.

My grandparents began to make yearly trips to Hawaii in the late 1920s, in part to visit with Harold Lyon, a former student of AP's who had become a professor at the University of Hawaii. The Lyon Arboretum in Honolulu is named after him. Thus began our family's long association with and love for the islands of Hawaii. In 1941, AP published a collection of stories and poems he had written over the years, entitled *The Seventh Reader,* about his life and the natural world, including his precious times in Hawaii.

At the age of fourteen, my mother became a boarding

Clockwise from top left: the Anderson family (Paul's maternal grandparents)— Louise, John, AP, Jean, Elizabeth, and Lydia, 1917; Paul's grandmother, Lydia McDougall Anderson, 1899; Paul's grandfather AP Anderson, 1933; Quaker Oats ad for Puffed Rice, 1924; Tower View Farm in Red Wing, Minnesota, circa 1917.

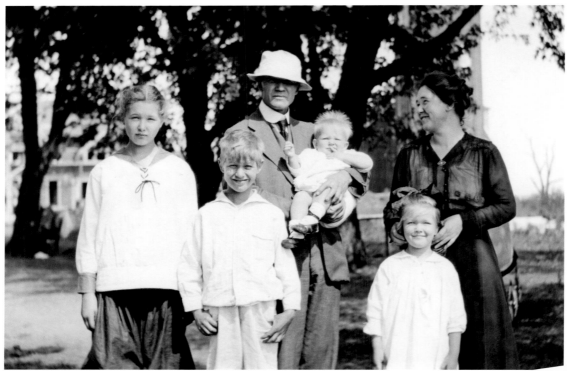

student at Punahou School, graduating in 1933. Decades later, after my father passed away in 1997, my mother and I would visit Hawaii together every year. She spent winters at my home on the ocean after I moved to Honolulu in 2004, and became reacquainted with some of the remarkable women who had been her classmates more than 75 years earlier.

My father, Frank Gunsaulus Chesley, was born in 1914 in Chicago, the third of four children in a family that was more cos-

mopolitan than my mother's in many ways. His childhood was marked by hardships due to the Great Depression. He told us that, when he finished grade school, he chose to go to Tilden Technical High School, in order to learn pragmatic skills to help support his family, if it should prove necessary.

He received a scholarship to attend Carleton College in Northfield, Minnesota, where he majored in chemistry and physics. There he met my mother. She was majoring in zoology and

loved her courses in geology from Laurence Gould, who had accompanied Admiral Byrd on his first expedition to Antarctica.

My parents always had an interest in travel and photography. They were married in Hawaii in 1938. On their honeymoon, traveling in the West, my mother had her Zeiss Ikon Nettar in the glove compartment of their old Plymouth Coupe. From a scenic overlook in Washington State, she carefully composed a photograph of Mt. Shuksan, covered in snow. Back in Boston, where the film was developed, the Kodak Company took notice, and displayed it as a framed print in Kodak shops all across the country.

My parents lived in Boston while my father pursued a graduate degree in chemistry at MIT. My mother also took graduate courses, in microbiology (she told me she received straight "A's"). During this time, my sisters Gretchen and Margaret were born. My father completed his PhD in chemistry in 1945, just at the end of World War II, and they moved back to my mother's home near Red Wing. I was born shortly thereafter.

My father, together with two of his graduate school colleagues, Demetrius Jelatis and Gordon Lee, soon established a small company, Central Research Laboratories, in my grandfather's by-then-vacant lab buildings on the family farm. They designed equipment for handling radioactive material for government labs and the growing nuclear industry.

Gretchen, Margaret, and I all have wonderful memories of growing up in Red Wing in the 1950s. We went to the same rural four-room school that my mother had attended. As children, we used to run through the long, scary, underground tunnels that connected the house, the water tower, and the research buildings. Our mission was to find Dad, who would still be working on scientific experiments into the evening, and bring him back for dinner. When we were older, Mom would let us have slumber parties with our friends in the top round room of the water tower. Every winter, we would bundle up for horse-and-sleigh rides in the often sub-zero weather, and sometimes Dad would pull us around the snow-covered fields on our toboggan with his Cadillac.

We always looked forward to the summers, when we would spend pretty much every waking moment outdoors. Collecting insects was a favorite with my mother, the trained zoologist, who taught us so much about natural history. We would also collect water samples from the swamp below the Indian mound, and look at them through my grandfather's old microscope. Our parents both loved the stars, so we spent many evenings gazing up at the skies through our telescope.

Our favorite memories were of loading up the station wagon and heading out for vacations, either exploring the West or visiting family in the East. We often traveled to Cape Cod in those years, to see our grandmother, Great-aunt Helen, and the many cousins on the Chesley side, whom we didn't see as frequently as our Anderson relatives. Our cousins played important roles in our early lives, and continued to be cherished connections as we became adults.

I have fond recollections of those visits to my grandmother, Mary Chesley—known to us as "Mimi." My grandfather, Harry Chesley, Sr., had passed away in 1946, shortly after he and Mimi retired to Cape Cod. Mimi was one of five children of Frank

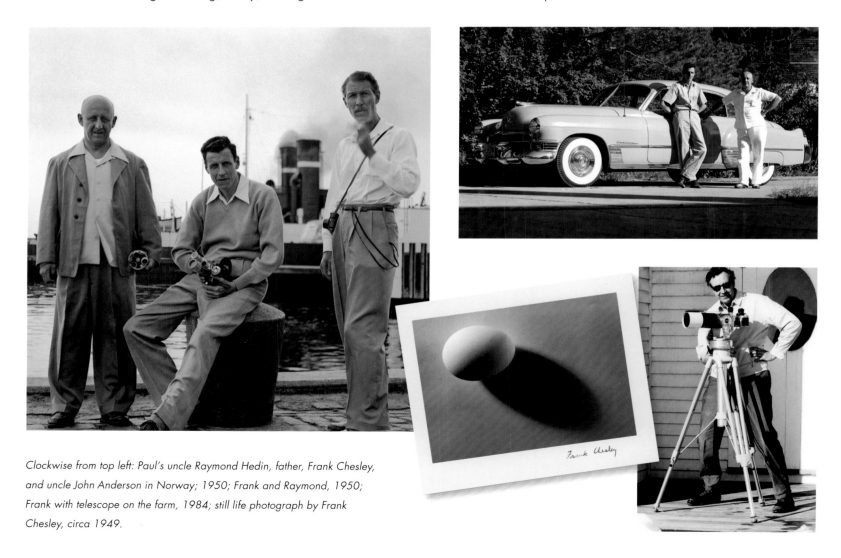

Clockwise from top left: Paul's uncle Raymond Hedin, father, Frank Chesley, and uncle John Anderson in Norway; 1950; Frank and Raymond, 1950; Frank with telescope on the farm, 1984; still life photograph by Frank Chesley, circa 1949.

Clockwise from top left: Paul's mother Jean and her sister Elizabeth with their father, AP Anderson, in Honolulu, 1932; Jean on a European summer trip, 1936 (by German photographer and filmmaker Ernest Kleinberg); physicist Niels Bohr and Paul's father, Frank, in Red Wing, Minnesota, 1958; Paul's aunt Eugenie Anderson and President John F. Kennedy, at the White House, 1962; Paul's parents at their wedding in Honolulu, 1938; Jean's Kodak Award-winning photo of Mt. Shuksan, taken on their honeymoon in 1938.

Wakeley Gunsaulus, a well-known minister in Chicago. He is especially remembered for his "Million Dollar Sermon" at the Plymouth Congregational Church in 1890—when he proposed a new kind of trade school "for the industrial age," with practical training in engineering, architecture, and other applied sciences. He stated that a million-dollar investment could make this school a reality. As the story goes, the industrialist Philip Armour was in the audience and offered his support. Together, they founded The Armour Institute, with Rev. Gunsaulus as its first president. The school later became the Illinois Institute of Technology (IIT).

On those visits to the Cape, we enjoyed spending time with

our great-aunt, Helen Gunsaulus, who had retired there after a career as a curator of Japanese ethnology at Chicago's Field Museum of Natural History. She shared stories with us about her 1925 yearlong trip around the world for the museum, by steamship and rail, with stops in Europe and Egypt; a stay with a British family in Lucknow, India; a visit to China; and several months in Japan. Seeing her souvenirs and artwork and hearing the accounts of her travels inspired me to look further beyond the world I knew.

Another great storyteller was my mother, who shared stories about her parents' lives and the hardships each had endured in their early years. She relayed her stories about our grandfather

AP's compassion during the Great Depression in the 1930s for "hobos" who came past the farm—he made a mark on the mailbox indicating there was always a pot of hot stew waiting for them inside if they needed a meal. This was my mother's way of teaching us respect for those experiencing hard times or who were different from others.

She also collected many stories about the Chesley side of the family, from my father's mother Mimi and Great-aunt Helen. This personal history, which she passed down to me, was a way of understanding and appreciating people of different backgrounds. It has enriched my own life—and in faraway places, it has helped me to relate, as humbly as possible, to peoples of many cultures and circumstances.

These stories also hinted of an intriguing world beyond our daily life in rural Minnesota. This vision was further magnified by my aunt Eugenie Anderson's career in politics. Married to my mother's brother, Uncle John—an artist who collaborated in the 1940s with the artist Charles Biederman—Eugenie was extremely active in populist Democratic Farmer-Labor politics in Minnesota. She was a strong supporter of Hubert Humphrey. President Truman appointed her as the first American woman ambassador, to Denmark

in 1949. Later, she was appointed by President Kennedy to be the U.S. Minister to Bulgaria; and by President Johnson to represent the country on the UN Trusteeship Council in 1965. She also served on the UN Security Council during this period.

I so clearly remember Uncle John's slideshows of Eugenie's official visit to Micronesia in 1967 as U.S. Representative to the Trusteeship Council of the United Nations. On one of my first trips overseas in the 1970s, Aunt Eugenie wrote a "letter of introduction" on official UN stationery for me to carry in case of an emergency. Later, when I was on assignment in Micronesia, she wrote letters of introduction for me to people she had met there many years before.

I have early memories of Aunt Eugenie welcoming visitors to her home in Red Wing, and often to our house. These occasions provided an excuse for me and my sisters to stay up late and peek at the goings-on from the top of the stairs. I remember visits from guests including Niels Bohr, the Nobel-prize-winning physicist; Prime Minister Hans Hedtoft of Denmark, who enjoyed touring the farm; and concert pianist Eugene Istomin.

Our world expanded yet again when we became a host family for foreign exchange student Ayako Mizuno, from Nagoya,

Clockwise from top left: Paul's sister Gretchen, 1951; cousin Barbara Hedin and Paul, 1949; sister Margaret (with her 4-H prize-winning calf) and Paul, circa 1955; exchange student Ayako Mizuno, 1958; the Chesley children on their first day of school, 1953.

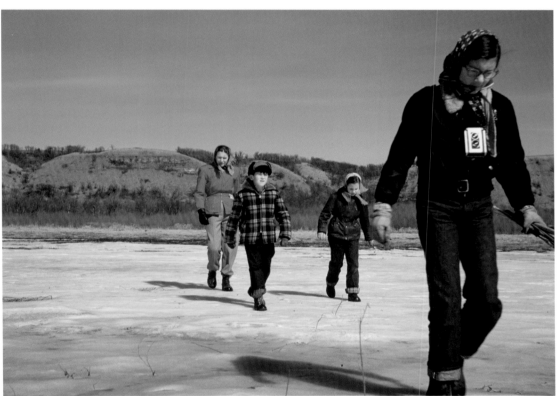
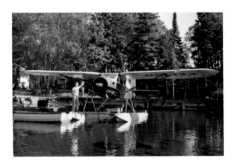

Japan. Attending Red Wing's Central High School with my sister Gretchen, Ayako was a wonderful cultural ambassador, providing me my first introduction to a country that would become one of my favorite places to photograph. When I was first working on picture stories on my own, in hopes of getting a foothold as a professional photographer, she graciously hosted me on my first trip to Japan, where she had become an expert translator and English teacher.

My mother lived to the age of ninety-three. A model for us all, she was loved by many. A strong advocate of local history, in mid-life she revitalized the Goodhue County Historical Society. She was instrumental in planning the Society's new museum. Serving on its board, and as its director, she planned exhibits; worked with her sister Elizabeth Hedin to preserve prehistoric village sites in the local area; and took on a myriad of other tasks making the Goodhue Country History Society one of state's finest museums. She also served on the boards of the Minnesota Historical Society and the Science Museum of Minnesota in St. Paul.

Gretchen, the elder of my two wonderful sisters, became

Clockwise from top left: Paul and his father, Frank, 1954; Paul's family on a trip to the Grand Canyon, 1954; Paul's mother, Jean, with her Zeiss Ikon camera, 1972; Jean, Paul, Margaret, and Gretchen on the frozen Cannon River, Minnesota, 1954; Paul next to a seaplane at Isle Royale National Park, Michigan, circa 1955; Margaret and Paul with their father at the United Nations building in New York, 1957.

a cultural anthropologist and married Jeff Lang, a well-known biologist specializing in crocodilians. Margaret, who studied design at the University of Minnesota, has long worked with her own designs and custom work using Marimekko fabric from Finland. Years ago, Margaret accompanied me on assignment to Malaysia and other parts of Asia, and both of my sisters have always been great supporters of my far-flung endeavors in photography.

My nieces and nephews, and now their children, all had a chance to know our parents well throughout their childhoods. I feel so fortunate to have grown up in family that cares so much about community, and I am glad to see the tradition continue through the next generations.

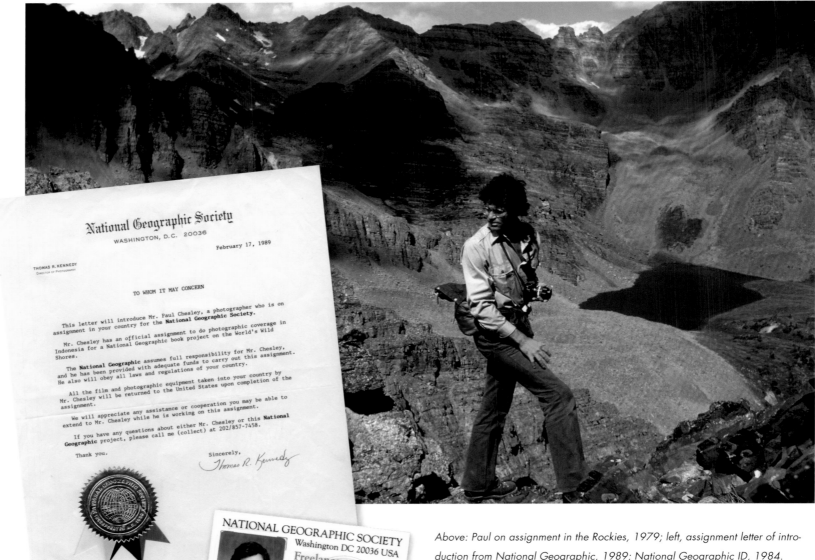

Above: Paul on assignment in the Rockies, 1979; left, assignment letter of introduction from National Geographic, 1989; National Geographic ID, 1984.

Many people ask me how I found my way into the world of professional photography. For me, a breakthrough was my discovery of Colorado Mountain College in Glenwood Springs, Colorado, where I took photography and color printing classes.

After completing my courses in 1970, I moved to Aspen, where I lived for more than thirty years. I began participating in workshops at the Center of the Eye, one of the earliest photography workshops in the U.S., founded by Cherie Hiser in 1969. Cherie brought in amazing photographers as guest teachers, including Minor White, Ernst Haas, and Jerry Uelsmann. These workshops were invaluable to my training in how to create a picture story.

Gaining confidence from these experiences, I made my first forays on my own to Japan, Ecuador, and the Galápagos. I began to develop a portfolio and started to get some assignments, including a cover story for German *GEO* in 1977. It caught the attention of the legendary director of photography at the National Geographic Society, Robert E. Gilka. He gave me my first assignment at the magazine, and soon I was doing a string of projects for the Society that went on for more than twenty-five years.

On a sad note, as we were preparing this book for publication, I heard the news that Bob Gilka had passed away, on June 25, 2013, at the age of 96. An icon in the photojournalism world, he had a seminal influence on my career. I am so thankful for his early confidence in my work. His legacy lives on in the vision he passed forward to generations of photojournalists and editors.

In 1977, photographers Nicholas de Vore III, David Hiser, Jonathan Wright, and I established our own agency, Photographers Aspen. Between my National Geographic assignments, which often went on for months, I did shoots for magazines including *Time, Newsweek, Fortune,* German *GEO, Stern,* and *Paris Match.* Janie Joseland Bennett was the director of our agency for more than fifteen years. Between our major shoots, Janie would get us interesting assignments at local events. At the Aspen Music Festival, I photographed Dorothy Delay of New York's Julliard School, and ten-year-old violin prodigy Sarah Chang. In 1988, at the Aspen Food and Wine Festival, I met Julia Child, and for several years thereafter, I would sit and talk with her for hours as she sat in her booth autographing books. I also fondly recall a trip to California with Cherie Hiser, when we visited Ansel Adams at his studio, and she introduced me to Imogene Cunningham, Judy Dater, Brett Weston, and Ruth Bernhard—photographers I had long admired.

In 1984 I received my first invitation to work on a "Day in the Life" project, from the co-creators of this famous book

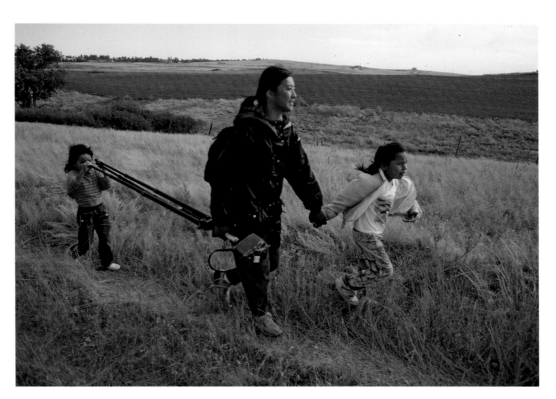

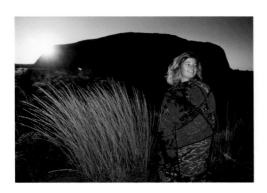

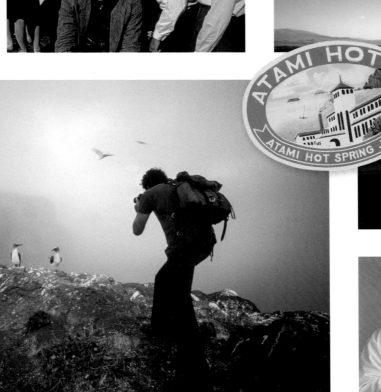

Clockwise from top left: Paul, David Hiser, Janie Joseland Bennett, and Nicholas deVore III, all of Photographers Aspen, 1990; Carole Lee Vowell on assignment with Paul in Minnesota, 1997; Paul working from a helicopter in Hawaii, 1987; Paul in the famous "solid gold bath" in Shujenzi, Japan, 1976; Paul and Carole on assignment at University Hospital in Denver, 1995; Paul in the Galápagos Islands, 1973; Paul's photo assistant Jyoti Mau in Honolulu, Hawaii, 2006; Paul in Red Square, Moscow, 1987; Janie Joseland Bennett, Director of Photographers Aspen, near Ayers Rock in Australia, 1987.

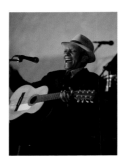

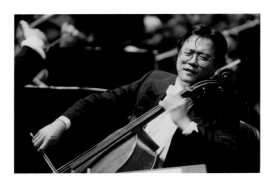

Clockwise from top left: Bill Gates at Microsoft, 1984; Compay Segundo of the Buena Vista Social Club in Havana, Cuba, 2003; artist Charles Biederman,1979; Paul with Maya Soetoro-Ng (sister of President Obama), 2011; Paul with President Ramos of the Philippines, his wife, and Marina Mahathir, 1995; Paul with Prime Minister Mahathir of Malaysia, 1991; Yo-Yo Ma, 1996.

series, Rick Smolan and David Cohen. These assignments were a dream come true: flying to exotic places, shooting for one day, and going to great parties before and afterwards, together with up to one hundred of the world's top photojournalists—many of whom remain my close friends to this day. At the end of these projects, I often took the opportunity to stay on in the countries—which included China, the U.S.S.R., and Japan—and not only shoot for myself, but also identify new story projects to propose to publishers.

I also enjoyed working on a series of "country books" produced by the French publisher Didier Millet. These projects were one-week shoots by thirty photographers, who fanned out across Thailand, Indonesia, the Philippines, Malaysia and Mauritius, as well as the ancient ruins of Borobudur in Java.

Our agency, Photographers Aspen, had by the late 1980s developed a reputation as a small but praised "boutique" agency. Our growing collection of photographs—stemming primarily from our projects for National Geographic—was sought after by European and American publications. We joined hands with Tony Stone Images in London, later to be affiliated with Getty Images.

In 1990, our agency director Janie, an Australian native, helped set up a trip for me to Australia's central desert—an unparalleled chance for me to photograph these indigenous peoples. On this trip, I reconnected with Dr. Grahame Webb, an old family friend and Australia's crocodilian expert, who provided valuable information for my next story in the Kimberleys in Western Australia.

Throughout the 1990s, I worked on a vast range of assignments in America, Europe, and Asia with my good friend and project manager, Carole Lee Vowell. She was amazing as a photographic assistant in the field, as well as planning the logistics, arranging permissions for our assignments, and organizing my photographic archives. I was honored when she was quoted in a *Sojourner* magazine article as saying, "Paul's sensitivity captures the gentle spirit in people." I appreciated her sentiment that it was a privilege when our subjects would allow us into their personal lives to photograph them.

Our first project together was photographing the Rocky Mountains for National Geographic—a memorable road trip, wending our way in a van and camping along the Rockies from Canada to New Mexico. We went on to shoot Navajo, Apache, and Pueblo peoples for the book *The Stories of Mothers & Daughters*; a book on Bangkok for Editions Didier Millet; an article on Miami's Art Deco District for *National Geographic Traveler*; the book *24 Hours in Cyberspace*; a *Newsweek* cover story on America's West; and a number of other special assignments. In our travels, we were often witnesses to historical moments, including the 1997 "changeover" in Hong Kong.

Over the years, I had many assignments relating to science and technology, allowing me access to the fascinating and hidden

realms of some of the world's most advanced research facilities. During these shoots, I often thought of my father, and my grandfather AP—they would have loved to see what I was documenting with my camera. These assignments included the Very Large Array (VLA) in Socorro, New Mexico (where astronomers scan the universe for any patterns that might signify intelligent life in other galaxies); aerodynamic research using dragonflies in wind tunnels at the University of Colorado; earthquake studies at the Scripps Institution of Oceanography, and tsunami research in Sendai, Japan. Assignments on emerging aerospace and defense technology included a trip into NORAD (the North American Aerospace Defense Command); "Star Wars" research at Lawrence Livermore National Laboratory; Titan (ICBM) missile production at Lockheed Martin Aircraft; and early drone aircraft and the F-22 fighter jet at Edwards Air Force Base. For me, all these projects were invaluable for learning about science and technology, as well as the world we live in and our fragile earth.

The process of working on this book has rekindled great memories of some of the well-known people I have photographed: Chuck Yeager, the first person to travel faster than sound; Apollo astronaut Buzz Aldrin; Microsoft founder Bill Gates, at age 27; President Bill Clinton; former Secretary of Defense Robert McNamara; and President Suharto of Indonesia. In the realm of culture and sports, the master cellist Yo-Yo Ma; Olympic ski racer Billy Kidd; singer and actress Olivia Newton-John; artist, writer, and photographer Peter Beard; and gonzo journalist Hunter Thompson, who became a very close friend over the years. One of my favorite experiences was photographing and spending time with Compay Segundo, of the Buena Vista Social Club, on his ninetieth birthday at the old Hotel Nacional de Cuba in Havana.

Despite my love for the Colorado mountains and my friends in Aspen, I made a decision to move to Honolulu in 2004. I have strong family roots in Hawaii, and am happy to be part of such a vibrant and strong arts community here, with many old and new friends. Hawaii is also a mite closer to the Asia that I love so much.

I am continuing to document peoples and places of this earth. My nieces and nephews—and my six great-nieces and great-nephews—are talented and energetic individuals. As I assemble this book, I am thinking of these next generations, now in full force, heading into the twenty-first century on pathways yet to be determined. I hope that in future years these children, and their children, will have a chance to look through my camera lens at the world as it was when I took these photos. It is my hope that these new generations might be inspired—as I was by these books and family stories that I read and heard as a child—to want to experience the greater world as it unfolds in their future.

Clockwise from top left: Paul's nieces Cornelia and Ursula Lang with friend Julie Weiss (center) in Red Wing, Minnesota, 1979; Paul's nephew Paul Cloak in Yellowstone National Park, 1980; Paul's sister Margaret and mother, Jean, 1988; Paul on assignment in Hawaii, 1985; Jean working on a museum project, 2008; Paul and Jean traveling to Asia, 1986.

AFTERWORD

Although I didn't get to know Paul until 2005 in Honolulu, we had many shared acquaintances across the years and the miles.

One of the more surprising longtime friendships I discovered in Paul's background was with Hunter S. Thompson. I had once met Hunter myself—in Vientiane, Laos, in April 1975, just as Saigon was falling. I was up there from Bangkok. Hunter was holding forth to an opium warlord at the bar of the Lang Xane Hotel. I recognized him by his signature aviator dark glasses and tattered safari hat. I elbowed in and asked, "Hey, Hunter, why aren't you following the end of this bloody war in Saigon?"

He looked right through me. Then he picked up his drink and started mumbling: "The embassy had a plan to get rid of us... gonna put Chivas in our helicopter gas tank...we'd crash and get stuck there...I got out of there with President Thieu, first-class, on Air France. He was carrying all the gold from the National Treasury... they put me off in Hong Kong and took off for Taiwan...I got a ten-ounce bar for a souvenir...so in Hongers I thought, well, I better write a story. So I flew to Laos for the real story...."

What could I say? That was the extent of our acquaintance. Later, I read some of Hunter's stuff and wished I'd gotten to know him better.

Paul, on the other hand, had been Hunter's neighbor in Colorado for many years, and had often visited his Owl Farm in Woody Creek. Hunter loved driving around on his bright red Ducati and firing off his Freedom Arms pistol—said to be the largest-caliber handgun in existence. He was fond of shooting up his own books in the snow and giving them to his friends (a very personal "autograph"). Hunter could never meet his article deadlines for *Rolling Stone* unless he was handcuffed to his table—a job that sometimes fell to Paul's lovely project manager, Carole Lee Vowell.

Hunter often entertained at the farm, tormenting his guests with a stuffed wolverine and mean peacocks. Paul said you could always count on a memorable evening in Hunter's kitchen. Another regular was Hunter's buddy Bob Braudis, the larger-than-life sheriff of Pitkin County, who would quote Latin and Greek. On several occasions, Paul met Peter Beard there. A well-known artist, wildlife photographer, conservationist, writer, and bon vivant, Peter became most famous for his artwork, which incorporated his photographs, writings, and artifacts, and focused on the wildlife of East Africa—

Clockwise from top: Paul with Hunter Thompson, 1989; Hunter and Peter Beard at Owl Farm, 1990; Covers of two of Hunter's books with photographs by Paul; Hunter with his prized Ducati, 1994.

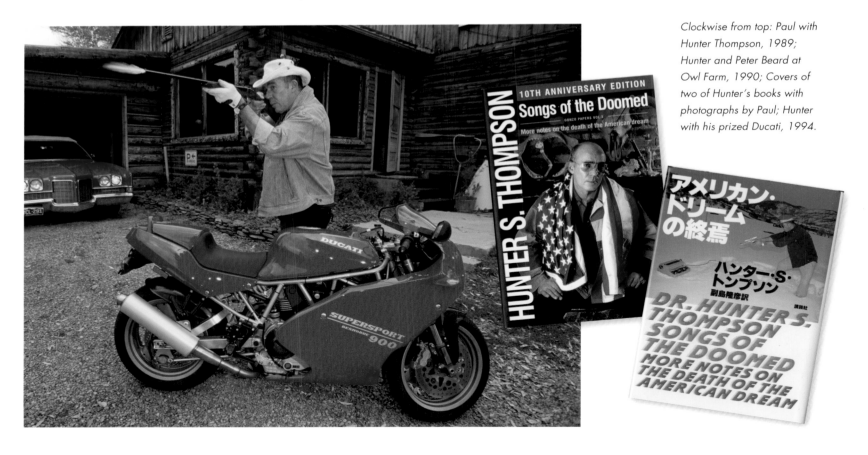

where he had made a second home. His book *The End of the Game* is a fabulous account of the history of that region and the whole ecological crisis.

Many years before, I had also known Peter—when we were ten years old at The Buckley School in New York. I visited the family in Tuxedo Park, where Peter's father took us skeet shooting. Another coincidence.

But everything comes to an end. Paul went to Hunter's funeral in 2005. After a lifetime living on the edge, Hunter had ultimately shot himself in his kitchen. The memorial was paid for by actor Johnny Depp, and attended by luminaries including John Kerry, actor Bill Murray, news anchor Ed Bradley, and Hunter's illustrator, Ralph Steadman.

Hunter's ashes were exploded upwards by multiple charges at the base of a stanchion almost as high as the Statue of Liberty, topped by his Gonzo-fist-and-peyote symbol. Shades of Timothy Leary! Hunter's last words were, "I guess you can't have it all. But I've given it my best shot!"

I was of the same generation as Hunter. We shared many of the same experiences. He reminded me of my wilder side—which, unlike him, I sometimes tried to keep in check. Seeking adventure, I had drifted around Central America after leaving Harvard. An attempt to join Castro in Cuba failed. I spent two years in the Army in Germany, then a year on the left bank in Paris in the so-called Beat Hotel on rue Git-le-Coeur. Then back to New York where I had been born, in a townhouse on the Upper East Side. But life had changed. Now I was on my own. I flew west.

I was passing the time in San Francisco's old North Beach neighborhood when a friend from my prep school, St. Paul's, sent me a one-way ticket to Thailand, where he had a job with Pan Am. I stayed in Southeast Asia on and off for twenty-five years, making my way as a stringer for various news organizations—including

Keith Lorenz photographed at his home in Hawaii by Paul Chesley, 2013.

the *San Francisco Chronicle*, Voice of America, and NBC News. Finally I came to live in Honolulu.

Maybe the whole thing is just one big fever dream from the malaria that I frequently caught staying with the Karen National Liberation Army in eastern Burma. Sometimes, when the fever returns, I remember a story my mother used to tell me. She said, "Keith, your own grandfather met President Lincoln. That's how short life is. It was 1864. My father—your grandfather—was four years old. He was with his mother on Fifth Avenue when Lincoln's carriage came by.

"The President was campaigning. Lincoln got out and went over to my father and shook his four-year-old hand as he cowered under his mother's skirts. And so young man, life goes by all too quickly. You better enjoy it!"

Many years later, I learned the Thai word for enjoyment. It is *sanuk*. Like Hunter—I've given it my best shot! —*Keith Lorenz*

Above: Keith's press ID and sport club membership card from his time in Asia; right, the Hotel Continental, a gathering place for many of the expats in Saigon, Vietnam, in the early 1960s.

SELECTED PUBLICATIONS

MAGAZINE ARTICLES

"A Day in the Life of China." *TIME International* (2 Oct., 1989)

"A Day in the Life of Ireland." *Newsweek* (27 Oct., 1986)

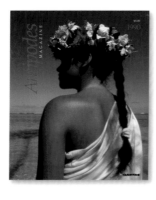

"A Day in the Life of Ireland." *TIME International* (9 Dec., 1991)

"A Day in the Life of the Soviet Union." *TIME* (26 Oct., 1987)

"A Day in the Life of the USSR." *The Sunday Times Magazine,* London (8 Nov., 1987)

"A Palauan Primer." Continental Airlines' *Pacifica* (1992)

"Academies Out of Line." *TIME* (18 April, 1994)

"Across Canada by Train." *National Geographic Traveler* (Winter, 1987-88)

"Bangkok." International *GEO* (Nov., 1994)

"Beyond Traps and Poison." *Audubon* (March/April, 1994)

"Blowing Hot and Cold." *The New York Times Magazine* (2 Oct., 1988)

"But It's Always Hot-spring Time in the Rockies." *Smithsonian* (Nov., 1977)

"Camping in the Snow." *National Wildlife* (Dec./Jan., 1979)

"Cleanroom Environments." *Microcontamination* (March, 1994)

"Clouds over Cheyenne Mountain." *TIME* (13 March, 2000)

"Contemplating Bali." *East West* (Winter, 1989)

"Continental Divide - La Barriera Selvaggia Che Divide In Due Gli Stati Uniti." *Airone* (May, 1987)

"Cows or Condos?" *TIME* (7 July, 1997)

Cover photos, *Aspen, the Magazine* (Dec./Jan., 1974-1975 and Dec./Jan., 1993-94)

"Cracks in the Japanese Work Ethic" and "Japan Takes a Swing at Leisure." *Fortune* (14 May, 1984)

"Dans le Grant Chaudron de Yellowstone." *GEO* (Oct., 1993)

"Das Geschob." *GEO* (Sept., 1980)

"Day in the Life of a Winner." *Mutual Funds* (Nov., 1998)

"Die Bizeps-Bande." *Stern* (5 Nov., 1987)

"Down and Out in Telluride." *TIME* (5 Sept., 1994)

"Along the Great Divide." *National Geographic* (Oct., 1979)

"America's Crown Jewels." *LIFE* (Summer Special) (1991)

"An Aspenite's Worldly Gaze." *Sojourner* (Winter-Spring, 1999-2000)

"ASIA Long March to Greatness." *TIME* Golden Anniversary Issue Asia (Oct.-Dec., 1996)

"...A Whale of a Whale's Tail." *Minneapolis Tribune* (17 Feb., 1980)

"Bangkok." *National Geographic Traveler* (March/April, 1989)

"Ein Vok Unter Dampf." *GEO* (1 Jan., 1980)

"Faster than a Speeding Bullet." *GEO* (Sept., 1980)

"Flash in Japan." *Scope* (31 July, 1981)

"Four Photographers: Four Color Viewpoints." *Modern Photography* (July, 1977)

"From Aspen to Faraway Places." *Empire Magazine of The Denver Post* (6 Aug., 1978)

"Galapagos: The Enchanted Isles." *Oceans* (1978)

"Gatesvision: The Macro Strategy at Microsoft." *Electronic Business* (1 May, 1984)

"Glacial Perspectives: Visions of Mont Blanc." *The New York Times Magazine* (4 March, 1990)

"Going Gonzo." *Cycle World* (March, 1995)

"Guam, Through the Looking Glass." *East West* (Fall/Winter, 1987)

"Hawai, un Ouraganau Paradis." *Terre Sauvage* (29 Nov., 1992)

"Hawaii." *GEO* special (15 Aug., 1984)

"Hawaii." *Travel & Leisure* supplement (Sept., 1993)

"Hawaii." *Amepnka* (1985)

"Here I Was Sitting at the Edge of Eternity." *LIFE* (Sept., 1989)

"Honolulu." *National Geographic Traveler* (Nov./Dec., 1990)

"Hot Springs of Yellowstone." *GEO* (Nov./Dec., 1992)

"How High Can They Fly." *TIME* (22 April, 1996)

"How to Afford Japan." *Travel & Leisure* (Aug., 1990)

"How to Photograph in Exotic Places." *National Geographic Traveler* (March/April, 1989)

"Hunting Hunter." *Signature* (March/April, 1992)

"In Colorado Country." *Travel & Leisure* (Aug., 1979)

"In His Own Backyard." *Camera* (Jan., 1977)

"Japan." *GEO* special (12 June, 1985)

"Japan." *Photographer's Companion* (2003)

"Just Another Ordinary Different Place." *Los Angeles Times Magazine* (8 March, 1992)

"Krill: Untapped Bounty from the Sea?" *National Geographic* (May, 1984)

"L'envoye Tres Special." *Newlook* (April, 1994)

"Le Japon Nu." *GEO* (18 Aug., 1980)

"License To Conceal." *TIME* (27 March, 1995)

"Life After John Denver." *Woman's Day* (9 Nov., 1992)

"Magic Trick Moves Out of the Lab and Into our Everyday Lives." *Smithsonian* (July, 1984)

"Master of Equipoise." *Quest/80* (April, 1980)

"Maui: Hawaii's Valley Isle." *National Geographic Traveler* (Spring, 1984)

"Miami's Art Deco District." *National Geographic Traveler* (Jan./Feb., 1994)

"Moby Dick Lasst Grussen." *Stern* (27 Oct., 1983)

Multiple articles. Qantas' *Antipodes* (1990)

A gift from Corinne Ching · Photographs by Paul Chesley 2012 Calendar

Los Angeles Times Magazine

AN AMERICAN IN TOKYO

A SEARCH FOR THE SOUL OF JAPAN

BY JONATHAN RAUCH

Multiple articles. Continental Airlines' *Pacific Travelogue* (1987)

"My Brother in Arms." *Rolling Stone* (24 March, 2005)

"No Walk in the Park." *National Geographic* (May, 2002)

"Nordic Portfolio." *Ski Canada's 1979 Cross Country Annual* (1979)

"On a Mission from God" and "Pohnpei Magic." Continental Airlines' *Pacifica* (Summer, 1994)

"On The Wing." *Camera* (May, 1977)

"Paul Chesley: Have Camera, Will Travel." *Thai Accent Lifestyle Magazine* (Feb., 1993)

"Paul Chesley's Japan." *Nikon World* (Feb., 1976)

"Photographer Paul Chesley: A Portfolio of his Work." *Holoholo: The Magazine of Island Air* (Sept.-Nov., 2008)

"Remembering the River of Dreams." Continental Airlines' *Pacific Travelogue* (1990)

"Saipan" and "Beachcomber Days." Continental Airlines' *Pacifica* (Autumn, 1993)

"Scoop Images, Photographers Aspen." *Photo Magazine* (June, 1990)

"Seafood Summit." *Oceans* (Oct., 1986)

"Shooting the Divide." *Aspen, the Magazine* (Fall, 1981)

"Sing a Song of Songsong: The Mystique of World War II Still Lingers on Saipan, Tinian and Rota." Continental Airlines' *Pacifica* (1992)

"Something to Read in the Baths." *Aspen, the Magazine* (Fall, 1977)

"Special Report/Pacific Rim." *Fortune* (7 Oct., 1991)

"Spielplatz der Natur." *GEO* special (6 Dec., 1993)

"Spring's Top Getaways." *San Jose Mercury News* (12 March, 1989)

"Survival is No Fluke." *National Wildlife* (Oct.-Nov., 1978)

"Taking the Plunge." *Discovery* (March, 1982)

"The Outside Trip-Finder." *Outside* (Feb., 1995)

"The Aspen Alternative." *American Photographer* (Jan., 1988)

"The Call of Sirena." Continental Airlines' *Pacifica* (1992)

"The Fast Track." *Science 81* (July/Aug., 1991)

"The Flight of the Dragonfly." *Air & Space* (Oct.-Nov., 1986)

"The Japanese Love to Bake Themselves in Beppu's 'Hells'." *Smithsonian* (July, 1980)

"The Journey Into the Heavenly Paradise Islands." Continental Airlines' *Pacifica* (1992)

"The Microbe Miners." *Audubon* (Nov./Dec., 1994)

"The Power of Letting Off Steam." *National Geographic* (Oct., 1977)

"The Preposterous Puffer." *National Geographic* (Aug., 1984)

"The War for the West." *Newsweek* (30 Sept., 1991)

"Time Off in Japan." *East West* (Spring, 1985)

"Un Jourau Japon." *Photo* (June, 1986)

"Unbreakable Bonds." *The Denver Post* (11 May, 1997)

Various articles. Continental Airlines' *Pacifica* (Winter, 1994)

"Wasser - Leben - Umwelt." *GEO* special (7 Nov., 1988)

"Weathermen's Lab is a Rocky Mountain High." *Smithsonian* (April, 1982)

"Welcome to Aspen." *LIFE* (Dec., 1989)

"Whalewatching in the World." *BBC Wildlife* (June, 1988)

"What Does Not Kill Me Makes Me Strong." *GQ* (March, 1992)

"Wo die Natur der Sieger Bleibt." *GEO* special (12 Aug., 1987)

"Woman Alive: Self Discovery in Yellowstone National Park." *Quest/77* (Nov./Dec., 1997)

"Wunder Aus Feuer Und Wasser." *GEO* (Feb., 1992)

"Yellowstone Abstractions." *U.S. Camera* (Fall, 1977)

"Yellowstone." *Travel & Leisure* (Jan., 1982)

BOOKS

24 Hours in Cyberspace. California: Que Macmillan Publishing, 1996.

A Day in the Life of Africa. San Francisco: Tides Foundation, 2002.

A Day in the Life of America. New York: Collins Publishers, 1986.

A Day in the Life of California. San Francisco: Collins Publishers, 1988.

A Day in the Life of Canada. Ontario, Canada: Collins Publishers, 1984.

A Day in the Life of China. San Francisco: Collins Publishers, 1989.

A Day in the Life of Hawaii. New York: Workman Publishing Company, 1984.

A Day in the Life of Ireland. San Francisco: Collins Publishers, 1991.

A Day in the Life of Israel. San Francisco: Collins Publishers, 1994.

A Day in the Life of Italy. San Francisco: Collins Publishers, 1990.

A Day in the Life of Japan. San Francisco: Collins Publishers, 1985.

A Day in the Life of Spain. New York: Collins Publishers, 1988.

A Day in the Life of Thailand. San Francisco: Collins Publishers, 1995.

A Day in the Life of the Soviet Union. New York: Collins Publishers, 1987.

A Day in the Life of the United States Armed Forces. New York: HarperCollins, 2003.

A World Between Waves. Washington, DC: Island Press, 1992.

Along the Continental Divide. Washington, DC: National Geographic Society, 1979. All photographs by Paul Chesley.

America Then & Now. San Francisco: Cohen Publishers, 1992.

America's Hidden Corners, Places off the Beaten Path. Washington, DC: National Geographic Society, 1983.

America's Wild Woodlands. Washington, DC: National Geographic Society, 1985.

Aspen: Portrait of a Rocky Mountain Town. Aspen, CO: Who Press, 1992.

Bangkok. Singapore: Editions Didier Millet, 1994. All photographs by Paul Chesley.

Beijing in Focus. China: Foreign Affairs Office of Beijing, 2000.

Beyond the Horizon. Washington, DC: National Geographic Society, 1992.

Blue Horizons. Washington, DC: National Geographic Society, 1985.

Borobudur. Singapore: Archipelago Press, 1990.

Bot. Netherlands: Uitgeverij De Geus bv, 1993.

Colorado. New York: Fodor's LLC, 2003. All photographs by Paul Chesley.

Das Bild Der Welt. Hamburg, Germany: GEO, 1996.

Das War 83. Hamburg, Germany: Stern, 1984.

Das Waren die 80er Jahre. Hamburg, Germany: Stern, 1989.

Discovery: The Hawaiian Odyssey. Honolulu: Bishop Museum Press, 1993.

Driving Guides to America: The Rockies. Washington,

DC: National Geographic Society, 1996.

Earth Science. Lexington, MA: DC Heath and Company, 1985.

Encyclopedia of Sacred Places. Santa Barbara, CA: Oxford University Press, 1997.

Excursion to Enchantment. Washington, DC: National Geographic Society, 1988.

Exploring America's Backcountry. Washington, DC: National Geographic Society, 1979.

Exploring Your World: The Adventure of Geography. Washington, DC: National Geographic Society, 1989.

Field Guide: Secrets to Making Great Pictures. Washington, DC: National Geographic Society, 1999.

Focus on China: Photos by Foreign Photographers. China: China Photography Publishing House, 1999.

Fodor's '96, Australia & New Zealand. New York: Fodor's Travel Publications, Inc., 1995.

Fodor's Thailand. New York: Fodor's Travel Publications, Inc., 1997.

Fodor's Hawaii. New York: Fodor's Travel Publications, Inc., 1991.